"唯物思维"首届国际当代材料艺术双年展作品集

"Material Thinking" 1st International Contemporary Material Art Biennale Catalogue

主　编　张敢
Chief Editor　Zhang Gan

执行主编　梁开
Executive Chief Editor　Liang Kai

中国建筑工业出版社

序一 /Preface I

塔特林用钢铁和玻璃为第三国际构建纪念塔(1919-1920)时,提出使用"真实的材料在真实的空间中",虽然这项设计成为未竟的事业,但"塔特林塔"却成为人们心中一座象征着理想主义的艺术丰碑。百年后的今天,随着时代的发展和科技的进步,我们对物质世界的认识更加丰富和深入,唯物主义再次出发,一股新唯物主义的浪潮兴起,它让我们重新理解物质,重新重视物质因素在塑造社会和表达人类愿景中的作用。

新唯物主义着眼于最新的物理学、生物学研究成果,重新审视我们对物质的惰性认识,赋予其能动、偶发、灵性的一面。它思考物质性是如何塑造我们的生活,以及我们与自己、与他人、与世界的关系,反思现代性所主张的人类中心主义,从而转入后人类主义的生态发展语境。着眼于当代艺术的发展,我们提出回到材料,重新建构和理解当代艺术,既是对当代艺术中过分强调观念的一种反拨,也是希望通过材料的视角打开不同的可能,期待不同的声音。

展览主题"唯物思维"与英文主题 Material Thinking 相辉映,既体现了"新唯物主义"视角下物质材料的主体性和能动性,也希望将唯物的思维方式和质性的研究方法引入当代材料艺术的探索中。这种"唯物思维"的方式与中国传统文化中的"天人合一""齐物""格物致知"等观念不谋而合,艺术家由此在"物我两忘"中完成艺术创作。这种物质与生命一体化的认知方式也升华了我们对作品的物性存在的认知:艺术家以形式开启质料,从而敞开了一个世界,并把我们卷入其中,进入一种"神与物游"之境。

同时,材料语言是一种共通的语言,一旦被赋予具有表现力的艺术形式,就可以打破不同语种的隔阂和观念的樊篱,让平等的沟通与对话成为可能。因而当首届国际当代材料艺术双年展作品征集信息发布后,我们欣喜地收到了来自全球80个国家和地区的两千余件报名作品。国际同行的认同和支持也让我们感到以"材料的视角"和"物的维度"来建构当代艺术的新路径、新理论与新格局的前景与可能。特别是在全球疫情维艰的岁月里,这场双年展由发起到筹备、再到最终落地举办历时3年有余,其能在艰难困苦之中玉汝于成、破茧成蝶,既得益于各国艺术家、学者对这项事业的鼎力支持,也更因其揭示了一种趋势,合乎艺术发展之逻辑与真谛。

伟大的艺术作品是民族的,也是世界的。我们希望通过"唯物思维"国际当代材料艺术双年展的创办为各国艺术家、学者提供持续的交流与研究平台,分享和借鉴不同民族、不同国家的艺术成果,在材料艺术的探索中凝聚人类共同体的生命情感与智慧。祝愿这场发轫于清华大学的国际材料艺术运动能够带着世界各国艺术家和学者对材料艺术的热爱共建新时代的艺术之塔、理想之塔与心灵之塔。

彭刚 教授
双年展总策划
清华大学副校长

With the notion of using "real materials in real space", Vladimir Tatlin used steel and glass to construct the monumental tower for the Third International (1919-1920). Although his design was never fully realized, Tatlin's Tower continues to stand as a symbol of utopian aspirations in people's hearts. Today, a century after the tower's conception, we have a richer and deeper understanding of the material world because of the developments of modern society and science. In this new era, we are thrilled that a wave of what we call New Materialism has emerged, which encourages us to reopen the issue of matter and to give material factors their due in shaping society and human prospects.

New Materialism focuses on the latest physics and biological research, and transforms the understanding of matter as an inert substance into that of living matter - which is active, creative, productive, and unpredictable. It re-examines the influence of materials shaping our everyday relationships to others, to ourselves, and to the world. We propose to reconstruct the perception of contemporary art from a material perspective, which is not only a response to the current overemphasis on concepts in the contemporary art world, but also a way to open up new possibilities through the lens of materials. We also welcome different voices and minorities that have been previously marginalized by mainstream art discourse.

Material Thinking is the fundamental concept of the exhibition, which focuses on the subjectivity and dynamism of materials, and introduces qualitative research into the exploration of contemporary material art. Material Thinking is, in part, inspired by traditional Chinese cultural concepts which explore the unity of man and nature, the equality of all things, and the acquisition of knowledge through the observation and comprehension of life experiences. The artist thus completes the artistic creation by integrating "self" with matters. The way of perceiving the integration of matter and life directs our perception of the physical existence of a work of art: the artist enlightens materials with forms, opening up a world where the minds and imaginations can freely engage with the art objects.

Meanwhile, the language of materials is a universal language, and once it is given a form through works of art, it can break down the barriers between different languages and conceptions, making universal communication and dialogue possible. Thus, when the call for works for the 1st International Contemporary Material Art Biennale was released, we were delighted to receive more than 2000 submissions from 80 countries and regions throughout the world. The recognition and support from our international colleagues deeply empowered our vision and inspired the courage to construct new paths, new theories, and new patterns of contemporary art through "material perspective" and "the dimension of materiality". This biennale, which was launched amid the global pandemic, took more than three years to be realized - from its initial conception and long preparation to the final event. Its success, in the midst of hardships and difficulties, is due to the full support of artists and intellectuals from all over the world, but also because it reveals a trend that is in line with the logic and inner truth of artistic development.

Great works of art belong to both their nations and the whole world. We hope that by establishing the International Contemporary Material Art Biennale, we will be able to provide a platform for artists and scholars from different countries to continuously exchange and research ideas - where they can share the artistic achievements of different peoples and countries, and express the emotions and wisdom of the human community through the exploration of material art. We hope that this international material art movement, initiated by Tsinghua University, will bring artists and scholars from all over the world together to build a tower of art - celebrating ideas, imaginations and creativities inspired by this new era defined by love for material art.

<div align="right">

Prof. Peng Gang
General Director of the Biennale
Vice President of Tsinghua University

</div>

序二 /Preface II

2022年，正值清华大学美术学院建院66周年之际，"唯物思维"首届国际当代材料艺术双年展——一个崭新的关于当代艺术的国际展事正式出发，在开启当代艺术新气象的同时也是一种历史的必然。清华大学美术学院的前身是中央工艺美术学院，老"中央工艺"的底色为学院新时期美术与设计的发展奠定了扎实的基础：一种基于材料的艺术认知。从光华路到清华园，清华大学的艺术与科学交融的视野，以及跨学科交流与研究的优势，为材料艺术的生发提供了历史底蕴、学科基础和国际视野。

如今，以"中国当代材料艺术国际交流展"为契机，我们发起"国际当代材料艺术双年展"，以材料视角重新审视当代艺术，让艺术创作重新重视物质的力量以及它在我们日常生活/经验中形成的方式，思考从物质材料到艺术媒介的转化过程，并在这个过程中逐渐展开历史的、生命的、社会的不同维度，在材料探索中重构当代艺术的新视野。展览自2019年末萌发筹备，虽受全球疫情的影响，但我们仍成功举办了与乌拉圭、阿根廷、波兰、西班牙4个国家的线上交流展。这些线上展览在国家之间的深入交流中，深化了我们对材料艺术的认知和理解，为双年展的落地实施积蓄了学术力量和国际影响。

我们提出以"材料、新材料与新唯物主义"的哲学视野为展览构建理论基础，希望在学术层面促进国际当代材料艺术的发展。这里的"新"材料，不仅包括随着科技发展新增或新发现的材料，也指以新的方式和视角重新理解材料，反思材料使用和现代人类生活之间关系，以及探索网络时代的人类如何通过材料与物质世界相连。在新唯物主义者眼中，物化是一个复杂的、多元的、相对开放的过程。人类完全沉浸在物化生产的偶发事件中，因而应给予物质性应有的地位，继而以此介入对社会政治的分析和再思考。由此，新唯物主义为当代材料艺术理论与价值的建构提供了哲学视野和学术前沿的支持。

截至2021年底，双年展收到了来自全球80个国家和地区的两千余件报名作品，经国际评委会评审，最终确定展出作品为168件/组，涉及来自亚洲、欧洲、美洲、大洋洲、非洲的58个国家和地区，严格的国际评审和广泛的全球参与为这个新出发的展览打下了扎实的基础。同时，与之相契合的理论构建也是提升展览学术品质的重要部分，于是我们发起了与展览同期举办的学术论坛，邀请全球学者、艺术家共同参与到关于当代材料艺术的历史与理论探讨中，共建当代材料艺术的学术品牌与理论高地。

该展览以双年展的机制不断推出新人力作令人期待，其在丰富国际当代材料艺术视野的同时，引领新时代艺术的潮流与发展。然而，对于一个刚出发的展览来说，实现自己的使命仍然任重道远。千里之行，始于足下，愿"唯物思维"国际当代材料艺术双年展暨学术研讨会能够行稳致远，绽放出更多艺术的光彩和思想的光辉。

马赛 教授
双年展学术主持
清华大学美术学院院长

In 2022, coinciding with the 66th anniversary of the founding of the Academy of Arts and Design, Tsinghua University, "Material Thinking" 1st International Contemporary Material Art Biennale is officially launched. This brand new international contemporary art exhibition is a historical necessity and simultaneously a prelude to a new phase of contemporary art in China. The Central Academy of Arts & Crafts was transformed into the Academy of Arts and Design, Tsinghua University in 1999. Prior to this transformation, the Central Academy of Arts & Crafts laid a solid foundation for the development of art and design at the academy, or more specifically, for the material-based cognition of art. From Guanghua Road to Tsinghua Campus, the vision cultivated at Tsinghua University, which focuses on the fusion of art and science, and on the advantages of interdisciplinary communication and research, has provided the historical heritage, disciplinary foundation, and international perspective for the development of material art.

Today, taking the opportunity from the Chinese Contemporary Material Art International Exchange Exhibitions, we launch the International Contemporary Material Art Biennale to celebrate contemporary art from the perspective of materials. We want to emphasize the power of matter in art creation, and to demonstrate the role of matter in our daily lives and experiences. More than that, the Biennale is a vehicle through which we may consider the processes involved when physical materials are transformed into art media. Various aspects of history, life and society are revealed during such observation, and a new vision of contemporary art presents itself through the exploration of materials. Preparations for the Biennale began at the end of 2019. Despite the impact of the global pandemic, we successfully held online exchange exhibitions with four countries: Uruguay, Argentina, Poland, and Spain. These online exhibitions have expanded our horizons and provided us with more concrete insights into material art through in-depth communication with artists worldwide. In addition, the accumulation of academic strengths and international influence through this process has facilitated the smooth launch of the Biennale.

We have chosen "Materials, New Materials and New Materialism" as the theoretical framework of the Biennale. We propose this philosophical vision with the aim of academically promoting international contemporary material art. The "new" materials we refer to include not only novel or newly discovered materials, due to technological breakthroughs, but also refer to the use of materials in new ways and perspectives. These perspectives reflect on the relationship between the use of materials and modern life, and they explore new connections between human beings and the material world in our Internet age. For a new materialist, materialization is a complex, diverse, and relatively open process. Human beings are completely immersed in the process of materialized production, so materiality should be given its due status, and should be involved in social and political analysis and reflection. New Materialism provides a philosophical vision and serves as the academic frontier for the development of the theory and the appreciation of the value of contemporary material art.

By the end of 2021, the Biennale had received over 2,000 applications from 80 countries and regions around the world. After a review by an international panel of judges, 168 works were admitted from 58 countries and regions, including Asia, Europe, America, Oceania and Africa. The meticulous international evaluation and extensive global participation offered an unconditional guarantee of quality and diversity in the Biennale. At the same time, theoretical artistic research is also considerably beneficial to the academic quality of the Biennale. Therefore, we launched an academic forum to be held concurrently with the exhibition, inviting scholars and artists from all over the world to participate in historical and theoretical discussions on contemporary material art. Through the holding of the symposium, we hope to develop an academic brand which will serve as a theoretical reference point for the contemporary material art world.

The biennial exhibition fills us with great excitement because it will continuously serve to introduce new masterpieces of art, as well as new artistic talents. While enriching our vision and understanding of contemporary material art, the exhibition helps to lead and showcase the trends and developments of contemporary art in the new era. There is still a long way to go, of course, for an exhibition that has only started to realize its mission. But a journey of a thousand miles, after all, begins with a single step. We hope that the "Material Thinking" International Contemporary Material Art Biennale & Symposium will leave a lasting mark on the contemporary art world, and will be a platform through which artistic and intellectual brilliance will thrive.

<div style="text-align: right;">
Prof. Ma Sai

Academic Host of the Biennale

Dean of Academy of Arts & Design, Tsinghua University
</div>

策展引言 /Curatorial Statement

在当代艺术中，"物的转向"已成为一种潮流，也是对20世纪60年代中叶到70年代初西方艺术中掀起的去物质化思潮及其追随者的一种反拨。不过，我们举办"唯物思维"国际当代材料艺术双年展的初衷绝非对这种潮流的迎合，而是顺应向艺术本体回归的趋势。"新唯物主义"哲学构建了一个关于"物质"的本体论，同时也与中华民族传统的"天人合一"思想相契合。我们将展览的中文主题定为"唯物思维"，既是对新唯物主义哲学的回应，同时也强调其仍是一种思维与认知方式。英文主题"Material Thinking（材料思考）"则突出物质的主体性与能动性。"材料艺术"这一名称的采用更强调"材料"的生成性，无论在英文还是中文的词义中，都有成为"一块儿材料"的构成涵义。

我们希望通过"唯物思维"国际当代材料艺术双年展暨学术研讨会，以及艺术家与理论家的持续探索和积累，为世界展现物质的无限可能性与独特性。本次展览共分为五个部分，分别是材料与形式、材料与观念、材料与身体、材料与性别和材料与可持续发展，它们代表了目前我们对当代材料艺术的思考。

优秀的艺术作品是内容与形式的完美结合，然而，作为承载媒介的材料往往被人们所忽视。艺术创作的过程是一个综合系统，艺术家需要锤炼形式、思考主题和探索材料，即使已经形成自己成熟风格的艺术家，也不会停下探寻的脚步。比如顾黎明和沈烈毅，他们就不约而同地将目光转向了石材。顾黎明受元代画家赵孟頫的画作《鹊华秋色》的启发，专程到济南东北的鹊山和华不注山，采用传统拓片的方法，用宣纸直接在自然中的岩石上拓印，以捕捉其丰富的肌理和质感，继而采用拼贴的手法来表现古人山水画的意境。这种超越中西绘画边界的尝试是非常有挑战意味的。沈烈毅则对用坚硬石材来表现柔软的水波感兴趣，他采用山西黑花岗石，结合精湛的雕琢和细腻的打磨，将两种极端的物质融为一体，相互映衬。可以说，沈烈毅的作品是对某一特殊材料特性的一次大胆尝试。

展览中，艺术家们对材料领域的探索已经广泛到超出我们的想象，他们会让那些我们熟视无睹的材料焕发出新的生机和光彩。同为纸媒材，王雷采用了搓绳编织的方式，李洪波采用了粘连拉伸的方式，原博采用了融铸重塑的方式，形式所带来的是对材料新的理解和开启，伴随着的是不同的文化认知和理念表达。芬兰参展艺术家亚内·佩尔托坎加斯创作的《众神系列之风神》，用回收的铁料进行创作，采用了北极地区土著民族的传统萨米手工艺。艺术家通过对飘浮在北极粗糙的旷野上的一片雪花的塑造表现了萨米神话中的风神形象，敏感而脆弱、空灵而飘渺，体现了其在艺术创作中物质、工艺、环境、文化、精神相统一的哲学思考。艺术家们对材料特性的探索为全新的形式语言的创造提供了可能。

艺术中的观念包含了艺术家对主客观世界的形而上的思考。但是，艺术不等于哲学，形式才是艺术呈现的最终形态，这里我们再次回到作为载体的材料。因此，材料与观念同样成为艺术家探索的领域。伴随着现代性发展所导致的膨胀的人类中心主义，人的主体性在哲学上的确立也让物质与自然客体化，此时，人只能获得关于物的现象和知识，却无法抵达物的本真。新唯物主义哲学所建构的基于物质的本体论其实并不难理解，它与"天人合一""万物有灵""万物直观人"这类概念本身并没有本质差异。现代文明所构建的科学和理性的方式无法抵达物之真谛，诉诸信仰又过于神秘，也许艺术可以达到，因艺术通过感性之物的开启，让物成为物，呈现出它与人之生存空间、生命现实、生活体验的真实关联。

In contemporary art, "material turn" has become a trend and is a response to the dematerialization trend in Western art from the mid-1960's to the early 1970's. Our intention, however, in organizing the *"Material Thinking" International Contemporary Material Art Biennale* is not to pander to this trend, but to return to the essence of art. The philosophy of *New Materialism* is based on the ontology of "matter" and corresponds to the traditional Chinese philosophy that emphasizes the unity of man and nature, and of heaven and man.

We can compare the subtle difference in linguistic meaning between the Chinese and English expressions of our theme "Material Thinking". The Chinese theme of the exhibition is a response to the philosophy of *New Materialism*, emphasizing and respecting that it is a way of thinking and cognition. The English theme "Material Thinking" highlights the subjectivity and vitality of matter. The term "material art", in both English and Chinese, emphasizes the process of "becoming" of any particular "material", or, in other words: "matter becoming a piece of material".

Through the *"Material Thinking" International Contemporary Material Art Biennale and Symposium*, we aspire to demonstrate the infinite possibilities and uniqueness of materials to the world. This is especially possible because of the continuous exploration by the artists we have gathered here, and the input of art theorists, who are all a vital part of this Biennale. The exhibition is divided into five thematic segments: material and form; material and concept; material and body; material and gender; and, material and sustainability. These segments represent our current perspectives on contemporary material art.

Excellent artworks are a perfect combination of content and form, but the material as the carrying medium is often overlooked. Art creation is a varied process, unique to each individual artist, wherein they must refine forms, think about themes, and explore materials. Even artists who have developed their own mature styles never stop exploring. An example of such exploration is that of artists Gu Liming and Shen Lieyi, who turned their attention to stone. Inspired by the Yuan Dynasty painter Zhao Mengfu's painting "Autumn Colors of Que-Hua Mountain", Gu Liming made a special trip to Que Mountain and Hua-Bu-Zhu Mountain, northeast of Jinan. The artist embraced the traditional method of topography, using Xuan paper to topographically capture rocks in nature, which showcased the rocks' rich texture; he then used a collage technique to express the mood of ancient landscape paintings. This attempt to transcend the boundary between Chinese and Western painting is very challenging. Shen Lieyi, on the other hand, is an artist interested in using hard stone to express soft water waves. He uses Shanxi black granite, combining exquisite carving and delicate polishing to blend the two extremes of matter (stone and water) into one - reflecting each other. It can be said that Shen Lieyi's works are a daring attempt to understand the characteristics of a particular material.

The artists in the exhibition have explored the field of materials more extensively than we can imagine, and they give new life and brilliance to those materials we are familiar with. When it comes to art made from paper, Wang Lei uses a twisting and weaving technique, Li Hongbo uses a sticking and stretching technique, and Yuan Bo uses a fusion and reshaping technique. These artistic methods bring new understandings to paper as an artistic medium, and they inspire different cultural perceptions and conceptual expressions of paper. *Ipmil No5 / Bieggagállis* by Finnish artist Janne Peltokangas is created from recycled iron, using the traditional Sami craftsmanship techniques of indigenous Arctic people. Through the shaping of a snowflake floating in the rough Arctic wilderness, the artist expresses the image of the wind god in Sami mythology. Sensitive, fragile, and ethereal, the artwork communicates his philosophical reflection on the unity of materiality, craftsmanship, environment, culture, and spirituality within artistic creation. The artists' explorations of the above-mentioned materials offer possibilities for creating new artistic languages in form sculpting.

A piece of art contains the artist's metaphysical reflection and conceptualization of the subjective and objective worlds. However, art is not the same as philosophy because art is tangible or sensory, and, in the case of material art, it is the form that is the final artistic presentation. Here, we must emphasize again the material as the carrier. Material and concept merge into the same field of exploration for the artist. Along with the development of the modern world, humanity has adopted an inflated anthropocentricity, and

因而，在艺术创作中，观念与材料之间就存在着一种辩证关系，观念因材料而彰显，材料因观念而富有深意。从这个角度讲，王家增的《物的褶皱》系列作品就是极具代表性的。他所选用的废旧的钢铁材料联系着曾经的工业时代和他个人经历的故事，这些冲压、塑形的钢铁既保有它们原本坚硬的个性，同时又被适合在一个难以逾越的框架之中。挪威艺术家奥西尔·伯顿的装置作品《丢失的事件》，由一系列混凝土铸件和回收的铝铸件构成，混凝土浇筑的是艺术家继承的衣物，回收的铝则被铸造成一些仿木制品穿插其中，我们无需知道艺术家本人及挪威国际铝业集团创始人的故事，也能从作品中感受到过去的"在场"和记忆的"味道"。白俄罗斯艺术家谢尔盖·贝罗基的作品《我们每天的面包》，5个"面包"中，一个是真实的面包，另外四个是包裹着纸币的透明树脂面包。作为食物的面包随着时间逐渐发霉、碎裂，而包含金钱的树脂面包却拥有了某种闪亮、永恒的特质。艺术家在材质的对比中敞开了关于真实与虚假、短暂与永恒、物质与金钱等问题讨论。

可见，作品所带来的思想观念的传达与讨论都不是刻意的，而是伴随着材料的物性存在自然生成，它不诉诸于概念理性的言语，却有足够深沉而动人的感性力量。康德说，人是自己的目的，那么，在艺术中，物质材料也是自己的目的，而非形式或观念的附庸或载体。一个卓越的艺术家绝不会认为自己作品中的材料是随意的、无足轻重的，如不建立物性根本之思，无以成就伟大的艺术作品。

美国学者简·罗伯逊与克雷格·迈克丹尼尔在他们合著的《当代艺术的主题》一书中，将当代艺术概括为七个主题，其中之一就是"身体"。但很多创作与理论仍将身体视为艺术的符号、概念的工具或表演的载体，与他们对物质材料的态度别无二致。我们如何开启艺术中的身体，其实与如何开启艺术中的物质材料一样，因为身体也是一种物。客体化和工具化的态度和方式显然无法开启灵性的身体，唯有在主体间（身体与身体/物）的互动和关系中，身心方能融合在一起，在艺术创作中展开绵延的生命之力，此时，身体亦是作品物性存在的一部分。

早在20世纪60年代，过程主义和后极简主义的艺术家们就在艺术创作中展开了材料与身体的探索。其中，罗伯特·莫里斯以工业毛毡为材料进行了一系列雕塑创作。他认为毛毡具有解剖特性，与人体相关联，像皮肤一样；同时它随着重力、压力、平衡和触觉而成形。莫里斯对毛毡材料的探索凸显了身体与材料的互动所具有的感性、偶发、随机、暂时的特质，他强调这是"让它成为自己的过程"。这些艺术家的探索在当时无疑是反传统、反主流的，尤其是面对现代主义所建构的抽象的、观念的、自足的、理性的艺术"正统"。但他们对材料与身体的探索至今仍具洞见性，因其将材料与身体置于艺术创作的主体地位，并注意到感性、偶发及过程的重要意义。

法国艺术家艾迪·伯纳德的作品多以麻纤维手工纸进行创作，在与这种植物材料长期的接触、互动、交流中，她感受到其中所蕴含的生命力及其与身体的密切关联。她的作品《野性的纸》是一件纸雕塑，特别的是，身体也是这件作品展示的一部分。当艺术家穿着这件纸作品翩翩起舞的时候，这种物质存在所具有的感官特质、自然力量与生命之力一起涌现，让植物世界与人类世界在此相遇。艺术家希望通过这件"舞蹈的"作品彰显其对于移动的锚、相互渗透的宇宙、相互联系的领域之思，身体成为作品的一部分，成为可移动的"根"，链接了人与自然。丹麦艺术家、学者夏洛特·厄斯特加德的作品则是她对人与物质关系研究课题的艺术探索。她在作品《羁绊》中邀请设计师、舞者和观众的加入，让他们以不同的方式穿着、穿越、改变这件作品，具身化地感受人本身、人的身体、物质及其超越性，以及诸者之间影响与被影响的羁绊关系，让作品在人与物质之间的动态关系中成长。

we have seen the establishment of human subjectivity in philosophy. Thus, we have objectified matter and nature, at which point one can only acquire stimulation from things and knowledge about things, but one cannot reach the truth of things. The material-based ontology constructed by the new materialist philosophy is not difficult to understand, and it does not differ fundamentally from such concepts as "the unity of heaven and man", "everything is spiritual", "everything is intuitive", "celestial unity", "animism", and "all things are intuitive". The scientific and rational approach constructed via modern civilization cannot reach the truth of things, and the truth is too mysterious to find through faith alone. Perhaps art can reach the truth, because art releases the sensuality of things; art lets "things" be "themselves", presenting their real connection with a living space, life's reality, and the life experience of human beings.

In art creation, there exists a dialectical relationship between concept and material, where a concept is revealed through the material, and the material becomes profoundly meaningful through the concept. From this perspective, Wang Jiazeng's series "The Fold of Things" is very representative. The scrap steel materials he uses are linked to the industrial era and to his personal story. The stamped and shaped steel retains its original hardness and character, but at the same time is fitted into an impenetrable framework. Norwegian artist Åsil Bøthun's installation "Lost Affairs" consists of a series of concrete castings and recycled aluminum castings; the concrete castings are of the artist's inherited clothing, and the recycled aluminum castings appear interspersed with faux woodwork. Without knowing the story of the artist and the founder of the Norwegian International Aluminum Group, we could still feel the presence of the past and experienced a taste of his memories from the work. The artwork "Our daily bread..." by Belarusian artist Sergei Belaoki features five "loaves" - one real loaf of bread, and four transparent resin loaves wrapped in banknotes. While the bread as food grows moldy and crumbles over time, the resin bread containing money possesses a certain shiny, timeless quality. Through the contrast of his materials, the artist inspires a discussion on the issues of truth and falsity, transience and eternity, and matter and money.

It is evident that the communication and discussion of ideas inspired by the works of art are not deliberate, but naturally generated along with the artistic existence of the materials. We are not just inspired by concepts or rational words, but by a deep, moving, and sensual power. If Kant said that man is his own purpose, then, in art, materials are also their own purpose, and are not a subordinate or meaningless carrier of forms or ideas. A remarkable artist will never consider the materials in his works to be arbitrary and insignificant. If he does not establish a fundamental conceptualization of materiality, he will not be able to achieve great works of art.

In their book *Themes of Contemporary Art*, American scholars Jane Robertson and Craig McDaniel outline seven themes in contemporary art, one of which is the "body". Many art creations and art theories view the body as a symbol of art, a conceptual tool, or a vehicle for performance, with the same views applied to materials. How we present the body in art is in fact the same as how we present the material in art, because the "body" is also an object. However, we cannot reach the spiritual "body" through cerebral objectification. Only through the interaction and relationship between subjects (body and body/object) can body and mind merge to create a continuous life force of artistic creation. When this happens, the spiritual body is also a part of the physical existence of the work.

As early as the 1960's, process and post-minimalist artists explored materials and the body in their artwork. Among them was Robert Morris, who created a series of sculptures using industrial felt as a material. He argued that felt has anatomical properties that relate to the human body, like skin; at the same time, felt is shaped using gravity, pressure, balance and touch. Morris' exploration of felt highlighted the sensual, episodic, random, and temporary nature of the body's interaction with the material, which he emphasized as "the process of letting it be itself". For Morris and artists like him, these types of explorations were undoubtedly anti-traditional and anti-mainstream at that time - especially in the face of the rational artistic "orthodoxy" constructed by modernism, which promoted abstract, conceptual, and self-sufficient art. However, this exploration of materials and the body remains relevant today, as it places materials and the body as the subjects of artistic creation, emphasizing the importance of sensuality, process, and episodicism (a philosophy of viewing life's events as unrelated, accidental fragments).

French artist Aïdée Bernard works mostly with handmade paper made of hemp fiber. In her long experience, interaction, and communication with this plant material, she feels the vitality contained in it and its close

其实，无论是这些身体直接参与展示的作品，还是身体未直接参与展示的作品，身体都是艺术作品物性敞开的不可或缺的部分，或者说艺术作品都是感性的、都是具身的。身体，连动着情感与生命之力，在与材料的互动乃至"纠缠"之中，通过艺术作品开启了一个生存的、体验的世界。因而，身体不是外在的，而是内在于艺术作品之中的，身体与材料不是对立的，而是在相互"纠缠"之中流变、生长、互启。

我们注意到，软材料及以往被视为具有工艺性质的材料可以容纳更多女性的、少数族群的声音。材料其实无分高低贵贱，但随着西方现代艺术的发展形成了纯粹的、自主的、独立的艺术话语来维持阶级和文化的划分，与女性和工艺相关的材料在这种划分中被贬低为装饰的、实用的、不独立自足的"次等"存在。随着女性主义艺术家的抗争与奋斗，更多女性主题的展览涌现，但这样的做法又走向另一个极端：让女性艺术家和女性艺术特殊化、标签化，有才华的女艺术家们绝不愿意被贴上强烈的性别标签，导致性别之间的隔绝和分裂。我想，材料艺术可以克服这种"不足"，真正实现在两性的互动和阴阳的平衡中的对话。

一种材料往往联系着特定的技艺与表现形式、群体与生存体验、历史与文化资源、认知与思维方式等，随着材料的拓展，不同的族群、不同的地域和不同文化的声音都将进入我们艺术交流的视野，构建更加多元、真实、平等的艺术世界，这也是"唯物思维"的应有之义。古巴参展艺术家纳蒂亚·迪亚兹·格拉薇兰在木质扶手椅上编织了一个正在"编织自己的女人"。作品中只见从摇椅上"生长"出来的四肢及翘着腿双手编织的动作，但我们知道这是一个女人，是每个家庭中的女性长辈，她在漫长的岁月和时光中编织着属于自己和家族的故事。乌拉圭参展艺术家玛丽亚·托兰德尔则用玻璃和大理石重新探讨女性气质，石头展现着女性坚实的灵魂，覆盖其上的玻璃则象征着脆弱、闪亮的特质，她将历史上著名女诗人／作家的诗句印在玻璃涂层上来展现女性精神世界的巨大能量。亚美尼亚青年艺术家利利特·斯捷潘尼亚用豆芽种植出了一个单词"BUT（但是）"，链接了女性与自然界的非线性结构、有机过程及直觉与感觉的相互作用。

还有更多艺术家的作品在不同材料的探索中触及到女性的生存体验与空间，她们没有声嘶力竭地呐喊，却在艺术的物性灵启中润物无声，让我们对女性的经验与价值感同身受、真切认同并肃然起敬，获得了人性的自我观照与自我圆满。

在前现代社会，人是自然的一部分，物质来源于大地，并回归于大地，并没有垃圾的概念。垃圾、污染、环境保护等概念是工业社会、科技进步、城市生活、现代文明的产物。商品以实用功能异化了物质，最终使物质变成了垃圾。而随着科技进步而产生的化学合成物导致这些"垃圾"难以降解，无法回归自然，造成环境污染。现代化和城市化让物质无法归"家"，人也无法归"家"。对物和物性的异化和扭曲，也即对人和人性的异化和扭曲。面对无法改变的现状和"回不去的故乡"，艺术是否可以改变对"垃圾"的态度？"垃圾"曾经是有实用价值的"商品"，在它不具备功能后重新回归放大的物质性，但这个物质性已非自然中的原初状态，它携带了人工状态、使用痕迹和历史记忆。如果以材料艺术的视角转换态度，这些"垃圾"可以"变废为宝"，成为艺术作品中的生成性"材料"，延长其物性存在的社会价值，被置于保存、保护、欣赏、展示的新空间和新语境中，在某种程度上实现可持续发展。

如今，塑料垃圾、纺织废品的污染是史无前例的。中国参展艺术家王绪远的作品《墨·影》即是以塑料垃圾为主材料，通过光与空间的错置，在宣纸上呈现出一幅广袤的冰山图。装置正面的静穆肃美与背面

relationship with the human body. Her work "Wild Paper" is a paper sculpture, in which the human body is a part of the presentation. When the artist wears this paper artwork and dances, the sensual qualities, natural power and life force of the hemp material emerge, allowing the plant world and the human world to encounter each other. Through this "dancing" work, the artist hopes to reveal her thoughts on the moving anchor, the interpenetrating universe, and the interconnected realms, where the body becomes a part of the work, a movable "root" that links man and nature. The work of Charlotte Østergaard, a Danish artist and scholar, is an artistic exploration of her research on the relationship between human beings and matter. In her work "Entanglements", she invites designers, dancers, and viewers to join her, allowing them to wear, travel through, and change the work in various ways. The artist seeks to embody the human being, the human body, matter and its transcendence, as well as the bonding and dynamic relationship between human being and matter.

It's important to note that whether these works directly involve the body or not, the body is an integral part of the physical existence of the artworks. In other words, the artworks are all perceptual and embodied. The body, which has the power of emotion and life, creates a world of existence and experience within the artworks, through its interactions and "entanglements" with the materials being used. Thus, the body is not external, but embedded in the artwork. The body and the material are not in opposition, but in mutual "entanglement" - they change, grow, and inspire each other.

Traditionally, soft materials and materials deemed as "crafty" in nature, tended to be associated with feminine or minority voices. Though there is no hierarchy of materials, Western modern art supported an art discourse which maintained class, gender, and cultural divisions. Materials associated with women and craft were relegated to a decorative, functional, non-self-sufficient, and "inferior" purpose. With the resistance and struggle of feminist artists, more female-themed art exhibitions have emerged, but this feminist approach has gone to the other extreme. The specialization and labeling of women artists and women's art, where talented women artists never want to be strongly gendered, has created isolation and division between men and women. I think that material art can overcome this division and truly encourage a dialogue and an authentic interaction between the two genders. Thus, we can balance the *yin and yang* within contemporary art.

A material is often linked to specific crafts and activities, groups and living experiences, history and cultural resources, cognition and attitudes, etc. With the expansion of the variety of materials, the voices of different ethnic groups, regions and cultures will enter our vision of artistic communication, building a more diverse, real, and equal art world. This new and welcome diversity helps to define the true meaning of "material thinking", which emphasizes the unity of man and nature, as well as the unity of our diverse humanity. Cuban artist Nadia Díaz Graverán weaved her artwork "Woman Who Weaves Herself" on a wooden armchair. The woven woman's limbs appear to grow out of the rocking chair - her hands knitting while her legs are crossed. We know that this represents a woman, the eldest woman in every family, who has been knitting her own story and that of her family over long years and vast amounts of time. Uruguayan artist Maria Torrendell revisits femininity with glass and marble. The stone reveals the solid soul of a woman, while the glass covering it symbolizes the fragile, shining quality on the surface. The artist prints the poems of famous female poets/writers from history on the glass coating to show the great energy of the female spirit. Lilit Stepanyan, a young Armenian artist, uses bean sprouts to grow the word "BUT", linking women to the non-linear structure of nature, organic processes, and the interplay between intuition and feeling.

There are more artists in this exhibition whose works touch on women's lives and experiences through the exploration of diverse materials. These works are not loud, but gently embellish the materiality and spirituality of art, allowing us to empathize with, truly identify with, and respect women's experience and value. We thus gain an authentic reflection and feel gratified about the essence of human nature.

Prior to the emergence of modern society, when man was a part of nature, and when matter originated from and returned to the earth, there was no concept of garbage. The concepts of garbage, pollution, and environmental protection are all products of industrial society, technological progress, urban life, and modern civilization. Various matter is turned into commodities, to be used for practical functions in modern life, and these commodities eventually become garbage. The countless chemical syntheses used

的凌乱堆砌形成鲜明的对比，引发人们对日常所见物品在不同的环境中所产生的截然相反的作用的思考。旅美英裔参展艺术家乔·汉密尔顿的参展作品《分层的闪亮岛》用回收的塑料垃圾改造成的"塑料纱线"和回收的毛线编织了一个躺在塑料海洋上的人体岛屿，引发对过度生产、污染和气候变化的反思。刚果（金）青年艺术家坎·萨鲁穆·卡霍亚和荷兰艺术家西比尔·黑恩都不约而同地采用了回收的易拉罐进行艺术创作，以不同的形式让人们忘记它们曾是废弃的材料，而是被错置的艺术物像。

还有更多艺术家以回收的旧报纸、书籍、茶叶袋等废弃的纸质材料进行创作，这些被使用过的材料所具有的历史痕迹与生活记忆也更加丰富了作品的物性表达。让这些沉默的、被排斥的、被掩盖的、被边缘化之物重新澄亮，回归生活的、经验的和意义的世界，在可持续发展之外，也折射着人类命运共同体的前途和路径。

事实上，当代材料艺术所引发的话题还有很多，每一个都值得拓展并做深入研究。作为一个展览，我觉得它的价值和意义在于提出问题，引发思考，总结现有的成果。我由衷地期待，随着"唯物思维"国际当代材料艺术双年展的日趋成熟，可以吸引更多艺术家、学者参与到我们的事业和讨论中来，不断丰富和积累关于当代材料艺术的成果和理论视野，为当代艺术的发展开启新的空间。

注：文中的"材料"指向物质材料，对非物质材料这里不做讨论。文中的"材料"一词等同于"物质"，不同的是，"材料"更强调"生成"含义。"材料"与"物质"不等同于"物"，"物"突出的是一种结果和状态，可以说"物"是由物质/材料构成的。对"物性"的理解可以参照对"人性"的理解，这里不做更多讨论。

张敢　教授
双年展总策展人
清华大学美术学院当代艺术研究所所长、《清华美术》主编

to create these commodities makes this "garbage" difficult to degrade, as matter has been permanently chemically altered. It cannot be returned to nature in its natural state, therefore causing environmental pollution. Thus, modernization and urbanization have made it impossible for matter to return to its "home" and, consequently, for people to return to their "home". The alienation and distortion of things and materiality is also the alienation and distortion of people and humanity.

Being faced with the unchangeable status of garbage and the idea of an "unreturnable homeland", can we still change our attitude towards "garbage" through art? Anything that is now considered "trash" was once a "commodity" with practical value, but after it ceased to function, it returned to an amplified materiality. And this "materiality" is no longer the matter that once had a natural state; instead, it is forever in an artificial state, and carries traces of use, and historical memory. If we change our attitude through the perspective of material art, this "trash" can be turned into treasure and become a generative "material" in art works, thus prolonging the social value of the material's existence. In addition, the works can be placed in new spaces and contexts for preservation, protection, appreciation, and display, and to some extent we can also achieve sustainable development in the art world.

Today, the pollution of plastic and textile waste is unprecedented. Chinese artist Wang Xuyuan's work "Ink - Shadow" is made from plastic waste as the main material. Through the positioning of light within the display space, the artwork presents a vast picture of icebergs on rice paper. The contrast between the quiet and solemn beauty of the front of the installation and messy "waste" piles in the back is striking, prompting people to think about the contrasting realities of objects they see every day in different environments. In her work "Stratified Shining Island", Jo Hamilton, a British-American artist, used recycled plastic waste (so-called "plarn") and recycled wool to weave a human island lying on plastic. The project is a reflection on overproduction, pollution and climate change. Young DRC artist Khen Salumu Kahoya and Dutch artist Sibyl Heijnen both coincidentally use recycled cans to create artworks. Because the artists have given the recycled cans new forms, viewers forget that they were once discarded materials - but rather seem like misplaced art objects.

There are more artists in our exhibition who use many other materials, such as recycled old newspapers, books, tea bags, and other discarded paper materials, to create their works. The historical traces and living memories of these used materials also enrich the physical expression of each work of art. These silent, rejected, concealed, and marginalized objects are thus allowed to shine again, and to return to the world of life, experience and meaning. These objects reflect the future and path of human destiny, human community, and they also, through being used once again, suggest sustainable development and practices.

There are many more topics inspired by contemporary material art, besides the ones covered in our exhibition, which are all worth expanding and doing in-depth research on. The value and significance of an exhibition lies in raising questions, provoking thoughts, and summarizing existing achievements. I sincerely hope that as the *"Material Thinking" International Contemporary Material Art Biennale* matures and grows, it can attract more artists and scholars to participate in our undertakings and discussions. We wish to continuously enrich and accumulate knowledge and theoretical vision about contemporary material art, and to open up new possibilities for the development of contemporary art.

Note: The term "material" in the text refers to physical materials; non-physical materials are not discussed here. "Material" in the text is equivalent to "matter", except that the word "material" emphasizes the process of becoming. "Material" and "matter" are not the same as an "object", because an "object" highlights a result and a state. It can be said that an "object" is composed of matter/material. The understanding of "materiality" can be referred to as the understanding of "humanity".

<div style="text-align: right;">
Prof. Zhang Gan

Chief Curator of the Biennale

Director of the Institute of Contemporary Art, Academy of Fine Arts, Tsinghua University

Editor-in-Chief of *Tsinghua Arts*
</div>

目录 /Contents

002 / 艾迪·伯纳德
野性的纸
Aïdée Bernard
Wild Paper

004 / 阿尔瓦罗·迭戈·戈麦斯·坎普萨诺
凤凰
Alvaro Diego Gomez Campuzano
The Phoenix

006 / 阿尔福斯·迪亚斯
阿里阿德涅之线
Alves Dias
O fio de Ariadne

008 / 安娜·约瓦诺夫斯卡
绿洲
Ana Jovanovska
OASES

010 / 安吉丽卡·卡斯蒂略
通往看不见的温暖之城
Angélica Castillo
Anima Mundi

012 / 安妮塔·布伦琴斯
Topolino
Anita Brendgens
Topolino

014 / 安娜·博雅杰娃
圆圈
Anna Boyadjieva
Circles

016 / 安娜·瓦格纳–奥特
建筑形式5号
Anna Wagner-Ott
Architectural Form #5

018 / 奥西尔·伯顿
丢失的事件
Åsil Bøthun
Lost Affairs

020 / 足立笃史
炎舞
Atsushi Adachi
Flame Dance

022 / 白明
器·形式与过程
Bai Ming
Appliance - Form and Process

024 / 白阅雨
折叠的空间·枯山水
Bai Yueyu
The Folded Space. Zen Garden

026 / 白紫千
生物发光体
Bai Ziqian
Bioluminescent Object

028 / 贝巴·奥西特
蓝色、灰色与红色方块
Baiba Osīte
Blue, Gray and Red Squares

030 / 巴图
游猎
Batu
Going On A Hunting Expedition

032 / 贝尼格娜·瓦拉·卡德兹·韦拉斯韦兹
精神空白
Benigna Wara Cardozo Velasquez
Mental Gaps

034 / 布里吉·阿玛尔
H154 / H360
Brigitte Amarger
H154 / H360

036 / 布罗尼斯拉瓦·巴基尔科娃
矩阵
Bronislava Bacilkova
Matrix

038 / 卡门·因巴赫·里格斯
女性地图（贾兹敏和她的家庭肖像）
Carmen Imbach Rigos
Female Maps (Jazmin and Family Portraits)

040 / 蔡陈林
可见的幻觉——蘑菇云3号
Cai Chenlin
Visible Illusion - Mushroom Cloud #3

042 / 柴鑫萌
二十四节气
Chai Xinmeng
Solar Terms

044 / 夏洛特·厄斯特加德
羁绊
Charlotte Østergaard
Entanglements

046 / 陈辉（绘）
大气影像
Chen Hui (painter)
Atmospheric Images

048 / 陈辉（雕）
穿过云雾的船
Chen Hui (sculptor)
Boat Through the Clouds

050 / 陈琦
观象
Chen Qi
Observation of the Celestial

052 / 陈焰
七天
Chen Yan
Seven Days

054 / 程向君
中国医书——面相
Cheng Xiangjun
Chinese Medical Book - Physiognomy

056 / 丹妮·梅尔曼·莎克特
无限
Danit Melman Shaked
Infinity

058 / 大卫·莫雷诺
教堂连接 001
David Moreno
Cathedral Connection 001

060 / 丹妮丝·布兰查德
神圣的外衣
Denise Blanchard
Sacred Mantle

062 / 戴安娜·格拉波夫斯卡
面具
Diana Grabowska
Mask

064 / 丁荭
枯木逢春
Ding Hong
The Spring of the Withered Trees

066 / 多洛·纳瓦斯
"水下"装置
Dolo Navas
"Underwater" Installation

068 / 董书兵
河运国安 & 构
Dong Shubing
Grand Canal：Prosperity & Construction

070 / 董洋洋、韩妤
混沌
Dong Yang-Yang，Han Yu
Chaos

072 / 董子瑗
一种状态
Dong Ziyuan
A State

074 / 爱莉迪亚·柯罗策
红线
Elidia Kreutzer
The Red Thread

076 / 埃尔克·曼克
社会中的裂隙
Elke Mank
Cracks in Society

078 / 艾玛·塞古拉·卡尔德隆
自爱·自理·自拥
Emma Segura Calderón
Me Quiero，Me Cuido，Me Abrazo

080 / 艾斯特·博尔内米萨
选择性的亲和关系
Eszter Bornemisza
Elective Affinities

082 / 冯崇利
痕—1
Feng Chongli
Trace -1

084 / 弗雷迪·科洛
形变
Freddy Coello
Metamorphosis

086 / 付钰涵
不能承受的生命之轻
Fu Yuhan
The Unbearable Lightness of Being

088 / 加夫列尔·阿尔瓦雷斯
鳄鱼求爱
Gabriel Álvarez
Crocodile Courtship

090 / 高扬
蒲公英
Gao Yang
Dandelion

092 / 葛平伟
结·屏
Ge Pingwei
Knot-Shield

094 / 顾黎明
山水赋——"鹊华秋色"图解（五联画）
Gu Liming
Shanshui Fu - Illustration of "Autumn Colors on the Que and Hua Mountains" (Five-couplet)

096 / 郭振宇
上帝视角
Guo Zhenyu
The "God's-Eye" View

098 / 合艺术小组：康悦、钱亮、付廷栋
羊毛物语
He Art Group：Kang Yue，Qian Liang，Fu Tingdong
Wool Story

100 / 黑余
草·书／金刚经
Hei Yu
Grass，Book/Diamond Sutra

102 / 海伦·查赫
词汇的消失
Helene Tschacher
The Disappearance of Words

104 / 侯吉明
修复计划
Hou Jiming
Restoration Plan

106 / 胡明哲
《空》之六
Hu Mingzhe
Empty VI

108 / 胡泉纯
爬山虎的家
Hu Quanchun
The Creeper's Home

110 / 胡伟
海礁 2
Hu Wei
Sea Reef 2

112 / 伊娃·科鲁米娜
孤独
Ieva Krūmiņa
Loneliness

114 / 艾瑞斯·薇薇安娜·帕瑞·罗马诺
来自"神秘森林"系列
Iris Viviana Perez Romero
From the *Mystic Forest* Series

116 / 伊维塔·托马诺娃
社交网络
Iveta Tomanová
Social Network

118 / 詹姆斯·约翰逊 – 佩金斯
千兆字节—伟大的战斗
James Johnson-Perkins
Gigatage - The Great Battle

120 / 亚内·佩尔托坎加斯
众神 5 号 / 风神
Janne Peltokangas
Ipmil No.5 / Bieggagállis

122 / 亚努什·库查尔斯基
自我表型
Janusz Kucharski
Own Phenotype

124 / 珍妮·德·雷梅克
封装的怀旧情结
Jeannine De Raeymaecker
Encapsulated Nostalgia

126 / 珍妮弗·罗伯森
构造线 II
Jennifer Robertson
Tectonic Lineation II

128 / 贾善国
庚子印记
Jia Shanguo
Gengzi Seal

130 / 蒋颜泽
消逝
Jiang Yanze
Fading

132 / 焦晨涛
此时彼时
Jiao Chentao
Here and Then

134 / 吉克楚哈莫
拉则格楚
Jike Chuhamo
Lazegechu

136 / 金晖
孤独的行星
Jin Hui
Lonely Planet

138 / 乔·汉密尔顿
分层的闪亮岛
Jo Hamilton
Stratified Shining Island

140 / 琼·舒尔茨
笔记系列
Joan Schulze
Notes Series

142 / 尤维塔·撒克朗斯凯特
你生气是为了快乐吗?
Jovita Sakalauskaite
Are You Angry To Be Happy?

144 / 朱迪特·埃斯特·卡尔帕蒂 / 艾斯德班·德·拉·托尔
深流
Judit Eszter Kárpáti / Esteban de la Torre
Deep Flux

146 / 坎禅·卡吉
哲人石
Kanchan Karjee
Philosopher Stone

148 / 坎菲丁·亚法
王国
Kanfitine Yaffah
The Kingdom

150 / 卡捷琳娜·博罗达夫琴科
全视之眼
Katerina Borodavchenko
All-Seeing Eye

152 / 凯蒂·泰勒
附着的物质
Katie Taylor
Bound Up Material

154 / 坎·萨鲁穆·卡霍亚
美丽的金沙萨
Khen Salumu Kahoya
KIN The Beautiful

156 / 克里斯蒂娜·萨德
雄伟的冰川
Krystyna Sadej
Majestic Glacier

158 / 克塞尼娅·申科夫斯卡娅
朝圣者们
Ksenia Shinkovskaya
Pilgrims

160 / 雷涛
白色幻想曲
Lei Tao
Fantasy in White

162 / 李博超
彩虹的碎片
Li Bochao
Fragments of Rainbow

164 / 李海斌
共·生
Li Haibin
Symbiosis

166 / 李浩宇
铭记·痕
Li Haoyu
Remember the Imprint

168 / 李鹤
　肉身·呼吸
　Li He
　Flesh-Breath

170 / 李洪波
　自然系列—木头
　Li Hongbo
　Nature Series - Wood

172 / 李嘉鑫
　桃花源·造园系列
　Li Jiaxin
　Peach Blossom Spring –Making Garden Series

174 / 李静
　钻·石
　Li Jing
　Diamond-Stone

176 / 李薇
　大漠孤烟
　Li Wei
　Solitary Smoke in the Desert

178 / 莉莉安娜·罗斯柴尔德
　地球母亲的声音
　Liliana Rothschild
　Mother Earth's Voice

180 / 利利特·斯捷潘尼亚
　但是
　Lilit Stepanyan
　BUT

182 / 林岗
　仁者乐山
　Lin Gang
　Benevolent As Mountains

184 / 林乐成、李广忠、赵嘉波
　竹之光
　Lin Lecheng, Li Guang-zhong, Zhao Jiabo
　The Light of Bamboo

186 / 刘烽
　乌夜啼、虞美人
　Liu Feng
　Crows Cry At Night, The Fair Lady Yu

188 / 卢德维卡·奥戈泽莱茨
　"空间结晶"系列之"爆炸 II"
　Ludwika Ogorzelec
　"Explosion II" from "Space Crystallization" series

190 / 卢德维卡·齐特凯维奇–奥斯特罗斯卡
　记忆
　Ludwika Zytkiewicz-Ostrowska
　Memories

192 / 罗幻
　神农计划系列
　Luo Huan
　Shennong Project Series

194 / 吕晶
　可购买的幻想
　Lyu Jing
　The Buyable Fantasy

196 / 吕越
　女红
　Lyu Yue
　Red Woman

198 / 马泉
　瓷沙编码
　Ma Quan
　The Code of Porcelain and Sand

200 / 马世昌
　土归土
　Ma Sai Cheong
　Earth to Earth

202 / 马文甲
　长城
　Ma Wenjia
　The Great Wall

204 / 马彦霞
　蔓延
　Ma Yanxia
　Spreading

206 / 玛丽·克莱因
　家中绿草如茵
　Mali Klein
　Green Grass of Home

208 / 马娜娜·迪兹卡什维利
　灰蝴蝶
　Manana Dzidzikashvili
　Gray Butterfly

210 / 玛丽亚·欧亨尼娅·莫亚
　触觉的自画像
　Maria Eugenia Moya
　Haptic Self Portrait

212 / 玛丽亚·奥尔特加·加尔韦斯
　地图
　María Ortega Galvez
　Geographic Maps

214 / 玛丽亚·托兰德尔
　谁说脆弱的？
　Maria Torrendell
　Who Said Fragile?

216 / 马丽贝尔·波特拉
　瀑布
　Maribel Portela
　Waterfall

218 / 玛丽卡·萨拉 / 理查德·弗莱芒特
　涡流
　Marika Szaraz / Richard Flament
　Vortex

220 / 玛苏玛·哈莱·赫瓦贾
　这不是一场会议
　Masuma Halai Khwaja
　Not a Conference

222 / 孟禄丁
　朱砂·祭
　Meng Luding
　Cinnabar · Sacrifice

224 / 米罗斯拉夫·布鲁斯
　纸的果实
　Miroslav Brooš
　Fruits of Paper

226 / 莫妮卡·莱曼
　雨林
　Monique Lehman
　Rainforest

228 / 纳蒂亚·迪亚兹·格拉薇兰
编织自己的女人
Nadia Díaz Graverán
Woman Who Weaves Herself

230 / 娜拉·吉琼
麻木
Nara Guichon
Dormência

232 / 娜塔莉亚·茨维特科娃
独角兽的头颅
Natalia Tsvetkova
Unicorn Skull

234 / 尼科·卡帕
发掘
Niko Kapa
Exhumations

236 / 尼娜·内纳多维茨
无题
Nina Nenadović
Untitled

238 / 帕维尔·基尔平斯基
空间的解剖学
Paweł Kiełpiński
Anatomy of Space

240 / 拉伊亚·约基宁
倾听一条河
Raija Jokinen
Listening to a Lake

242 / 拉奎尔·勒杰尔格
在空旷中
Raquel Lejtreger
Out in the Open

244 / 鲁兹卡·扎捷克
评论
Ruzica Zajec
Comment

246 / 塞菲·加尔
时间的层次
Sefi Gal
Time Layers

248 / 谢尔盖·贝罗基
我们每天的面包
Sergei Belaoki
Our Daily Bread

250 / 沈烈毅
雨
Shen Lieyi
Rain

252 / 石富
猫
Shi Fu
Cat

254 / 石梅
一刀流
Shi Mei
One-Sword School

256 / 西比尔·黑恩
收集的风景
Sibyl Heijnen
Collected Scenery

258 / 西蒙·法格斯
五条腿的蜘蛛
Simon Fagéus
The Five-Legged Spider

260 / 宋春阳
惹
Song Chunyang
Provoking Series

262 / 宋克
物语
Song Ke
The Language of Objects

264 / 孙继巍
浮生
Sun Jiwei
The Floating Life

266 / 孙永康
永线
Sun Young Kang
The Endless Line

268 / 孙月
"新石器时代"工业印章
Sun Yue
"Neolithic" Industrial Seals

270 / 苏珊·泰伯·阿维拉
森林
Susan Taber Avila
The Forest

272 / 谭勋
彩虹中国计划之2、3、4号
Tan Xun
Rainbow China Project No. 2, 3, 4

274 / 缇娜·玛莱
海流之下
Tina Marais
Under Currents

276 / 乌苏拉·盖伯·森格
今日的游牧民Ⅲ
Ursula Gerber Senger
Present Day Nomads Ⅲ

278 / 万里雅
天长地久系列 – 5d
Wan Liya
Everlasting Series - 5d

280 / 王海燕
蕾丝系列
Wang Haiyan
Lace Series

282 / 王建
马
Wang Jian
Horse

284 / 王家增
物的褶皱系列
Wang Jiazeng
The Folds of Things Series

286 / 王雷
文锦中华 2018
Wang Lei
Brocade for China 2018

288 / 王立伟
蓝色骨头
Wang Liwei
Blue Bones

290 / 王晓昕
冥想之联
Wang Xiaoxin
Connected Meditation

292 / 王绪远
墨·影
Wang Xuyuan
Ink & Shadow

294 / 王忠民
沉默？
Wang Zhongmin
Silence?

296 / 瓦达·纳伊姆·布哈里
空间中的躯体
Wardah Naeem Bukhari
Body in Space

298 / 瓦坦舒特·汤加特雅
东方思维
Wattanchot Tungateja
Oriental Mind

300 / 吴昊宇
新石器 2020—No.1
Wu Haoyu
Neolithic 2020-No.1

302 / 吴九沫
《舞者》系列
Wu Jiumo
"Dancer" Series

304 / 向阳
《陶瓷系列》之喜字双罐、三色冬瓜罐
Xiang Yang
The Ceramic Series - Double Jars with the "Xi" Character & Tricolor Winter Melon Jar

306 / 闫晓静
灵云
Yan Xiaojing
Spirit Cloud

308 / 徐小鼎
《城市肌理》系列之北京、香港
Xu Xiaoding
City Texture Series - Beijing, Hong Kong

310 / 许正龙
凳之根
Xu Zhenglong
The Root of a Stool

312 / 杨思嘉
皮肤分解
Yang Sijia
Decomposition of Skins

314 / 杨洋
咫尺天涯
Yang Yang
So Close, Yet Worlds Apart

316 / 余慧娟
《褪》系列
Yu Huijuan
"Fade" Series

318 / 原博
灵璧问道
Yuan Bo
Asking for the Tao at *Lingbi*

320 / 张筠
惊蛰系列 –3–18A
Zhang Jun
Awakening of Insects Series - 3-18A

322 / 张伦伦
场所中的雕塑
Zhang Lunlun
Sculptures in Sites

324 / 张姗姗
1271-D
Zhang Shanshan
1271-D

326 / 张雯迪
玩偶 6 号
Zhang Wendi
Toy Figure No.6

328 / 张晓雪
低烧 1~8 号
Zhang Xiaoxue
Low Fever No.1-No.8

330 / 张元
红荷湿地
Zhang Yuan
Red Lotus Wetland

332 / 郅敏
天象四神—朱雀
Zhi Min
The Four Celestial Godly Tokens - Chinese Phoenix (*Zhuque*)

334 / 周军南
纸衣系列Ⅲ—石窟
Zhou Junnan
Paper Clothes Series Ⅲ - Grotto

336 / 周小瓯
退一步
Zhou Xiaoou
One Step Back

"唯物思维"首届国际当代材料艺术双年展 | 作品集

艾迪·伯纳德
Aïdée Bernard

（法国 France）

野性的纸	**Wild Paper**
麻纤维手工纸	hand-made paper of cellulose fibers of hemp

ϕ100cm

这件纸雕塑与身体一起翩翩起舞，像绽放的花朵，展示着生命的力量，是对伟大女性的致敬。在作者看来，纸材料是一种短暂的物质，可回收，可改变，充满了自然的力量，具有感官强烈的品质。纸纤维敏感而富有韧性，其短暂的特质就像人类的生命，可以在永恒的变化中再生、传递、绵延。在与身体的互动中，作品在舞动、在呼吸，让植物世界与人类世界在此相遇。这件可以舞蹈的作品体现了作者对移动的锚、相互渗透的宇宙、相互联系的领域等问题的思考。她希望为流动性找到一种"基础"，正如身体在这件作品中成为可移动的"根"，链接了人与自然，达到一种"天人合一"之境——一种依存且自由、独特且普遍的境界。

This paper statue, dancing along with the body like a blooming flower, demonstrates the power of life, and also reveals solemn reverence for great women. The artist regards paper as a transient substance that is recyclable, changeable, and full of the power of nature, possessing the characteristics of sensual intensity. Sensitive and tough, paper fiber is transient, and thus, resembles human life; it is able to resurrect, pass on, and continue like human generations. The work dances and breathes, connecting the plant world and the human world through the interaction with the body. This work, which is capable of dancing, embodies the author's reflections on various themes, such as moving anchors, interpenetrating universes, and interdependent reigns. She hopes to find a "foundation" for fluidity, just as the body is playing the role of a movable "root" in this work - by linking man and nature, and achieving a state of harmony between man and nature - a dependent yet free, unique yet universal realm.

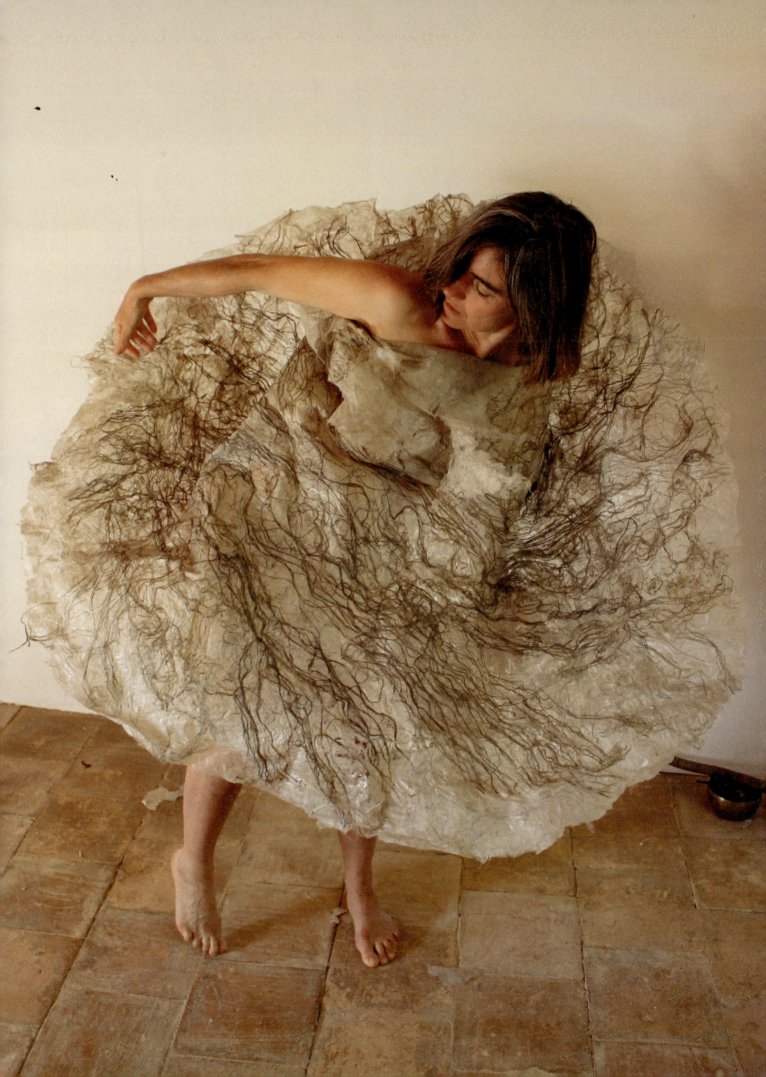

阿尔瓦罗·迭戈·戈麦斯·坎普萨诺
Alvaro Diego Gomez Campuzano

（哥伦比亚 Colombia）

凤凰	**The Phoenix**
不锈钢链环	stainless steel chainmail

<div align="center">128cm × 128cm × 60cm</div>

凤凰是传说中智慧的象征，存在于很多古文化中。凤凰代表着最高的美德和繁荣的力量。它也代表着阴阳，即构成宇宙的二元性。凤凰自诞生以来就以传播其珍视的知识为使命，激励着包括艺术家和科学家在内的求知者，它已经成为力量、净化、希望、不朽以及精神和身体再生的象征。作者采用了不锈钢材料以"链甲"这种古老的网格技术，将金属环缠绕成构成复杂的图案，并置于空中展示，赋予其一种自由和变化的精神。作品采用了一丝不苟且充满活力的手法，暗示着对更新和变化概念的象征性重建，与21世纪的时代精神相映成趣。不锈钢代表着保护和强度，以这种新兴的工业材料表现传统的凤凰主题，希望把观众从当下带到过去，并提出已经展开并绵延至未来的问题——关于当下价值与追求的反思。

The phoenix is a symbol of wisdom in legends. In many ancient cultures, the phoenix represents the highest virtue and power of prosperity. It also represents yin and yang, the duality that makes up the universe. Since its inception, the Phoenix has been on a mission to spread its cherished knowledge, inspiring knowledge seekers, including artists and scientists, and thus has become a symbol of strength, purification, hope and immortality, as well as spiritual and physical regeneration. The author uses stainless steel material with the ancient grid technique of "chain mail", winding metal rings into complex patterns, and placing them in the air for display, giving them a spirit of freedom and change. A meticulous and energetic approach is adopted to suggest a symbolic reconstruction of the concept of renewal and change, which is in keeping with the zeitgeist of the 21st century. The artist uses stainless steel, an emerging industrial material representing protection and strength to express the traditional phoenix theme, hoping to bring the audience from the present to the past, and to raise questions that have unfolded at the moment and stretched into the future—reflections on current values and pursuits.

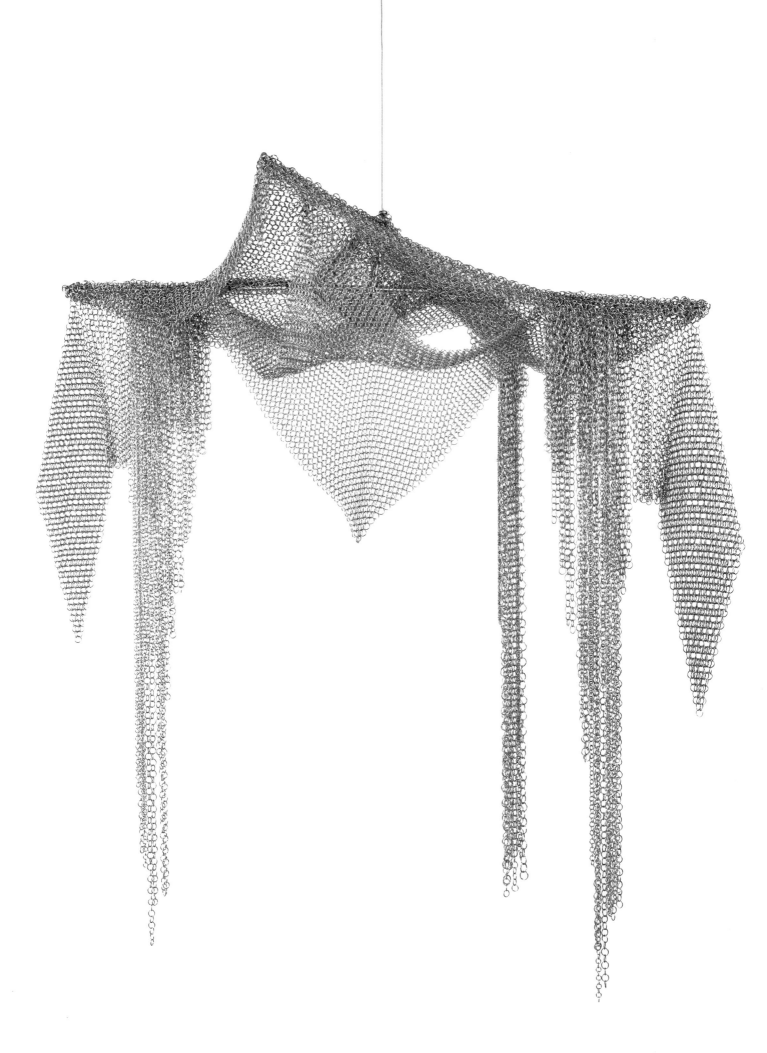

阿尔福斯·迪亚斯
Alves Dias

（葡萄牙 Portugal）

阿里阿德涅之线	O fio de Ariadne
金属丝、胶带、帆布、丙烯颜料、金箔、聚酯线、棉线、竹箱	wire, adhesive tape, canvas, acrylic paint, gold leaf, polyester threads, cotton threads, bamboo box

70cm × 42cm × 14cm

艺术家的童年时代充满了幻想和传说，培养了他对神话故事的浓厚兴趣，这件作品的主题是"阿里阿德涅之线"：米诺斯的公主阿里阿德涅给勇敢的雅典王子忒修斯一卷线，帮助他在战胜米诺陶诺斯后，走出迷宫逃出生天。艺术家用铁丝来构建忒修斯的骨架，然后用纸胶带反复包裹、缠绕，直到呈现理想的人形，最后再用一层精细的聚酯线网覆盖。由细密和重复的线交叉构成的网最终成为一个复杂的网络，人们顺着这些线条便能看到忒修斯的身体是如何由纸胶带构建起来的。为了把忒修斯的雕像安装在墙上，艺术家使用了一个竹盒，它的盖子上放置着雕像，而在盒子的另一部分，艺术家粘上了一块涂有丙烯颜料和金箔的画布，以这种方式描绘出迷宫，并在画布上放置了一卷棉线——"阿里阿德涅之线"——其末端则握在忒修斯手中，这位勇士正低着头，注视着他将赖以逃生的线索。但这一神话中的迷宫也是象征性的，艺术家试图在日常生活中找到人生迷途里的"阿里阿德涅之线"，通过编织，在寻找新的造型语言、新材料和新技术的过程中开辟一条通往精神自由的道路。

The artist's childhood is full of fantasy and legends, which nurtured his keen interest in mythology. The theme of this work is "The Thread of Ariadne": Princess Ariadne of Crete gives the brave Athenian Prince Theseus a ball of thread to help him escape from the labyrinth after defeating the Minotaur. The artist used iron wire to construct Theseus' skeleton, and then kept wrapping the skeleton with washi tape until the ideal human form was made, before the final covering with a fine layer of polyester wire mesh. The net formed by the intersection of fine and repeated lines eventually becomes a complex network, and people can see how Theseus' body is constructed by paper tape along these lines. To fix the statue of Theseus on the wall, the artist used a bamboo box with the statue placed on the lid, while on the other part of the box the artist glued a canvas coated with acrylic paint and gold leaf to make the labyrinth. A ball of cotton thread was placed on the canvas — "Ariadne thread" —the end of which was held in the hands of Theseus, who was looking down at the clues to escape. But the labyrinth in this myth is also symbolic. The artist tries to find the "Ariadne's thread" in daily life. Through weaving, he opens up a path toward the spiritual freedom in the process of searching for new modeling languages, new materials and new technologies.

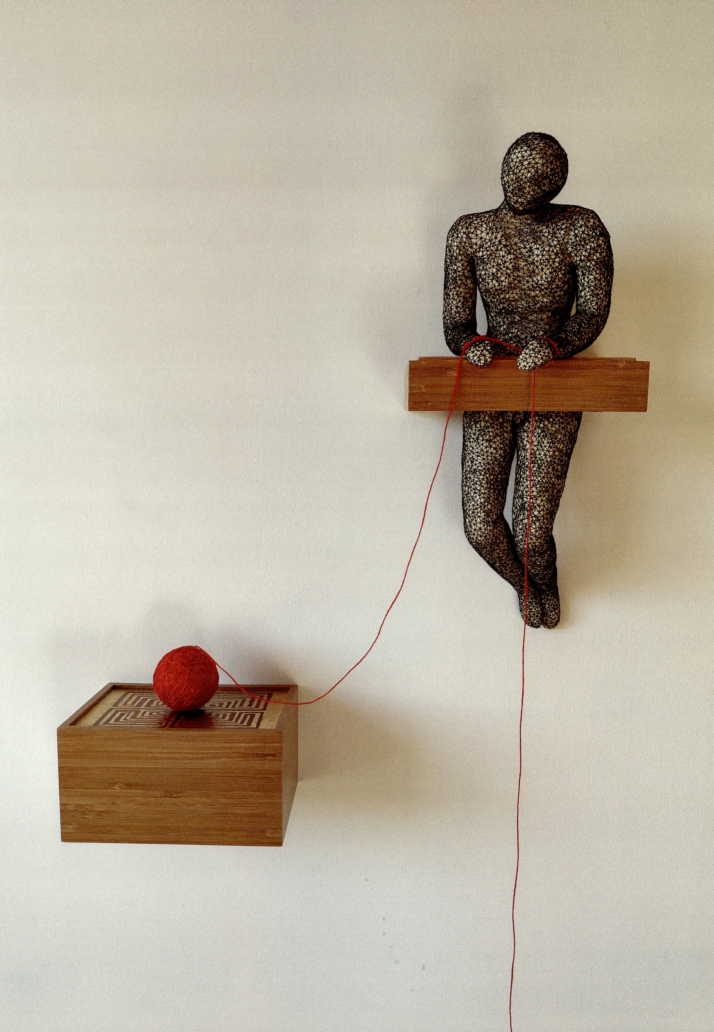

安娜·约瓦诺夫斯卡
Ana Jovanovska

（马其顿 Macedonia）

绿洲	OASES
透明的环氧树脂蜡、回收的塑料娃娃、压制的花和叶	transparent epoxy resin wax, recycled plastic dolls, pressed flowers and leaves
每个约 10cm×13cm×2cm（each）	

我们如何建立自己的时间胶囊？在作品《绿洲》中，艺术家用透明的环氧树脂封存了一片片叶、一朵朵花和穿插其中的塑料娃娃部件，构造了一个个沉静而迷人的绿洲，似乎应和了作品主题中的应有之义——

在困境中的一方和平、安全、幸福之地。构成这件作品的主要材料均由回收而来，包括旧的塑料娃娃，塑料制品，未使用的指甲油，由剩余的无机颜料制成的颜色，旧的合成假发等。作者用了近一年的时间，经历了四季的植物生长、培育和采集，然后经选择、干燥和压制成了作品中的花朵和叶子。经重新加工的塑料娃娃部件与不同的花叶重组、排列，脱离了原有的语义，形成了各自崭新的故事。穿插于其中的面孔是模糊的，为观众提供了带入自己的机会。作为时间胶囊，作者希望通过它们唤起并重建人与植物、文化与自然、真实与虚幻、物质与思想、个人与人际之间的紧张联系。

How do we build our own time capsule? In the work "OASES", the artist seals leaves, flowers and plastic doll parts interspersed with transparent epoxy resin, constructing quiet and charming oases, which seem to fit the meaning of the work's theme - a place of peace, safety, and happiness for people in distress. The main materials that make up this work are all recycled, including old plastic dolls, plastic products, unused nail polish, colors made from leftover inorganic pigments, old synthetic wigs, and so on. The author spent nearly a year experiencing plant growth, cultivation and collection in the four seasons, and then selected, dried and pressed the flowers and leaves in the work. After being reorganized and rearranged with various flowers and leaves, the reworked plastic doll parts have been separated from the original semantics and form their own new stories. The looks interspersed are blurred, allowing the audience to insert themselves. The author intends to evoke and recreate through time capsules the tense connections between people and plants, culture and nature, reality and fantasy, matter and thought, as well as personal and interpersonal.

安吉丽卡·卡斯蒂略
Angélica Castillo

（委内瑞拉 Venezuela）

通往看不见的温暖之城	Anima Mundi
压制的植物纸	pressed vegetal paper

<center>57cm × 32cm × 18cm</center>

"Anima Mundi"在意大利作家卡尔维诺的小说中被描述为看不见的城市。它是水手的城市，是漂洋过海者的城市，是海盗和冒险家的城市。它是旅程和轨迹，是寻找更好生活的渴望和需要，是一个可以称之为家的温暖地方。旅行者们如果想要抵达这座城市，需要熟悉所有的航海仪器，并在北极星的指引下，才不会迷失方向。当冒险家和智者横渡汪洋大海，踏上充满鲜花、弦乐和热情欢迎者的新陆地，终于找到了温暖的家。这件作品则让这场或真实或虚构的旅行变得可见，以女人体的形式展现通往南美洲的海上航线，并在上面刻画了地图、星象、船只、港口、行李、新语言等，象征着应许之地，隐喻着慈爱的母亲，承载着冒险家的梦想。作者通过透着温暖的光的人体雕塑为这个没有结局的奇妙故事赋予了光明和可见的物质性。

"Anima Mundi" is an invisible city in a novel by Italo Calvino, an Italian writer. It is a city of sailors, of wanderers across oceans, and of corsairs and adventurers. The city is a journey, with its trajectory: the desire and need to seek a better life, and a warm place to call home. In order to reach the city without getting lost, travelers need to be familiar with all kinds of the navigational instruments, and follow the guidance of the North Star. This work visualizes the described journey, be real or fabricated: adventurers and wise men crossed the ocean, set foot on this new land full of flowers, orchestral music, handkerchiefs for tears, and luggage carriers, and they finally found their warm home. The sea route to South America is presented in the form of a woman's body, on which maps, stars, ships, ports, luggage, wares, new languages, etc., are depicted. South America here symbolizes the promised land, metaphorized as a loving mother, who carries the adventurer's dream. The work itself is a narrative that intends to give light and visible materiality to a marvelous story that has no end.

安妮塔·布伦琴斯
Anita Brendgens

（德国 Germany）

Topolino	Topolino
手工纸、线	handmade paper, strings
125cm × 370cm × 120cm	

白色的片段，悬浮的物品，记忆的空间，艺术家用纸塑造了一个"无止境"的世界。艺术家的作品多以"记忆"为主题，悬浮在空间中的白色纸装置成为她艺术的特色和标志。这些纸浆物品的模型都来自于艺术家本人、家人和朋友的日常物品，包括衣、食、住、行等各个方面，它们无疑是熟悉而亲切的，充满了纪念意义。然而，经过白色纸浆的重塑，这些记忆中的"物品"变得碎片化、脆弱、半透明，悬置在空中的它们似乎脱离了现实。这便是艺术家所创造的记忆的模样，通过作品将观者带入另一个光明的、梦幻的世界。这件作品源自作者朋友的老式汽车，曾作为婚礼用车，对他们来说意义重大。当这件充满个人记忆的物品"漂浮"在欧洲火车站展场时，一个有趣的对话产生了。

Fragments of white, free-floating objects, spaces of memory: the artist uses paper to create an unfinished world. As she said, most of her works take the theme of "memory", and adopt a unique mark through the floating installation of white paper. The models of the paper objects are common daily things, such as clothing, food, housing, transportation, etc., of the artist herself, her families, or her friends, and are undoubtedly familiar, intimate, and full of commemorative significance. However, after being reshaped with white pulp, these floating "objects" from memory become fragmented, fragile, translucent, and seemingly out of reality. This is the appearance that the artist endows to memories, and by such works the audience can enter another bright and dreamy world. This work is inspired by a loved vintage car from the artist's old friend that was once used as a wedding car. An interesting dialogue took place when the object, full of personal memories, floated in the air at the exhibition in the European railway station.

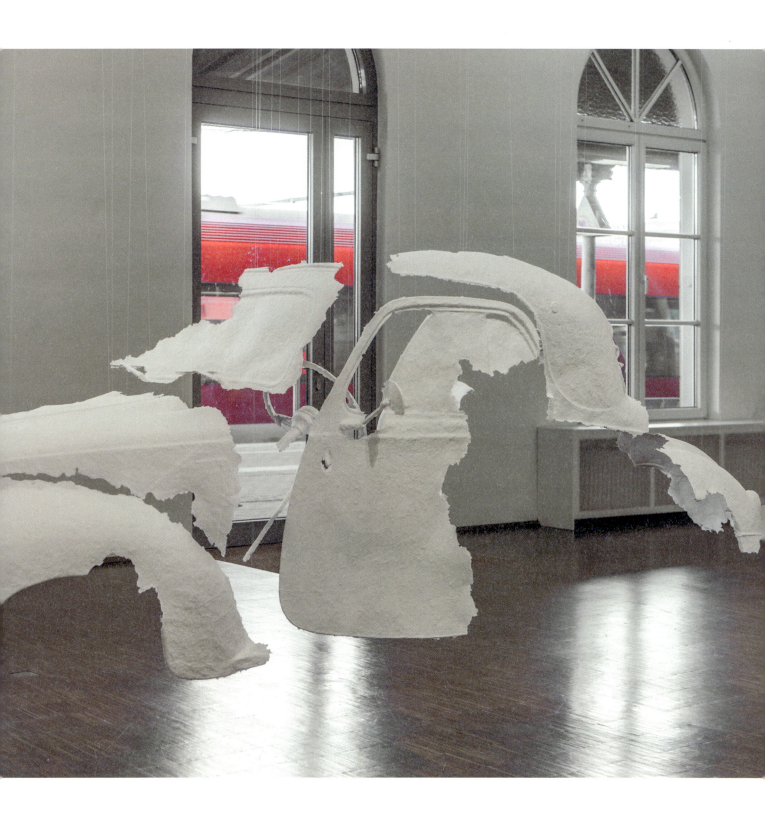

安娜·博雅杰娃
Anna Boyadjieva

（保加利亚 Bulgaria）

圆圈	Circles
金属丝、棉线、树枝、纺织品、金属网、尼龙网	metal wire, cotton threads, branches, textiles, metal mesh, nylon mesh

165cm × 165cm × 10cm

20世纪60年代后，材料开始被作为一种表达工具，并成为先锋艺术的基础。艺术家创作的"圆圈"则利用了金属丝、棉线、树枝等受到概念艺术家们追捧的材料，表达了她对地球脆弱性的关注："圆"的完美形状象征着地球，而各种形式化的花卉和动物主题则构成地球的诸多变体。从人类分析性的眼光看来，这些可以是受伤的树木，是金属的花朵和鸟雀，是各种结构和网络。从审美角度来看，这件作品则是艺术家的花边技术在新材料中应用而创作出的"图形绘画"。作品的透明性和其在白色背景上投射的阴影使其描绘的画面更为复杂化。她以此发出保护地球的呼吁，并希望大家重视艺术家在这一最重要目标中的作用：通过他们的作品和材料选择，艺术家们正帮助重建一个干净、健康、美丽的地球。

After the 1960s, materials began to be used as a tool of expression and became the basis of avant-garde art. *Circles* is a combination of metal wire, cotton thread, tree branches and other materials. These loves of conceptual artists are adopted to emphasize the earth's fragility: on the circular perfection of the earth itself, sundries of formalized plants and animals are creating its diversified variations. For humans, there are wounded trees, flowers and birds in metal. Or analytically, these can be structures and networks. But talking about its artistic expression, the lace technique is applied on new materials to create a "graphic drawing". Its transparency and the shadows it casted on the white background to further complicate the overall picture it generates. Through this work, she calls for protecting our planet, and urges more understanding of the role of artists, who can use their works, especially the utilization of certain materials, to help build a clean, healthy, and beautiful planet.

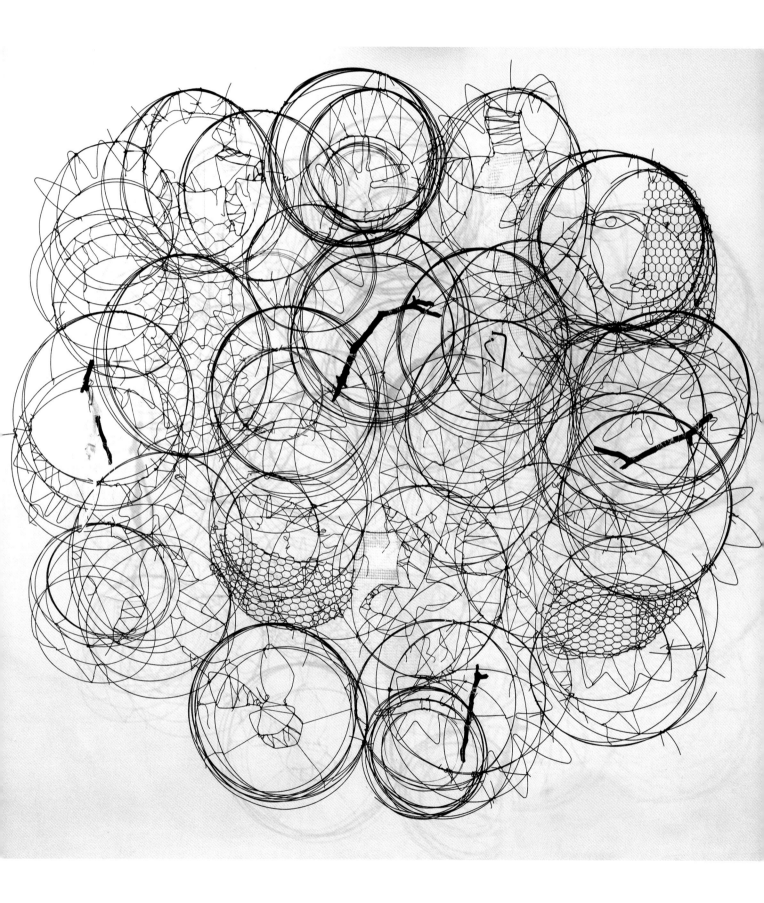

安娜·瓦格纳 – 奥特
Anna Wagner-Ott

（加拿大 Canada）

建筑形式 5 号	Architectural Form #5
布料、金属丝、蜡、丙烯颜料、线	fabric, wire, wax, acrylic paint, threads

<div align="center">18cm × 20cm × 40cm</div>

艺术家每一件雕塑创作都开始于一组对立关系，如物理上的推力与拉力、光明与黑暗、束缚与开放、窒息与舒畅等。此后，艺术的过程方法和材料属性则会主导作品的创作。艺术家非常善于在常见的纺织材料中表现悖论式的效果。该作名为"建筑形式"，仿佛一团生了锈的扭曲的钢筋被捆扎在一起。艺术家使用缝纫机将一些织物缝制在一起，然后将其浸入蜡液，从而得到柔软与坚硬结合的奇特材料；然后再将其他经处理的各式材料堆加、削除、层垒、剥离、粘连，以至破坏、再重构，最终放弃控制，而让作品自身生长。艺术家非常着迷于这种材料主导的创作方式，她的雕塑关注生命的脆弱与死亡的结局，但同样也展现着在生命易逝却璀璨的光芒。

The artist's work always starts from a set of opposites, such as pulling and pushing, the light and the dark, the tied and the untied, repression and relaxation, etc... Thus, the processing method and the artistic properties of materials dominate artistic creation. The artist excels in presenting paradoxical effects using common textile materials. The work is called *Architectural Form*, suggesting a bundled, rusty, and twisted steel bar. The artist uses a sewing machine to sew some fabrics together, and then immerses them in wax to obtain a unique material that combines softness and hardness. Then, other materials are stacked, cut, piled up, peeled, glued, destroyed and reconstructed. Finally, the control of the work is given up to let the work flow by itself. The artist is fascinated by this kind of material-oriented method of creation. Her sculptures focus on the fragility of life and the end of death, and also show the brightness of life.

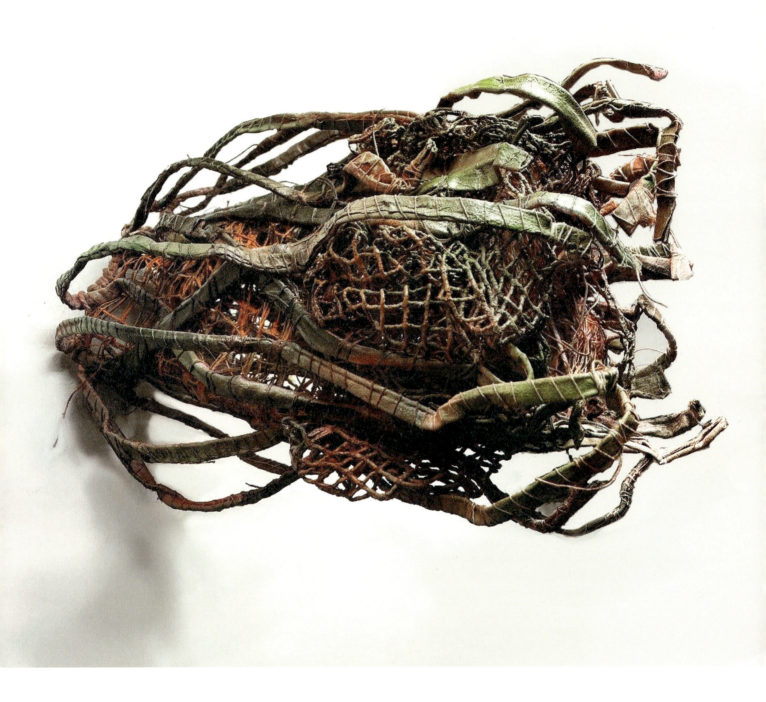

奥西尔·伯顿
Åsil Bøthun

（挪威 Norway）

丢失的事件	Lost Affairs
混凝土、铝	concrete, aluminum
500cm × 150cm × 110cm	

这件作品试图通过凝固个人物品的碎片来锚定对过去的记忆。该装置由两部分构成：一系列混凝土铸件和一系列回收铝铸件。混凝土铸件是将承装一些继承之物（书籍、衣服和其他个人物品等）的行李箱或其他包裹浇铸在混凝土中。作者以铸造的方式拉开了与原物件的距离，但人们仍能看到原物件的部分碎片。不同的是，作者用回收的铝材料铸造了一些木制品，穿插在混凝土元素之间。这些"木"构建灵感取自太空舱下面的支架——一种可以模拟地球磁场的建筑形式。这些"木片"的痕迹及个人物件的痕迹无声地见证了科学家克里斯蒂安·伯克兰的故事，他是国际铝业公司挪威海德鲁集团的创始人之一，在太平洋的一场海难中失去了所有的财产。作者希望通过物质的回响让人们在保留过去遗存和痕迹的地方获得"在场"的感受。

For the purpose of anchoring the past memories in the solidified fragments of personal objects, this installation is designed into two parts: one is a series of concrete castings and the other is a series of recycled aluminum castings. Concrete castings are made by covering suitcases or other packages that contain inherited objects (books, clothes, and other personal objects) with concrete. The artist defamiliarizes the cast objects from the audience while they can still see parts of the objects. In contrast, the woodwork casted by recycled aluminum is interspersed with the concrete elements. The inspiration for these is the stand underneath a terrella, a construction that can simulate the earth's magnetic field. These traces of "wooden pieces" and personal objects have silently witnessed the story of Kristian Birkeland, a scientist and one of the founders of Norsk Hydro, an international aluminum corporation, who lost all his possessions in a shipwreck on the Pacific Ocean. The works appear as physical echoes and sensed history manifested in objects, that hold the resemblance of a place with remains and traces from the past.

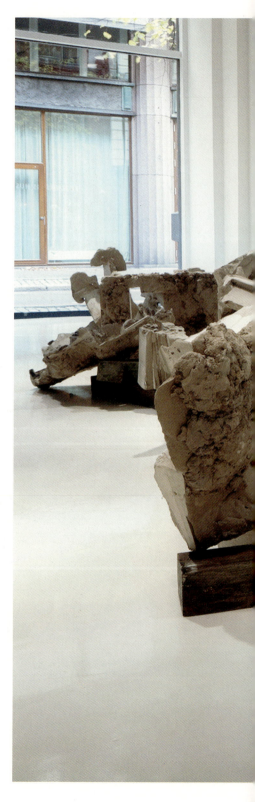

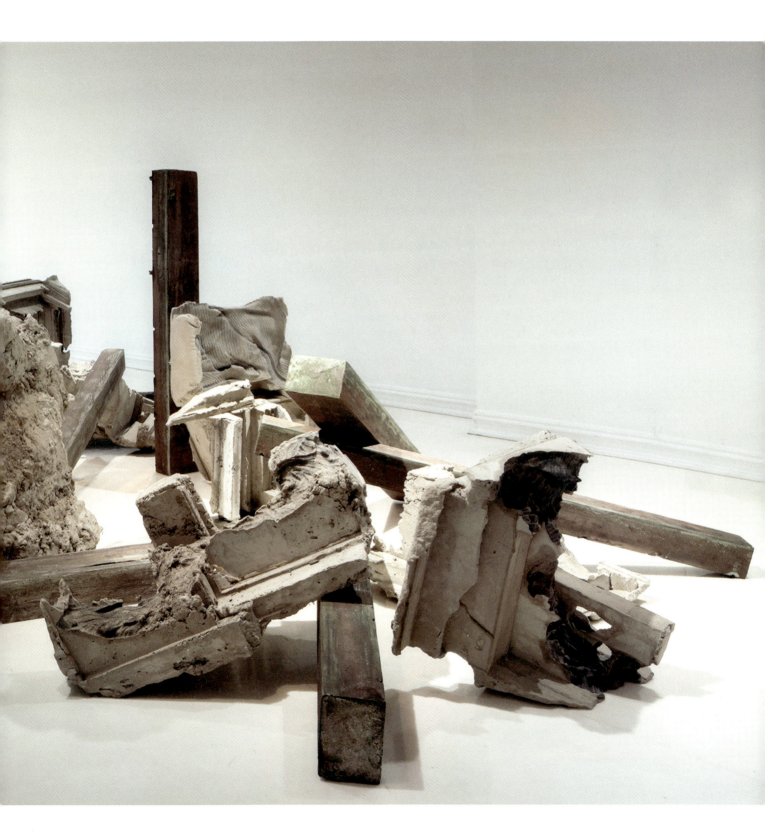

足立笃史
Atsushi Adachi

（日本 Japan）

炎舞	Flame Dance
报纸、日本打字机、木桌、线、网	newspapers, Japanese typewriter, wooden desk, thread, net

600cm × 600cm × 700cm

飞舞的纸人，盘旋而上，似熊熊火焰，正应和了这件作品的名称"炎舞"——火之舞蹈。在日本古代，纸人被称作"Hitogata（人形）"，作为人的替身，用以祈福避害。作者选用了日本从古至今的报纸制作了这些"Hitogata"，因为报纸承载着信息、记录着历史，无论正确与否，都成为"被镌刻的记忆"。一台日本打字机被置于舞人下方，代表"正在刻写记忆"。每片纸人代表着一个个体，一群纸人则象征着由个体组成的社会。个体不可免于信息、社会、历史、环境的影响，同时，个体的记忆和故事又构成了群体的历史和叙事。作品中螺旋飞舞、交织升腾的纸人也象征着构成社会历史的DNA——由个与群镌刻在时间长河中的记忆。

The paper figurines fly upward and dance like the flickering flames, as this work is named "Flame Dance" - the dance of flames. In ancient Japan, these paper figurines were used in blessing rites to bear the misfortunes of humanity, and are thus called "Hitogata（human's figure）". The artist selects Japanese newspapers from early times to the present as the materials of these "Hitogata", because newspapers are bearers of information and recorders of history, and be they authentic or not, represent "engraved memories". A kanji printer is placed right below the dancing figurines, as if it is now "engraving memories". Every figurine represents an individual, and a group of figurines symbolizes the society formed by individuals. Individuals are inevitably influenced by information, society, history, and environment, while their memories and stories constitute the history and narratives of the group. These paper figurines - hovering, dancing, intertwining, and rising, also symbolize the historical DNA of the society—the memories engraved in the long river of time by individuals and groups.

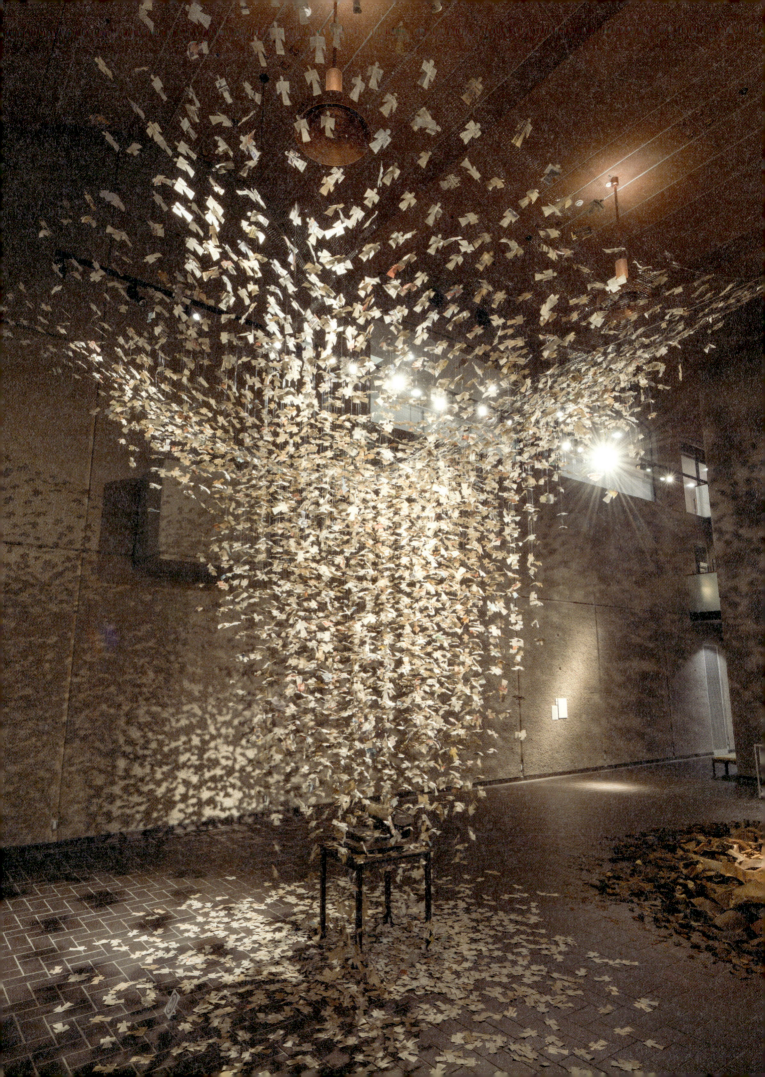

白明
Bai Ming

（中国 China）

器 · 形式与过程	Appliance - Form and Process
瓷	porcelain
每件 18~22cm（each）	

瓶形器物是一种司空见惯的日常用具，从模具里取出的器物均拥有同样的标准和形态，艺术家通过对作品的施压和刻画处理使之原本一致的形态变得各具不同，给每一件相似形态的作品赋予符号化的、绘画性的从平面到立体且多样性的装饰转换，以及雕塑性的空间与塑造，使它在统一的形态中拥有各自鲜明的"面容"。一切的改变都是形式，一切的记录也是过程，这组作品既是记录各自形态的改变过程，也是最终呈现各异态之间的变化过程，将实用之物向非实用化转换不仅是形式的探究，更是观看与观想的改变。与其他现成物不同，该作品以矩阵的方式陈列，既强调了它们的整体面貌，也凸显出了个体的差异，更保留了作为外在的"力"的施加过程。

Bottles are common instruments for our daily life. Using molds, these bottles are produced with specific standards and shapes. The artist then varies each "consistent form" (created with the mold) by applying pressure and carving techniques to each bottle. Moreover, he exhibits the varied bottles in a symbolized and artistic installation of 2D and 3D space. In addition, the entire work is shaped to form a sculpture. In the end, each bottle is given a unique and distinct visage while maintaining a uniform structure. All changes are formed, and all records are processed. Therefore, this set of works not only records the changes of each form, but also ultimately presents the changing processes of different states. The transformation of practical objects into non-practical ones is not only an exploration in terms of forms, but also encourages from the viewer a change in perspective. Different from other ready-made objects, this work is displayed in a matrix, which not only emphasizes the appearance of the bottles in unity, but also highlights the individual differences. In addition, the process of applying external "force" is also expressed here.

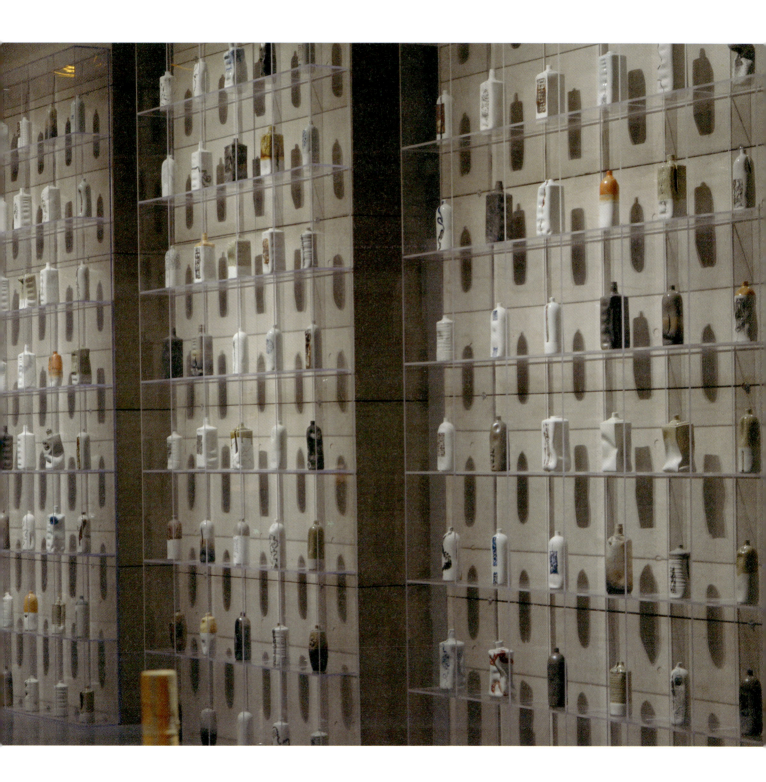

白阅雨
Bai Yueyu

（中国 China）

折叠的空间·枯山水	The Folded Space. Zen Garden
大漆、瓦灰、银箔、蛋壳、色漆粉	lacquer, tile ash, silver leaf, eggshell, lacquer powder
200cm × 100cm	

这件作品试图通过画面结构和材料的抽象折叠，唤醒遥远却又似曾相识的记忆，以达到和真实、时间有关的联想。作者选择历史悠久、自然、有机的大漆和当代、人造、相对稳定的金属材料并置，探讨不同物质进入画面空间的无形规则秩序后会发生怎样的变化。金属材质恒定，漆有生机、多变，但是进入画面的空间，银箔被腐蚀变化，漆却永恒。作品中，银箔开辟的空间如同枯山水中岩石和白砂的地面，这个空间包含记忆，回溯却又迷惑。枯山水中"无为"的变化源自环境，这些物质或许不具生命却能装裱自然。作者希望通过大漆和不同材质的呼应构建一个人为的虚拟空间，表达材料本身所具有的空间性和空间本身的不确定性。

The purpose of this work is to evoke distant yet familiar memories. This painting uses different materials to express abstract, but basic structures; and space, to achieve an association with reality and time. The artist combines traditional natural material lacquer with contemporary, man-made, relatively stable, metallic materials, to explore what happens when different substances challenge the invisible rules and order of the "painting space". The metal material is constant, and the lacquer is vibrant and changeable. However, when entering the space of the painting, the silver foil is corroded and changed, whereas the lacquer is eternal. The space created by the silver foil in the painting is like the ground of rocks and white sand in the Zen garden, a space that evokes memories, which are misty yet confusing. These substances may not be alive, but they can frame nature. The artist hopes to build an artificial virtual space through the echo of lacquer and other different materials, to show the spatiality of the material itself and the uncertainty of the space.

白紫千
Bai Ziqian

（中国 China）

生物发光体	**Bioluminescent Object**
光纤、织物、纸、LED、触觉传感器	optical fiber, fabric, paper, LED, tactile sensors

300cm × 300cm × 300cm

此实体交互装置灵感来源于电影《阿凡达》中潘多拉星球的奇幻发光生物。在潘多拉星球，光子作为能量流动的载体在植物脉络和动物血管中流动，链接生物体和潘多拉的生态系统。土著种族通过对这些能量的微妙感知，与潘多拉星球的生物和环境进行沟通和交流，形成了奇幻、绚丽的视觉效果。同时，土著种族在获取、依赖、回报、敬畏的关系中，与潘多拉星球的生态系统和谐共处，达到能量流动的平衡，传达了敬畏和热爱赖以生存的星球的可持续概念。这组可触控变色的发光装置，模拟了发光生物体的形态与激发特性。作品通过模仿自然界中常见的蜂巢结构和多层褶状结构，将平面的柔性材料有机地组织成为立体支撑结构，创造出装置结构中无缝嵌入的脉络和生物膜，为装置注入生命力。此作品意在通过使用最自然和原始的触摸感知方式，扰动仿生装置的电子流动，从而转化为光子流动来视觉化人与环境交互时的能量流动，唤起人们与环境交互，融入自然的本能。

This work of physical interaction is inspired by the luminescent fauna of Pandora in the movie Avatar. In Pandora, photons, as energy carriers, flow in plant veins and animal blood vessels, linking organisms with Pandora's ecosystem. Through the subtle perception of photons, the Na'vi communicate with the creatures and environment of Pandora. And this gives the audience a fantastic visual experience. Meanwhile, these aboriginals enjoy harmonious coexistence with the ecosystem in terms of acquisition, reliance, reward and awe. So, they can maintain the balance of energy flow, and convey the concept of sustainable awe and love for where they live. In this sense, this group of touch-sensitive color-changing luminous devices simulates the shape of these luminous organisms, as well as their characteristics of excited luminescence. By adopting the honeycomb and the multi-layered pleated structures that are commonly seen in nature, the work organically assembles the flexible 2-D materials into a 3-D supporting structure. In doing so, the veins and biofilms are seamlessly embedded in the structure to inject vitality into the work. It is intended to disturb the electronic flow of the bionic devices in the most natural and original way, i.e., touch-based perception. By constituting a flow of photons to visualize the energy flow in the human-environment interactions, this work arouses the human instinct to communicate with and integrate into the natural environment.

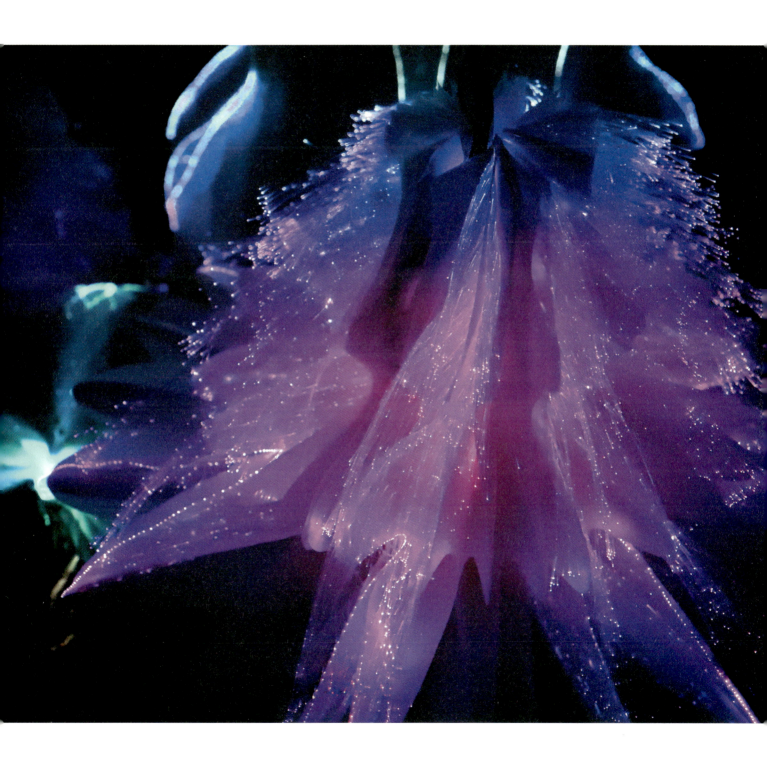

贝巴·奥西特
Baiba Osīte

（拉脱维亚 Latvia）

蓝色、灰色与红色方块	Blue, Gray and Red Squares
帆布、浮木	canvas, driftwood
70cm×70cm×3	

脱离树干的树枝，随着溪流漂入波罗的海，经过冲洗、打磨、抛光获得新颜，并成为艺术家作品的有机组成部分。在《旧约》中，海洋是民族的象征，作者的很多作品灵感来自于波罗的海。这件作品便是由海岸边回收的漂木组成，深蓝色是居住在海边的利沃尼亚人民族服饰普遍采用的颜色，联系着民族、海洋和国

家；灰白色是木条在自然中的材料色调，象征着人与自然的纯粹而直接的联系，也象征着纯洁而清澈的灵魂；红色是血的颜色，是生命的象征，代表着生机和力量。一根根漂木代表着一个个个体，作者保留了漂木经过岁月洗礼的肌理和痕迹，让它们重新获得生命。作者以"人之海"为喻，将漂木和不同的色彩相结合，串联起海洋和民族、人类与自然、社群与生命等。在她看来，材料是艺术家探讨人类存在的灵感之源，同时，艺术家在创作过程中也实现了从"艺术作为一种对象"到"艺术作为一种体验"的过渡。

Branches that fall off of trees drift into the Baltic Sea via the rivers. The branches gain a new look after washing, burnishing and polishing, after which they become an organic part of the artist's works. In the *Old Testament*, the sea is a symbol of the nation, and many of the artist's works are inspired by the Baltic Sea. This work is composed of driftwood recycled from the coast. Blue is the color commonly used in the clothes and accessories of the Livonians, who live by the sea; gray is the original color of the wood strips found in nature, symbolizing the pure and direct connection between man and nature; red is the color of blood, a symbol of life, representing vitality and strength. These pieces of driftwood represent individuals. Having been baptized over time, these driftwoods, of which the texture and traces have been preserved by the artist; they are reborn by forming groups, societies and nations. The artist uses "a sea of people" as a metaphor, combining driftwoods and different colors to connect the sea and the people, humanity and nature, community and life. In her opinion, materials are the source of inspiration for artists to explore human existence. The artist also emphasizes the transition during the process of creation from "art as an object" to "art as an experience".

巴图
Batu

（中国 China）

游猎	**Going On A Hunting Expedition**
布上皮革、丙烯、油彩等	leather, acrylic, oil, etc. on canvas
90cm × 160cm	

作品从鄂尔多斯青铜饰牌动物咬斗纹得到启发，将写意性和极简风格相融合，以皮革为材料创作了这件充满游牧文化特质的作品。作者根据材料的特性，采用了以拼贴为主加打磨、喷染、绘制等手段来完成。在制作过程中，借鉴青铜饰牌浮雕工艺的装饰效果，利用皮革的柔韧度和可塑性在制底环节强化画面构成元素的凹凸效果和节奏，从而加强视觉的触感。在色调处理上尽可能保留原材料"味道"的基础上，采取浓墨重彩平涂的方式映衬画面焦点，力求凸显材料本身的质感、量感和皮革特有的肌理效果，让观者通过作品感受深邃而神秘、广袤而原生态的草原"游猎"之情、之境。

Inspired by the animal bite pattern of Ordos' bronze plaques, this leather work of spirituality-focused simplicity suggests the characteristics of nomadic culture. Based on the properties of the material, the author mainly uses collage to complete the work, with the combination of polishing, spraying and painting. The production adopts the decorative effect of bronze plaque embossing. Moreover, in the making of the base, the flexibility and plasticity of leather is utilized. The whole picture then acquires a concave and convex effect and rhythm, and the visual texture is also enhanced. As for color processing, the character of the raw material is retained as much as possible. The focus of the picture is highlighted with heavy coloring on the line drawing, so that the texture and bulkiness of the material and the effect of leather can be maximized. In doing so, the audience can "feel" the deep, mysterious, and vast hunting grasslands that nomadic culture relied upon.

贝尼格娜·瓦拉·卡德兹·韦拉斯韦兹
Benigna Wara Cardozo Velasquez

（玻利维亚 Bolivia）

精神空白	**Mental Gaps**
人发	human hair

<div align="center">100cm × 70cm × 5cm</div>

千丝万缕，间插无数大大小小的孔洞，艺术家用自己的头发制作了这件作品《精神空白》。精神空白，暗指那些在生活中产生的空白，那些包括对人、生物、记忆、物件等事物的忘却。如今，技术接管了人们的日常生活，人们不再记得生日、电话号码或眼前的风景。人们所有的记忆都存在一个芯片里，没有这些芯片，人们几乎不记得任何事情。头发是神经的连接丝，脱离的发丝象征着人的精神、思想和记忆，在艺术家手中呈现出"千疮百孔"的状态，反思了科技进步导致的记忆退化、精神空白，甚至情感缺失。这件作品常常在暗箱中展示，观众需要用手机灯照射观看，当墙面上落下斑驳多孔的投影时，喻示着是科技在人类大脑中留下的空洞影像，引领观众反思科技对人类精神和情感带来的负面影响。

Mental Gaps was created using the artist's own hair, intricately interspersed with holes, large and small. The holes refer to the gaps generated in life, the oblivion of people, creatures, memories, objects, etc.. Today, technology has taken over people's daily lives, and people no longer remember birthdays, phone numbers, or even the landscapes in front of them. All of their memories are now stored in a chip, without which people can hardly remember anything. Hairs here represent neural connection filaments. The detached hairs symbolize the state of the "riddled holes" of the human spirit, and the thoughts and memories of the artist herself. She reflects upon memory degradation, spiritual blankness, and even a lack of emotions caused by technological advances. This work is often displayed in a dark box, and the audience needs to use the light of mobile phones to illuminate it. When the muddled and porous projection is on the wall, it symbolizes the empty image left by technology in the human brain, and leads the audience to reflect on the negative impacts of technology on the human spirit and emotions.

布里吉·阿玛尔
Brigitte Amarger

（法国 France）

H154 / H360	H154 / H360
纺织品、X 光片	textiles, X-Rays

墙面方块 20cm×20cm×40、地面方块 38cm×38cm×4、
地面人体 117cm×60cm、墙面人体 215cm×160cm×120cm
（40 squares on the wall, 20×20cm each; 4 squares on the floor,
38×38cm each; the body on the floor, 117×60cm;
the body on the wall, 215×160×120cm）

当人体的 X 光影像与织物的 X 光影像叠合交织，艺术家在解剖结构的移植和重建中，探索外科医生与艺术家之间的关联。将新的技术与废弃材料相结合，以艺术的方式完成对人（特别是人在社会中的位置及留下的痕迹）的反思，成为艺术家追寻的目标。艺术家选取废弃的材料，包括织物和 X 光片等为主要媒材，源于她对医学的兴趣和环保的理念。她像科学家一样在实验室里探究和创造一个个关于废弃织物的样本，用激光在废弃的人体 X 光片上复刻织物的影像，试图赋予这些废弃之物以新的生命。织物被称为人的第二皮肤，这些被使用过的织物，成为皮肤上的记忆。作者将这些曾经外在的"皮肤"刻写在记录内在的 X 光片上，模糊了内与外、表与里的界限，创造了令人意想不到的医学图像：一个被雕刻的、记忆的、内化的纺织品印记。作品以 H+（超人主义 Transhumanism 的缩写）命名，在关注人体复杂性和神秘性之外，更关注因科技进步所迎来的未来 H+。

With the X-ray image of the human body and that of fabrics overlapping, the artist tries to explore their connection with surgeons through the transplant and reconstruction of anatomic structures. It is her pursuit to reflect on people, especially on their position in society as well as the traces they leave through combining new technologies with waste materials. She chooses waste materials, including fabrics and X-ray films, as the main materials, due to her interest in medicine and her passion for environmental protection. She explores and creates samples about waste fabrics in the laboratory like a scientist, and uses laser to recreate the images of fabrics on waste human body X-ray films, in an attempt to give these waste materials new life. Fabrics are called the second skin of the human being, and these fabrics that have been used now become memories on the skin. The author engraves these once-external "skins" on the X-ray films, which are generally used to record the internal state of the human being, thus obscuring the boundary of external and internal, and that of surface and core. In this way she has created an unexpected medical image: an engraved, memorized, internalized textile mark. Named H+ (the abbreviation of transhumanism), this work focuses on the complexity and mystery of the human body, and pays more attention to the future H+ brought about by technological progress.

布罗尼斯拉瓦·巴基尔科娃
Bronislava Bacilkova

(捷克 Czech Republic)

矩阵	**Matrix**
亚麻线、棉线、珠子	linen thread, cotton thread, beads
30cm × 70cm	

受到电影《黑客帝国》的启发,艺术家持续地思考这个问题:人究竟应当如何与技术共存?她尝试通过一种看似与现代世界无关的材料——传统纺织纤维——来表达她的思考,但计算机的发明及二进制与纺织技术密切相关。作品中的暗色代表着关闭的显示器,一个没有真实色彩的人造世界。这里有一些没有任何装饰的空白,只有一行行单调的针脚。暗色的排布偶尔被亮绿色的数字打破,它们被刻意地垂直排列。而这些数字则代表着计算机的想象世界(实际上可能仅仅是1和0)。圆点在这些排列中制造节奏,同时也产生间隔将数字分组。在整体形态上,所有的东西都仿佛在缓慢地向地面坠落,营造出一种不稳定性和焦虑感。该作品仅是整个"矩阵"——今天我们生活其中的这个虚拟世界——的一小部分。这些技术手段构建了我们现在的世界,赋予我们祖先们未曾拥有过的选择权力。却引发了艺术家的隐忧:它或许很美好,但同时也可能很残酷。

How should we coexist with technology? The artist's constant consideration of this question is inspired by the film *The Matrix*. As a product of her cerebration, this work adopts textile fiber, a traditional material seemingly irrelevant to modernity, to reveal the affinity between textiles and the origin of computers' binary systems. The dark colors in the work symbolize the unlit display, an artificial world without true colors. On the unadorned blankness of the display, monotonous lines of pins repeat, occasionally broken by bright green numbers. Deliberately arranged vertically, these numbers hint at a virtual world possibly constituted merely by "1"s and "0"s. The dots create a rhythm for the pattern, and there are set intervals between the groups of numbers. Through this pattern, the fabricated world seems to be constantly sinking with an aura of instability and anxiety. The work is but a snatch of the "Matrix" - the exact virtual world of ours. Modern technologies do shape the world, granting us unexampled possibilities, but the artist can't help to worry that it may be beautiful, but may also be cruel.

卡门·因巴赫·里格斯
Carmen Imbach Rigos

（阿根廷 / 乌拉圭 Argentina/ Uruguay）

女性地图（贾兹敏和她的家庭肖像）	Female Maps (Jazmin and Family Portraits)
缝纫线、花边、丝	sewing thread, macrame, silk

70cm × 70cm × 250cm

卡门的研究和创作反思了女性手工艺作为一种身份认同，交织了社会与政治问题。她探讨了维系家庭世界的情感联系，创作了一个和平共处的交互网络。在日常家庭生活中，与女性有关的技艺与物料，如缝纫、纺纱和编织，都是她创作的依据。在这个语境中，作为一个女人定义了家庭生活的界限和她在家庭中的角色。她提到童年时未说出口的东西是如何产生深远影响的。这件装置由几件裙子与一个女孩、一个男孩的形象组成。这些裙子形成一个没有身体的框架结构，像一堵"墙"保护被困在家庭暴力中的儿童。光线穿过经线，在空旷的空间中投射阴影，创造了一个既无形又可见的世界。光的作用是"照亮"家庭中隐藏的秘密。线的排列是一种隐喻，通过她童年经历的镜头来表达她寻找身份的主题。它们很容易缠结和松动，但又很容易重新组装。

Carmen's work investigates gender identity and reflects on women's hand-made work; it touches on both social and political issues. She probes the affective bonds that sustain the domestic universe and that create webs of interconnection for peaceful coexistence. The daily routines of domestic life, the techniques and materiality associated with women - such as sewing, spinning, and weaving - are the parameters upon which her work is based. Within this context, being female defines the boundaries of domesticity and her role in the family. She makes reference to how the unspoken in childhood have profound effects. The installation consists of several dresses and the image of a girl and a boy. The dresses are arranged to create a framework of absent bodies and a "wall" of protection for a childhood trapped within family violence. A light is directed through the warp, casting shadows within the empty spaces, creating both an invisible and visible world. The light is significant in its role of 'shining a light' on hidden family secrets. The thread arrangements are metaphors to express her theme of the search for identity seen through the lens of her childhood experiences. They can easily become tangled and loose, but the installation can easily be reassembled.

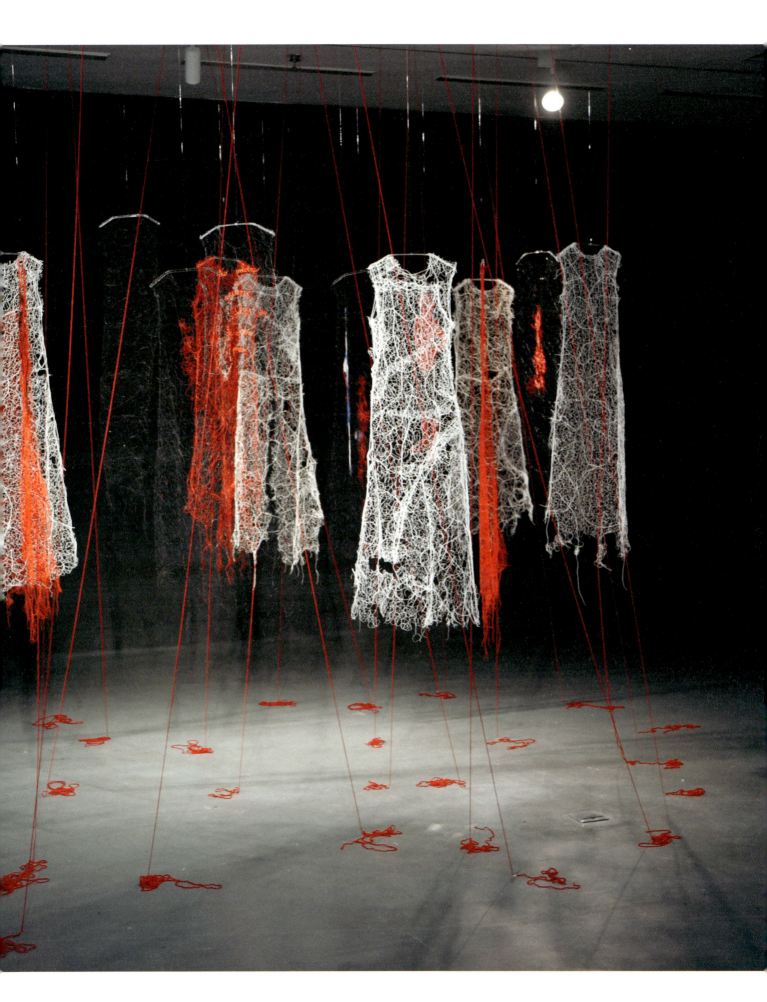

蔡陈林
Cai Chenlin

（中国 China）

可见的幻觉——蘑菇云 3 号	Visible Illusion - Mushroom Cloud #3
透明亚克力板上油画、亚克力螺丝	oil painting on acrylic board, acrylic screws

46cm × 30cm × 21cm

东方的山水画和西方的风景画在语境上并非完全相同。西方的风景画侧重于描绘自然现象和景物，东方山水画则更强调画面中描绘的风景所蕴含的意境和哲学深意。因此在"可见的幻觉"系列作品中，艺术家以历史上核爆蘑菇云的照片为风景，将平面的图像转换为三维的空间绘画。将蘑菇云的图像进行三维分解，绘制在多层透明亚克力板上面。这种呈现方式类似于医学上的 CT 断层扫描图，科学与艺术的景观在特定形式上进行了组合。细胞状的绘画肌理通过叠加组合，幻化成升腾的蘑菇云，同时包含了毁灭与重生的意象。作品将历史事件与当下生存环境联系起来，赋予特定"风景"某种"意境"。

Eastern landscape painting and western landscape painting are not identical in context. Western landscape painting focuses on the description of natural phenomena and scenery, while eastern landscape painting emphasizes the artistic conception and philosophical meaning of the depicted scenery. Therefore, in the *Visible Illusion Series*, the artist takes photos of mushroom clouds made by nuclear explosions in history as the scenery. The 2-D images are transformed into a 3-D painting. In this work, the mushroom cloud image is decomposed into three dimensions and drawn on a multi-layer transparent acrylic sheet. This method of presentation is similar to medical CT tomography, in which the landscapes of science and art are combined into a specific form. The cellular texture of the painting is transformed into a rising mushroom cloud through superposition and combination. An image of both destruction and rebirth is presented to connect historical events with the current living environment. And certain "artistic conceptions" are given to specific "landscapes".

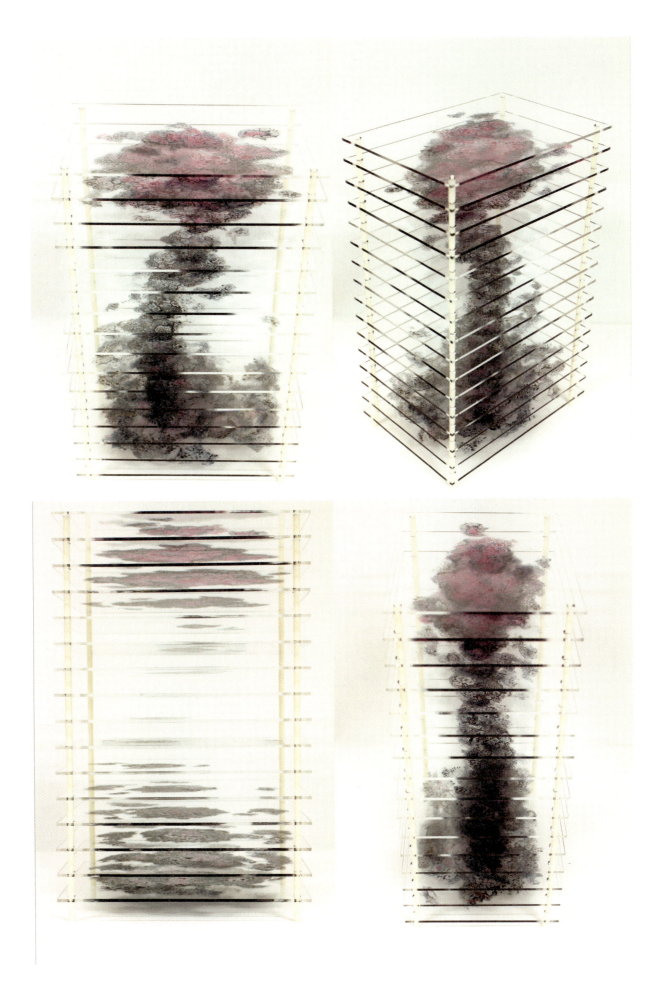

柴鑫萌
Chai Xinmeng

（中国 China）

二十四节气	**Solar Terms**
圆木、纤维等	wood, fiber, etc.
200cm × 150cm × 10cm	

作品形象的灵感源自艺术家对山水风光、烟云水汽、树木花卉等自然风景如何在雕塑中呈现的兴趣，艺术家将自己看到的不同时间、地点的风景表现了出来。作品的主要材料为木和纤维，每一片圆木的局部都有用纤维材料置换的部分，纤维的部分做出了山水、草木等自然形象的形态，在抽象化的风景中融入了对传统节气的表现与营造，串联了一个四季轮回的节气图景。艺术家关注雕塑创作中的材料表现与形式语言，寻找着更为丰富的表现对象，在这组作品中，旨在凸显自然幻化的意象美，通过模仿、幻化自然，呈现出丰富的想象空间与诗情画意，进而触及观者心底温存的传统记忆。

The inspirations for the images used in the work are generated by the artist's interest in the sculptural presentation of landscape, climates, organic life, and other kinds of scenery. The artist expresses the scenery that she saw in different places and at different time points. The main materials of the work are wood and fiber. Fiber materials are incorporated into parts of all the logs, in which natural images of sundries are delicately depicted. And the annual cycles as well as the traditional Chinese solar terms are integrated into the abstract scenery. The artist is concerned about the material expression and formal language in sculpture creation, and is looking for more abundant objects of expression. The aim of this group of works is to highlight the beauty of natural images. Through imitation and fantastic depiction of nature, a rich imaginary and poetic space is generated, so as to awaken the memory of the audience about traditions deep in their hearts.

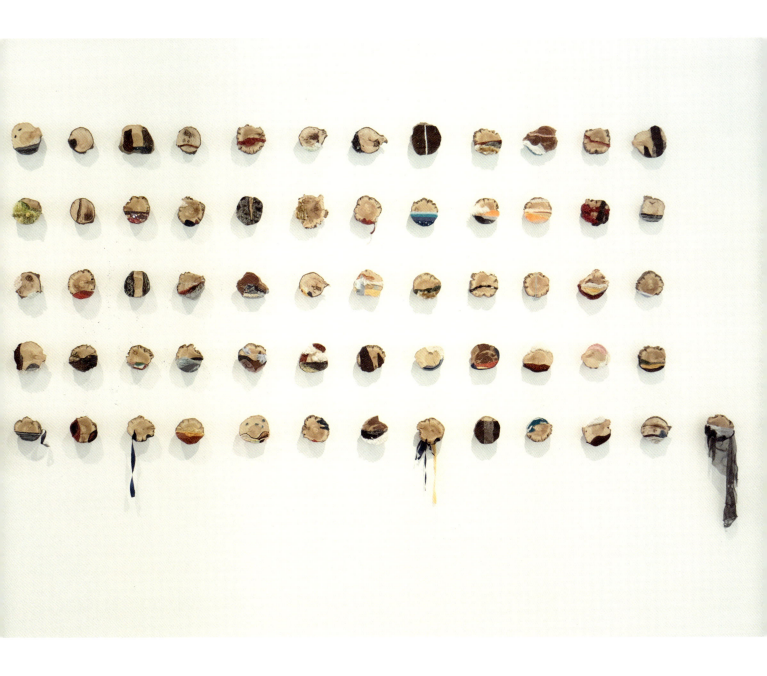

夏洛特·厄斯特加德
Charlotte Østergaard

（丹麦 Denmark）

羁绊	Entanglements
混合纤维（涤纶、棉、羊毛）	mixed fiber (polyester, cotton, wool)
230cm × 130cm × 100cm	

两片"羁绊"缠结悬挂在顶棚上，自由下垂，在它们之间形成空间。艺术家的想法受到多纳·哈拉维"结亲"理念和简·本内特的新唯物主义思想的影响，她认为"横向地体验人与其他物质的关系"，是一种"道德任务"，人们在其中感受人本身、人的身体、物质及其超越性，以及诸者之间影响与被影响的羁绊关系，最终"向更生态的敏感性迈出一步"。她因此确定了一种特殊的创作思路：在材料和技术之外，让作品在人和物质之间的动态关系中成长（让物质引领道路）。她首先将两件织物悬挂起来，然后邀请设计师、舞者的加入，她们以不同的方式穿着、穿越、探索这件作品，具身化地扩展物质与人的"亲缘"，并且在其上留存一些痕迹：拖动、拉拽、糅合——最终成为作品的生长。它最终成为一个可供展示的对象，也可以被穿戴起来，"人性而又超人"，并且同时有着某种表演的潜质。

The two-piece *"Entanglements"* are dangling from the ceiling, creating a space between them. This work is influenced by Donna Haraway's "Making Kin" and Jane Bennet's new materialist ideas. Jane regards "the experience of the relationship between man and other substances laterally" as a kind of "ethical task". Her duty is to make people empathize with human beings, the human body, matter and its transcendence. Moreover, she seeks to immerse people in the entangled relationship between the influencing and the influenced, so they can eventually "take a step toward more ecological sensibility". The artist follows her own path, thereby realizing her creativity outside of materials and techniques in this work. She allowed the material-flow to 'lead the way', and to reproduce itself via the dynamic relationship between humans and materials. Designers and dancers are invited to the in-between space: wearing, traversing, and exploring the work in their own ways. The "kinship" between materials and humans is thus formed through the traces of dragging, pulling, blending, etc.. The work ends up being an object to be displayed, but also an object to be worn. It is "human and more-than-human", and at the same time, has some sort of performative potential.

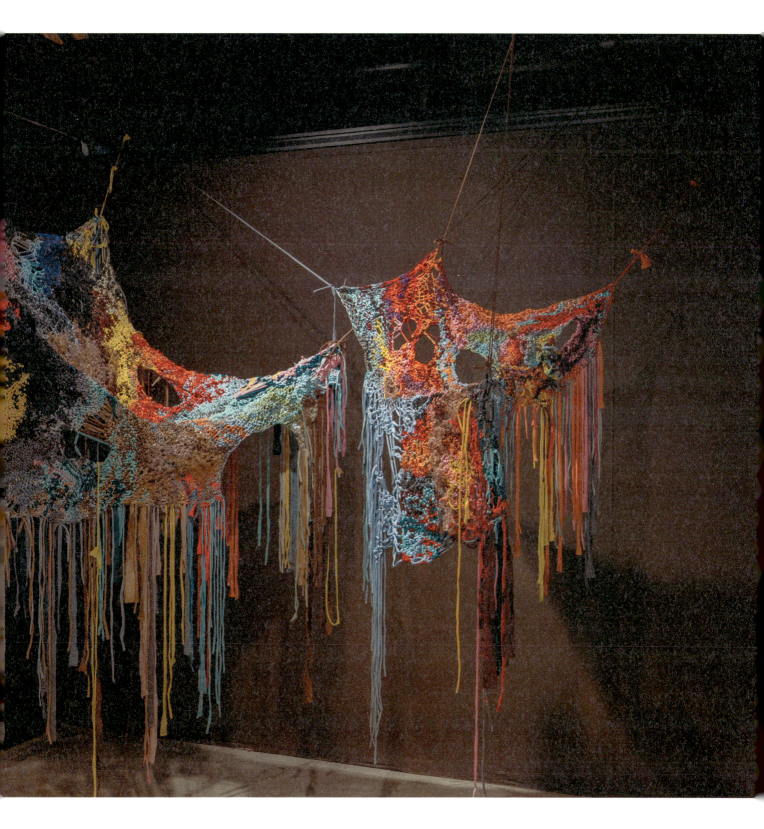

陈辉（绘）
Chen Hui (painter)

（中国 China）

大气影像	**Atmospheric Images**
皮纸、宿墨、酒精、油烟墨、树脂胶、醋酸乙烯、洗手液、稀释材料、发泡剂	leather paper, ink, alcohol, fuming ink, resin glue, vinyl acetate, hand sanitizer, thinner material, foaming agent

960cm × 200cm

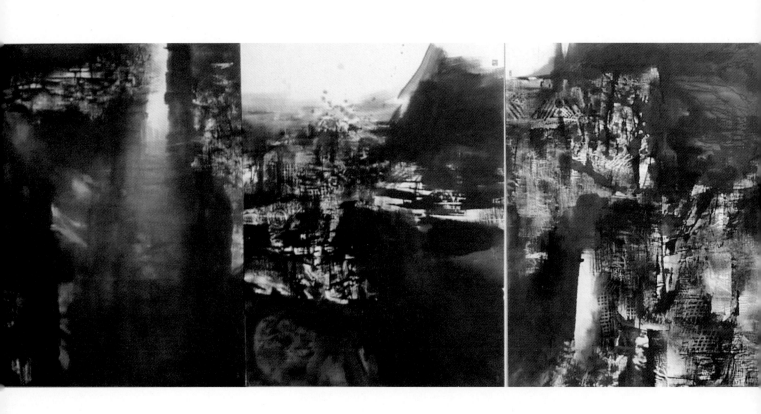

《大气影像》是以中国传统水墨为主要媒介创作的绘画作品。在这组作品之中，艺术家将物理光影与道家自然哲学融合在了一起，并通过水墨阐释了中国传统美学的气韵和意境之美。从图像本身来说，作品并不局限在具体的物象，其以广阔无垠传递出强烈的崇高美学的特质。虚与实、明与暗、动与静、黑与白，这些既对立又辩证的哲学关系，构成了画面形式背后的哲学规则。这幅作品试图通过中国古代道家"天人合一"之思想，表现宇宙天体、自然万物和谐共生的理想幻化图景。通过图像的科学发现与艺术想象的图像的对比与移植，引发我们对人类生存环境问题的再思考，对发现宇宙的奥秘与探索人之情感世界的关照。

Atmospheric Images are paintings adopting Chinese traditional ink as the main medium. In this group of works, the artist combines lights and shadows with Taoist natural philosophy, and explains the profundity and beauty of traditional Chinese aesthetics through Chinese ink. As for the content, the work is not limited to specific objects. The ambiguity of its content represents sublime aesthetics. As for the significance, the contradictory and dialectical philosophical relationships between the vague and the concrete, the bright and the dark, the dynamic and the static, and the black and the white, form the background philosophy of the painting. This work attempts to express an ideal vision of the harmony and coexistence of the cosmic celestial bodies and all things in nature, through the ancient Chinese Taoist idea of "the unity of heaven and man". Through contrast and an artistic imagination of how we perceive "images", the works provoke the viewer to reflect upon human existence, to care about the study of the various mysteries of the universe, and to explore the emotional world of human beings.

陈辉（雕）
Chen Hui（sculptor）

（中国 China）

穿过云雾的船	Boat Through the Clouds
包装盒打碎的纸浆、竹子	pulp made from mashed packaging boxes, bamboo
325cm × 180cm × 120cm	

艺术家用回收的快递纸箱还原的纸浆为材料，组合以船、帆、云雾、天使等意象符号，塑造了一艘在太空中行进，在云雾中迷途的飞行器。梦一般的场景表达了当代人面对生活与未来既焦虑而又期待的复杂情绪：网络、信息和科技的发展使一切都飞速地产生着变化，明天已然遥不可知。在此，回收纸箱并非是单纯的物质材料，而是在消费社会中被赋予了社会属性的材料，象征着人们不断膨胀增长、毫无节制的消费欲望，使雕塑形态传递出更加深刻的意义。

The artist uses the pulp restored from recycled express cartons as the material, and combines the images of ship, sail, cloud, angel, etc. into an aircraft that travels in space and gets lost in the clouds. This dream-like scene expresses the complex emotions of contemporary people: in the face of the present moment, they are stricken with both anxiety and expectation waiting for the future. The development of the Internet, information, and technology, makes everything change rapidly, making every "tomorrow" so uncertain. Here, the recycled cartons are not only physical materials, but are symbols of our consumerist society. The work, therefore, profoundly symbolizes people's unrestrained consumption desires, which are continuously growing.

陈琦
Chen Qi

(中国 China)

观象	**Observation of the Celestial**
纸	paper
160cm × 260cm × 30cm × 4	

历史是文明全体成员的集体记忆，也是文明得以存续发展的维系。知识和情感的传承则以书籍作为最普遍的载体，发挥着超越山川和岁月的恒久力量。但太阳终将熄灭，或许远在此之前人类就将迎来末日，那些曾经家喻户晓的故事也将被遗忘。这些记载了数代人的辉煌与磨难的纸张，或因疏于管理，或因年代久远，也必然葬于虫豸之口。这些渺小的生命用极其缓慢却颇具决定性的步伐侵蚀着比它们强大得多的生物全部的精魂，留下一个个同心圆般的虫洞。这些虫洞是生命活动的印记，也是人类某种毁灭进程的确证。艺术家用纸雕层层叠加构建了许多类似虫洞的形式，仿佛从书的扉页一直深入封底，自今朝的琐碎一直通往历史的缘起，成为蜿蜒的时间隧道，连接着万物的生灭轮回。

In the collective memory of a civilization, history sustains the existence and development of the civilization. The inheritance of knowledge and feelings, similarly, survives vicissitudes through literature. But the sun will eventually die, perhaps long before the end of mankind, and those household stories will disappear. Numerous writings on paper, and the glory and suffering of generations of people recorded within, see their ineluctable end in the guts of insects when they are abandoned and decaying. In extremely slow but steady rhythms, these tiny creatures erode us down to our souls, despite us being creatures far more powerful than them. The circles left behind after the erosion represent the activities of life and the extinction of humanity. The artist simulates these "wormholes" by overlaying paper sculptures, as if they permeate a book from the first page to the back cover. They become the winding time tunnel straight from the trivialities of the present to the very beginning of history. The circles representing all things' creation and destruction are thereby connected.

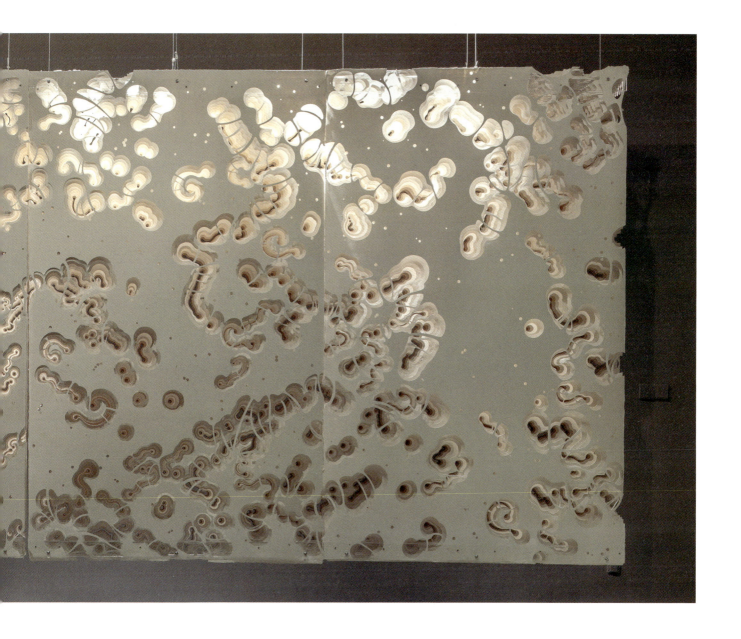

陈焰
Chen Yan

（中国 China）

七天	**Seven Days**
银盐胶片刻画	silver film engraving
300cm × 80cm × 7	

《七天》是以银盐胶片为材料经刻画创作而成的综合材料作品。该作品以底片代替纸张、以刻刀代替画笔，由点及面所产生的痕迹展现了创作主体在创作过程之中即兴、偶然的精神状态。该作品创作于疫情期间，许多有关生命的感悟和思索被作者转化成为"七天"的抽象笔势，平静、焦灼、兴奋、癫狂等诸多情绪都转变为行为笔势的瞬息状态，成为无言之书写。在展示之中，经由灯箱和光线的透射作用，所有刻画痕迹透出灵性的光芒，在黑色展厅展现出独特的光影造型的美感，但又带着某种隐隐的刺痛感。

Seven Days is a mixed media work created by engraving on silver film. The work uses film instead of paper and a carving knife instead of a brush, and the traces produced by the points and surfaces show the improvised and accidental state of mind of the creative subject in the process of creation. The work was created during the epidemic period, and the artist transformed many feelings and thoughts about life into the abstract gestures of "Seven Days". In the exhibition, through the lightbox and the light transmission, all the traces of carvings shine with spirituality, showing the unique beauty of light and shadow modeling in the black exhibition hall, but also inspiring a certain hidden tingling feeling.

程向君
Cheng Xiangjun

（中国 China）

中国医书——面相	Chinese Medical Book - Physiognomy
木板、亚麻布、漆	plank, linen, lacquer
120cm × 90cm	

艺术家这一系列的漆画作品始于 1996 年。由于对中国传统文化有浓厚的兴趣，艺术家在对个人的创作状态和传统漆画系统进行梳理与思考时，决定运用特定的文化符号，以"中国医书"为主要元素进行现代漆画的探索。他结合自己对现当代艺术思潮和审美趣味变化趋势的感悟，在创作实践中不断对传统漆艺及材料特性进行再认识与再把握，确立了个人在漆画领域的研究目标：通过综合材料及综合表现手法探索出现代漆画的新形式。作品运用丝网印刷技巧自然地与漆艺传统媒材相结合，拓展了漆媒材表现的可能性。漆、纤维、石粉，本都是独立的物质材料语言，通过与漆自然结合，丰富了材料语言，传达出一种温厚的文化沧桑感和更为灵动的远古气息。

This series of lacquer paintings was first launched in 1996. Due to the artist's strong interest in traditional Chinese culture, his summary and reflection of his personal creative state and traditional lacquer painting system led to an exploration into modern lacquer painting with "Chinese Medical Books", a series of specific cultural symbols, as the main elements. Using his insights into the modern and contemporary art trends, and the transformation of aesthetic tastes, he constantly re-examines and reviews traditional lacquer art and the characteristics of its materials during his creative practices. Based on this process, he has determined his research objective in the field of lacquer painting: using comprehensive materials and expression techniques to explore new forms of modern lacquer painting. This work naturally combines screen printing with the traditional media of lacquer art, to expand the potential expressiveness of lacquer media. Lacquer, fiber, and stone powder all have their independent material languages. But their natural combination within the lacquer creates a more expressive material language. In this language, the ever-changing cultures become more moderate, and the solemnity of remote antiquity becomes more vivid.

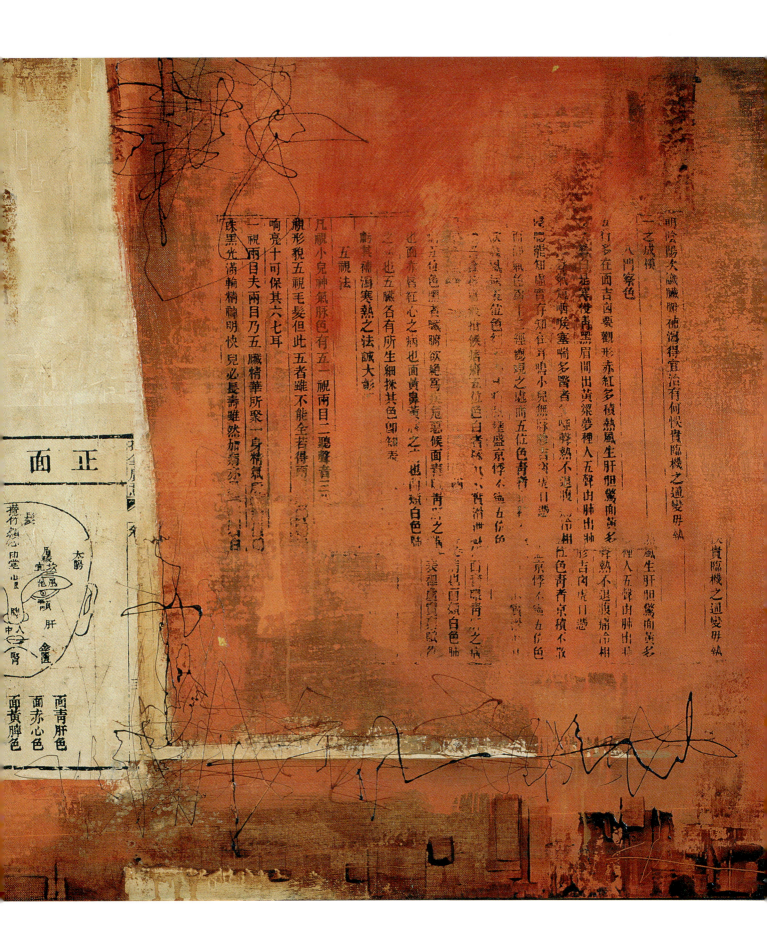

丹妮·梅尔曼·莎克特
Danit Melman Shaked

（以色列 Israel）

无限	Infinity
镍铬合金丝、液体黏土、耐火土、再生纸、漆（天然、黑色和红色）、赤土粉和颜料	nichrome wire, liquid clay, chamotte, recycled paper, natural, black and red lacquer, terra cotta powder and pigments
40cm×137cm×60cm	

对于艺术家而言，艺术创作是整理思绪的一种方式，是在周遭的混乱中提炼出秩序的手段，能够平衡她的内在和外在世界。因此，源于一种塑造"无形"的欲望，她非常乐于探索材料的可能性，希望在创作中由材料的性质和技术手段带领自己的精神走入某种未知。在这里，艺术家使用镍铬合金线手动塑造形状，再用液态黏土、耐火土及再生纸的混合物覆盖，将其置于电窑中缓慢燃烧至1020℃，最后使用天然的黑红漆液，陶土粉和颜料进行层层覆盖，塑造出这样一团复杂、扭曲而又无法把握的"线"。它灵活易变，可以存在于不同尺寸的空间之中，观者的视角在空与满之间交替。这代表了意识的灵活性，其本质是变动不居的，一遍又一遍地在我们的脑海中死亡和重生。

Creating art, for Danit, is a means to organize ideas, to distill order from surrounding chaos, and to find balance between the inner and outer worlds. Therefore, she is ready to explore the possibility of materials, and hopes to allow the characteristics of materials and the techniques during her creative activities, to take her spirit to somewhere unknown. Her mind is full of a desire to shape the "invisible". Here, the artist uses nichrome wire to manually form the shape, then covers it with a mixture of liquid clay, fireclay and recycled paper. After the slow heating in an electric kiln to 1020℃, natural black-red lacquer, clay powder and pigment are applied in sequence to create the final ball of such complex, twisted and unmanageable "thread". It is flexible, changeable, and able to fit in spaces of different sizes. The viewer's perspective alternates between the empty and the full, where lines and spaces meet, and the light and the dark alternate along the lines. It represents the flexibility of consciousness, which is intrinsically fluid, dying and reborn in our minds over and over again.

大卫·莫雷诺
David Moreno

（西班牙 Spain）

教堂连接 001	**Cathedral Connection 001**
钢（钢琴线）、银焊料、铜锈色	steel (piano wire) , silver solder, brass patina
90cm × 90cm × 20cm	

莫雷诺的雕塑代表了一种想象中的建筑，它介于概念和现实之间。他的作品一丝不苟：每条线都是用银丝点焊而成。这是"大教堂连接"系列的第一件作品，它将在未来的几年里为他开启一条全新的探索之路。一方面，房子消失了，取而代之的是楼梯和罗马式门廊。灵活的链接被刚性的台阶所取代。"关系"是这件作品所提出的另一个问题。下降和上升可以有多种解释：从神秘的经验到权力的结构。另一方面，金色首次出现在他的雕塑中，从那时起，他也在自己的其他系列作品中开始使用这种颜色。

Moreno's sculptures represent an imaginary architecture that is halfway between concept and realization. His work is meticulous: each line welded with a point of silver wire. This is the first piece in the Cathedral Connection series, which will open a whole new avenue of exploration for him in the following years. On the one hand, the house disappears, and in its place, the stairs and Romanesque porticoes appear. Flexible links are replaced by rigid steps. The relationship between the steps is another issue raised up by this work. The descents and ascents can have multiple interpretations: from mystical experience to power structures. The golden color makes its appearance for the first time in this Moreno sculpture, and the artist plans to use it in other series of his work.

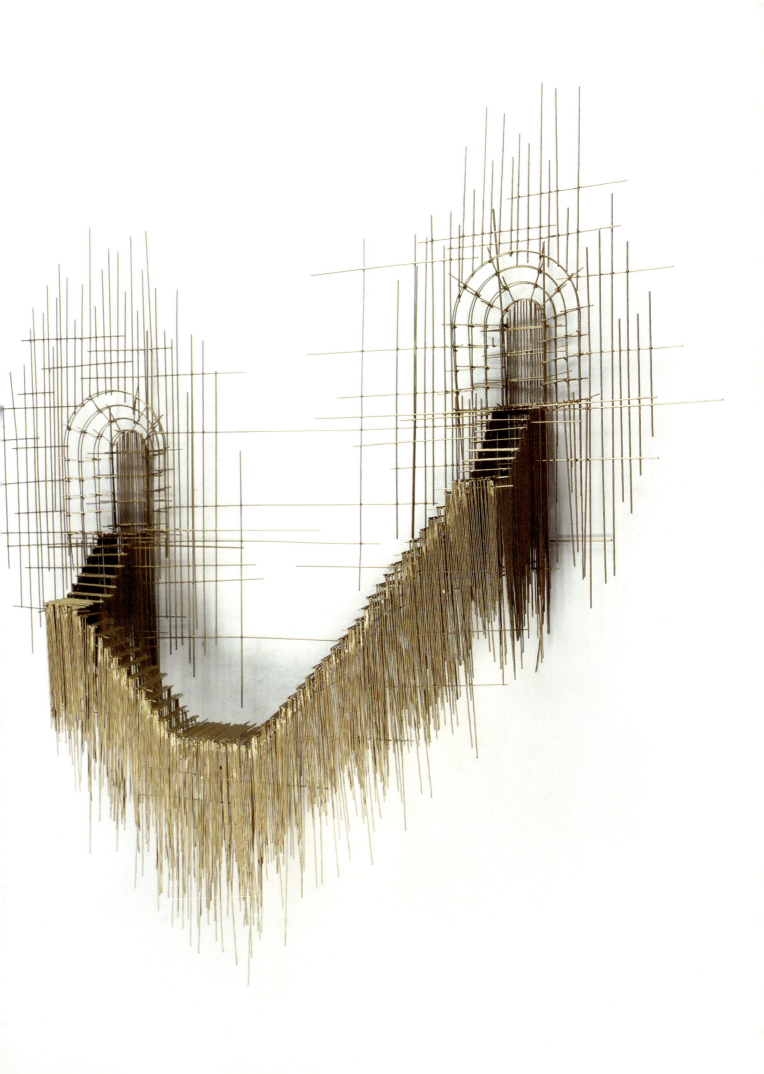

丹妮丝·布兰查德
Denise Blanchard

（智利 Chile）

神圣的外衣	Sacred Mantle
回收的茶袋和尼龙网	used tea bags and nylon net

600cm × 240cm

智利人热爱喝茶，泡过的茶袋拥有丰富的色彩和肌理，铁锈般古旧的颜色充满了回忆感和叙事性，同时用回收的茶袋创作也应和了环保的理念。这件装置作品受到了艺术家工作室附近的社区的参与和支持，大家共同提供和收集"材料"，并采用缝纫、编织、刺绣等方式共同参与制作。艺术家将女性有关的传统工艺和女性服装概念运用到作品的创作中，不同的是材料的变化——回收茶包的采用，打破了与缝纫有关的女性工艺和材料的传统系统的意义，用它们作为近年来女性经历的变化的隐喻，反思几个世纪以来女性所扮演角色的广度。作者将这件用废弃回收茶袋编织出的关于女性的历史与现实故事命名为"神圣的外衣"，隐喻女性以微小之物织就伟大、以平常织就非凡的神话。

Chilean people adore drinking tea. The brewed tea bags are rich in colors and textures, and the old rust-like colors can bring back memories and tell stories. At the same time, creation using recycled tea bags conforms to the concept of environmental protection. This installation has received support from communities near the studio of the artist. They provided and collected materials and participated jointly in the creation through sewing, knitting and embroidery. Traditional arts and crafts, as well as inspiration from women's costumes, are applied in the work. Recycled tea bags, which are not an option for traditional materials, are also adopted, breaking the traditions of materials used in women's sewing. They are regarded as a metaphor for the changes women have experienced in recent years, and reflect on the breadth of roles women have played over the centuries. The artist named this historical and realistic story about women woven from discarded and recycled tea bags as "Sacred Mantle", which is a metaphor for the fact that women weave greatness with small things, and create splendor with ordinary things.

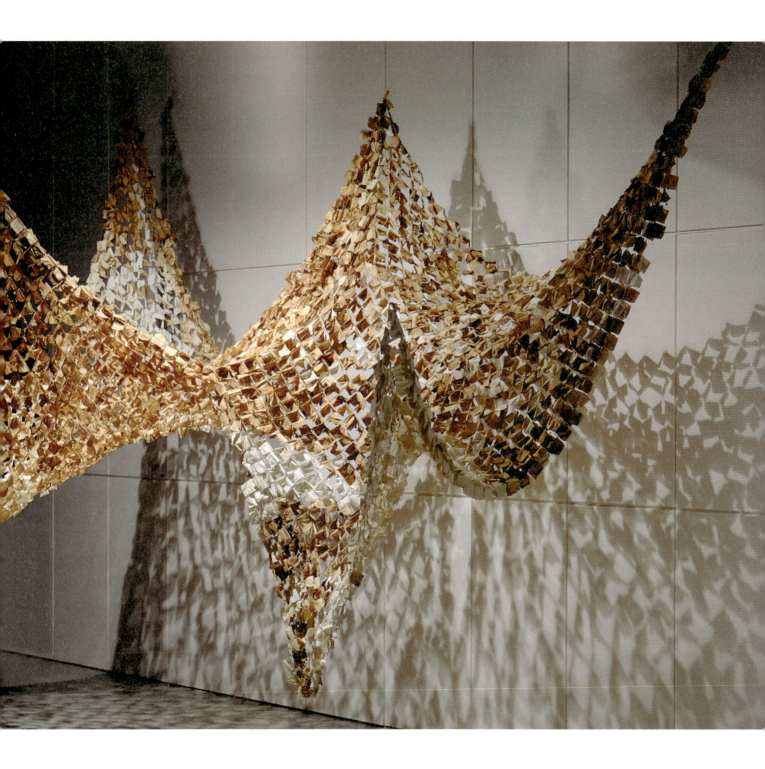

戴安娜·格拉波夫斯卡
Diana Grabowska

（波兰 Poland）

面具	**Mask**
棉、丝、氨纶、塑料、磁铁	cotton, silk, spandex, plastic, magnets
21cm × 17cm × 23cm	

《面具》是传统雕塑与现成品相结合的作品，与后现代主义的女性主义有关。该作品由女性内衣构筑，艺术家将女性内衣拆解之后改造成为可以穿戴的面具。作为面具本身，它也是可以灵活拆解的。将内衣转变为面具，这使作品兼具私密性与公共性，而艺术家本人也希望借助物品等转变探讨亲密性问题。但由于艺术家采用了非常女性化和私密化的材料，作品不可避免地引发了与女性身体相关的联想。作为公共场合之中的观看者被裹挟其中，自动处在了"偷窥者"的视角，并诱发了与此对应的心理机制。

Combining traditional sculpture with ready-made objects, *Mask* echoes of postmodern feminism. Fragments of women's underwear metamorphose into a wearable mask. As a mask, it seizes the potential for flexible disassembling, a flexibility between private and public domains. In doing so, the artist probes into the area of intimacy, though its irrefutable implication for feminine sexuality haunts the materials. The viewers, in a public place, being coerced into the perspective of a "voyeur", are automatically generating the corresponding psychological mechanism.

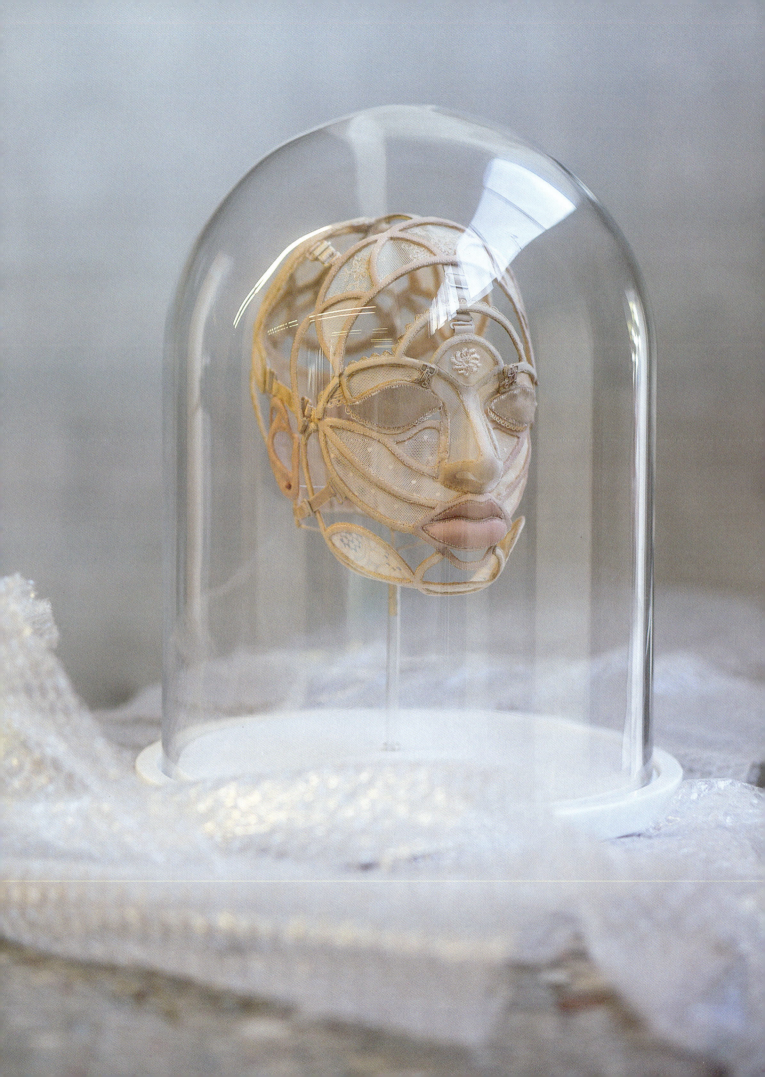

丁荭
Ding Hong

（中国 China）

枯木逢春	The Spring of the Withered Trees
宣纸、水性颜料、矿物质颜料	Xuan paper, water-based pigments, mineral pigments
180cm × 388cm	

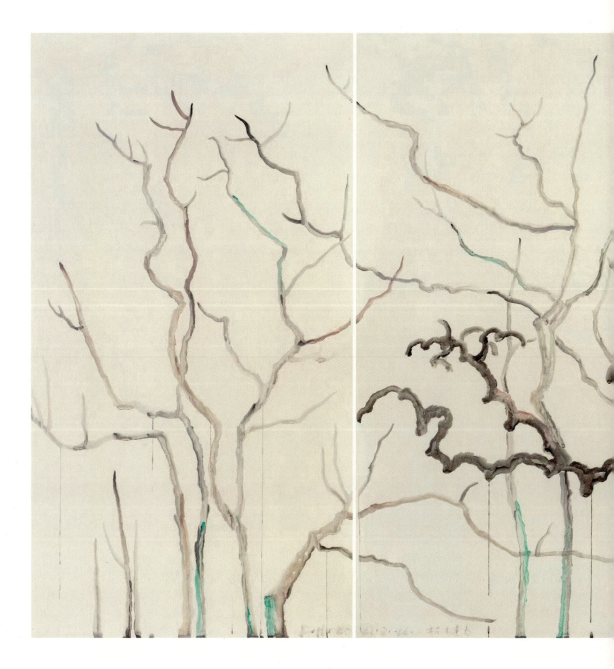

面对冬日里的枯木，人们多会激发一种衰败、萧瑟之情。这些树木无疑面临着寒冷的威胁，生存的挑战。然而，在艺术家的眼中，她看到了枝丫中透露着的生命力和倔强，看到了生命将伴随着春意而来的迸发与流淌。这种认知与情绪也反映在艺术家创作的过程中，水、颜料、宣纸不仅仅是手中的材料和工具，也是参与创作的主体。当物象的形态与艺术家的情绪交融，一种昂立的姿态随着画笔在纸上的滑动而成型，枯木的春天便开启了。

When faced with withered trees in winter, people mostly experience a feeling of decay and depression. These trees undoubtedly face the threat of cold and the challenge of survival. However, in the artist's eyes, she sees the vitality and stubbornness revealed in the branches, and feels the burst and flow of life that will come with the spring. This perception and emotion are also reflected in the artist's creative process, where water, paint and rice paper are not only the materials and tools in hand, but also the subjects involved in the creation. When the forms of the objects and the artist's emotions intermingled, the shape of an upright posture was formed as the artist's brush slid across the paper. Thus, *The Spring of the Withered Trees* came to be.

多洛·纳瓦斯
Dolo Navas

（西班牙 Spain）

"水下"装置	"Underwater" Installation
透明的充气家具、回收的酒瓶	transparent inflatable furniture, recycled wine bottles
多件作品组合，尺寸可变（installation of several pieces, size variable）	

法国诗人保罗·瓦勒里的著名诗句给了艺术家以灵感："我们内心最深处的东西是我们的表面（皮肤）"，促使艺术家思考深度与表面的问题。她选择玻璃瓶作为载体，为了表现"皮肤"是一种容器，同时也是

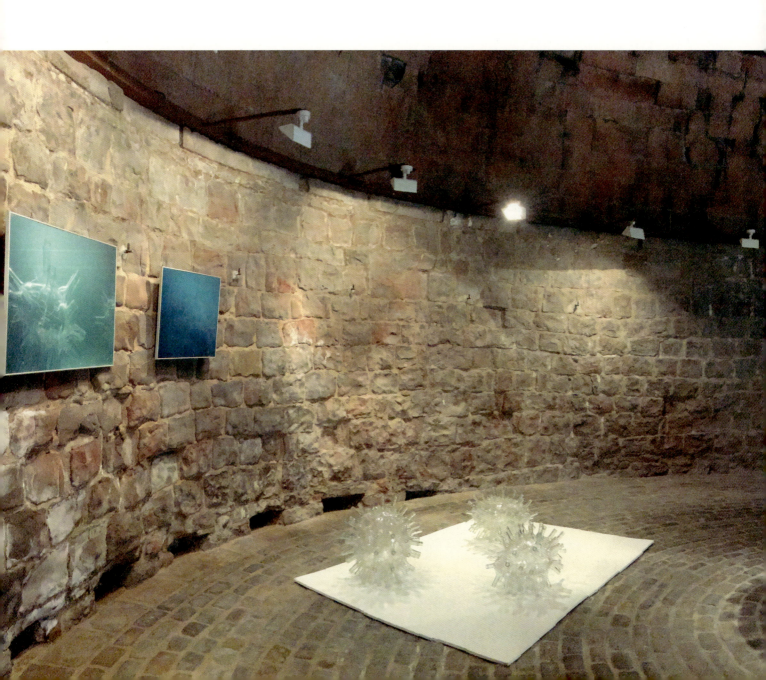

一种通道。皮肤容纳了来自身体表面体验的精神内容：其感官是记忆的第一道痕迹，并被整合到心灵中，让我们能够接触到自己的感觉、自己的极限以及内在感和现实感；同时，皮肤也是与他人交流的第一工具和场所，除了微风和雨水，母亲的触摸、情人的爱抚，甚至敌人的利刃，皮肤记录着这些与他人最密切的经验。而被连接、组合的玻璃容器，它们被置于空气中，置于海水中，仿佛一个个独立的皮肤细薄连成一片，在表面凝聚了深度，进行着物质交换的同时构成一道精神自我的屏障，形成一个复杂而微妙的隐喻体系。

The famous poem of the French poet Paul Valéry inspired the artist："The deepest thing in our heart is our surface（skin）". The artist is prompted to think about the relationship between the depth and the surface. She chooses the glass bottle as the carrier to show that "skin" is a container and a channel. The skin as the surface contains the spiritual content of the body's experience：its senses are the first traces of memory；they are integrated into the mind, so that we can get in touch with our own feelings, limits, inner senses, and sense of reality. Meanwhile, skin is also the first instrument and location for communication with others. In addition to the breeze and rain, the mother's touch, the lover's caress, and even the enemy's sharp blade, the closest experiences with others are recorded by the skin. The air and the sea water are poured into the connected and combined glass containers, as if the containers were divided into thin pieces of skin. The depth is condensed on the surface, forming a barrier of spiritual self that still allows the exchange of materials, and a complex and subtle metaphoric system.

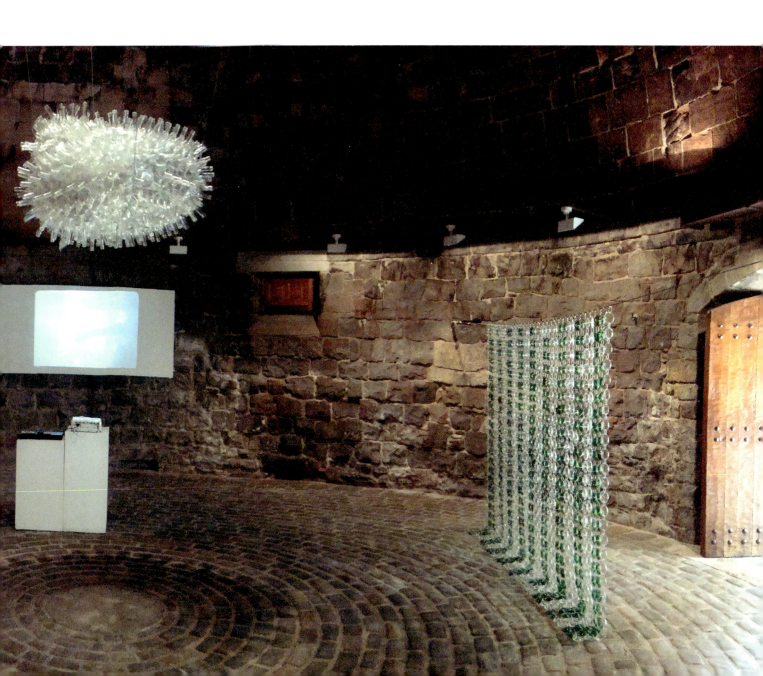

董书兵
Dong Shubing

（中国 China）

河运国安 & 构	**Grand Canal: Prosperity & Construction**
PVC 管	PVC tube
50cm × 25cm × 70cm，50cm × 30cm × 80cm	

艺术家选择了帆船和牌楼两种意象，用白色的 PVC 管架构起简洁明丽的形式。帆船的造型源自于宋画《清明上河图》中的漕运船只，此种单桅帆船主要用于货运，承载着古代漕运系统中沟通南北的最基本任务，是中国运河文化的代表性印记和符号；牌楼，则是古代社会表彰功勋、政德、科第及忠孝节义的礼仪性建筑，中国许多巍峨的牌楼历史悠久，屹立不倒，成为历史痕迹与集体记忆的载体。作品中，大量白色的直线在结构上进行虚实的穿插，制造出疏密上的节奏变幻，呈现出若隐若现的空灵之感；同时，也以此弱化了对货船与牌楼的现实描摹，在跨越时空的视觉体验中，二者的抽象文化意味得以慢慢浮现。

The artist constructed these simple and bright forms with white PVC pipes based on the images of a sailboat and an archway. The sailboat is inspired by the historic cargo ships displayed along the river during the *Qingming Festival*. This kind of sailboat with one mast was mainly used for freight in the past and had the task of communicating between the north and the south, in the ancient canal transport system. The sailboat is also the symbol of Chinese canal culture. The archway is a ceremonial construct in ancient Chinese society used to honor merit, political virtues, moral virtues, and educational achievements. Numerous majestic arches in China survive today and have become the carriers of history and collective memory. In this work, abundant straight white lines penetrate the structure with different densities and rhythms, so as to convey an implicit sense of ethereal beauty; its connection with real cargo ships and archways is thereby weakened. In this visual experience beyond space and time, the abstract cultural meanings of the two images gradually become visible.

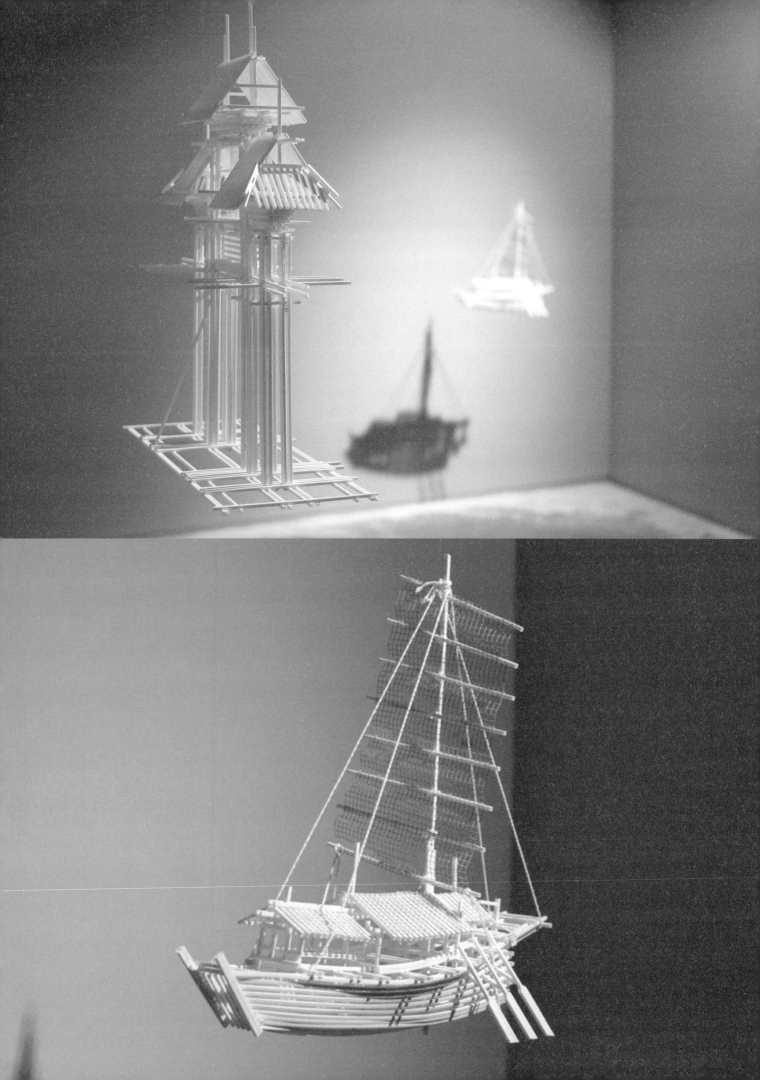

董洋洋、韩妤
Dong Yang-Yang, Han Yu

（中国 China）

混沌	**Chaos**
签字笔、水彩纸	roller pen, watercolor paper
	1000cm × 152cm

艺术家通过线圈的不停绘制，伴随着手工劳作与身体律动，探讨了宇宙与生命中有序与无序的问题。作品灵感来自于一次在医院的经历：他看到一位老大爷在焦急地等待他的小孙子，由于手术时间太长，他在楼道双手背后来回走步——在无助的、漫长的踱步中等待。艺术家深受触动，于是用484根签字笔在一张宽1m，长10m的纸上重复画圈，不停地重复，发泄着无助的情绪。可是伴随着画笔，他逐渐感到身体的释然与放松。虽然纸是卷着的，艺术家没有关注作品整体的造型，但随着画面的延展，似乎在未知中有着可知，在无序中包含着秩序。艺术家强调行动和过程在艺术创作中所具有的意义，并由此感悟到生活在劳作中形成了规律和秩序。

Through the ceaseless drawing of circles, the artists probe into the issue of order and disorder in the universe and life, via manual labor and body rhythm. The inspiration comes from an experience in the hospital: an old man was anxiously waiting for his grandson because his surgery lasted for too long. He walked back and forth with his hands behind his back in the corridor - waiting helplessly. Deeply moved by the experience, the artists used 484 signature pens to repeatedly draw circles. On this piece of paper, one meter wide and ten meters long, their helpless feelings were boldly flowing. But wielding the pens gradually made the artist calm. When the paper was rolled, the artist could not see the overview. But as the picture extended, something knowable seemed to appear in the unknown, and order seemed to appear from disorder. Now, the inspiration is refreshed by highlighting actions and processes through artistic creation, the artists have realized that rules and order in life come from labor.

董子瑗
Dong Ziyuan

(中国台湾 Taiwan, China)

一种状态	**A State**
纸	paper
	50cm × 50cm × 300cm

《一种状态》是以气球和报纸制作的"活动雕塑"作品。该作品将报纸以拓印的方式翻制为一件雕塑台,而雕塑台上的"雕塑"则是几只氢气球(这些氢气球则将雕塑台带到了天空)。就传统雕塑来说,它们受制于"重力"的物理特性,并普遍围绕体量和空间构成其创作"语言"。但该作品反其道而行,它解构了居于雕塑核心的"重力"问题。这样的创作与构思颠覆了艺术史的逻辑,具有达达主义的幽默特质。报纸承载着各类即时信息,是现代社会之中形成"想象的共同体"的关键技术,以此为材料亦包含了对于媒介问题的反思。

A State is a moving sculpture made of balloons and newspapers. This work consists of a sculptured platform made of newspaper. On this platform are several sculptures in the form of hydrogen-filled balloons. These balloons make the platform "float" in the air. With gravity at its core, the language of creation for traditional sculptures is expressed via volume and space. But this work deconstructs this core and finds an alternative approach. In this approach, the logic of art history is overturned and a Dadaist humor is incorporated. In addition, as the conductor of instant news, real or fake, shared with the masses, newspapers serve as the major source of "imagined communities" in contemporary society. Therefore, using newspapers as a material also represents the artist's reflections on the issues of the media.

爱莉迪亚·柯罗策
Elidia Kreutzer

（奥地利 Austria）

红线	The Red Thread
铁锈、颜料、画布	rust, pigments, canvas
50cm × 80cm × 3	

锈蚀，是时间流逝的具象见证。这是艺术家在作为造型艺术的学生时发现的概念。生活在一个沿海城市，她喜欢观察大海是如何锈蚀船舶上的金属。她发现，在这一功能损毁的过程中，原本光洁而"冰冷"的工业化产物却开始显得生机勃勃而"温暖"，单调的金属色开始萌生出红色、绿色、黄色和许多其他色彩，其本身就成为一种特殊的自发艺术品。作为氧化物的钢铁在她的作品里呈现出一种复合的情绪，同时彰显着人类的强大和弱小。她认为"锈蚀"构建了一条边界，将生命和时间的复杂矛盾关系分隔开，与人类历史的沟壑相平行。带锈的艺术对她而言成了一面微妙的镜子，可以改变现实，照亮琐碎，赋予短暂的生命以尊严。

Rust is a concrete witness to the passage of time. The artist came up with this idea when she was a student of plastic arts. Living in a coastal city, she enjoys watching how ships rust away at sea. In this process of malfunction, the smooth but "cold" industrial products become coarse but "warm", and the monotonous metallic colors turn to red, green, yellow and many others. With regard to such ideas, this work is a special kind of spontaneous creation. Steel, as an oxide, conveys here a complex mood, by which the strengths and weaknesses of human beings are highlighted. The artist believes that "rust" marks the perplexing and contradictory boundary between life and time, paralleling the veins of human history. Rusty art, in such a subtle sense, stands as a mirror to her. It transforms reality, illuminates trivialities and dignifies the transient lives of humans.

埃尔克·曼克
Elke Mank

（德国 Germany）

社会中的裂隙	Cracks in Society
水晶玻璃、报纸、带刺铁丝、头发	crystal glass, newspaper, barbed wire, hair
$\phi 11cm \times h12cm$，$\phi 13cm \times h11cm$，$\phi 9cm \times h11cm$	

浑圆透明的水晶玻璃是富足与平静的象征，其外部虽然绑着铁丝、报纸和头发，但使其濒临崩溃的却是其自身的裂隙，这是艺术家给出的比喻。被锯开的水晶玻璃象征着德国社会面对难民问题的分歧：施以援手，熟视无睹，还是强烈反对？捆绑的头发喻示着人种、外貌、习俗的差异；缠绕的报纸倾诉着政论和舆论的嘈杂与"不确定性"；带刺的铁丝则像横亘在边境的界线，时时刺痛着内心和生命。艺术家以材料的语言揭示了欧洲平静富饶表面下的内部冲突、社会分裂等问题。

These pieces of water-view glass are made round and transparent, so as to symbolize abundance and tranquility. Bound with barbed iron wire, tangled newspapers, or bundled hair, though, the huge sawed cracks still make them appear on the verge of collapse, either physically or metaphorically. The cracks hint at the divisions in German society on the issue of refugees: accepting, neglecting, or refusing? Hair represents discrepancy in races, appearances and customs; the newspapers are the noise and "uncertainty" in political and public opinion; the wire represents borders, which are a sting in the heart for all people from time to time. The artist uses the language of materials to reveal that the internal conflicts and social divisions under the calm and prosperous surface in Europe are far greater than the threat of the refugee issue.

艾玛·塞古拉·卡尔德隆
Emma Segura Calderón

（哥斯达黎加 Costa Rica）

自爱·自理·自拥	Me Quiero, Me Cuido, Me Abrazo
头发、天然胭脂虫红和茶叶染料、棉布	hair, natural cochineal and tea dye, cotton fabric

22cm × 40cm × 2.5cm × 3

艺术家探索的核心是将织物作为写作形式的可能。这一系列手工刺绣作品则是其探索过程的一部分。棉织物上的刺绣点缀茶色和胭脂虫染料，作为三段语句置入皮肤的隐喻：我爱自己（me quiero），我照顾自己（me cuido），我拥抱自己（me abrazo）。如何理解这种写作形式？这不仅仅是将文本和符号翻译成纺织品，因为在纺织材料的构建系统中，艺术家发现了一种将形式与意义在超越、多元层面上结合的路径。作品中关于文本和纺织品之间的边界开始模糊，以表面织物作为一种媒介的潜力：线的交织、链接和混合成为意义的支撑。与文本阅读不同的是，纺织品阅读需要读者自身的体验，而无需百科全书式的严谨。阅读纺织品会破坏人们惯常的感知层次结构，因为触摸取代了视觉占据知觉的中心地位。通过这种方式，触觉感知允许读者通过触摸分解纹理、图案与材料，并最终构建意义。

The core of the artist's exploration is the possibility of using fabric as a writing platform. This series of hand embroidery is a part of this exploration. The embroidery on the cotton fabric is decorated with tawny and cochineal dyes, and spells the following three sentences on the surface: I love myself (me quiero), I take care of myself (me cuido), and I embrace myself (me abrazo). How should one understand this piece? This is not just a translation of texts and symbols into textiles, but also the discovery of a new way to combine forms and meanings on a transcending and pluralistic level, based on the construction mechanism of textiles. In this work, the imagined boundary between texts and textiles begins to blur, and the fabric surface shows potential as a medium: the interweaving, linking and mixing between lines becomes the support of meanings. Different from text reading, textile reading requires the reader's own experience, while encyclopedic meticulousness is not necessary. Reading textiles will change people's habitual perceptual hierarchy, because touch replaces vision to occupy the central position of perception. In this way, haptic perception (tactile sense) allows the reader to decompose textures, patterns and materials through touching, and ultimately will construct new meaning.

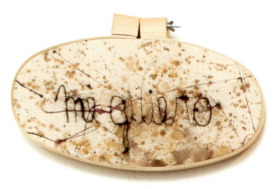
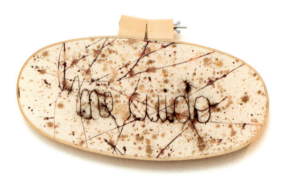

艾斯特·博尔内米萨
Eszter Bornemisza

（匈牙利 Hungary）

选择性的亲和关系	Elective Affinities
PUR 泡沫、自制的纸浆、套印的报纸、荨麻纱、线轴	PUR foam, self-made paper-pulp of rush and sedge, overprinted newspaper, nettle yarn, spools

60cm × 90cm × 150cm

这件作品借用了歌德描绘人类激情的著名小说之题，探讨了人格的复杂性和人际关系的微妙变化。即使是真诚的人，在不同的情况下也会展示更多不同的面孔。于是，观者发现每个悬垂物包含两副背对的抽象"面孔"，而面孔内侧以套印报纸绘制了面部轮廓剪影，同时布满了反转的地图图像。长长的荨麻绳将两副"面孔"缠绕、包裹、连接在一起，显示了整体人格的复杂性和充满矛盾的内在自我。当观众经过悬挂的物体时，微小的空气流动会促使它们转身，有些会面对面地接触，而另一些会转到一边，露出它们的一个轮廓或其内部的反面，喻指人际关系和情绪会时时进行着微妙的变化。

Borrowing the title of Goethe's famous novel depicting human passions, this work explores the complexities of personality and the subtle changes in human relationships. Even sincere people show different faces in various situations. As a result, the viewer finds that each overhang contains two abstract "faces" facing away from each other, while the inside draws outline of faces on the overprinted newspapers, full of inverted map images. The long nettle ropes connect the two "faces", twisted, wrapped, and linked together, revealing the complexity of the overall personality and the inner self full of contradictions. As viewers are passing by the suspended objects, even small air disturbances prompt the objects to turn around. Sometimes they touch each other face-to-face; other times they expose the outline of only one side of the face, or the interior side of the face - alluding to the shifting nuances of human emotions and interpersonal relationships.

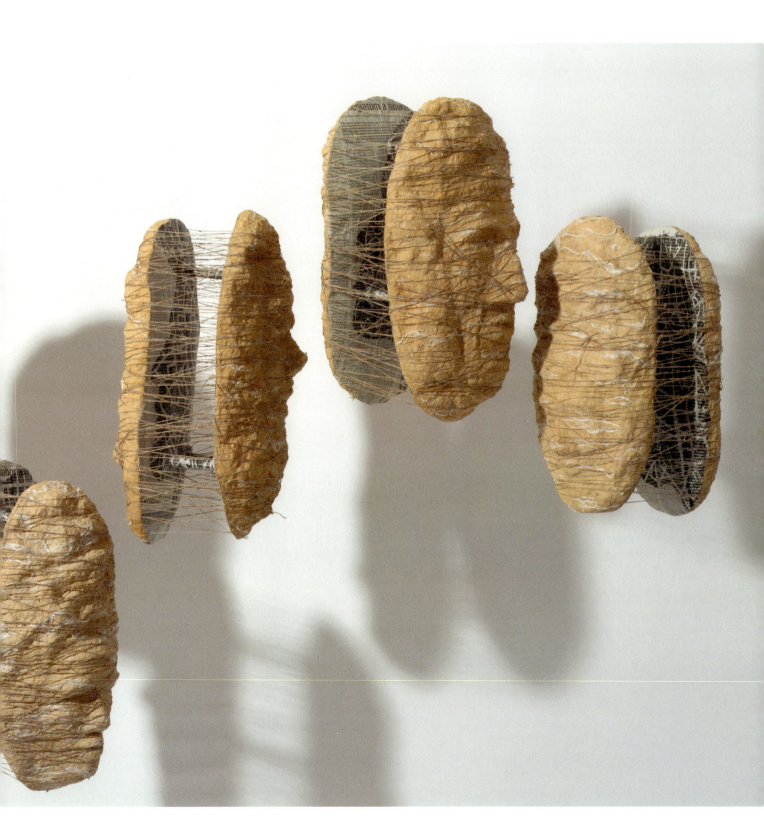

冯崇利
Feng Chongli

（中国 China）

痕—1	**Trace -1**
钢、不锈钢	steel, stainless steel

150cm × 30cm × 30.75cm

《痕-1》是以钢材和不锈钢为主要材料创作而成的雕塑作品。该作品具有几何状的外在形态，但其内部却蕴含着不规则的"负空间"造型。正是这样独特的造型方式，将西方现代雕塑和中国传统美学融合在了同一件作品之中，并以后者作为主导型文化。但就内部"负空间"来说，其与中国传统绘画又有相通之处，在"似与不似"之间引发观者产生多样化的联想。整个作品在"正"与"负""抽象"与"意象""明"与"暗"之间产生了多重对比，极为巧妙地体现着中国传统辩证哲学的思想。

Trace-1 is a sculpture made of steel and stainless steel. The work has an external geometric form, but inside, it contains an irregular "negative space". This unique form fuses modern Western sculpture and traditional Chinese aesthetics into one work, with the latter being the dominant culture represented. However, in terms of the internal "negative space", there is a connection to traditional Chinese painting, which provokes diverse associations between "resemblance and dissimilarity" in the viewer. The entire work is a mixture of positive versus negative, abstract versus imagery, and bright versus dark, which is a clear reflection of traditional Chinese dialectical philosophy.

弗雷迪·科洛
Freddy Coello

（厄瓜多尔 Ecuador）

形变	**Metamorphosis**
金属丝网	metal mesh
100cm × 160cm × 160cm	

《形变》是一组以金属丝网塑造而成的抽象雕塑，作品因悬挂和转动形成多变的造型。这是艺术家在疫情期间创作的作品，以金属丝网为材质，作品显得既通透又脆弱。在疫情最严重时期，各种信息不断传来，既有亲友患病去世的悲伤信息，也有患病后康复的好消息。突如其来的疫情打破了人们的"正常"生活，混乱与恐惧似乎永无尽头。对应于疫情期间各种复杂情绪，艺术家"冥想"之后创作了这些作品，他将种种与疫情相关的情绪转化为不规则的造型物。如今疫情的影响已经减弱，我们有了回顾和反思的契机。疫情永久地改变了人们的生活，但美好的日子终将到来。

Metamorphosis is a group of abstract sculptures made of wire mesh. Suspended, rotating, and changeable, a flexibility in the work is born. As an epidemic-era creation, its transparency and fragility from metal mesh serve as a good self-explanation. Torrents of messages poured through those worst times: deaths of kin and friends, good news about recovery … people's "normal" lives were broken in a sudden way, with unending feelings of chaos and fear. Paralleling various subtle emotions during the epidemic, the artist created these works after "meditating". Each of them in an irregular shape represents an unspeakable but unique subtlety. Now that the epidemic has subsided, we have an opportunity to review and reflect, and life is returning to normal. The pandemic has changed people's lives forever, but better days will come.

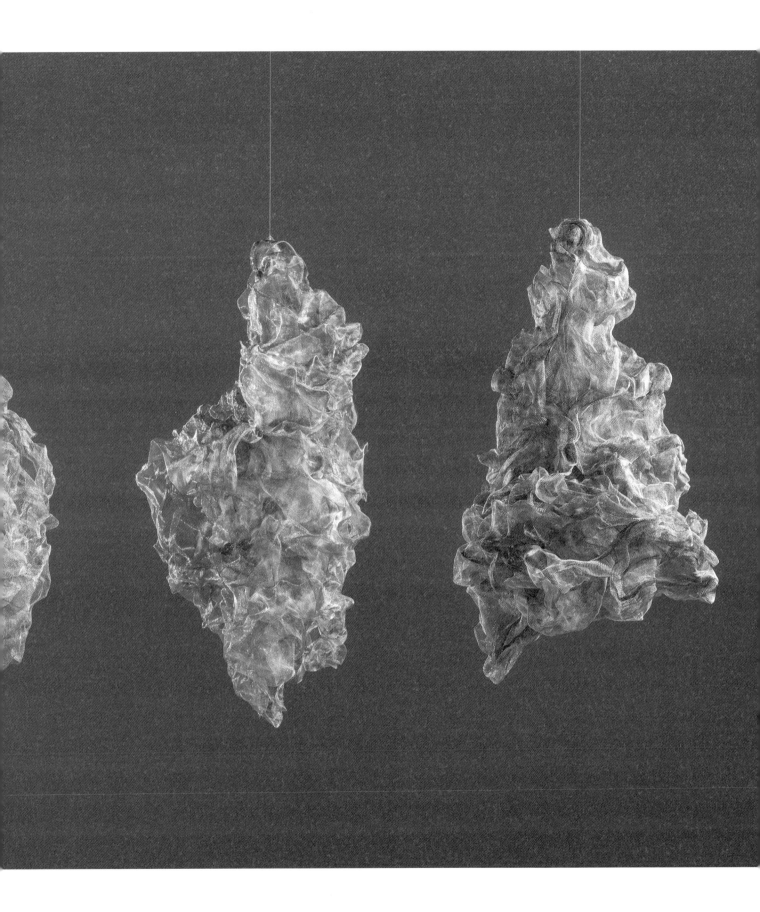

付钰涵
Fu Yuhan

(中国 China)

不能承受的生命之轻	The Unbearable Lightness of Being
亚克力、转印纸、丝网	acrylic, transfer paper, silk screen

265cm × 200cm × 10cm

新冠肺炎疫情突袭而来，笼罩全球，互联网、大数据发挥着超前的作用，人们比以往更加依赖数字信息。然而，数据信息在保护人的同时，也阻隔人们对生命存在的直观感受。当生命状态用流动的、可存储的数据去表述，其神圣、崇高的本质被遮蔽，生命的重与轻又该如何衡量？于是，艺术家尝试塑造一种虚空的、程式化的形状来反思这一问题。丝网，单薄，半透明，冰冷的金属数字不断在上面重复。数字化，这种时代的新形态，似乎可以迅速地"扫描"并"重绘"任何事物，包括信息、物资，甚至生命。当生命衰亡与重生被表述为一串串的数字，从自然中孕育出的生命正逐渐失去神圣、崇高的意义。作品以薄纱层叠而现的一行行闪亮的金属数字，似乎叙述着数字化背后一系列魔幻现实主义的故事。

COVID-19 swept the globe very suddenly. In response to the disaster, the Internet and big data have taken the lead. But such unprecedented reliance on digital intelligence, though a means by which we could protect ourselves from the virus, blocks humanity's intuition and sense of being. When our existence takes the form of data, transmitted and stored, the nobility and sacredness of our being is obscured. How should we measure the weight of being? The artist's answer lies in the work presented: a stylized void in which thin, translucent, cold metal figures of mesh wire are repeatedly shown. In this digital age, we seem to be able to quickly "scan" and "redraw" everything, including information, materials, and even existence. When life is presented as a series of numbers, it loses its sacred, natural, and noble significance. The glittering metal figures made of layers of mesh seem to describe a series of stories - a magic realism behind this new digital age.

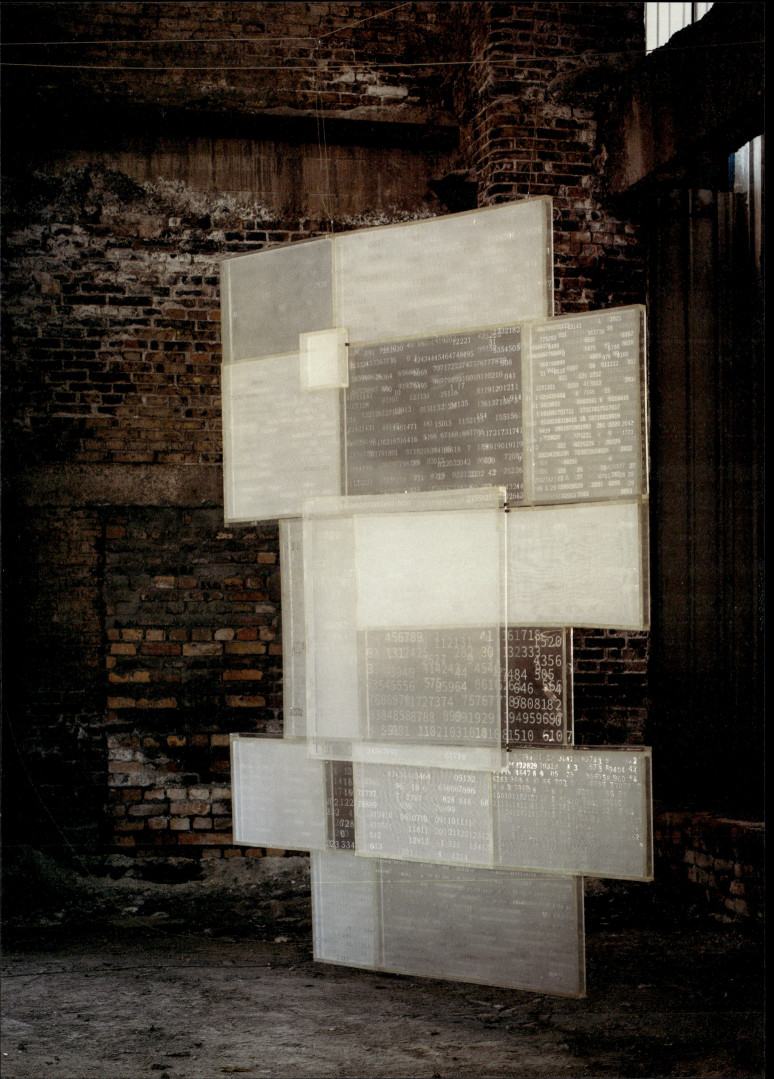

加夫列尔·阿尔瓦雷斯
Gabriel Álvarez

（阿根廷 Argentina）

鳄鱼求爱	Crocodile Courtship
沙子、塑料填充物、帆布上的丙烯	sand, plastic filling, acrylic on canvas

120cm × 180cm

艺术家的系列作品都采用了这种网格的结构与形式。作品中沙子材料和刻画痕迹很容易让人们联想到孩童在沙滩上作画，加上鲜艳的色彩，充满了活泼、欢乐的气息。在艺术家看来，颜色和形式是材料不可分割的一部分，材料本身构成了一种话语，或者说一种视觉语言。在艺术家的作品中，这种视觉语言以切口的形式出现，以最原始的方式生成原始图画。艺术家痴迷于这些网格结构，在看似简单的视觉文本和生活背景之间建立起了一个复杂的世界。同时，材料、颜色、形式的选择也受到艺术家拉丁美洲的身份观念、日常生活及特定城市的影响。材料成为艺术家构建艺术作品、追踪视觉代码及重建艺术话语的关键。

The grid structure is used in the artist's series of works. The sand material and carved marks in the works are easily reminiscent of children drawing on the beach, and with the bright colors, they are full of a lively and joyful atmosphere. In the artist's view, color and form are inseparable parts of the material, and the material itself constitutes a discourse, or a visual language. In the artist's works, this visual language appears in the form of incisions that generate original drawings in the most primitive way. The artist is obsessed with these grid structures, building a complex world between the seemingly simple visual text and the context of life. At the same time, the choice of materials, colors, and forms are influenced by the artist's Latin American identity concepts, daily life, and specific cities. Materials become key to the artist's construction of artworks, tracing visual codes and reconstructing artistic discourse.

高扬
Gao Yang

（中国 China）

蒲公英	**Dandelion**
竹签	bamboo stick
58cm × 105cm × 45cm	

现在工业化生产充斥着生活的各个角落，人们逐渐意识到工业生产对环境的伤害，也厌倦了工业制品的冷漠——大量复制，缺乏个性。艺术家希望通过这个作品让人们重新发现手工与自然材质的价值。这件"家具"完全由竹子制成。作者将竹棍的末端锤打并劈开，手工将竹签相互穿插咬合，无附加任何连接方式辅助，制作出类似于蒲公英的外形；又对每一部分都进行细致的分层，创造出一种庞大的奥斯曼风格的结构。最终，这种完全坚硬的东方材料奇迹般地编织出一团柔软的黄云。该作品是一个人与材料沟通的过程，也是一个自然材料以自然的方式成为一件物品的过程。这个漫长的过程呈现出丰富细腻的手工艺痕迹。在这个快节奏的时代，让人们静下心慢慢体会身边的事物，是他创作"蒲公英"的初衷。

Since every corner of life is filled with industrial products, people have now, over time, realized the harm to the environment that humans have caused. Many are tired of the indifference of companies and the lack of variety and uniqueness available today in manufactured products - because of modern mass production. The artist hopes that this work can help people rediscover the value of handicraft and natural materials. This "furniture" is completely made of bamboo. The artist hammered and split the ends of the bamboo sticks, and interwove the split bamboo sticks by hand, without any additional assistance, so as to make the work into the shape of a dandelion. The work was then carefully layered to create a massive Ottoman style. In the end, the completely hard oriental material was miraculously woven into a soft block of yellow cloud. The work shows the communicative process between humans and materials, and the natural transformation of a natural material into an object. This winding process presents rich and delicate traces of handicraft. The primary intention of this work is to ask people in this fast-paced era to slow down and delicately appreciate the objects around them.

葛平伟
Ge Pingwei

（中国 China）

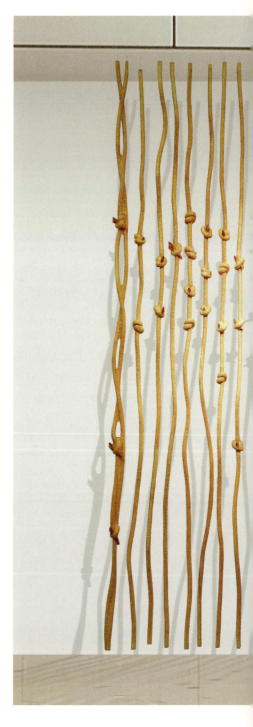

结·屏	Knot-Shield
木	wood
尺寸可变（size variable）	

《结·屏》是以木头这种传统材料创作完成的雕塑作品。在作品之中，共有两种"结"的形态：一种是木头原生的"结"，另一种是以造型方式模拟雕刻而成的绳"结"。作为前者，它是自然造化的实在产物，作为后者则是人依据概念创造出的"形象"。正是以这样的手法，在同一件作品之中，基于同样材质却衍生出了两种截然不同的"物"的概念。与此同时，该作品在"形象"与"观念"两个层面展开着比较，探讨了作为艺术材质本身可以容纳的多重观念的可能性。

Knot-Shield is a sculpture made of wood, a traditional material. In this work, the "knots" are both the original knots from the wood itself, and the engraved knot designs. The former knots are substantive products of nature, while the latter knots are images created based on a concept. Therefore, the two ideas of an object born from the same material conflict with each other in the same work. Meanwhile, the work compares the "images" and the "concepts" of the two kinds of knots, in order to explore the possibility of the simultaneous accommodation of multiple concepts into an artistic material.

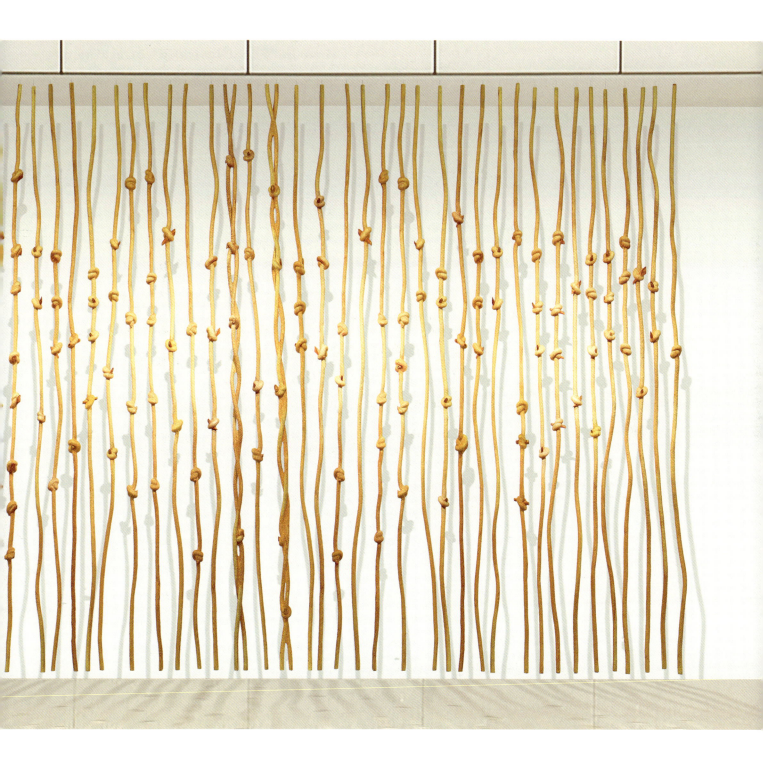

顾黎明
Gu Liming

（中国 China）

山水赋——"鹊华秋色"图解（五联画）	Shanshui Fu - Illustration of "Autumn Colors on the Que and Hua Mountains" (Five-couplet)
布面丙烯、色粉、水彩、树脂胶、宣纸及拓印拼贴	acrylic, toner, watercolor, resin glue, rice paper, and rubbing collage on canvas

1200cm × 180cm

《山水赋》系列试图探讨传统山水秩序在今天所遭遇的问题。艺术家效仿前人掌控山水的艺术要素，从作品如赵孟頫的《鹊华秋色图》，到画论如荆浩的《山水赋》，从《芥子园画谱》、手稿山水、图像色彩、拓印形态及拼贴解构五个角度，借助水彩、丙烯、宣纸拓印等多种媒介材质，以片段性的拼合方式，构建"触感"的痕迹。这种"触感"，不仅人们是对陌生事物的身体性感觉，也是人在世界中的身体性存在的方式。以此来表达当代语境下，我们与前人对自然认识的差异与冲突，呈现当下人的心理状态。艺术家通过仿效与追忆，在前人的历史文化状态与现实的在场冲突中，试图重构一个现代与传统、人与自然相互对立的当代山水境遇。

The "*Shanshui Fu*" series attempts to explore the problems encountered in contemporary discussions of the traditional landscape order. The artist imitates the artistic elements of *Shanshui*（mountains and waters）of his predecessors, from Zhao Mengfu's work *Autumn Colors on the Que and Hua Mountains*, to Jing Hao's theory of *Shanshui Fu*. The artist discusses the five themes of *Manual of the Mustard Seed Garden* and the manuscripts of *Shanshui paintings*（images and colors, patterns of copies, and collage of deconstruction）in his *Painting Pentad*. With the help of watercolor, acrylic, Chinese art paper for copying, and other media, the artist pieces together the creative fragments to construct traces of "tangibility". This "tangibility" is not only our physical sensation of unfamiliar things, but the essential experience of our physical existence in contemporary times. The contemporary mentality is thus demonstrated; and, the conflicts and differences regarding the recognition of nature in the contemporary context versus that of our predecessors, is also expressed. Through imitation and recollection, the artist attempts to reconstruct the status quo of contemporary *Shanshui*, in which modernity and tradition, as well as man and nature, are antagonistic with each other. Meanwhile, this reconstruction is based on the present conflict between reality and the historical and cultural state of our predecessors.

郭振宇
Guo Zhenyu

（中国 China）

上帝视角	The "God's-Eye" View
木、铁等	wood, iron, etc.

300cm × 450cm × 25cm

作品给予了观众一个俯瞰人类文明遗迹的"上帝视角"。艺术家在一棵被锯开的树干上，雕刻出不同文明的符号和痕迹；再将树干进行焚烧与冲刷，形成的残痕与灰迹喻指着沧海桑田与岁月洗礼；最后，艺术家用传统修补行业特制的巨大锔子（扁平的两脚铁钉）把这些"文明"连接起来，形成一个整体。在艺术家看来，文明并不是一个"摧毁—重建"或"破坏—修复"的过程，例如当工业文明取代农耕文明之后，原有的生存模式早已不复存在，所谓的"建设"只是人类的自以为是。因而艺术家通过"上帝视角"的塑造，希望提醒人类超越生命和文明局限，在一个高智慧凝合的角度，理解宇宙规律和文明宿命，为未来找到新的融合发展的可能。

The audience obtains a "God's-eye" view of relics of human civilizations through this work. Symbols and traces of different civilizations are carved on a sawed trunk. After burning and scouring, the residue and ash marks show the challenges of history in the passing of fickle time. Finally, a specially-made giant ju-zi (flat two-leg iron nails) used in the traditional repair industry, connects these "civilizations" together. For the artist, civilization is not a process of "destruction-reconstruction/restoration". For example, when industrialization occurred in agricultural civilization, the original living pattern of humanity disappeared. And such "construction" is but the self-righteousness of human beings. Therefore, through this 'God's-eye' view, a reminder of life's transcendence and civilization's limitations is made for us. The audience is asked to understand the laws of the universe and the fate of civilization from a highly intelligent perspective, and to find new possibilities for integration and development in the future.

合艺术小组：康悦、钱亮、付廷栋
He Art Group：Kang Yue，Qian Liang，Fu Tingdong

（中国 China）

羊毛物语	**Wool Story**
彩色羊毛、羊毛毡	colored wool, wool felt
	175cm × 75cm × 10cm

《羊毛物语》用羊毛、毛毡材料对历史风物青花的再制，在扎针引线的手作中完成了文化考古学意义上的历史碎片向当代文化精神图像的转变。利用"青花"这一中式之物，在硬与软、似与不似之间化整为零，表达刚柔之道，彰显艺术构造、材料语言的魅力。通过对这种"非常态"——由物理之碎到文化碎片之思，引起人们对熟识之物的重新审视和思考，反观其材料转化背后的社会精神状态，在日常中发现非"常"，在习惯中发现惊喜。

This work aims to represent a cultural journey into the past, and to transform the historical remains into images of contemporary culture. Pieces of blue and white porcelain (the historical remains) are felted with wool and then tended with embroidery. Based on the traditional image of Chinese blue and white porcelain, the boundaries between the hard and the soft, as well as between the similar and the not similar, are broken. This balance between hardness and softness manifests the charisma of artistic construction and material language. And by the neat state of irregularity, the physical fragments arouse aesthetic reconsideration from the viewer. They are encouraged to gain a new appreciation of familiar things in daily life, and to ponder the social influences brought about by unsuspected changes in daily routines.

黑余
Hei Yu

（中国 China）

草・书 / 金刚经	Grass, Book / Diamond Sutra
自制蔺草纤维	handmade rush fiber
	200cm × 30cm × 24

该作品是艺术家用一种新近接触的植物——蔺草——的纤维，以传统手工造纸方法制作成的"纸"的一次作品尝试。他选取了一部讨论"空相不二"的佛家经典《金刚经》，采用香在纸上烫烧文字的方式，作为观念的"字"与作为载体的"纸"一起回溯到初始的草之间，处在一种更为整体的关系之中。作品里的文字只是符号，其本身并不具备任何实质的意义，当这些文字不断被呈现的时候，正是其自我消解的开始。作者所关注的正是这样一种悖论：字，因为其被反复呈现而消亡；而纸，这种自一出现便被作为承载文字的物，在这样的一种运作过程中，却因为其消亡而被呈现。艺术家希望作品能引领观者进入一种更加细微的体察——看到物象的本源，由字及纸，由纸及物，由物及相，由相及空，反之亦然。

This work is an attempt by the artist to use the fibers of a newly encountered plant, mat grass (rush fiber), to make "paper" using traditional hand-made methods. He chose words from the Buddhist classic *Diamond Sutra*, which discusses "emptiness and appearance", and used the method of burning incense to write on the paper. The "word" as the idea and the "paper" as the carrier jointly go back to the original material of grass in a more holistic relationship. The words in the work are just symbols, and they do not have any substantive meaning. When these words are constantly presented, their self-disintegration begins. What the artist is demonstrating is exactly this paradox: words die because they are repeatedly presented; paper, which has been used as a carrier of words since its invention, is contrarily presented in this process. The artist hopes that the work can lead the viewer to enter a more subtle state of observation - to see the origin of objects, from words to paper, from paper to objects, from objects to appearance, from appearance to emptiness, and vice versa.

海伦·查赫
Helene Tschacher

（德国 Germany）

词汇的消失	The Disappearance of Words
书籍	books
	220cm × 52cm × 5cm

纸张在我们的世界里随处可见。作为信息的载体，纸被造成平面，以高度机械化的方式被大量生产。进入电脑时代，图书馆、百科全书正在被数字化，信息已经变得通货膨胀，过度消耗着人们的时间管理。纸张已经展开了社会的历史，"白纸黑字"的印刷品现在与可擦除的数字"打印"竞争。对造纸艺术家而言，纸所具有的可塑性、纹理及有机的原材料，具有无限的可能性和吸引力。在作品《词汇的消失》中，艺术家打断了这种持续的数据流，并将溢出的信息汇集起来，转化成一种信息垃圾的形式。书籍被剪开、折叠、累积，完整的故事、文字和内容已被打散，你可以阅读它们，但文本只能被零散地解码，无法再被理解。艺术家专注于探索纸材料的力量和表现力，及这种材料所带来的文字变化，以艺术的形式将这些工业时代的褪色文件转化为"考古学的对象"。

When the historical narratives of society began to include the mere existence of paper, it is undeniable that this was a time when the competition between the "black and white" print and the erasable digital "print" began. For papermaking artists, the plasticity, texture, and the organic raw material quality of paper, have infinite possibilities and appeal. In *The Disappearance of Words*, the artist interrupts the continuity of data flow and compiles the overflowed information as a design in the form of information garbage. Books are cut open, folded, and piled up, where intact stories, texts and content have been broken up. You can read them, but only through fragmentary decoding; its content can no longer be understood. The artist focuses on exploring the power and expression of paper as well as the influence of paper on characters, and artistically transforms these faded documents of the industrial era into "archaeological objects".

侯吉明
Hou Jiming

(中国 China)

修复计划	**Restoration Plan**
综合材料	mixed materials
	50cm × 60cm

艺术家通过拆解和重构敦煌、龟兹壁画图像元素，将壁画残像等传统文化符号与今日之报刊、书籍碎片等当代意象相结合，催生出新的时代图景。在艺术家看来，所谓的"修复"并非仅限于外在物象上的还原，而是以特定的地理风物为线索，将中国传统的美学并置于当代巨变的时空观语境中，以一种创造性的方式复苏民族文化与精神。作品以抽象拼贴的方式重构传统，泛黄的手稿与报纸，粗粝凸显的麻布肌理，散落的图像与符号，营造出了历经岁月沧桑的敦煌壁画气质，在交织的时空语境中讲述着民族文化的故事与传统再造的潜力。

One part of this work is made from traditional cultural symbols - dissected and reconstructed materials from the murals of Dunhuang and Kucha. The other part is made from contemporary images, using the debris of books and newspapers. The artist combines these parts together to create a new vision of modern times. In the artist's view, the so-called "restoration" is not only about external objects. Restoration involves considering the drastic shifts in contemporary concepts of space and time, and contemplating those shifts alongside traditional Chinese aesthetics from specific geographical areas. In doing so, "restoration" of the national culture and spirit can be achieved in a creative way. The work reconstructs traditions through abstract collage. The aging manuscripts and newspapers, the rough and prominent linen texture, and the scattered images and symbols create the character of Dunhuang murals. Through the vicissitudes of life, these murals recount the revived stories of this nation and its culture in woven time and space.

胡明哲
Hu Mingzhe

（中国 China）

《空》之六	**Empty VI**
岩彩、纤维	rock color, fiber
	280cm × 560cm

"空"是中国传统文化中最重要也最复杂的意象之一,《清静经》有云"观空亦空,空无所空;所空既无,无无亦无","空"既是世间万物的源起,也是六道众生的结局。将复杂的汉语文化语义转化为视觉形式,"空"则可以被理解为天空、空气、空间、时空等形象,亦可被理解为空灵、空洞、虚空、空寂等情绪。艺术家对于这些作品的阐释是——其个人生命与性质同一的自然物质"岩彩"邂逅,二者自然而然地交融,凝结为一个暂时的结晶,成为刹那的实有和永恒的虚无中宇宙的一部分。

"Emptiness" is one of the most important and complex concepts in traditional Chinese culture. *Qingjing Sutra* notes: "Observing the emptiness is also empty, and there is nothing empty; since emptiness is empty, the emptiness of emptiness is also empty". "Emptiness" is the origin of all things and also the end of all beings. Transforming complex Chinese cultural meanings into visual forms: "emptiness" can be understood in images of the sky, climate, space, time, etc.; and, can also be understood through emotions like spiritual emptiness, meaningless emptiness, lonely emptiness, and quiet emptiness, etc. The artist's work is inspired by his consistent personal life encounters with natural "rock color" material. She naturally blends it and condenses it into a temporary crystal. The mixture then becomes a part of the universe in momentary reality and eternal emptiness.

胡泉纯
Hu Quanchun

（中国 China）

爬山虎的家	The Creeper's Home
耐候钢	weathered steel
200cm × 98cm × 104cm	

在江南棚户区随处可见爬满爬山虎的房子，这种景象体现了人与自然的和谐共处，也构成人通常对于家园的记忆。爬山虎依附在建筑上生长的同时，也忠实地塑造出了建筑空间形体转折与围合。《爬山虎的家》这件作品通过"抽离"爬山虎所依附的建筑物，仅留下盘根错节、带有建筑形体空间记忆的爬山虎。作品的尺度以棚户区旧房子的实际尺寸为依据，材料采用拆迁现场废弃的钢筋焊接，整体营造出爬山虎对房子的包裹状态，形成通透虚空的形体。此次展出的是设计模型作品。

Houses covered with ivy can be seen everywhere in the shantytowns in the south of the Yangtze River. This scene reflects the harmonious coexistence between man and nature, and it represents a person's memory of their homeland. While the ivy grows attached to the building, it also faithfully embodies the shapes and corners of the architectural space. *The Creeper's Home* works by "extracting" the building that the creeper is attached to, leaving only the intricate creeper growth along with the memory of the architectural shape and space. The ivy wraps the invisible house, forming a transparent and empty shape. The scale of the work is based on the actual size of the old houses in the shantytowns, and the materials are welded with discarded steel bars from the demolition site. This piece is a design model work.

胡伟
Hu Wei

（中国 China）

海礁 2	Sea Reef 2
木质构造、宣纸、麻纸、（矿物/植物/土质）颜料、金银粉、金属渣	wooden construction, rice paper, linen paper, mineral/vegetable/earth pigments, gold and silver powder, metal slag

180cm × 720cm × 3

这组作品来自艺术家举办的一个题为"潮"的个展。这个展览以海洋为主题，不仅使用了宣纸、皮纸、麻纸、天然矿物/植物/土质颜料、墨、金银粉和箔等绘画材料，也使用了海砂、金属和海洋化石碴沫以及漂浮物等与主题相关的材料。墙面作品与地面"类装置"的作品多采用了海泥、砂石、金属所具有的暗棕、黄咖、铁锈色调，营造了一个苍茫、深沉的海域空间。观众置身其中，似乎能感受到海风、海浪及阵阵飘来的海腥味。这既是物质的结果，也是艺术的结果。艺术家用形式重新开启了物质的空间、海洋的环境，并传递出对人类生存境遇的思考：大海每天都在重复它的运动，在潮起潮落之间，孕育着沧海桑田和世界巨变。

This series stems from the artist's solo exhibition, "Tide", which adopts the ocean as the theme. Materials related to the theme include sea sand, metal and marine fossil residues, floating objects, etc. Painting materials include rice paper, leather paper, hemp paper, natural mineral/plant/soil pigments, ink, gold and silver powder, foil, etc. Works on the wall and quasi-installations on the ground mostly use dark brown, yellow coffee, and rust color of sea mud, sand and metal, respectively, so that the vast space and depth of the sea is created. The audience seems to be able to feel the wind, waves, and smells of the sea. This is the result of both material and art. The artist reopens the material space to simulate the ocean environment. In doing so, he conveys his thoughts about human survival: the sea repeats its movement every day, and between the ebb and flow of the tide, it manifests the vicissitudes of life and great changes in the world.

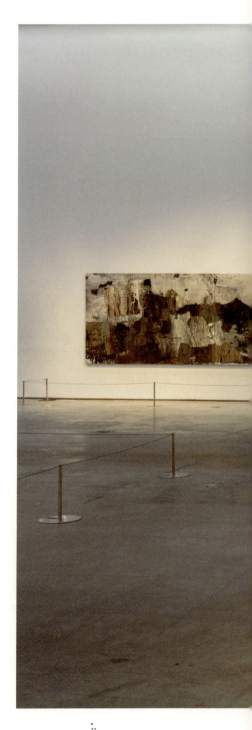

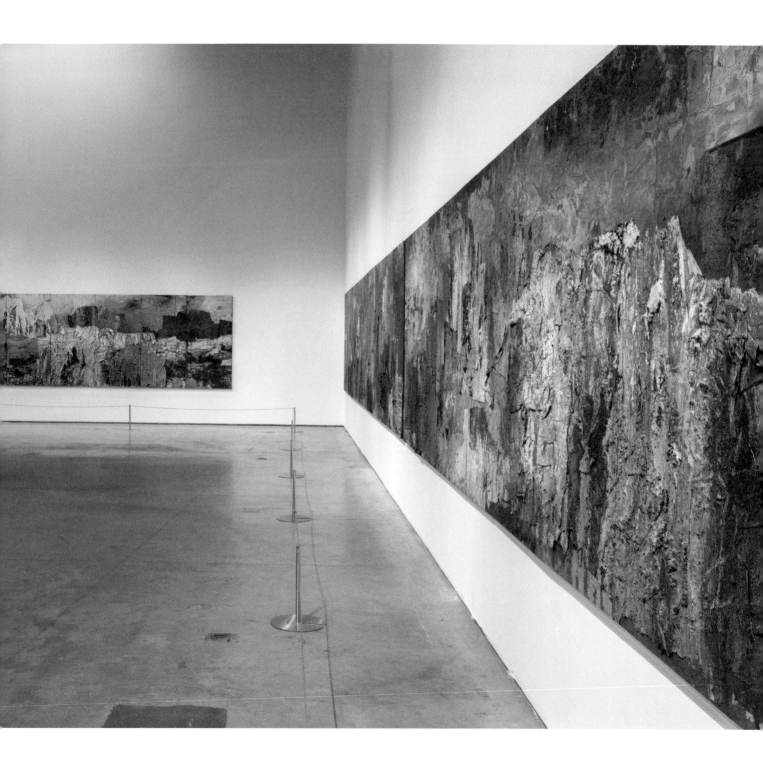

伊娃·科鲁米娜
Ieva Krūmiņa

（拉脱维亚 Latvia）

孤独	**Loneliness**
聚乙烯废料、丝网印刷、丙烯酸树脂	polyethylene waste, silk screen print, acrylic
100cm × 130cm	

艺术家通过形式和材料体现了对于生命两种维度的思考，她首先讨论的是当一个人处于一大群人中间时的感受，其次也希望能够在关注个体的同时，表现出每个人对宇宙的感知，表现出对生命与时间的思考。于是她选择使用镀金的聚乙烯来制作成千上万个小肖像。聚乙烯（日常生活中最常用的塑料之一）有很多含义，它曾是科学进步的象征，现在则变成破坏环境、带来灾难的无用之物。作品中每一幅肖像都是单独丝网印刷在聚乙烯上，然后与其他数百幅肖像粘贴在一起。这件作品非常薄且易碎，但同时其材料（聚乙烯）却将一直与我们同在，并且在此后至少500年内都不会分解。在这样一个微妙的聚合中，我们既能看到作为个体的存在问题：尽管周围有成千上万的人，但人们却仍然无比孤独；也能看到作为整体的人类生命的处境：极为脆弱易逝，但同时无时无刻不在影响着未来无数代人。

The artist presents the two dimensions of thoughts on life via forms and materials. Firstly, she discusses the feelings of a person in the middle of a large group of people. Secondly, she hopes to demonstrate the perception of the cosmos, of life and of time from the perspective of every individual, rather than focusing solely on individuality. She chose to use gold-plated polyethylene to create small portraits of numerous individuals. Polyethylene, one of the most commonly used plastics in everyday life, has many meanings. It was once a symbol of scientific progress, but it is now a useless and harmful substance that destroys the environment and has disastrous consequences. Each portrait in the work is individually screen-printed on polyethylene and glued together with hundreds of other portraits. This work is very thin and fragile, but at the same time, its material (polyethylene) will always be with us and will not decompose for at least 500 years. In such a subtle aggregation, we can see both the problem of being an individual: people are lonely, despite being surrounded by thousands of others; and the situation of human life as a whole: it is extremely fragile and prone to flee easily, but at the same time, it affects countless generations into the future constantly.

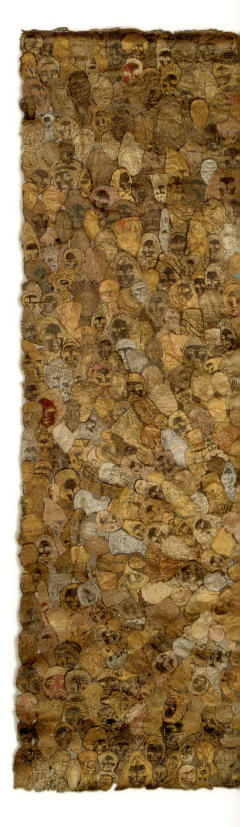

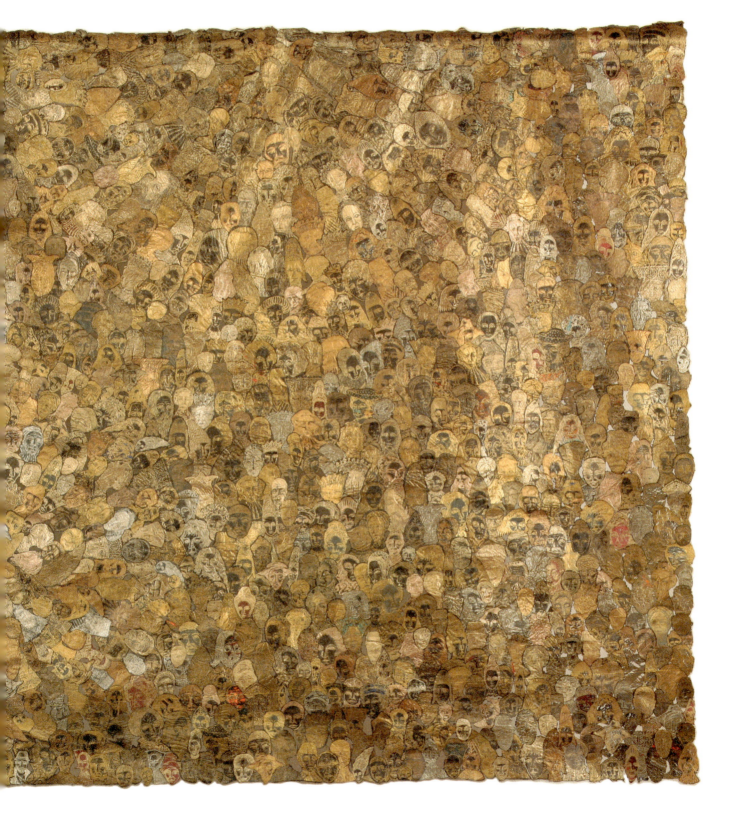

艾瑞斯·薇薇安娜·帕瑞·罗马诺
Iris Viviana Perez Romero

(多米尼加共和国 Dominican Republic)

来自"神秘森林"系列	From the *Mystic Forest* Series
木、陶瓷	wood, ceramic
183cm × 178cm × 178cm	

这组作品和它们的创作者都来自加勒比群岛多米尼加的热带丛林,充满神秘热切的气息。艺术家选择了圣克里斯托瓦尔地区坎佩切海岸的独特树木和当地的黏土材料来制作这些雕塑。这种树木在艺术家的文化语境中是家园的象征,而黏土制作的有机形状和象形图案则代表着居住其中各种动植物,当然也包括人类;黏土是加勒比地区原住民社会中日常用品、宗教仪式以及工艺品的主要材料,同时还作为楔形文字等古老文字的承载,连接着人们的文化艺术、生活方式、神话信仰和历史故事。艺术家精心选择了这些特别的材料结合以富有生气的形象搭建了一个明丽的木头家园,同时也布置了一场热烈的宗教仪式,继承原住民向女神阿塔贝的许愿:庄稼丰收,人丁兴旺和部族健康——同样携带着艺术家为今人所作的祈祷:和平的世界与新生的自然。

Hailing from the tropical jungles of the Caribbean archipelago of Dominica, the artist bestows upon her creations an aura that is intrinsically tinged with mystery and passion. The wood and clay for the sculptures are from the Campeche Coast in the city of San Cristobal. The wood is a symbol of home in the artist's culture, and the sundry shapes and pictograms from clay represent the flora and fauna there, including traces of humans. Clay is commonly used by indigenous Caribbeans for ceremonies and handicrafts. It is also the carrier of cuneiform and several other forms of ancient writing. Therefore, the work is also designed to link the culture, art, lifestyles, myths, beliefs and historical stories of humanity. The carefully selected materials vividly constitute a bright wooden dwelling, where a warm religious ceremony is going on. The indigenous people worship the goddess Atabey, and wish the tribe a good harvest, and a prosperous and healthy state of the people. The artist, in the same way, prays for a peaceful world and a brand new nature.

伊维塔·托马诺娃
Iveta Tomanová

(斯洛伐克 Slovakia)

社交网络	Social Network
纸张、有机玻璃、电脑键盘、橡胶胶水、丙烯颜料、电线	paper, plexiglass, computer keyboard, rubber glue, acrylic paints, wires
装置尺寸可变,每个人物高约60cm(installation size variable, each figure approximately 60cm high)	

社交网络、搜索引擎、电脑游戏,这是一种生活方式。技术不再像以前那样是达到目的的手段,它本身就是一个目的,人们花费大量的资源来生活在这个平行世界。艺术家伊维塔近期的作品以小型人物雕塑的创作为主,主题多为对当代社会、技术和虚拟世界的反思和批判。"TROLL"指的是互联网巨魔,这个系列的作品反思了"巨魔"们对网络世界信息的操纵和扭曲,使得互联网上充斥着骗局、假新闻……图像无处不在,图像空间显得如此真实,一个新的虚拟时代正如火如荼地进行着。作品中的白色"巨魔"们以不同的形式与屏幕互动,象征着思维的变形和思想的操纵,引导观者反思这些问题:面对这些问题我们能做什么,以及我们要如何面对自我毁灭。

Social networks, search engines, computer games - they are all about a lifestyle. Technology is no longer a means to achieve an objective. Now, it is an objective itself, through which a parallel world is born, where people spend vast resources to maintain their lifestyles. Iveta's recent works mainly focus on small figure sculptures, which reflect and criticize contemporary society, technology, and the virtual world. "TROLL" refers to internet trolls, and this series of works reflect on the manipulation and distortion of information present in the online world, instigated by "trolls", making the internet awash with scams and fake news. Images are everywhere, and the virtual space constructed by images seems so authentic; a new era of virtuality is coming into full swing. The white "trolls" in the work are interacting with different kinds of screens, a metaphor for the metamorphosed and manipulated mindset of mankind. The question remains for us to consider: what can we do in the face of these problems, and about self-destruction?

詹姆斯·约翰逊－佩金斯
James Johnson-Perkins

（英国 UK）

千兆字节—伟大的战斗	Gigatage - The Great Battle
综合材料	mixed materials
	700cm × 200cm

当图像呈现出肉眼无法轻易捕捉的巨量信息，是否会改变作为视觉动物的人类认识世界的方式？千兆像素图像是 21 世纪初开始出现的数字图像技术概念。这类图像通常由 10 亿（10^9）以上的像素点构成，经特殊手段摄制或拼贴而成，其巨大的信息数量级和复杂的制作过程，改变了人们对图像本身的传统认识，因此逐渐被艺术家们视为一种创作手段。艺术家在他的超大规模数字印象系列作品《千兆字节》中，以世界各地的著名景点和城市广场为基底创作了一些同时涵盖现代与历史要素的"风景画"。在作品《伟

大的战斗》中，艺术家选择了传统观念中的"艺术之都"威尼斯作为背景，却在其中添加了无数杂乱的意象，从亨利八世到蝙蝠侠，从莎士比亚到哥斯拉，从马桶塞到千年隼，艺术家似乎要将人类文明中所有曾留下印记的事物都呈现出来，在圣马可的运河上再造一场穿越时空的大狂欢。但它们并非和平相处，作为一个巨大的信息集合，所有的字符、记忆都融合到了一起，艺术家认为这是童年记忆、教育经历和怀旧情绪杂糅后呈现的直观画面，在这里，这些形象都如同艺术家本人的生命和记忆一样，卷入了一场史诗级伦理战争。

When images present a huge amount of information that cannot be easily captured by the naked eye, will it change the way humans, as visual animals, understand the world? Gigapixel image is a concept of digital image technology that first appeared at the beginning of the 21st century. This kind of image is usually composed of more than one billion (10^9) pixels, which are shot or spliced by special means. The huge amount of information it contains and its complex production process have changed people's traditional understanding of an image. As a consequence, it has been gradually adopted by artists as a means of creation. In the artist's large-scale digital impression series *Gigabyte*, the artist has created some "landscapes" that cover both modern and historical elements based on famous scenic spots and city squares worldwide. In this work, Venice, the traditional "capital of art", is chosen as the background, and numerous messy images are added in. From Henry Ⅷ to Batman, from Shakespeare to Godzilla, from the toilet plug to the Millennium Falcon, the artist seems to put all the marks of human civilization into a great carnival across time and space on the canal of San Marco. But they do not live together peacefully. In such a huge collection of information, all characters and memories are fused together. The artist believes that this is an intuitive picture where childhood memory, educational experience and nostalgia are mixed together. Here, these images are involved in an epic ethical war just like the artist's own life and memory.

亚内·佩尔托坎加斯
Janne Peltokangas

（芬兰 Finland）

众神 5 号 / 风神	Ipmil No.5 / Bieggagállis
铁	iron

<div align="center">34cm × 20cm × 31cm</div>

风是什么样子？雪花是什么样子？风吹起的雪花移动在北极粗糙的旷野上又是什么样子？艺术家用从废料场收集的金属材料制作了这件作品，成为他"众神"系列作品的一部分，名之为"风人"，即风之神。"众神"系列取自传统的萨米神话中对神灵的想象，萨米人是居住在北极地区的芬兰—乌戈尔土著民族，有着独特的传统、环境和文化信仰。艺术家采用了传统的萨米手工艺（又名 Duodji），意味着制作者自己从周围的环境中收集、生产和加工他的材料，这种工艺本身暗含着特有的方法和对象、过程和工艺，形成了物质与精神相统一的哲学。在艺术家看来，材料是有生命的、是永恒的，随着时间的推移，会有无限的形状。这些回收的铁料在艺术家重塑的过程中，不再是坚硬而强大的，反而显示了敏感而脆弱的特性。作品将精神世界的空灵与缥缈编织成钢铁的形态，同时，雪花造型层层叠叠、锈迹斑斑的表面表现了北极粗糙的地貌特征。

What does the wind look like? What do snowflakes look like? What about wind-blown snowflakes moving across the rough Arctic wilderness? The artist created this work from metal materials collected from the scrap yard, which became part of his *Ipmil* series of works, in the name of "*Bieaggagállis*" (The God of the Wind). The "*Ipmil*" series draws its strength from the traditional Sámi mythology, using imagery of gods. The Sami people are the Finno-Ugric indigenous peoples living in the Arctic region, with unique traditions, environments and cultural beliefs. The artist employs traditional Sami craftsmanship (also called Duodji), which entails an artist collecting, producing, and processing his materials from the surrounding environment. This is a unique craft and process, which inherently implies a philosophy of unity of material and spirit. In the artist's view, materials are eternal lives that possess infinite shapes over time. In the process of remodeling, these recycled iron materials are no longer hard and strong, but sensitive and fragile. The work subtly weaves the ethereal nature of the spiritual world into the form of steel. At the same time, the layered and rusted surface of snowflakes expresses the rough topographical features of the Arctic.

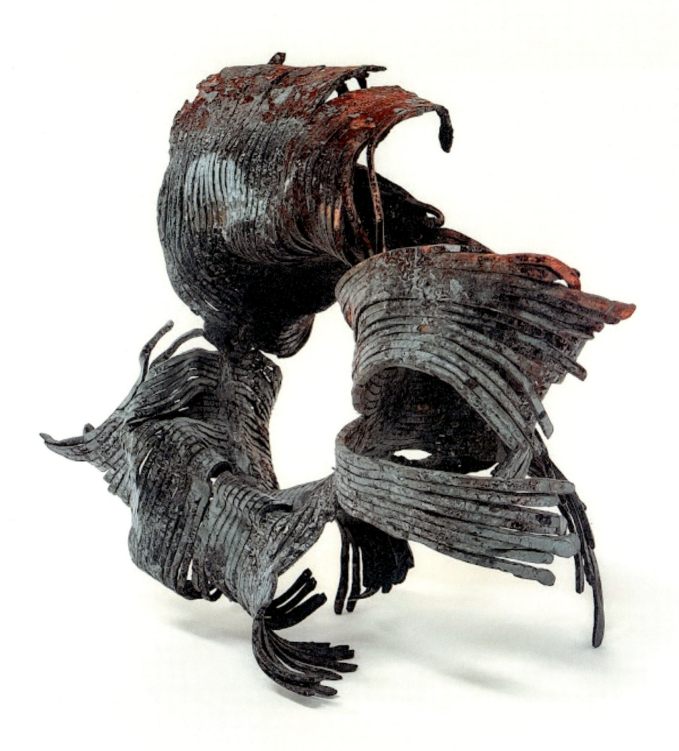

亚努什·库查尔斯基
Janusz Kucharski

（波兰 Poland）

自我表型	**Own Phenotype**
提花剪纸卡、自画像照片、纸、胶水、蜡笔、聚酯线、木粉、灯光	jacquard cut card, photo of a self-portrait, paper, glue, crayons, polyester string, wood dust, light
95cm × 88cm，尺寸可变（size variable）	

艺术家从20世纪90年代就开始在作品中使用提花纹板，用它们来创作了许多绘画、雕塑或装置作品。艺术家将"表型"这一生物学概念进行了扩充，将其视为：有机体的一系列基因特征，再结合以生态圈、生物变异、环境影响、精神素质和教育等，最终呈现的物理形态。他认为人就如同这些纸板——每一个都有自身的编号，艺术的表现方式则如同教育和环境，二者结合才是艺术家心目中的人类的"表型"。"自我表型"的一系列作品都是在尝试表现自画像穿越棱镜后的效果，它思考了一个人在物理上和精神上的诸多因素之间的复杂关系。作品的基础是剪成碎片的提花纹板，再用聚酯纤维的线连接起来。然后，来自不同摄影师的艺术家肖像照片碎片则被一个个贴到这些三角形上。观者也将可以改变这一"浮雕"的形态，"肖像"也以此呈现出不同的面部表情。

The artist has been using jacquard cards in painting, including relief painting, structural drawing, objects, and installations, since the 1990's. He combines the biological concept of phenotype and the jacquard cards to create the "phenotype" of humans in his works. For him, phenotype is the expression of the human genotype under the ecological, biological, environmental, psychological, educational, and other influences. And jacquard cards indicate that every human is numbered in this society, while artistic expression is like the influences. The "Own Phenotype" series seeks to present a through-the-prism effect on self-portraits. By such an effect, the complex relationship between multiple physiological and psychological factors of an individual is highlighted. As for this group of works, jacquard sheets are cut into triangular pieces, and connected by threads of polyester. And fragments of the artist's portraits by different photographers are then affixed to these triangles one by one. Noticeably, the viewers can also change the form of the "relief" by themselves to obtain diversified facial expressions of the "portrait".

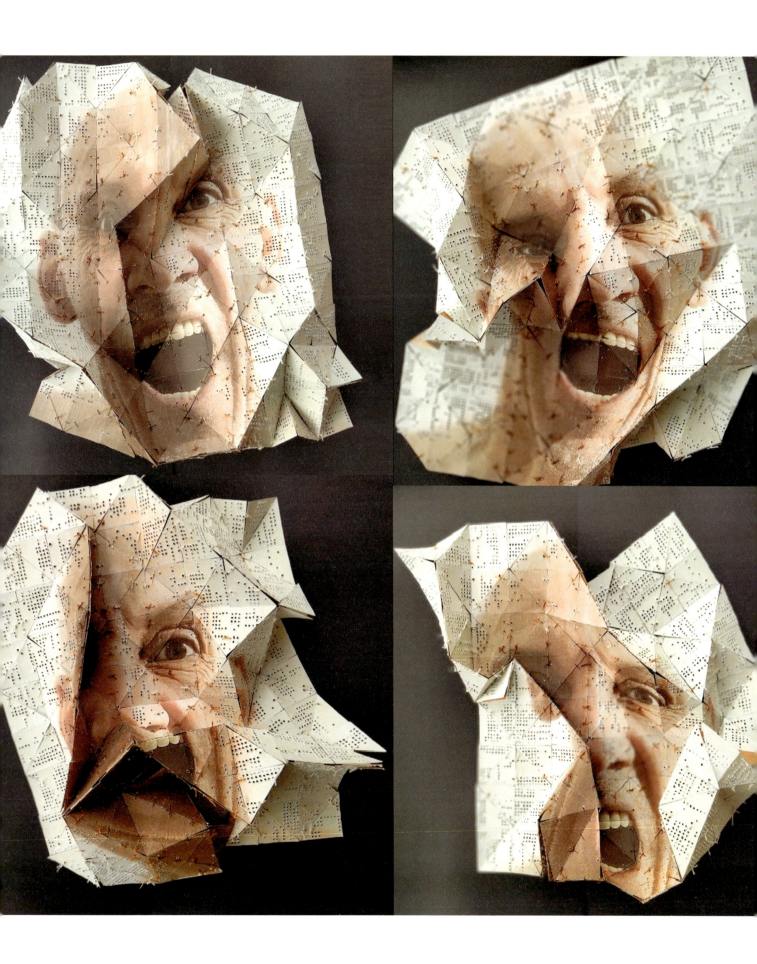

珍妮·德·雷梅克
Jeannine De Raeymaecker

（比利时 Belgium）

封装的怀旧情结	**Encapsulated Nostalgia**
用旧照片制作的手工纸、麻布、黄麻	handmade paper out of old photographs, abaca, jute

235cm × 75cm × 28cm

因对纸的热爱，艺术家选择以手工纸创作作为自己的表达方式。作家将灵感写在纸上，她则用纸将自己的感觉转换成物质。这件作品名为《封装的怀旧情结》，艺术家在重温过去的同时，想以一种无形的方式为未来封装记忆。于是，她将老照片剪裁，与麻布相融合成新的纸张，然后用黄麻织物将其包裹起来，缝缀在一起，成为一串串"封存的记忆"。这个漫长的制作过程对艺术家来说就像是一场冥想，纸张在回收的过程中，被重生并封存在循环结构的系统中。在这里，纸张不再是承载书写或绘画的"表面"，而是解放了的、成就了的自己。艺术家以这样的短句来总结自己的创作：

创造结构是我艺术表达的主要手段。
节奏和重复是一种冥想，一段反思。
简而饰之，但越少越好。
在多样性中寻找统一性。

A passion for paper lead to the artist's selection of handmade paper as her channel of artistic expression. Artistic inspirations are inscribed on the paper, and are thus transformed from sensations to matters. The documented paper, now an *"Encapsulated Nostalgia"*, functions as the formless encapsulation for the future, of the memories that the artist is recalling. She additionally cut out old photos, merged them with linen into new paper, then wrapped the new paper in jute fabric, before stitching them together into a string of "sealed memories". The long process of production is like a meditation for the artist. During the process of recycling, the reborn paper is sealed in the recycling system. Here, paper is no longer a "flat surface" for writing or painting, but has a liberated and accomplished "self". The artist summarizes her creation as such:
Creating structures is my principal means.
Rhythm and repetition are a meditation, a time to reflect.
Simplicity, with a few additions, the less the better.
I search for unity in diversity.

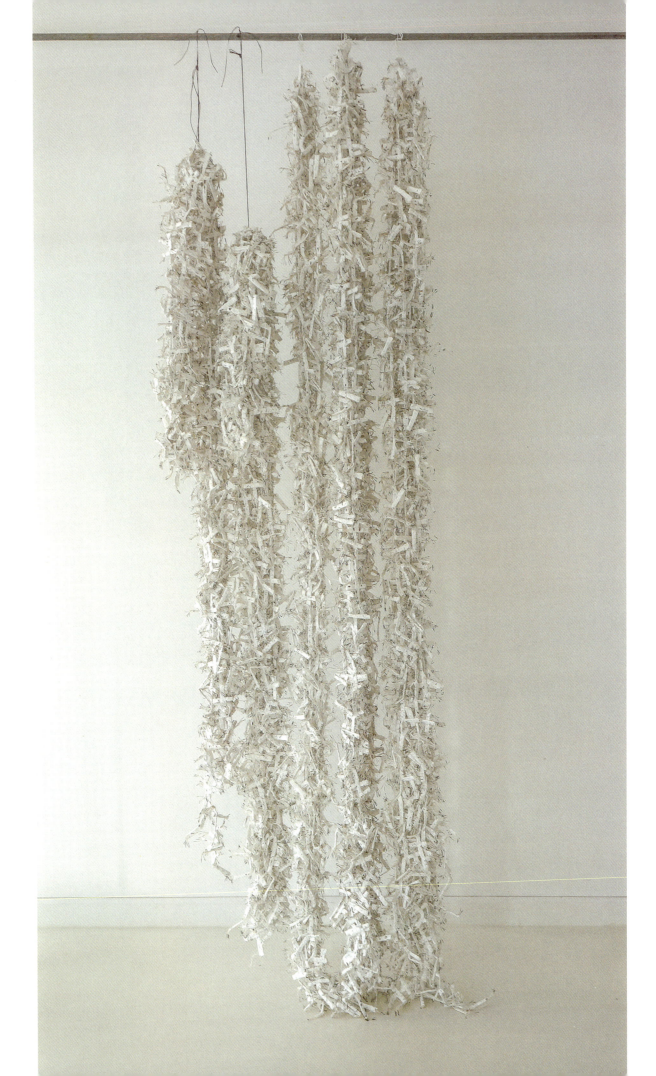

珍妮弗·罗伯森
Jennifer Robertson

（澳大利亚 Australia）

构造线 II	Tectonic Lineation II
石英纤维、碳纤维或聚酯、不锈钢、丝绸	quartz fiber, carbon fiber/poly, stainless steel, silk
350cm × 90cm × 15cm	

这一作品诞生于地质学与纺织艺术的结合。艺术家选择了石英纤维作为最主要的创作材料。这种矿物材料通常被用以制作光纤，因为它具有独特的能力，可以在深空和地球之间的天线中持续传输数据。这些矿物材料需要运用专业知识进行特殊处理。它们原本都没有弹性，并且在编织过程中常常体现出不同的物理特征：变化的张力、弹性和不同的卷曲，使得在织机上利用这些特殊纤维进行编织变得非常困难，但最终效果往往也出人意料。在形式上，作品也与地质学紧密相关，艺术家努力使其成为一种大自然中地质构造和变质反应之间的视觉叙述。她参考了风化裸露的岩层和地层，大地在风和水的侵蚀下呈现出柔软的纺织雕塑曲线，这些褶皱与沟壑成为岁月和成长的隐喻。艺术家认为，作为进行中的一系列创新编织复合材料探索的一部分，"构造线"正在创造一种新的编织语言。

This work was born from the combination of geology and textile art. The artist chooses quartz fiber as the main material. Quartz fiber is usually used to make optical fiber due to its unique ability to continuously transmit data through the antenna between deep space and the earth. But before becoming functional, the fiber needs special treatment with professional knowledge. The fiber was originally inelastic, and often showed varying physical characteristics in the weaving process: the tension, elasticity and curve of the fiber differ, making its weaving on the loom very difficult. But the final product is often unexpectedly good. In terms of the form, the work is also closely related to geology. The artist tries to make it a visual narrative between the geological structure and the metamorphic reaction. She refers to the eroded rock strata and the earth. The earth shows curves under the erosion of wind and water in the form of soft textile sculpture. And the curves become metaphors for time and development. The artist believes that, as a part of the ongoing exploration of a series of innovative braided composites, "tectonic lines" are creating a new weaving language.

贾善国
Jia Shanguo

（中国 China）

庚子印记	***Gengzi* Seal**
大漆、综合材料	Chinese lacquer, mixed materials

<div align="center">120cm × 132cm × 72cm</div>

新冠肺炎疫情席卷而来，影响着人们的行为习惯、生活方式，乃至世界格局及走向。作为历史的见证者，艺术家想用自己的方式来表现人类这段特殊的经历。疫情让人类失语，这一"失语"，既指世界重回"宁静"，也指现代文明面对病毒的脆弱无力。这使艺术家联想到语言障碍的特殊人群；而中国古代重大事件的铸鼎传统，则成为作品形式方面的启示。于是艺术家携吕梁残疾人职业学校聋人部孩子们共同创作了该鼎。

作品采用了"亚克力胎漆器"工艺。大漆是应用历史已超八千年的天然材料；亚克力则是石油工业的副产品，作为生产物是时代的象征，而同时也作为污染物腐蚀着海洋，严重威胁着人类的生存。鼎的亚克力胎体经火烧扭曲，布满孔洞，象征疫情将成为人类永远的伤疤。再经裱麻、刮灰、打磨、刷漆，透明、虚幻、易碎的亚克力被覆盖、包裹，仿佛用古老的方法为人类疗伤。两种反差的材料融入一件作品，代表着传统与现代的矛盾。

The COVID-19 epidemic swept the world, affecting peoples' behavior, lifestyle, and even the pattern and trend of the world. As a witness to history, the artist wants to express this unprecedented experience of humanity in his own unique way. This "speechless" state refers not only to the transformation of the world into utter silence, but also to the fragility and powerlessness of modern civilizations in the face of viruses. This reminds the artist of a special group of people with speech disorders. That, and the tradition of casting cauldrons for major events in ancient China, have inspired the shape of this artwork. The artist and the children from the department for deaf students of *Lvliang Vocational School for the Disabled* jointly created the cauldron.

The work adopts the techniques of "acrylic-based lacquerware". Lacquer is a natural material that has been used by humans for more than 8,000 years; acrylic, as a by-product of the oil industry, is a symbol of contemporary times, and is also a pollutant that damages the ocean and threatens the survival of human beings. The acrylic base of the cauldron was distorted and riddled by burning, symbolizing that the epidemic will become an eternal scar for mankind. After mounting with fiber, supplying with muddled materials, polishing and lacquering, the transparent, illusory, and fragile acrylic is covered and wrapped, as if human beings are healed by some ancient method. Two materials, in contrast, are integrated into one piece, representing the contradiction between tradition and modernity.

蒋颜泽
Jiang Yanze

(中国 China)

消逝	Fading
蜂窝陶瓷废料、陶泥、石膏、金属丝	discarded honeycomb ceramics, clay, plaster, wire
80cm × 40cm × 50cm	

《消逝》是以蜂窝陶瓷为材料创作的都市景观作品。蜂窝陶瓷是一种内部结构类似蜂窝的陶瓷，它们在当下被广泛应用于工业净化领域。因为类似蜂窝的造型，蜂窝陶瓷也因为规则的排列极具几何化的美感。该作品以这种几何形态构筑了现代城市的风景。该作品既像乐高积木搭就的都市建筑，又像现代都市的建筑废墟，同时又指向中国传统的风景绘画艺术，其形象的含混使它同时指向多个维度的文化思考，于工业文明的秩序之美的间隙中若隐若现，流露出对于久远年代的伤感与怀念。

Fading is an urban landscape design based on honeycomb ceramic. This ceramic, with a honeycomb-like internal structure, is widely applied in contemporary industrial purification. The honeycomb-like morphology and its orderly pattern present a geometric beauty. By using this material, this work creates the geometry of modern urban landscapes. With a resemblance to an urban building of Lego blocks, and a metropolitan ruin from modern times, this work also echoes traditional Chinese landscape painting. The vagueness of its image reflects the multi-dimensional cultural concept of this work. In the gap between the orderly beauty of industrial civilization, a melancholy and nostalgia for the remote ages is born.

焦晨涛
Jiao Chentao

（中国 China）

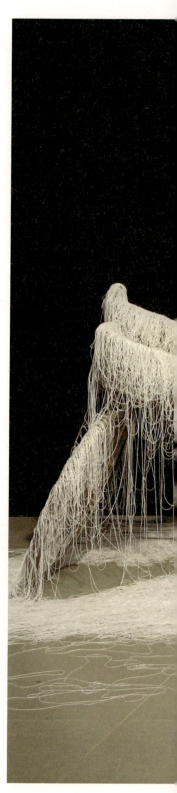

此时彼时	Here and Then
a. 影像—行为，2 小时 18 分 25 秒；b. 装置，棉线、自行车、电视、缝纫机、电扇等老旧物件 注：视频与作品同时展出	a. Video-Behavior, 2 hours, 18 minutes, 25 seconds; b. Equipment, cotton thread, bicycle, television, sewing machine, electric fan and other old items Note: The video and the work are on display together
尺寸可变（size variable）	

艺术家的灵感来自家里一张 30 年前的老照片：风起云涌的 20 世纪 70-80 年代，中国家庭的基本样子，照片中的家具物件就是当时家里最主要的财产，每一件都糅杂了诸多情绪的碎片。该作品或像是一场追溯过去的仪式，以行为的方式，长达 8305 秒实时拍摄，借用白纱线这一媒介，表达自己对记忆、时间、时空理解的延伸。纱线仿佛蚕丝一般缓慢织造出记忆的网络，又如神经元之间的纤丝不断降落到这些物件之上，将过去与当下勾结，使自己与父辈们关联。这一整场的表演本身也伴随着时间的流逝，情绪与思索恰如尘埃落定，层层覆盖具象化的过去，隐约显现出情感的碰撞。此时此刻如一段生命存在于作品之中不断地生长。

The artist was inspired by an old family photo from 30 years ago, which shows the basic appearance of a Chinese family in the turbulent 70s and 80s. The furniture in the photo was the main property of the family at that time, and each piece of furniture carried many emotional family memories. This work of behavioral art is like a ceremony tracing back to the past. It is shot in real time for 8305 seconds, and it uses the medium of white yarn to express the extension of the artist's understanding of memory, time, and space. The silk-like yarn slowly weaves into a network of memories, representing the dendrites of neurons that constantly fall onto these objects, and connect the past and the present, as well as the artist himself with his parents' generation. This whole performance is accompanied by the passage of time. The emotions and thoughts (the yarn) are just like dust falling to the ground. They cover the concrete past layer by layer, subtly representing the collision of emotions. At this moment, a piece of life seems to emerge from this work, and it grows constantly.

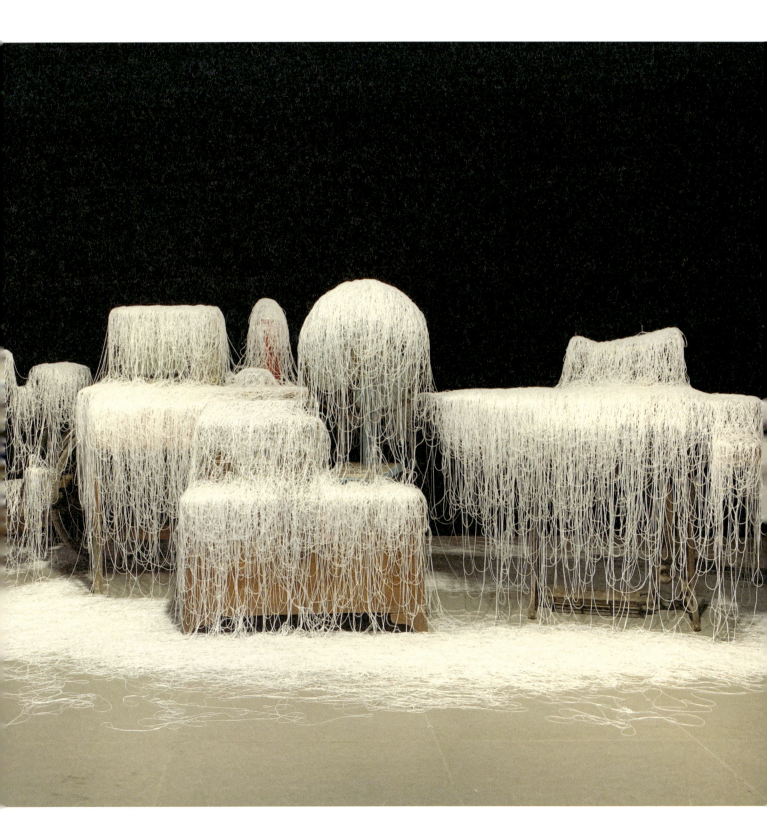

吉克楚哈莫
Jike Chuhamo

（中国 China）

拉则格楚	***Lazegechu***
纸浆	paper pulp
165cm × 110cm × 230cm	

艺术家作为彝族年轻的一代人，以继承、发扬彝语及彝族文化为己任，借用彝族神话中重要的拉则格楚故事创作了这件作品。传说中彝族大毕摩（彝语中"吟诵诗经的长者"之意，即部落中的宗教祭司与授业智者）阿苏拉则生前制了许多彝文，死后担心无人再能识得这些文字，故化作一只鸟，到他那生来就不会讲话的儿子拉则格楚身边，并指引他去森林。从此，鸟儿每天高声歌唱，并吐出血滴在阔叶上写成漂亮的文字，儿子也照着叶子上的笔画，专心画着而忘了时间。一天，母亲上山找到儿子，鸟儿一惊走了，拉则格楚则一惊而开口说话了。

或许我们都是生来"不会讲话"的拉则格楚，"忘记"由祖先所留下的"本能"，而迷失了前进的方向。因此艺术家采用彝族传统服饰"查尔瓦"的形态，又结合以宗教仪式的举办场所"洞穴"的意象，创作了雕塑的主体部分，表面以纸浆打造肌理，其上则附以毕摩绘画，内容围绕"拉则格楚"，融汇多个彝族经典神话传说；四周则散置更小的毕摩仪式泥塑。作品同时也是互动装置，通过拍击特定点位触发声音传感器，仿佛先祖沉沉的教诲从大地深处传来。

Belonging to the younger generation of the *Yi* people, the artist considers inheriting and promoting the *Yi* language and culture as her duty. This work is created in this context and is based on the important *Yi* legend of *Lazegechu*. According to the legend, the Big Bimo (literally meaning the elder who recites poems and scriptures, and referring to a priest or a mentor in the *Yi* tribe), Asu Laze, created many *Yi* characters before his death. After his death, he was afraid that no one would recognize these characters, so he turned into a bird and went to his son, *Lazegechu*, who was born unable to speak, and guided him to the forest. From then on, the bird sang loudly every day and spit out blood drops to form beautiful characters on the broad leaves of trees. *Lazegechu* followed the characters on the leaves and was so concentrated on reading that he forgot the time. One day, *Lazegechu*'s mother went up the mountain to look for her son. Once she found her son, the bird was startled away, and *Lazegechu* was also startled, and was suddenly able to speak.

Perhaps we are all *Lazegechu*, and we are born "speechless". We forget the instinct inherited from our ancestors, and we lose the direction of moving forward. Therefore, the artist adopts the form of the traditional *Yi* costume "Chalwa" and the image of the "cave", where tribal rituals are held, to create the main part of the sculpture. The texture of the surface of the sculpture is attributed to paper pulp. And Bimo paintings that describe main story of *Lazegechu*, and other classical *Yi* legends, are attached to the surface. Smaller clay sculptures for Bimo rituals are scattered around the main sculpture. The work is also an interactive installation. By tapping specific locations on the work, a sound sensor is activated, and the teachings from the *Yi* ancestors are played as if from the depths of the earth.

金晖
Jin Hui

（中国 China）

孤独的行星	**Lonely Planet**
漆、麻布、纸、黏土、金属箔	lacquer, linen, paper, clay, metal foil
120cm × 120cm × 5cm	

《孤独的行星》是以漆为主要材料创作而成的综合材料作品。该作品立足漆本身的材料特性进行本体语言的探索，以纸浆工艺与天然漆色相结合，形成了"行星"表面的粗犷的肌理与苍茫的状态。作品在"器物"与"绘画""立体"和"平面"方面均有展开。"象"的问题构成了这件作品探讨的核心，这种"象"消弭了易于识别的形象或形式，成为一种含蓄但磅礴的"气韵"之"象"，在"似与不似之间"强调了主体的感受性而非理性。该作品以工艺为起点，但以哲学为终点，作品立足东方美学进行演绎和表达，整个作品具有一种超然物外的精神属性。

Lonely Planet is a mixed media work created with lacquer as the main material. The work explores the ontological language based on the material characteristics of lacquer itself, combining the pulping process with natural lacquer colors to create the rough texture and pale state of the surface of the "planet". The work can be viewed as "artifact" and "painting", "three-dimensional", and "flat". The question of "*Xiang*" (similar to "Image" in Taoist terminology) is the core of this work; it dissolves easily identifiable images or forms and becomes a subtle, but majestic "*qi* rhyme". The "*Xiang*" emphasizes the subject's sensibility rather than rationality in the question of likeability versus un-likeability. The work starts with craftsmanship but ends with philosophy. The work is based on oriental aesthetics for interpretation and expression, and the whole work has a spiritual attribute of transcendence.

乔·汉密尔顿
Jo Hamilton

（英国 / 美国 UK/USA）

分层的闪亮岛	**Stratified Shining Island**
钩织毛线、回收的家用塑料	crocheted yarn, upcycled household plastic
	84cm × 343cm

在艺术史上，男艺术家画笔下的女性裸体比比皆是，因而，女艺术家表现男性裸体是一个颇具戏谑意味的挑战。艺术家汉密尔顿以毛线和钩针编织这种充满女性意味的材料与方式，描绘了一个充满肌肉感的

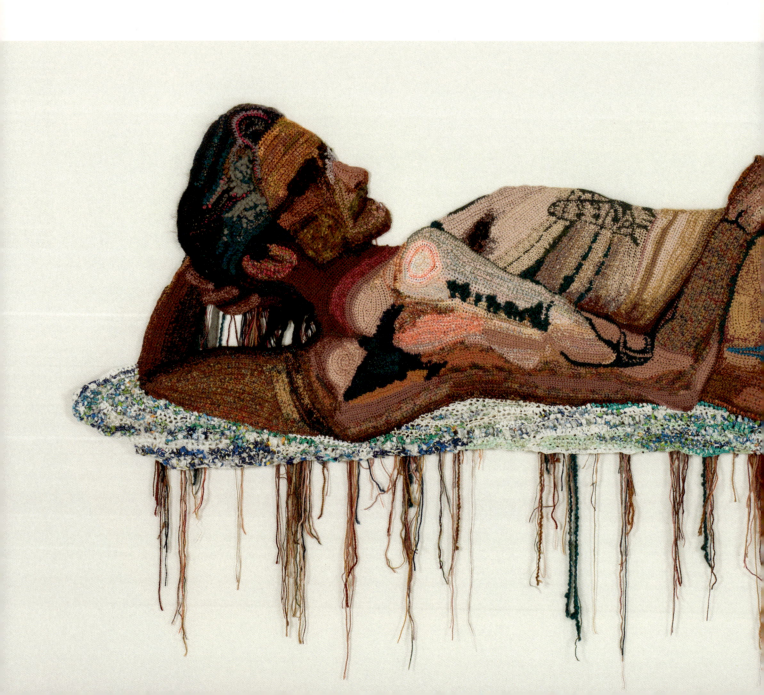

男裸体像，挑战以往的性别歧视和观看传统。学油画出身的汉密尔顿最终选择了小的时候祖母教她钩针编织作为自己的艺术语言，因为这门代代相传的手工艺代表了一代又一代女性，每一个结都记录了每时每刻，这种材料的亲近感和触感相比静态和严肃的绘画更活泼生动。在这件作品中，艺术家用"毛线"画笔表现了自己的模特好友，不同于以往的同类型作品，作品中所有的材料均由回收而来，包括艺术家将家里的塑料垃圾升级改造成"plarn"（即塑料纱线）织成的"闪亮岛"。作品《分层的闪亮岛》喻指一个已经凝固成陆地的人，躺在塑料的海洋中，体现了对过度生产、污染和气候变化的反思。

In the history of art, female nudes painted by male artists are a common phenomenon, which brings a playful challenge for female artists to paint male nudes. Using such feminine material and method as wool and crochet, artist Jo Hamilton paints a muscular male nude, fighting against old sexism and conventions of viewing. Hamilton, who studied oil painting, eventually chose crochet as her artistic language, which she learnt from her grandmother when she was a child, as this handicraft handed down from generation to generation represents generations of women, and every knot records every moment. The intimacy and tactility of such materials are more lively and vivid than static and serious paintings. In this work, the artist paints a portrait of her model friend with wool as her tool. Unlike previous works of the same type, all materials in the work are recycled, including the "shining island" woven from "plarn" (i.e. plastic yarn) which is the product of the artist's upcycling of plastic waste at home. The work "Stratified Shining Island" indicates a person who has solidified into land, lying in a sea of plastic, which demonstrates her reflection on overproduction, pollution and climate change.

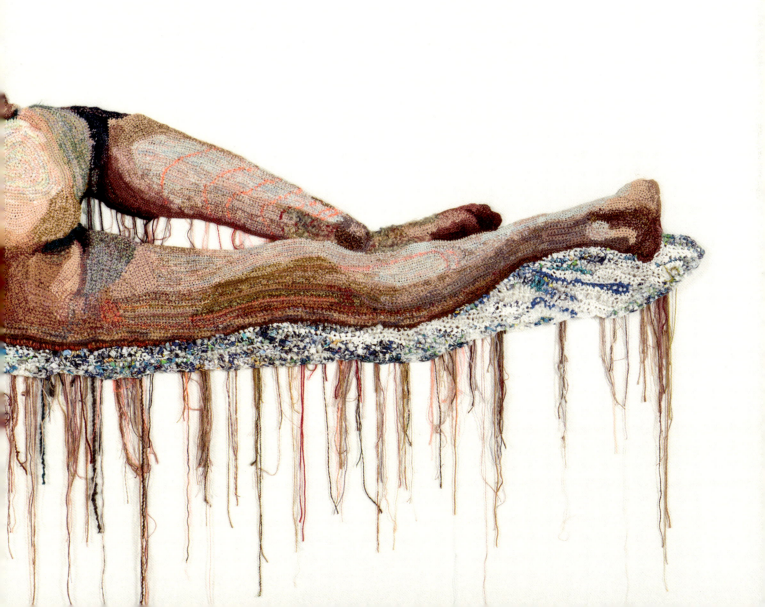

琼·舒尔茨
Joan Schulze

（美国 USA）

笔记系列	Notes Series
纸、包装胶带、丝线	paper, packing tape, silk
50cm × 46cm × 2	

舒尔茨把绘画融入她的拼贴作品中，她以丝质透明硬纱为"纸"，将这些重新组合的绘画在缝纫机上用黑线缝缀。对复印技术的使用让她的绘画更有实验性，她在复印机上折叠、放大绘画，然后再印到丝绸上。舒尔茨通过编辑和纸质拷贝创作了更大的绘画。她将被转印的丝绸绘画缝合在一起，拼贴后再以棉絮层叠加。最终拼贴上新缝的线与印刷的线形成对比，产生一种动态的张力。她的最新作品继续采用拼贴技术和包装胶带结合的方法来探索"无意识的绘画"过程。舒尔茨把这类作品叫作条带拼贴或绘画。拼贴作品《笔记》系列表现了这一新的探索。作为诗人的她写道：

无意识地图绘着
使不可见的，可见
让隐私的背面突显
把背面带到前面
从旧事物中牵引出新的绘画

Schulze integrated drawing into her collages. Using silk organza as "paper", she stitches these reassembled drawings with black thread on a sewing machine. Her paintings are very experimental with the use of photocopying, and they are folded and enlarged on a copier, and printed on silk. Through editing and paper copies, Schulze creates larger paintings, which are sewed together, collaged and then layered with batting. The newly stitched thread on the final collage contrasts with the printed thread, creating a dynamic tension. Her latest work continues to explore the process of "Unconscious Drawings" using a combination of collage techniques and packing tape. Schulze refers to them as tape strip collages or drawings. The collage *Notes Series* stands as a proof of this new exploration. As a poet she writes:

The Unconscious Drawing
Make the not seen, seen
Emphasize the private face of the quilt, the back
Bring the back to the front
Compile new drawings from the old

尤维塔·撒克朗斯凯特
Jovita Sakalauskaite

（土耳其 Turkey）

你生气是为了快乐吗？	Are You Angry To Be Happy?
羊毛、牙签	wool, toothpicks

30cm × 40cm × 60cm × 2

《你生气是为了快乐吗？》艺术家尤维塔的这组作品探讨了这一关于认知和情绪的问题，是她近年来毛毡雕塑头像系列的延续。这系列作品以细腻入微的面部表情塑造、牙签或金属针做的尖锐发型为特征，多是关于情绪、人性、本能、人与社会等问题的思考。身处互联网生活中，人们的生活方式、行动和感受，特别是那些通过社交媒体反映和发布的，与我们"真实或真正"的个性和情感不一致，让人们逐渐陷入自我重复的、自我模仿的认知失调中。向右看，你是快乐的，向左转，发现自己被愤怒所覆盖……在这组作品中，单面雕塑象征着俏皮、戏谑的情绪，双面雕塑将一个人的情绪复杂化，似乎经历了一个由单纯青年到复杂中年的变化，观者不禁发问：哪张脸才是真的？

Through her work *Are You Angry To Be Happy*? Jovita uses the techniques from her recent years' "felted head sculpture series" to explore cognition and emotions. Characterized by delicate facial expressions and spiky hairs made of toothpicks or metal needles, the works are mostly about emotions, humanity, instinct, and the interaction between people and society. The lifestyles, actions, and feelings of people living on the Internet, especially those reflected and published through social media, are inconsistent with their "real/authentic" personalities and emotions, so they will gradually fall into the cognitive dissonance of self-repetition and self-imitation. Looking to the right, you are happy, while facing the left, you are drowned in anger... the single-sided sculpture shows the simplicity of a cunning and playful temperament, compared to the double-sided sculpture which demonstrates the complicated emotions that a person can have. Confronting this shift from an innocent young person to a subtle middle-aged person, the viewers can't help but ask: which face is the real one?

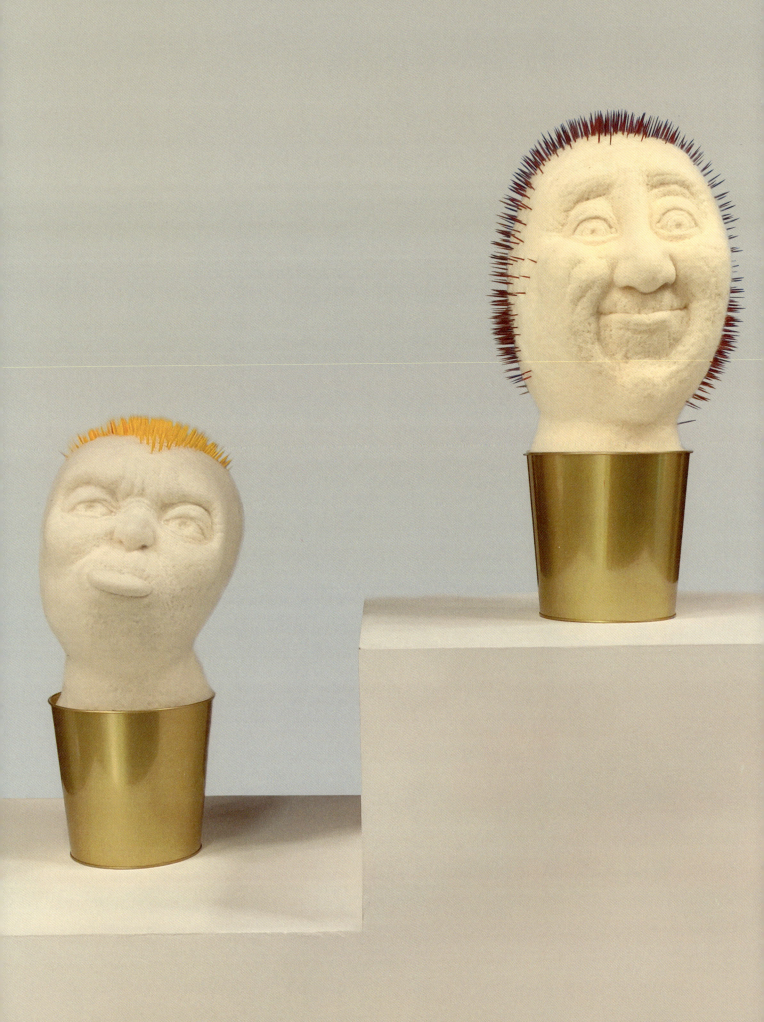

朱迪特·埃斯特·卡尔帕蒂 /
艾斯德班·德·拉·托尔
Judit Eszter Kárpáti / Esteban de la Torre

（墨西哥 / 匈牙利 Mexico/Hungary）

深流	**Deep Flux**
纺织品、反应性颜料、定制代码和电子器件、挤制铝材	textile, reactive pigment, custom code and electronics, extruded aluminum

<div align="center">80cm × 80cm × 30cm</div>

《深流》是一幅永远自我绘画的画布。艺术家利用生成对抗网络（GAN）训练了一个简单的绘画智能，为设定好的画笔系统假设三轴结构，并特意使其笔迹在短时间内迅速消退，实现了动态画布在时空上的无限制延伸。而图像则纯粹产生自该智能受训过的神经网络，基于各类艺术运动的庞大数据集，包括传统艺术和20世纪70年代以来的计算机艺术作品。其图像创作对于该智能无疑是无意义的，但其背后的庞大历史却使得观者产生阐释和叙述的倾向，从而形成精神和物质的矛盾对照。《深流》大胆运用了新的动态交互材料，探索"物质"的表现性。此处的"物质"不仅是流连于物理性表面的传统艺术作品，还包括代码、时间等非物质性的因素，进入"物质世界"的深层维度。它创造了一种高度混合的新的物质性图像，同时存在于虚拟和现实世界，赋予"物件"以音乐一样的精神性，时间则在其中成为不可或缺的材料。

Deep Flux is a canvas that always paints on itself. The artist trained a simple AI to paint using Generative Adversarial Networks. Within the xyz-axis structure for the set brush system, the painting was deliberately made to fade quickly, so that the dynamics of painting is extended inexhaustibly in space and time. Moreover, the artistic movement of the AI is based on a huge database of traditional arts and computer art, collected since the 1970's. Thus, the meaningless AI movement is transformed into a narrative that is able to be interpreted. The viewers then experience the contradiction between the spiritual and the material. *Deep Flux* also boldly adopts new dynamic interactive materials to explore the expressiveness of "substance". The "substance" here is not only a traditional artwork that lingers on the physical surface, but also includes non-material factors such as code and time. These factors can enter the deep dimensions of the "material world" to create a highly mixed image of new materiality. In both the virtual and the real, the "object" acquires a musical spirituality, and renders time into an indispensable material.

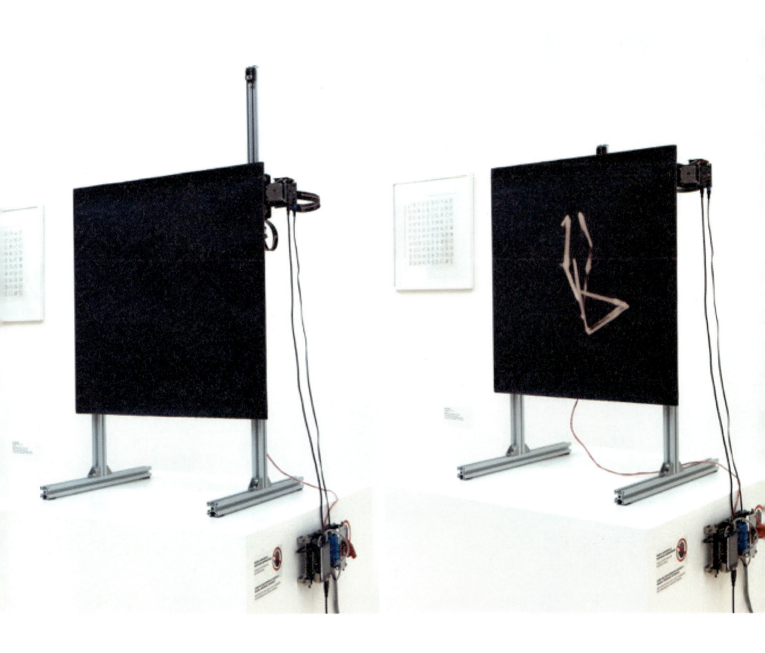

坎禅·卡吉
Kanchan Karjee

（印度 India）

哲人石	**Philosopher Stone**
硅、电机	silicon, electric motor

70cm × 50cm × 45cm

艺术家用乳胶和石膏制作了这件作品，其外表与真正雕塑工作中所采用的石料别无二致。尽管石块常常是雕塑作坊中最重要的物件，但作为原材料，其本身的特征却几乎从未被当作严肃之物来展示过。对坎禅而言，石料的切割有一种高度的肉体性：一个艺术家用锤子和凿子在石块上工作的场景对他来说就是雕塑原本的真实模样。将形象从石块中一点点雕造出来是一个缓慢而冗长沉闷的过程，更是一个石料与双手、与肌肉在某种意义上相互交融的过程，而正是从这样的联系中艺术家获得了这一作品的构想：一个形似石头的颤动之物，拥有生物般的呼吸和震颤的能力，成为一个富有生命且能够思考的"哲人石"。

The artist uses latex and plaster to make this work almost indistinguishable from a real stone sculpture. As the most essential raw materials in sculpture workshops, the very objects of stone blocks themselves are never seriously treated. For Kanchan, the cutting of stone has a high degree of freshness: an artist hammering and chiseling on the stone, making an original picture in the form of a sculptural creation. Slow and tedious, carving requires diligence. Spiritually, your hands and muscles also blend into the process. That is how the artist contrives this work: a quivering object in the shape of a stone, able to breathe and tremble like a creature, a "philosopher's stone" full of vitality and inspiration.

坎菲丁·亚法
Kanfitine Yaffah

（多哥 Togo）

王国	**The Kingdom**
石板、纤维、丙烯颜料等	slate, fabric, acrylic paint, etc.
100cm × 100cm	

非洲艺术家坎菲丁善于利用复合的多种异质材料，将抽象形式与具象表现相结合，呈现一些真实的当地问题。在他的文化中，石板一度是重要的书写材料。在一位领袖坐上他的宝座之前，他必须经过长期的指导和教育，而没有石板作为工具这就不可能发生。直至今天，在最基础的公民教育中，作为任何长期学习的基础，作为记录和书写工具的石板是并且将继续是不可否认的关键。在艺术家的眼中，石板本身就成为当地人的第一个知识。他借用这一意象，将几块石板拼接在一起，结合色块和布料，以及教学时会用到的网格板，表达出对教育的强调和重视。

The African artist excels in using a variety of composite heterogeneous materials to combine abstract forms with concrete expressions of some real local problems. In his culture, slate was once an important writing material. Before a leader can take the throne, he must go through long-term guidance and education, and this cannot happen without this tool. Even today, the most basic civic education in Africa still adopts and will continue to use slate. It is used as the key recording and writing tool to teach the basis for any long-term learning. For the artist, stone slabs are the first source of knowledge for the local people. Using this image, he spliced several stone slabs and combined them with colored blocks, cloth, and grid boards used in teaching. In doing so, he wants to emphasize the significance of education.

卡捷琳娜·博罗达夫琴科
Katerina Borodavchenko

（俄罗斯 Russia）

全视之眼	All-Seeing Eye
聚乙烯密封线束、钢丝、照片	polyethylene sealing harness, steel wire, photo
70cm×60cm×35cm	

无数的眼睛像是从各处爬出来一样，形成了全方位、全视角的跟踪和监视。究竟是什么令我们恐慌、焦虑、不安？是无言的观察者，隐形的间谍，还是心中的道德律？艺术家以"触角"的形式表现物体，这些带眼睛的触角在我们周围的一切事物中生长，捆绑在房屋、灯柱等建筑元素上，构造了一种"全视之眼"。这里的"全视之眼"可以是充斥在社会中和日常生活中无所不在的监控器、摄像头和数据追踪，也可以是内在于精神世界的上帝之眼、良心之眼。隐私的泄漏、良心的谴责、他者的评价折磨考验着每一个人，艺术家用无限伸张、扭曲盘旋的"全视之眼"营造出一种紧张不安的氛围。

Countless eyes seem to be crawling out from everywhere, tracking and monitoring us in all directions and perspectives. What on earth is it that makes us horrified, anxious and upset? Is it a silent watcher, an invisible spy, or our conscience? The artist presents her objects in the form of "tentacles", and these tentacles, with eyes on them, metaphorically grow in everything around us. Bundled on architectural elements, like houses and lamp posts, they constitute an "all-seeing eye". The "all-seeing eye" mentioned here can be perceived as numerous ubiquitous monitors, cameras, and data tracking devices, used commonly in today's society and in our daily lives – like an eye of God, and the eye of our consciousness within our spiritual world. This "eye" is hindering our privacy, condemning our conscience, and overwhelming us with comments from others, which torment and test everyone. The artist uses the ever-expanding, distorting and hovering "all-seeing eye" to create an anxious atmosphere.

凯蒂·泰勒
Katie Taylor

（英国 UK）

附着的物质	**Bound Up Material**
明胶生物塑料	gelatin bioplastic

59.5cm × 59.5cm × 5cm

艺术家认为，人类遗骸以外的物件或物质以某种方式物理地绑定或附着在它们上，从而成为它们的一部分，因而将作品命名为《附着的物质》。艺术家选择使用明胶生物塑料，它由猪的皮肤、骨骼和结缔组织中的胶原蛋白制成。其次，该材料透明且难以存续，在物理上象征着某物的缺失；另外，作为一种可生物降解的材料，生物塑料会慢慢分解（就像身体一样），并最终成为周围环境的一部分；最后，当这些物品从生物塑料的"皮肤"中被制作出来时，其表面会残留种种类似皮革的痕迹，显示出每件物品的个性——比如暗示着生活经验的折痕和压纹。艺术家希望关注那些社会中不被看见的人，他们孤独，无家可归，身份不明，甚至其死亡也无人知晓，仅仅成为数据库中的符号。但他们的死亡和痛苦都是真实的，他们遗存的每一个物件似乎都有一个故事要讲。

The artist believes that non-human substances are somehow physically bound or attached to human remains and thus become a part of them, hence the name *Bound Up Material*. Firstly, the artist follows a forensic lead and adopts gelatin bio-plastic that is made from collagen proteins from the skin, bones and connective tissue of pigs. Secondly, its physically transparent and unsustainable characteristics symbolize a kind of absence; also, being a biodegradable material, it will slowly decompose like the body, and eventually go back to nature. And finally, since these objects have bio-plastic "skin", marks on the skin will remain on their surfaces, granting each of them a unique individuality. These traces of "lives" include creases and bulges. The artist creates this work to call for more focus on the socially invisible, the lonely, the homeless, the unidentified, and even the unknown dead. They may only exist as an entry in a database, but their deaths and suffering are real, and every object they once used seems to have a story to tell.

坎·萨鲁穆·卡霍亚
Khen Salumu Kahoya

〔刚果（金）D.R. Congo〕

美丽的金沙萨	KIN The Beautiful
回收的金属板和易拉罐	recycled metal sheets and cans

67.5cm × 120.5cm

艺术家卡霍亚的作品多反映自己的家乡——金沙萨人民的日常生活，通过回收和再利用的金属板、易拉罐、电线、棚架、塑料等废弃物来进行艺术创作，希望唤起人们环境保护和爱护城市的意识。在作品《美丽的金沙萨》中，作者以一张三色的网状画布为背景，在上面叠加了人物剪影和由回收的金属板制成的建筑物，街上收集的易拉罐被巧妙地用作人物服饰和日常物件，表现了中央车站广场生机勃勃的场景：左边为殖民地遗产建筑，右边为全国独立选举委员会总部，熙熙攘攘的街道上，车辆和行人来来往往。艺术家用这些废弃的材料创作了一个美丽的都市街景，也寄予了自己对首都金沙萨再现辉煌与璀璨的希望。

Ken's works mostly reflect the daily life of the people of his hometown, Kinshasa. The artist uses recycled and reused metal plates, cans, wires, scaffolding, plastics and other waste to create artistic creations, hoping to arouse people's awareness of environmental protection and care for the city. In *KIN The Beautiful*, the artist uses a three-color mesh canvas as the background, on which human silhouettes and buildings made of recycled metal sheets are juxtaposed, and cans collected from the street are intricately used as the costumes and daily objects to depict the vibrant vividness of the central station square: the colonial heritage building on the left, the headquarters of the Independent National Electoral Commission on the right, and the bustling streets with vehicles and pedestrians coming and going in the middle. The artist used waste to reflect the beauty of the vista of the urban streets, and he also placed his hopes again on the restoration of that splendid capital, Kinshasa.

克里斯蒂娜·萨德
Krystyna Sadej

(加拿大 / 波兰 Canada / Poland)

雄伟的冰川	**Majestic Glacier**
透明的、蓝色和白色的塑料箔、白色棉花	transparent, blue and white plastic foil, white cotton
200cm × 220cm × 25cm	

《雄伟的冰川》是艺术家正在进行的"冰川和冰山"系列的一部分,其创作动机来源于她对冰川结构的深深迷恋。而在今日剧烈的气候异常变化进程中,这些震慑人心的古代自然奇观正以极其惊人的速度融化,这是艺术家关注的中心。艺术家希望提高人们对地球冰川困境的认识,她选择了透明、白色和蓝色的塑料箔(可回收的环保材料),再以特殊的编织技术将其制作成毛毯一般的装置。这些雪白的装置具有令人敬畏的光泽,可以完美地捕捉光影,获得类似于冰川的闪烁图像。它们最初被悬置于森林中,仿佛正是某种远古的地质遗迹,又同时发出对今人警告般的沉吟。

The artist's on going "Glaciers and Icebergs" series is the product of her deep fascination with glacial structures. Drastic climate change is melting these shocking wonders from ancient times at an alarmingly quick speed. Worrying about it, the artist calls for more awareness on the plight of glaciers. As a part of the series, this creation uses transparent, white and blue plastic foils. This recyclable and eco-friendly material is then crafted into a blanket-like installation using a special weaving technique. With an awe-inspiring sheen, the snow-white installation perfectly captures the light and shadow of a glistening glacier, as if in a photograph. It was initially suspended in the forest, as if it were an ancient geological relic, sending warnings to the viewers.

克塞尼娅·申科夫斯卡娅
Ksenia Shinkovskaya

（拉脱维亚 Latvia）

朝圣者们	Pilgrims
羊毛毡、浮木	wool felt, driftwood
3000cm×5000cm×30cm	

在 2021 年的新冠肺炎疫情期间，艺术家一度被隔离，无法与家人朋友们见面，深受思念折磨的她们开始互赠礼物，也正是此时艺术家收到了这些浮木。这些来自大自然的神秘碎片让她得以与朋友们产生了某种精神上的联系——肉体深陷困境，灵魂却嗅到来自旷野和人性的气息——她想起了莎士比亚关于朝圣者的诗句：

此时我开始回忆曾经涉足的远方，
如朝圣般热切地希望与你相见，
尽力抬起我沉重的眼帘，
凝望那不见五指的黑暗茫茫。

于是，艺术家决定用这些浮木制作一系列的形象，并选择了她认为最能代表温暖的古老材料——毡来与其配合。她深爱这些由水、风和太阳塑造的自然雕塑，为其加上拙朴的仿生线条，并不断地使用来自世界各地的浮木来制作它们。她希望以此来提醒人们：人也是自然的一部分，人将在对自然的虔诚中获得平衡与安宁。

During the 2021 outbreak of COVID-19, the artist was quarantined and could not see her family and friends. They started to give gifts to each other because of their longing for each other. And it is exactly at this point that the artist received samples of driftwood. This mysterious shard from nature inspired in her a kind of spiritual connection with her friends - "While the body is in deep trouble, the soul smells the wilderness and humanity". She also remembered Shakespeare's verse about pilgrims:

For then my thoughts, from far where I abide,
Intend a zealous pilgrimage to thee,
And keep my drooping eyelids open wide,
Looking on darkness which the blind do see.

Thus, the artist decided to use the driftwood to create a series of images, along with the application of felt, which is the most representative ancient material for warmth in the artist's view. She loves the driftwood fragments, and considers them natural 'sculptures' shaped by water, wind and sun. She tries to add rustic biomimetic lines to driftwood from around the world to create these images. She wants to use them to remind people that we are all a part of nature, and we will gain balance and peace through our piety to nature.

雷涛
Lei Tao

（中国 China）

白色幻想曲	**Fantasy in White**
棉签、羽毛、云母、石英砂、纤维、胶囊、蛋壳、镜面玻璃	cotton swab, feather, mica, quartz sand, fiber, capsule, eggshell, mirror glass
	35cm × 35cm × 6

这组作品是一场关于材料的大胆实验，每一张作品都有不同材料与白色颜料的碰撞和对话。在作品中，棉签被排列成一支错落有致的队伍，与白色石英砂展开对话，像一群可爱的大头娃娃徜徉在白色沙滩上；闪闪发光的云母和轻盈的羽毛交织；微妙的丝网纱幔与细碎的云石纠缠环绕；还有透明胶囊里装点的玻璃珠……这些材料与意象来源于生活，也来源于想象。每一件作品都有自己的性格和内涵，在其中材料并不服务于形式，而是与精神深处形成共鸣。有的材质代表了单纯，有的代表了生活的沧桑与粗粝；有的意味着生命中那些轻盈欢乐的时刻，有的则代表着沉重与无奈。白色本来是最沉静的颜色，但在想象面前，却爆发出惊人的高光。

The concept of this work comes from a bold material experiment. Each circular sample in this series demonstrates the unique collision and dialogue between a material and a white pigment. In the work, cotton swabs are arranged into an orderly "team", conversing with white quartz sand, like a group of lovely big-headed dolls wandering on the white beach; glistening mica and light feathers interweave; delicate mesh encircles cloudy marble; and, glass beads stay in transparent capsules.

In this work, imagination bursts out of daily life. All the materials not only produce shapes, but also precipitate different kinds of dispositions that echo with spiritual essence. Some materials are simple, while others indicate the vicissitudes of life; some exhibit the happy moments in life, while others are so heavy and helpless. White is the most solemn color. But with imagination, it bursts out with an amazing glow.

李博超
Li Bochao

(中国 China)

彩虹的碎片	**Fragments of Rainbow**
纸浆、大漆、亚麻、金属、水彩	paper pulp, lacquer, linen, metal, watercolor
	135cm × 110cm

大漆和纸的结合并不是全新的尝试，在漆器制胎上，常见纸胎。大漆的打磨、髹涂通常是建立在坚硬内核基础上的，然而，艺术家在探索中选择了柔软的纸张，使得漆失去了打磨的基础。作品通过手工纸丰富的纹理，结合漆色的变化，呈现出更多细节。画面中没有太多具体的内容，像是随手的生活记录。作品中的水彩纸是其他作品的"边角料"，在画面中一跃成为"主角"的一抹亮色。画面右上角有几个模糊的儿童图像，和"边角料"一样是碎片化的生活片段。作品中粗糙的片状物体是壮族手工纱纸，运用"浇纸法"制作而成，艺术家在造纸过程中特意没有把纸浆搅拌均匀，使得成团的纸浆在干燥后呈现更明显的肌理感。作品中纸张所呈现的褐色和黑色是大漆的色彩，通过调整漆液的浓度在纱纸上染出层次变化，效果类似宣纸上的墨色变化。

The combination of lacquer and paper is not a new attempt. Paper is common in lacquer making. The polishing and painting of large slices of lacquer is usually accomplished using hard paper. However, the artist chose soft paper in his exploration, which made the paint lose its polished foundation. The work presents the rich texture of handmade paper and the nuances of lacquer color. With less concreteness in content, the work looks like a casual daily record. The collage of watercolor paper, often used as a minor addition in other works, becomes here an enlivening protagonist. The faint portrayal of several children in the upper right corner represents a montage of our daily life. The large slice of *Zhuang* yarn paper in the work has a coarse texture (made in a hand-made process of 'pulp-pouring'). The artist deliberately did not stir the pulp evenly in the process of paper-making, so that the clustered pulp would present a more obvious texture after drying. The brown and black of the diversely concentrated lacquer on the paper offers a gradation of light and shade in a Chinese art paper style.

李海斌
Li Haibin

（中国 China）

共·生	Symbiosis
树枝、螺丝	tree branches, screws
200cm × 110cm × 175cm	

新冠肺炎疫情暴发引发了生命、自然、社会、经济之间的连锁反应，人们深刻体会到了其中"一荣俱荣，一损俱损"的连接与共生关系。作者将抽象的"连接"关系提炼并具象化，选用树枝与螺丝作为主要材料，在造型上顺应树枝生长与延展的脉络，将不同方向生长的枝头"连接"在一起，形成一个闭环。其中，连接方式选用了现代工业的产物"螺钉"、植物繁殖技术"嫁接"与传统工艺"榫卯"，多样的连接方式并置使用，用以表达事物之间多样复杂的连接关系。作者通过对连接的解构创造了一种新的艺术语境，试图打破单一、孤立的认知习惯，启发观者以"连接"作为我们认知世界的视角，来思考人与物、自然物与人造物以及人与社会之间相互依存和谐共生的关系。

The outbreak of COVID-19 triggered a chain reaction between life, nature, society and the economy. People have deeply realized the connection and symbiotic relationship that we have, because we all share prosperity and losses, along with all other people on this earth. In this work, the artist ponders and visualizes the abstract relationship between branches and screws. The shape of this work conforms to the veins of branches that grow and extend. The ends of all branches, in different directions of growth, are connected together by screws, which are industrial products. This was inspired by the plant propagation technology called "grafting", and the traditional technique of "tenon and mortise". The various means of connection are juxtaposed to express the complexity of connections between things and events. By deconstructing "connection", the artist suggests a new artistic context, in which single and isolated cognitive habits are broken. The audience is inspired to use "connection" as the perspective of recognizing the world. From this perspective, mutual reliance and harmonious coexistence between humans and objects, natural objects and man-made objects, as well as humans and society, are to be considered.

李浩宇
Li Haoyu

(中国 China)

铭记·痕	Remember the Imprint
白坯布、麻布、铁丝、金线、化学试剂等	white cloth, linen, iron wire, gold wire, chemical reagent, etc.

215cm × 75cm × 60cm, 220cm × 92cm × 13cm

《铭记·痕》是以化学和艺术两种学科为知识背景创作的综合材料作品,一件作品可以看作是综合材料的绘画作品,另一件作品则是"软雕塑"作品。在这些作品之中,枪支都是重复出现的造型元素,它们是以白坯布和化学试剂制作而成。变异的造型、重叠的状态,加之"锈蚀"的着色,造就出的是战场上损毁或遗弃的武器,隐喻着战争这一人类永恒的主题。在人类文明之中,战争从未真正消失,它如同幽灵一般时刻萦绕在文明的周遭。

Remember the Imprint is a work of mixed media based on the subjects of chemistry and art. One part of the work can be regarded as a painting, while the other part can be "a soft sculpture". Guns are a recurring design element in these works, and are made of white cloth and chemical reagents. The works, made to have an abandoned and damaged character, are meant to evoke battlefield scenarios through their aberrant design, overlapping elements, and rusted coloring. War, the eternal theme of humanity, thus becomes the motif of this metaphoric work. Wars never disappear, but haunt civilizations like undying ghosts.

李鹤
Li He

（中国 China）

肉身·呼吸	**Flesh-Breath**
彩色线缆	colored cable
	100cm × 28cm × 26cm

这件作品来自艺术家的"身体·呼吸"系列作品，从精细的竹丝编织到彩色线缆编织，作品的材料发生了明显的变化。与之相应的，这些"肉身"的姿态也发生了变化：竹丝身体多是趴卧，而线缆身体则是

仰卧，且有一种抬头起身的动势。以竹丝为材料的身体是放松的，亲近自然的，趴卧在大地上，吸收万物营养，呼吸天地精华；以电缆为材料的身体则从属于现代的、工业的、消费的社会，在忙碌的世界，呼吸着欲望横飞的空气，或许有那么一个短暂闲暇，但仍要挣扎起身"战斗"。无论是竹丝，还是电缆，肉身都是抽象的、概括的，代表着平凡的个体、芸芸的众生。只不过，在材料与姿态的变化间，引发着对肉身与灵魂、生命与自然、个体与社会的思考。艺术家用手工编织的方式让思考的时间在指尖缓慢地流淌，让编织的节奏与韵律布满身体，这何尝不是一场呼吸与冥想之旅呢？

This work comes from the artist's *The Body · Breath* series of works. From fine bamboo silk weaving to color cable weaving, the series presents human-like sculptures in two very different mediums. The character of these "flesh bodies" depends on the materials used: most of the bamboo silk bodies suggest relaxation, while the cable bodies suggest stiffness and agitation. The body made of bamboo silk has a relaxed, almost natural state. It lies on the ground, absorbing nutrients from all things, and breathing the essence of the sky and the earth. The body made of cable is subordinate to our modern, industrial and consumer society. In this busy world, breathing the air of desire may allow for transient leisure, but people still have to struggle for survival. Whether it is made of bamboo silk or cable, the body is abstract and general. It symbolizes ordinary individuals and all living beings. However, between the changes in materials and posture, there is a reflection on the relationship between the body and the soul, life and nature, as well as individuals versus society. The artist uses hand weaving to let the time for thinking flow slowly at the fingertips, and to let the rhythm of weaving control the body. Isn't this a journey of breathing and meditation?

李洪波
Li Hongbo

（中国 China）

自然系列—木头	Nature Series - Wood
纸	paper
30cm × 300cm × 9	

树，自然界的物种之一。不同的地域和生长环境造就了树木不甚相同的性格及样貌，不论是松柏的挺拔，抑或是垂柳的婀娜，世人皆熟识且视为常态。人们在自然中繁衍生息，便把自己的情感注入对山石、花草、树木的解读中，而树木特有的灵性则常常令世人以情寄之。作品中的"木头"是由纸质材料制成，表面看似惯常的"木头"却是由纸一张张粘连而成，通过拉抻、扭转改变了其固有的外形，抛却了其硬邦邦的质感，在其原有的坚韧挺拔之中融入了更多的轻柔多姿。艺术家将木头的外形以延展的纸张来表现，将两个熟悉的事物构成陌生化的悖论组合，是树生成了纸，还是纸生成了树？在张弛、回转间，有情世界的多变和无常也悄然体现。

Trees have many species in nature. Different regions and habitats create different characters and appearances of trees. People are familiar with trees. So, people deem trees to be common, be they tall or straight, pines or cypresses, or gracefully weeping willows. People prosper in nature, and they are inspired by rocks, flowers and trees. The unique spirituality of trees often summons people's deep sentiments. The "wood" in the work is made of paper, while the seemingly unconventional "wood" on the surface is made of paper sheets. Through stretching and twisting, it changes its inherent shape, discards its hard texture, and integrates more gentle features into its original stoicism. The artist represents the shape of wood with extended paper, and combines two familiar things into a strange paradoxical combination. Do trees generate paper, or does paper generate trees? The vicissitude and impermanence of the world of sensibility is also quietly reflected between the loose and the tight.

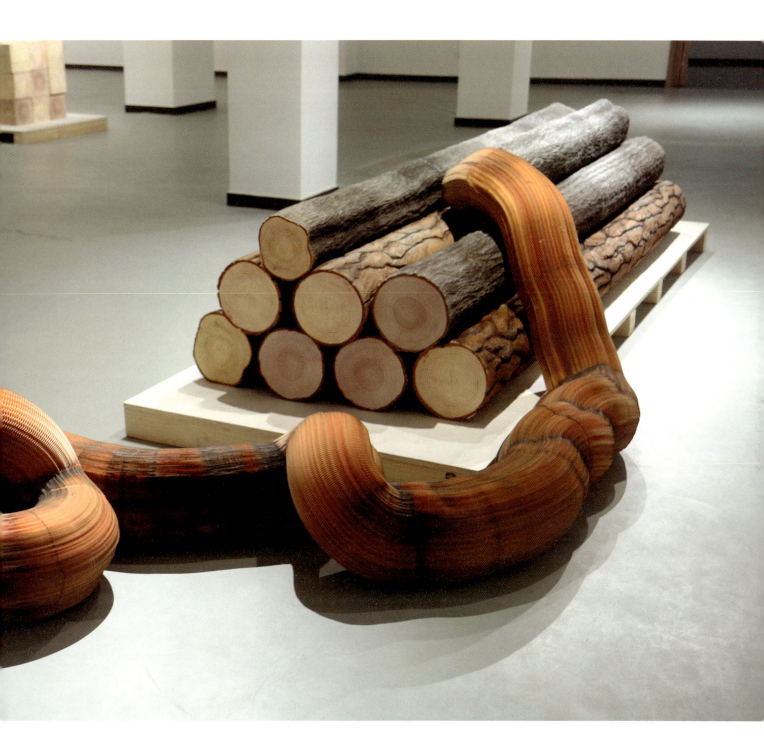

李嘉鑫
Li Jiaxin

（中国 China）

桃花源·造园系列	Peach Blossom Spring –Making Garden Series
木头、不锈钢、灯光装置	wood, stainless steel, light installations
尺寸可变（size variable）	

作品以著名的典故《桃花源记》为线索展开，结合中国传统绘画中的造型语言及笔墨手法，转化为综合材料，解构传统绘画，以景观装置再现"桃源"。作品中诸多元素皆源于传统绘画中的景观局部，通过人造灯光的介入与传统景观元素的解构、并置完成当下表达。灯光装置通过不同强弱亮度和色彩的光线变化，为观看氛围的营造提供了新的可能性。这些光线犹如三维空间中的运笔、赋色与皴擦，光影交错之间笔丰墨健，光怪陆离恰似叠层晕染。

The work is based on clues from the famous literary story *The Peach Blossom Spring*, and was created using the design language and painting techniques of traditional Chinese painting. The work deconstructs the traditional forms of painting in mixed media, in which the *Peach Blossom Spring* recurs in the form of landscape installation. Many elements in the work represent parts of the landscape in the style of traditional Chinese painting. The positioning of artificial lights in this work visually deconstructs and juxtaposes traditional landscape elements, bringing the viewer into the present moment. The lighting devices provide new possibilities for the viewing atmosphere through the changing intensity and color. The lights are like 3D brush strokes for coloring and texturing in three-dimensional space. In the interface of lights and shadows, a vigorously treated painting with abundant content and blooming effects seems to be unfolded before the audience.

李静
Li Jing

（中国 China）

钻·石	**Diamond-Stone**
吹制及热塑玻璃、人造钻石、不锈钢	blown and thermoplastic glass, synthetic diamonds, stainless steel
40cm×100cm×100cm	

《钻·石》是以玻璃、人造钻石和不锈钢等现代材质创作完成的作品。在造型上，该作品选取了中国园林景观的假山石这种与传统文人美学紧密联系的文化符号。通过材料的置换，作品以透明的现代材料取代了传统假山石的石质材料。从语言学到符号学，该作品在"所指"和"能指"的对应关系上制造了一种分离，从而解构了假山石这一中国传统文化符号。因为这样的艺术方法，完成后的作品在传统文化和当代文化之间制造出了某种文化的张力，既熟悉又陌生，以其矛盾性和模糊性引发人们的思考。

Diamond-Stone is a work completed with modern materials such as glass, artificial diamonds, and stainless steel. In terms of shape, the work suggests the rock formations of Chinese landscapes, a cultural symbol closely associated with traditional literati aesthetics. Through material substitution, the work replaces the stone material of regular rocks with transparent modern material. From linguistics to semiotics, the work creates a separation in the correspondence between "signified" and "signifier", thus deconstructing the traditional Chinese cultural symbol of rock formations. Because of this artistic method, the completed work creates a certain cultural tension between traditional and contemporary culture, which is both familiar and unfamiliar, and provokes people to think through its contradiction and ambiguity.

李薇
Li Wei

（中国 China）

大漠孤烟	Solitary Smoke in the Desert
绡、水纱	raw silk，water yarn
	140cm × 1200cm

作品名称取自唐代诗人王维的诗句"大漠孤烟直，长河落日圆。"诗句描绘了边陲大漠中壮阔雄奇的景象，也传递了诗人豁达、孤寂、雄壮的心境。作品运用传统植物染色，提取茶果壳等植物汁液，对绡、

水纱进行渐变色晕染，将真丝与植物染色以染绘的形式融为一体，表现了漫漫丝路上辽阔空旷的意境。作品整体呈现出沙黄色调，用丝纱的延展与堆叠营造出绵延起伏的大漠景象，纱的飘逸与虚透让风起沙扬之景扑面而来，虚实之中将辽远阔大、风起沙涌的景象表现得淋漓尽致。同时，以天然之材（蚕丝）、植物之色、手工之艺表现自然之美，也体现了艺术家生态环保、和合共生的创作理念。

The title of the work is taken from a poem by Wang Wei, a poet of the Tang Dynasty: "In the boundless desert lonely smokes rises straight; Over endless river the sun sinks round." The poem describes the magnificence of the desert, and the poet's open-minded, lonely, but ambitious sentiment is conveyed. The work uses traditional plant dyeing from tea and fruit shells, which gradually shades the silk and water yarn. By integrating silk and plant dyeing, the vast and empty artistic conception of the long silk road is presented. The whole work presents as a sandy yellow tone to create a continuous and undulating desert scenario, through the extension and stacking of silk yarn. The elegant and transparent yarn vividly recalls the vast and distant scene where wind and sand blow to your face. Meanwhile, the beauty of nature is expressed by natural materials (silk), plant colors, and handicrafts. By these methods, the artist's creative concepts of ecological protection and harmonious coexistence are expressed.

莉莉安娜·罗斯柴尔德
Liliana Rothschild

(阿根廷 Argentina)

地球母亲的声音	Mother Earth's Voice
有机纤维、印刷油墨、颜料、线	organic fiber, printing ink, paint, thread

<div align="center">130cm × 60cm</div>

在艺术家看来,她用于创作的材料——有机纤维是作品的灵魂。在多年的实验和研究中,她发现丝瓜的果实在干燥后所形成的纤维是一种非常有韧性的材料,给了艺术家表达自我的诸多可能,包括与其他材料和工艺的结合。在这件作品中,作者采用了木刻的冲压工艺,先在木质基底上做切口,然后压印在丝瓜纤维上,让人联想起古老的南美陶工在黏土上做切口的场景。作者对有机材料的兴趣便源于它与自然、与大地的关系,并希望通过基于这种天然材料的创作来感受自然界的节奏,感受与之密切相连的南美洲土著文化。因而,这件作品既是"地球母亲的声音",也是"祖先的歌"。一块块独立的方格代表着完全隔离期间的区域,上面的图像暗示了一种充满活力的自然,浮现出思想、色彩和辉煌。穿插其中的丝线和纤维组件将这些"隔离"区域连接起来,将植被从一个表面引向另一个表面,在空间中持续地生长、绵延,带来了希望、机遇和交流。

From the artist's perspective, the material she uses in her creation—organic fibers—is the soul of the work. Through years of experimentation and research, she has found that the fiber formed by Luffa fruit after drying is a very ductile material, providing the artist with many possibilities for self-expression, which includes combination with other materials and techniques. In this work, the woodcut stamping technique is adopted, first making incisions on the wooden base, and then embossing on the loofah fibers, which is reminiscent of the scene of ancient South American potters making incisions in clay. The author's interest in organic materials stems from her relationship with nature and the earth, and she hopes to feel the rhythm of nature and the closely related South American indigenous culture through creations based on this natural material. Thus, this work is both "Mother Earth's Voice" and "Ancestors' Song". Separate squares represent totally isolated areas, and the image on the surface suggests a vibrant nature with ideas, colors and splendor emerging. Interspersed silk and fibrous assemblies link these "isolated" areas, leading vegetation to break the boundaries, helping them continuously grow and extend from one place to another, and bringing hope, opportunity and exchange.

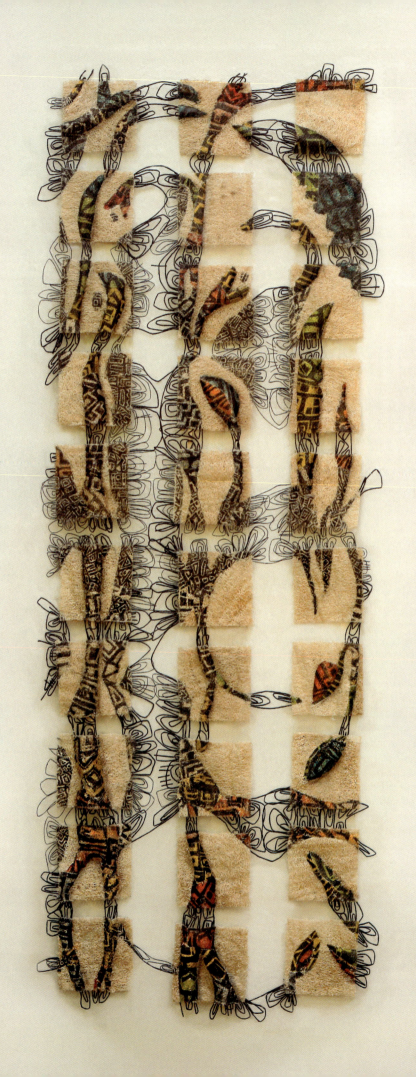

利利特·斯捷潘尼亚
Lilit Stepanyan

（亚美尼亚 Armenia）

但是	BUT
草、土、纸板	grass, land, cardboard
90cm×150cm	

《但是》意味着否认、打破、改变、反对、驳回、限定、让路等。它的意指可以起到关键甚至决定性的作用。在这个装置中，女人与自然界中的非线性结构、有机过程和连接的直觉和感觉相互作用。《但是》打破了完全的解放，妇女被解放了，但一系列的压迫是多重的，父权制仍然存在，自然被解放了，但只是很小的程度。自然界被破坏了，但这些小芽的残余物抵消了环境的灾难性影响，它们是顽强的，能够战斗。它们需要人类的小小干预，它们将继续给予生命、繁衍和传播。作品中使用的植物从出生的那一刻起就需要不断地照顾，并被人类的干预所拯救。艺术家通过使用植物作为艺术媒介来创造当代艺术对象，来突出它们所具有的多重意义表达的潜力。

BUT means to deny, break, change, oppose, reject, restrict, give way, etc... Its denotations can play a crucial or even decisive role, for example, in terms of the value comparison between happiness, success, revolution, time, etc.. For the artist, women interact with the intuition and feeling of non-linear structures, organic processes and connections in nature. In this installation, *BUT* breaks the misconception of total liberation. Women were liberated, but there were multiple series of oppression, and patriarchy remained. Women were only liberated to a small degree. The set natural world is destroyed, but the remnants of these little sprouts alleviate the catastrophic effects on the environment. And in this sense, these sprouts are tenacious and warrior-like. They need intervention from us even though we are insignificant, and they will continue to give life, reproduce and spread. The plants used in the work require constant care from the moment of birth, which is also human intervention. The artist highlights their potential for multiple expressions of meaning by using plants as an artistic medium to create contemporary art objects.

林岗
Lin Gang

（中国 China）

仁者乐山	**Benevolent As Mountains**
金属	metal
270cm × 150cm × 380cm	

艺术家的《仁者乐山》系列作品以"山"为主题，用不锈钢片代替竹篾，编织了心中的山石形象。山水，是中国艺术的核心母题之一，它代表着古今中国文人的精神追求：仁者乐山，智者乐水。艺术家以太湖石为表现形象，因其来自江南，太湖石既象征着山，也连接着水，凝聚着文人的山水趣味。金属片编织而成的太湖石在阳光下波光粼粼，如同江南湖面上不断绽放的涟漪。艺术家用工业材料编织了传统文人的梦，展现了一种传统与现代相结合的刚柔并济的品格，每一片编织仿佛折射着过去又揭示着未来。

This series uses *Benevolent As Mountains* as the title and theme. The artist uses stainless steel sheets (in place of bamboo strip) to weave his concept of mountains and rocks. Landscape is one of the core motifs in Chinese art. It represents the spiritual pursuit of ancient and modern Chinese literati: benevolent as mountains, wise as water. The artist uses a Taihu stone as a model image because he comes from the regions south of the Yangtze River. Taihu stones not only symbolize mountains, but also bare a connection with water. The stones reflect the landscape tastes of literati. The Taihu stone, woven from metal sheets, sparkles in the sun, like the ripples on the river. The artist weaves the dream of traditional literati with industrial materials to create a combination of hardness and softness, and of tradition and modernity. Each piece of the work seems to reflect the past and reveal the future.

林乐成、李广忠、赵嘉波
Lin Lecheng，Li Guangzhong，Zhao Jiabo

（中国 China）

竹之光	The Light of Bamboo
竹、金属、LED	bamboo, metal, LED
420cm × 1100cm	

浙西龙游是中国著名的竹之乡。漫山遍野的高大毛竹，傲然挺拔，生机盎然。创作团队因乡村振兴战略项目走进这片竹之乡，在山间行走、采风，从自然中撷取创作灵感。风起云涌，竹林如波浪般起伏，于是作者以自然中的波纹起伏之形赋予竹媒材，经过历时一年的竹炭化与竹成型的工艺探索，形成了这一个个如云朵般漂浮、如浪花般涌动的竹灯装置。起初，这些装置是龙游"取之于斯、用之于斯"的在地艺术装置，后来，它们逐渐出现在城市中的商业空间与展示空间中，成为摩登都市中的一抹自然之光。

Longyou, in western Zhejiang, is a famous bamboo town in China. The tall bamboo trees stand proudly upright, and full of vitality, all over the mountains. The creation team came to this bamboo town as part of a project for the national strategy of rural revitalization. The team members walked in the mountains and collected inspiration from nature. The wind and the clouds rose, and the bamboo forest fluctuated like waves. With these inspirations in mind, the artists adopted bamboo as the medium, and carved it in the form of natural waves. After one year's exploration of bamboo carbonizing and bamboo molding technology, the bamboo lamp installations have been completed. They float like clouds and fluctuate like waves. These installations have been displayed as local art installations in Longyou, in commercial spaces, and in exhibition spaces within modern cities to inspire "natural" scenery.

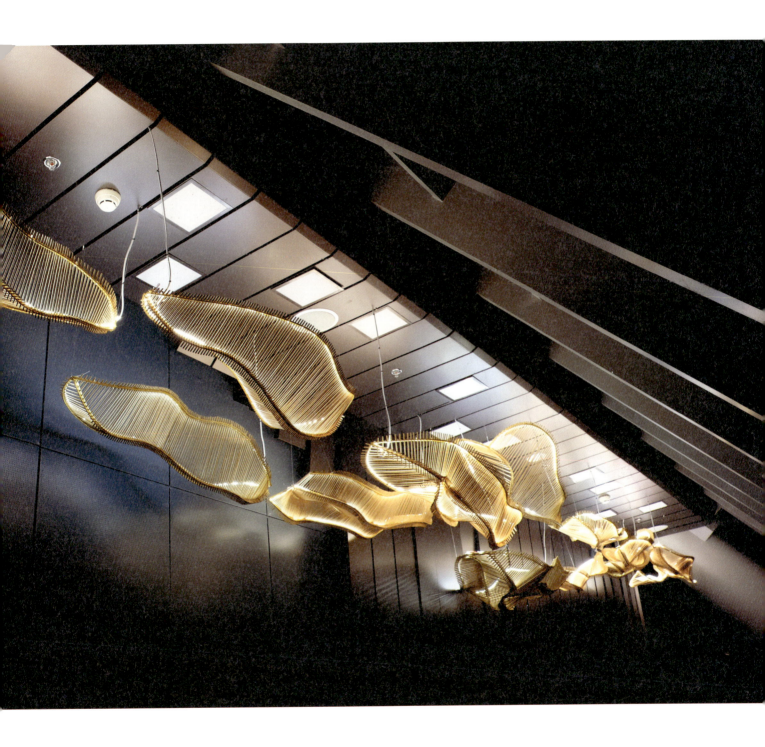

刘烽
Liu Feng

（中国 China）

乌夜啼、虞美人	**Crows Cry At Night, The Fair Lady Yu**
宣纸、墨水、电机、不锈钢等	*Xuan* paper, ink, motor, stainless steel, etc.
	500cm × 300cm × 230cm

《乌夜啼、虞美人》是以宣纸为材料创作的声光电结合的装置作品。这些作品以宣纸为造型，以光影的投射进行二次造型，加之以声响效果，综合调用了人的多种感官。就方法而论，该作品非常类似于"手影"的表演形式。这件作品之中共有两个造型物：前者是"造型之物"，后者是"投影之物"。它们二者既相互关联又产生差异，并因这种反差对比激发人们的兴趣。值得注意的是，宣纸与墨是所有材料之中最具文化属性的材料，指向中国传统的水墨艺术。虽无书写渲染，但"黑—白""虚—实"的辩证哲学却是中国传统智慧的无形体现。

Crows Cry At Night, *The Fair Lady Yu* is an installation work made of Chinese art paper, which integrates sound and light. The design of the paper is redesigned in the form of shadows created by the projection of light, along with additional sound effects. Therefore, the senses of the audience can be integrally motivated. The creation is methodologically similar to the performance of hand shadow puppetry. The designed object and its projected shadow present the same object in two different forms: simultaneously related and different from each other. This contrast can arouse the interest of the audience. Noticeably, Chinese art paper and ink (*Mo*) are materials with abundant cultural attributes, because they refer to traditional Chinese ink art. Although they are not subject to traditional artistic practice in this work, the dialectical ideas of "black-white" and "virtual-real" from these materials are an intangible demonstration of traditional Chinese wisdom.

卢德维卡·奥戈泽莱茨
Ludwika Ogorzelec

（波兰 Poland）

"空间结晶"系列之"爆炸Ⅱ"	"Explosion Ⅱ" from "Space Crystallization" series
玻璃、钢丝	glass, steel wire
特定地点的雕塑，尺寸可变（site specific sculpture, size variable）	

人们惯常认识中的雕塑，往往是厚重的、坚实的、浑然一体的。而艺术家却舍弃了厚重与坚实，选择了轻盈与透明；舍弃了块面和体积，选择了线条和空间。她将大量的玻璃碎片与钢线组合，搭建起一个动态的场景，在其中，一个类似玻璃立方体的复杂结构正在解体，或重生。无数细碎的玻璃碎块相互穿插，光线在其中往复穿梭，观者的思绪也随之闪烁。钢铁成为结构的支撑，同时也与透明空灵的玻璃对照，形成一种审美上的冲突感。这件特定场景的作品试图刺透文化上的刻板印象，引发普通的人类情感共鸣。它邀请观者进入、穿越艺术家创造的新空间，使得思维从繁琐的世俗生存中解脱而进入短暂的顿悟。艺术家将她的雕塑视为一种源自不断运动的生命与机械世界的转瞬即逝，在精神与物质、意义与荒谬之间寻求微妙的平衡。

In people's common perceptions, sculptures are thick, solid and integrated. To challenge this perception, the artist gives up "compactness" and she welcomes lightness and transparency. The abandonment of block face and volume, the inheritance of line and space, and the combination of numerous glass fragments and steel wires jointly build a dynamic scene. In this scene, a complex structure similar to a glass cube is disintegrating or regenerating. Numerous tiny pieces of glass are interspersed with each other. And the light shuttles back and forth among them, as the audience's thoughts flicker. The steel becomes the support of the structure. Meanwhile, the steel contrasts the transparent and ethereal glass to form an aesthetic atmosphere of conflict. This work of specific scenes tries to break the cultural stereotypes and arouse the resonance of universal human emotions. It invites the audience to enter and pass through the new space created by the artist, to free their minds from tedious secular existence, and to enter into a brief moment of enlightenment. The artist regards her sculpture as a transient shift from the moving life and mechanical world, and seeks a delicate balance between spirit and material, meaning and absurdity.

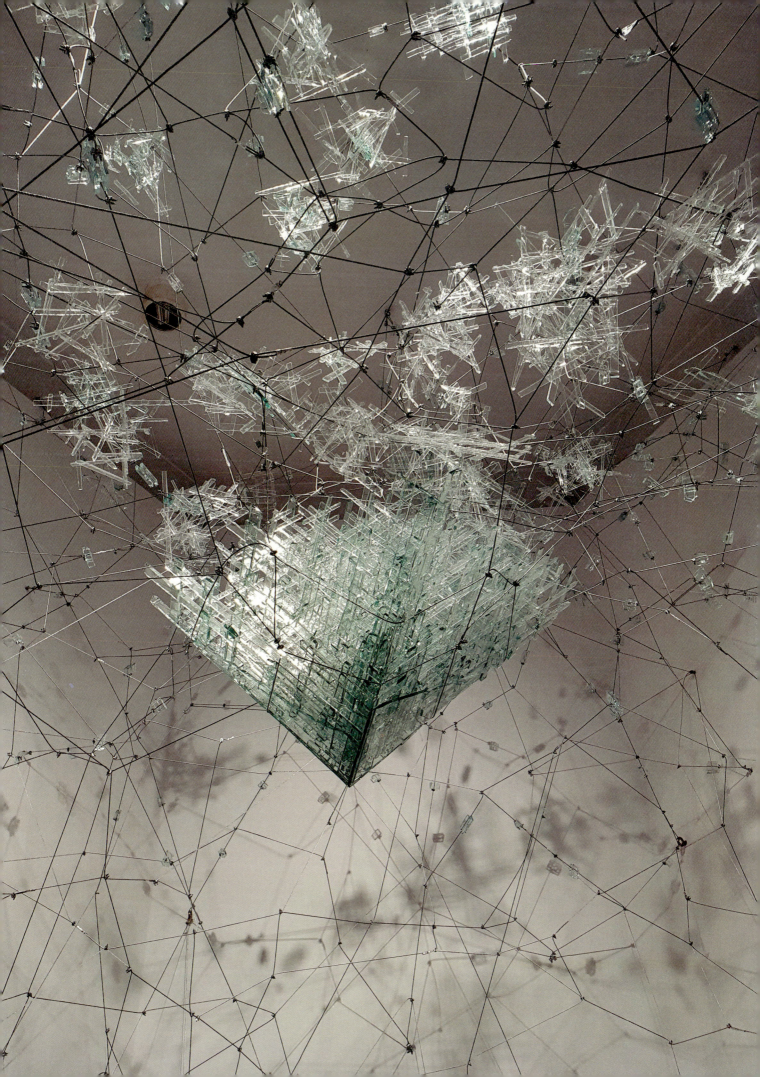

卢德维卡·齐特凯维奇 – 奥斯特罗斯卡
Ludwika Zytkiewicz-Ostrowska

（波兰 Poland）

记忆	**Memories**
丝球	silk balls
装置尺寸可变（size variable installation）	

在《记忆》系列中，艺术家利用丝绸缠绕出了数十个小球，并组建为一个整体的空间装置。每个小球都是一个可移动的模块，艺术家按照一定的方向、质量和动态关系来组织它们，产生一种关于运动和动态系统的印象。多变的丝绸纹理则鼓励观者进行触摸。观者被活动的浮雕结构所包围，"被迫"与这些材料和物体产生生理上的亲密关系。艺术家利用这些装置创造出一种模糊而杂糅的感受体验，其中概念运用、视觉效果和空间安排是艺术家对"完美表现"的探索成果。她实际上在邀请观者（在这一意义层面更多的是"接受者"）与她一同漫步，在视觉与现实、思考和观看之间漫步。

The artist pieced together this installation in space with over 80 silk-wrapped small balls. The movable balls are organized following specific directional, mass, and dynamic patterns. The formed relationship between the balls therefore presents a system of motion and dynamics. Moreover, the changing texture of silk attracts the viewers to touch them, while these movable reliefs "force" the viewers to generate a physical intimacy with these modules. The artist uses the installation to create an ambiguous and hybrid experience, in which concepts, visual effects and spatial arrangements are the result of the artist's exploration of "perfect representation". She is actually inviting the "recipients" to roam with her, between visions and realities, thinking and seeing.

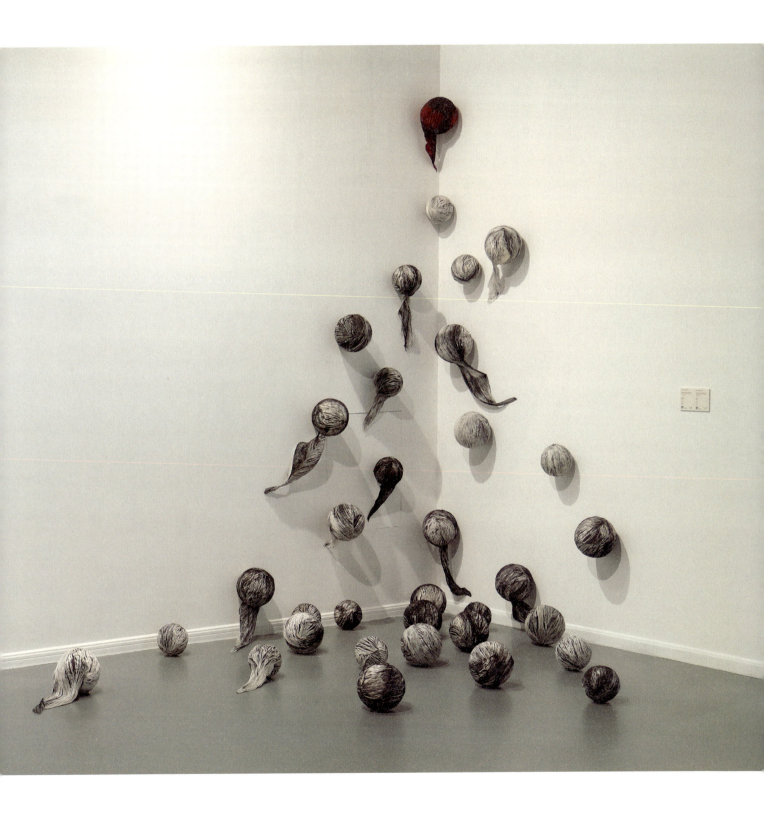

罗幻
Luo Huan

（中国 China）

神农计划系列	***Shennong* Project Series**
现成品、木	ready-made objects, wood
60cm×86cm×50cm，90cm×110cm×98cm	

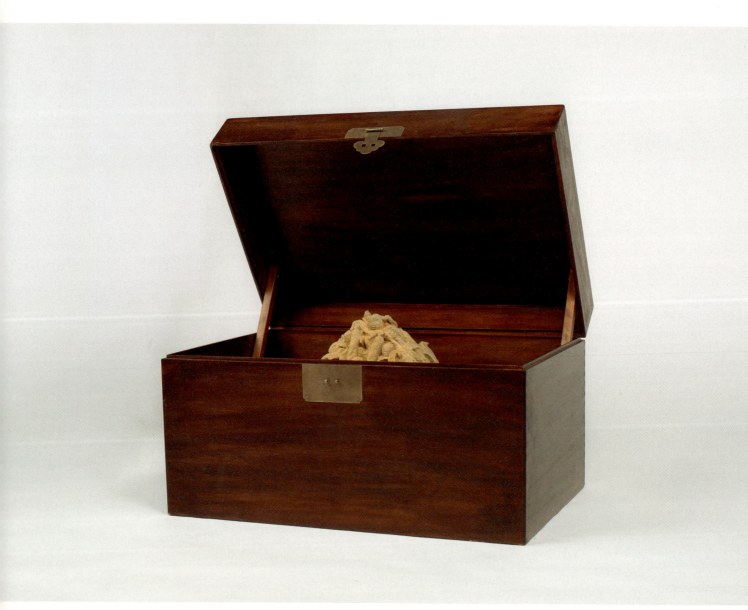

《神农计划》系列是以樟木为材料创作完成的雕塑作品。该作品将一年四季和中国传统的阴阳哲学相对应，并以中国传统药材的"气味"为灵感，为作品增加新的感官维度。在现场展出时，因为所用材料为樟木，作品具有的浓郁天然气味，使得整个作品成为视觉、触觉、味觉、时间性为一体的场域系统，给观者以全方位的直接感受。除此之外，该作品也希望发挥"药"一般的功效，突破时空与感官的同时，触及人的内在，并以此探讨艺术、身体和心灵的疗愈联系。

Shennong Plan is a sculpture made of camphor wood. The work is inspired by the "smell" of traditional Chinese medicinal herbs and correlates to the four seasons of the year and the ancient Chinese concept of *yin and yang*. Because of the camphor wood, the works have a strong natural odor when shown on site, making the entire work a field system of visual, tactile, gustatory, and temporal, giving the viewer an overall intuitive experience. Furthermore, the work intends to have a "medicinal" impact, breaking through time, space, and the senses, while reaching the inner world of the human being, and therefore, exploring the healing relationship between art, body, and mind.

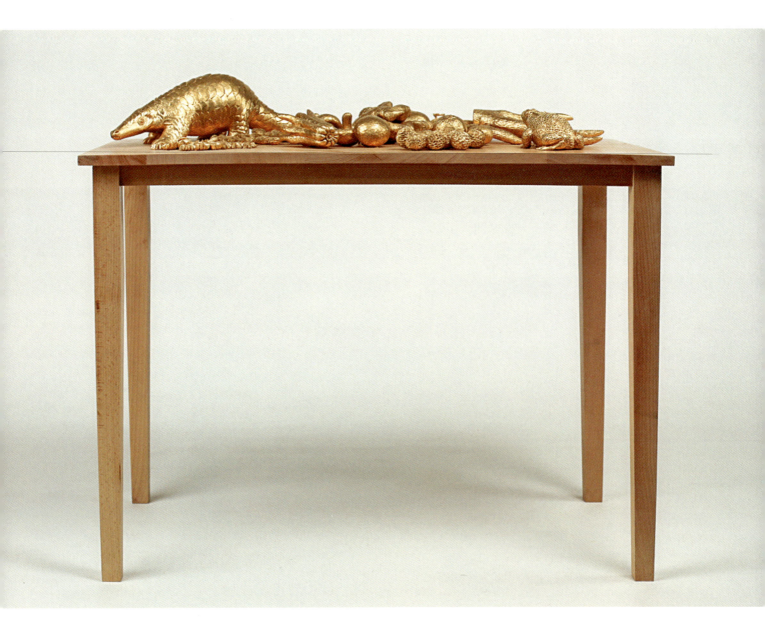

吕晶
Lyu Jing

（中国 China）

可购买的幻想	The Buyable Fantasy
短袖T恤、土、布料、快递包装、衣架、视频	t-shirt, soil, fabric, express package, hanger, video
尺寸可变（size variable）	

安妮·伦纳德在批判消费主义时曾说过:"没有所谓的'离开',当你把某样东西扔掉或退掉的时候,它仍终将有个去处。"快速而不间断的时尚消费导致了大量的"退换",以追求绝对的自我满足,但是这种满足感只是暂时的。消费主义所承诺的绝对幸福是一个谎言,一个空虚的自我,一个永无止境的追求,一个可供购买的幻想。艺术家使用了大量废弃的快递包装,它们是时代的体验者和观察者,见证了网上快速时尚和邮政系统之间的交织,以及我们的每一个选择和产品的目的地。当这些庞杂的消费信息充斥着我们的周遭,投射到被人们或选择或退还的衣物上时,关于消费的虚妄则被昭示。

In Annie Leonard's criticism of consumerism, there is no such thing that can 'disappear'. When you throw something away or return it, it still needs to go somewhere. The rapid and uninterrupted fashion consumption has led to a large number of "returns" to pursue absolute self-satisfaction, but this satisfaction is only temporary. The absolute happiness promised by consumerism is a lie for an empty self; it is an endless pursuit, and a purchasable illusion. The artist uses numerous used express packages. These packages have experienced and observed the times, witnessing the interweaving between online fast fashion and the postal system; they have traveled to each destination of our choice to deliver us our products. When the multitudinous and miscellaneous information about consumption fills each inch of our surroundings in the form of clothes to be discarded or chosen, the illusion of consumerism is revealed.

吕越
Lyu Yue

（中国 China）

女红	Red Woman
丝绸、玫瑰花、玻璃钢	silk, roses, fiberglass
尺寸可变（size variable）	

艺术家借用女红的"红"（gong）字的另一个读音红（hong）作为作品的视觉基调，以丝绸材质、做工讲究的紧身胸衣作为作品的主体，描绘女性的柔弱与坚强。女红在中国原指女人的手工活，借助多音字，作者不仅将外沿延伸到颜色，还暗指女性本身。作品通过复杂的剪裁和做工制成有硬度的胸衣，用来塑造女人的身体；以高胸细腰曲线以及扁平直线的不同造型，呈现女性形象内在的多元性。整个系列作品由900朵玫瑰组成，与红色的胸衣相得益彰，在为期20天的展览中，记录花朵含苞、开放、干枯的过程，引发如何看待逝去的过往以及昨日辉煌的思考。

The Chinese word *nugong/nuhong* refers to traditional women's work, especially needlework. The artist utilizes the rhyming of the Chinese words *"gong/hong"* (work/red) to play on the relationship of the content and color in this work. Silky corsets of fine handwork serve as the core of this piece, to represent the tenderness and strength of femininity. Complicated tailoring and craftsmanship are incorporated into both the symbolization of women and the formal expression of women's bodies. From the S shape to the flat curve, the diversity of feminine figures is represented within the design. A total of 900 roses are used in this series, and they echo femininity harmoniously along with the corsets. During the 20 days of the exhibition, the roses were recorded in bud-form, in bloom, and in decay, provoking our reflection of the past and its glory.

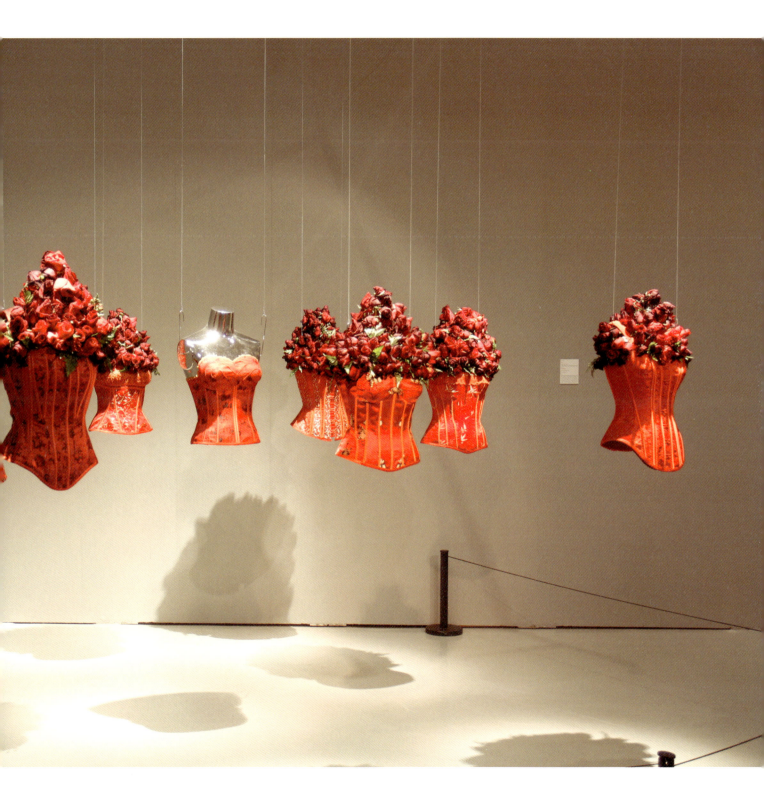

马泉
Ma Quan

（中国 China）

瓷沙编码	The Code of Porcelain and Sand
瓷泥、沙	porcelain clay, sand

200cm × 200cm × 20cm

源于对沙漠的兴趣和探索，艺术家十年来不断以"日志"，记录沙漠，丈量自己。相较于传统的文字写作，他以手稿、绘画、视频影像、声音艺术丰富着他的"日志"。作为沙漠主题多媒介叙事的一部分，作品《瓷沙编码》用沙子烧制而成的数百个瓷片，每一个瓷片的表层印有编号，形状相同但色彩却显现出一些微细的差异变化。有意思的是，无论把它们以何种形式展现出来都不失为一种秩序。每一个瓷片表层上的色彩差异就像每一颗沙粒表层上的凹凸不平，作者以一种特别的方式把它们之间的差异再现出来，但却去除了任何物的实用目的和视觉愉悦。这里，物的无意义的指涉再一次把观者们带出了思考的惯性和事物固有定义的边界。

The artist, a passionate explorer of the desert, has been keeping a "journal" over the last ten years to record and measure various experiences he has had in the desert. He chose a unique way to record his information, as opposed to using the form of traditional writing. The artist uses manuscripts, paintings, video images, and sound art to record his "journal". As part of a multi-media narrative, the desert themed *The Code of Porcelain and Sand* was made with hundreds of pieces of porcelain. The porcelain was made of sand, with the surface of each piece engraved with codes, all with the same shape, but slightly different in color. The difference in color on the surface of each porcelain tile represents the unevenness on the surface of each piece of sand. The artist displays the difference between them in a unique way. There is order in the presentation of the tiles, and even though the colors vary, we never lose the orderly appearance. The artist hopes to bring all people out of the habitual direction of "thinking" and to break the boundaries of the inherent definition of things.

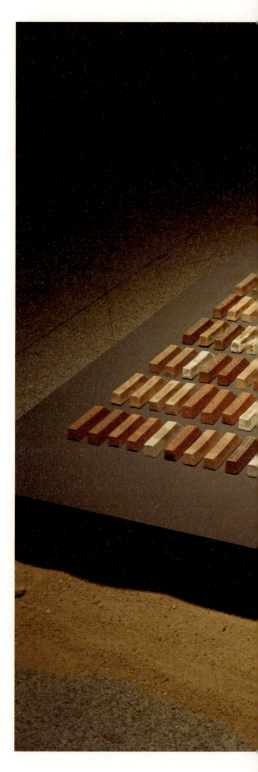

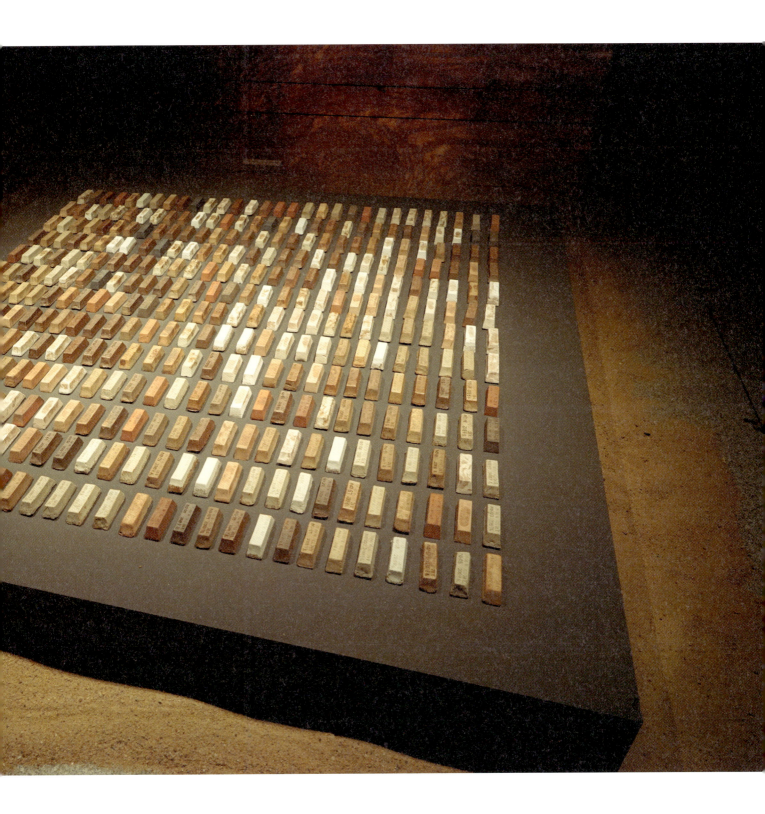

马世昌
Ma Sai Cheong

(澳大利亚 Australia)

土归土	Earth to Earth
白瓷、红砖	white porcelain, red tiles
50cm×45cm×200cm	

这是一组半抽象白瓷坐在红色土砖上排列而成的装置。白瓷简单卷折成人形坐衣，弯曲婉转犹如德化白瓷观音的衣纹，衣纹崩裂又颇有西方古典雕塑风韵。艺术家通过这样的方式，借坐像人衣的自然形态去

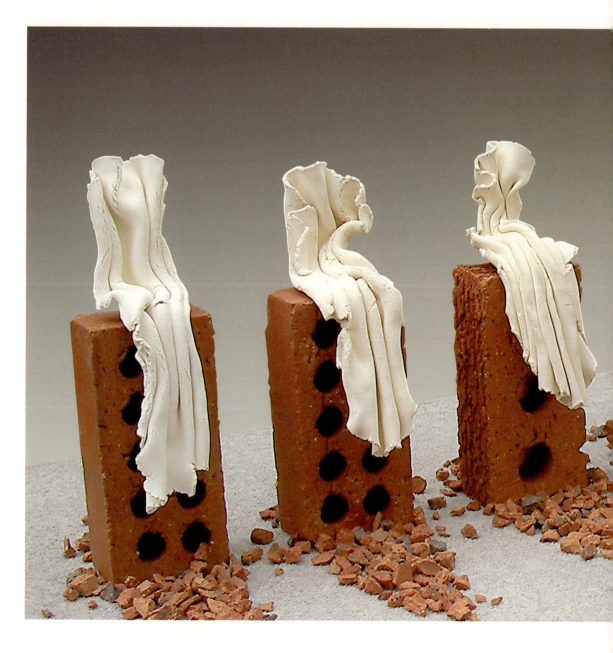

展现瓷土的质感和天然美,也暗示出"无相众生"的佛理。坐像之下的红砖本是粗糙的建材,在其中挖孔也是出于实用与经济的考量,却在形式上产生了特殊的趣味。砖块能堆垒广厦万间,这象征着人生在世的功业。艺术家利用物料的特性配合两种形象去发挥瓷土与砖石的个性:一红一白、一粗一细、一刚一柔、一个说事、一个说人。这些物料是创作的媒介载体,其本身同时也承载信息,构成形象的土块终将崩解为物质本身。化灿烂于平淡,这也是物质的自然规律,显尽无常,不喜不悲。

This is a set of semi-abstract white porcelain sitting on red adobe. The white porcelain is wrinkled into a human shaped garment, curved and tactful, inheriting the pattern of the Dehua porcelain statue of Guanyin. Meanwhile, it also incorporates the charm of western classical sculpture in its cracking clothing pattern. The Buddhist "formless" form of clothes with this natural sitting posture is then distinctively presented, as are the texture and natural beauty of porcelain clay. The red bricks under the seated statue are originally coarse building materials. In them, the drilled holes for practical reasons now generate a special interest in their form. Bricks can make thousands of buildings, which symbolizes the achievements of life in this world. The artist combines the image of the two materials to bring out the individuality of the clay and the stone: one red and one white, one thick and one thin, one firm and one soft, one talking about things and the other talking about people. These materials are the carriers of creativity and messages. No matter what clods form an image, they will eventually disintegrate into the material itself. Turning the splendid into the dull is also the natural routine of the material. Impermanence is always shown, neither for joy nor for sorrow.

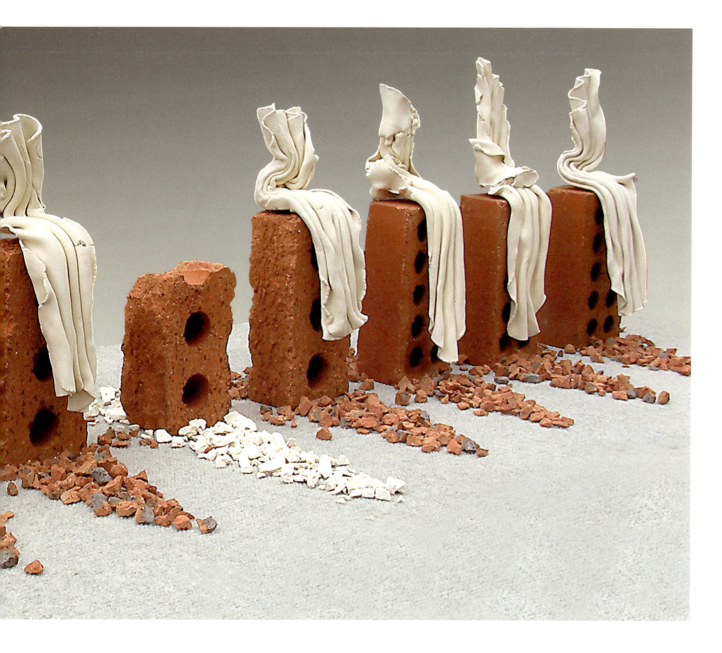

马文甲
Ma Wenjia

（中国 China）

长城	**The Great Wall**
木、玻璃	wood, glass
75cm×45cm×15cm	

"木雕镶眼睛"是作者独特的艺术表达，但相较于这一可能被符号化的"特征"，艺术家更关注的是作品能给其生命价值带来的改变。眼睛意味着观看，而在艺术观看中，物的"眼睛"也就成为生命自主性

的体现。木头本是生命,但在今天人们都把它看成是材料,忘却了其之前是活生生的树木。同样,对于生活中的日常之物:在奔波的生活中一次次地被使用打包的纸箱、不断地被折叠洗熨的衣物,在各种工作和学习的变迁中不断使用的档案袋、书籍等。它们身上细枝末节的痕迹,或是代表了自身的遭遇,或是使用者的一段回忆,同时也可能代表我们自己。这些"物"都伴随着我们的成长,是我们生命形态的见证者。艺术家希望通过艺术创作在有限的生活中找到无限的生命的原本模样,他说:"(与木头一样)我虽是有生命的,但不是所有人都会将我当作生命,他们不会希望了解我的精力和性格,而通过作品他们注意到我强烈的生命独特性,那么,我也将变得有价值。"

The artist has a unique artistic expression by carving eyes within his wooden carvings. Through such symbols, he explores how his work can change the value of life. Eyes are for watching, so the "eyes" of objects become the embodiment of life. Wood is an organism, but it is treated as a material. And so, who will remember that it was once a living tree? This is the case for common daily things: cartons that have been repetitively packed and unpacked; clothes that have been repetitively folded and ironed; and, bags and books that have been restlessly used in the continuum of work and studies. The "wear and tear" on these objects represent their own experiences, or the memories of their users. These objects accompany our growth and are witnesses of what our life is. The artist hopes to restore the infinity of life from finite life. He says: "Although I am alive (like wood), not everyone will treat me as they consciously treat a living organism. They don't want to know my enthusiasm and personality. But they will notice the strong uniqueness of my life through my work, and I will in turn become valuable."

马彦霞
Ma Yanxia

(中国 China)

蔓延	**Spreading**
金属丝	wire
200cm × 250cm × 25cm	

《蔓延》是以金属丝经过编织加工等技术手段创作而成的作品。因为以金属丝为基本构成材料，作品于造型之中显得通透，既实在又虚无。完成后的作品形象若有似无，形体与轮廓弥散在了空气之中，所有的重量似乎都消失殆尽了。此外，从形式本身的构成来说，作品的丝线又像生物体的血管一样蔓延滋生，像素描的线条一般具有绘画的质感，并不复杂的物象本身同时兼具多重审美特质。

Spreading is a work made of metal wire by weaving and processing techniques. Because the wire is the basic material, the work is transparent in its shape, making it both real and void. The final piece appears non-existent, the outlines and contours are diffused into the air, and all the weight appears to dissipate. In addition, in terms of the composition, the threads of the work extend and grow like the veins of a living organism, similar to line drawings with the texture of a matte painting. The uncomplicated objects themselves have multiple aesthetic qualities at the same time.

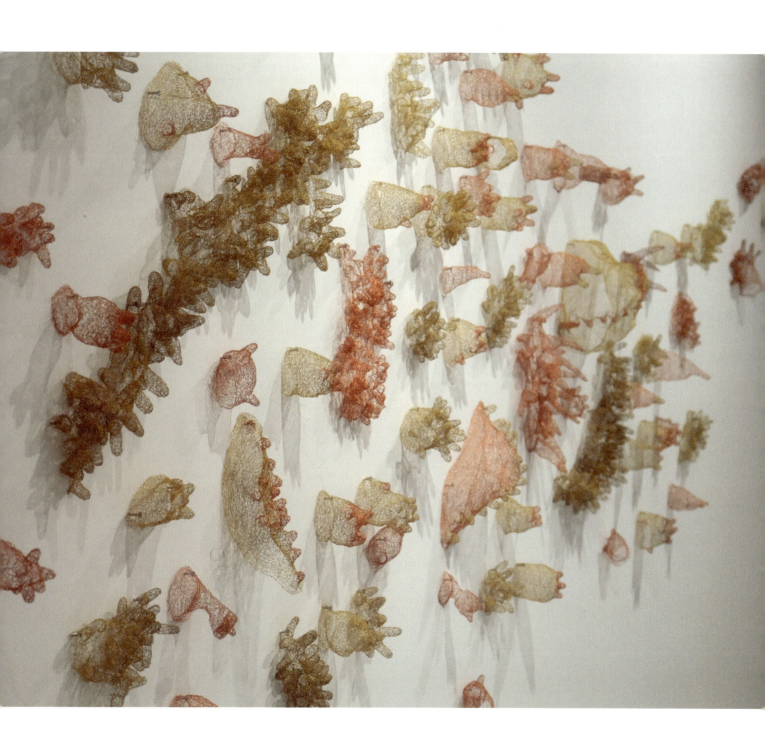

玛丽·克莱因
Mali Klein

（荷兰 Netherlands）

家中绿草如茵	**Green Grass of Home**
草	grass

<div align="center">80cm × 200cm × 2cm</div>

如何能够在日常的消费品生产中加入更多自然、有机的材料，以建立起一个更环保、更可持续的社会？这仿佛已经超越了一个艺术家的职能范畴，但玛丽找到了自己的道路：她用随处可见的草拼凑出一张张墙纸，并且利用同样的材料制作了一些副产品：背包、衣物、凉鞋、女士内裤，甚至100%用草制作的珠宝。艺术家认为这是一种能够引发人们对材料进行深思的方式：对于草而言，一旦它脱离了土壤，时间和阳光则在其转变为一种有机材料的过程中起到至关重要的作用。深绿色会慢慢褪去，并在春秋流转中变成黄色。她认为，"绿色"不再仅仅是一种潮流，而已经是许多家庭的生活方式，是自然，是树木，是生活，是开始、迭代与未来。

How can we incorporate more natural and organic materials into the production of everyday goods for the purpose of building a greener and more sustainable society? This question seems to be beyond the purview of an artist, but Mary found her own answer: she pieced together wallpapers from grass that could be found everywhere, and made some by-products from the same material, including backpacks, clothes, sandals, panties, and even 100% grass jewelry. For the artist, it is an approach for encouraging people to ponder upon the material: once grass is out of the soil, time and sunlight play crucial roles in its transformation into an organic material. Its dark green will gradually fade into yellow during the transition from spring to autumn. She believes that "green" is no longer just a trend, but is already the way of life for many families - it is nature, trees, life, the beginning, the iteration, and the future.

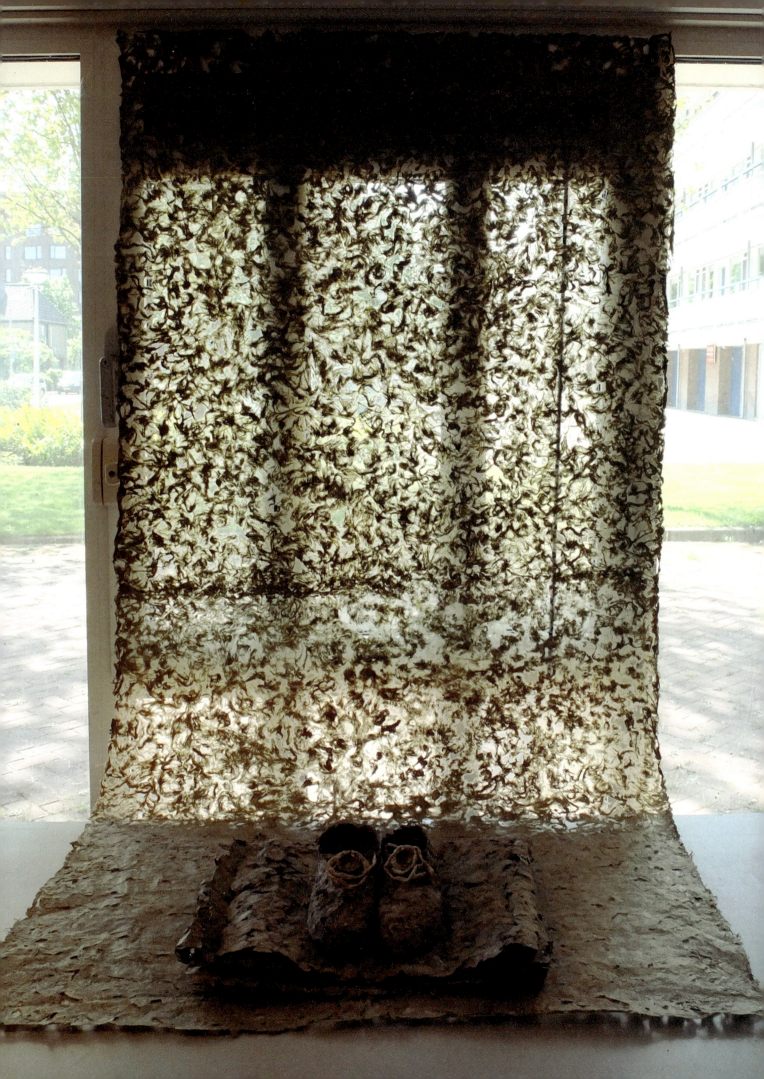

马娜娜·迪兹卡什维利
Manana Dzidzikashvili

（格鲁吉亚 Georgia）

灰蝴蝶	Gray Butterfly
拼贴绘画	collage painting
18cm×40cm	

自古以来，蝴蝶就与春天、美丽和永恒有关。它们被认为是不朽、幸福和忠诚的象征。这件作品的灵感来自一只灰色的蝴蝶，它不能再飞了，它倒下了，这是它生命的结束。但艺术家将这只蝴蝶置于明亮的春色之中，不同的灰色调被用于它的着色中。虽然蝴蝶的生命短暂，但艺术家通过作品赋予它们永恒的生命。艺术家采用了拼贴绘画的创作方式，书籍杂志上的片段成为激发艺术家创作的原材料，即兴的图像碎片拼贴与加之于上的绘画形成了新的语义，色彩节奏的变化传递出一种即兴的情绪，就像波洛克的行动绘画，所有的色彩、节奏、情绪、意义都在过程中产生。

Since time immemorial, butterflies have been associated with spring, beauty and eternity. They are considered symbols of immortality, happiness and loyalty. This work was inspired by a gray butterfly, which could no longer fly and which fell down; this was the end of its life. The butterfly is depicted in the work against the background of bright spring colors; different gray tones are used in its coloring. Although the life span of butterflies is very short, the artist decided to give them eternal life through her work. The artist uses collage painting, where fragments from books and magazines become the raw material that inspires the artist's work. The improvised collage of image fragments, and the painting added on top of them, form a new semantic meaning. The color rhythm conveys an improvised mood, just like Pollock's action painting, where all colors, rhythms, moods and meanings are embodied in the process.

玛丽亚·欧亨尼娅·莫亚
Maria Eugenia Moya

(秘鲁 Peru)

触觉的自画像	Haptic Self Portrait
小麦粉、人的头发、指甲、种子、黄铁矿、小链子、卵石、薰衣草、石膏作品碎片	wheat flour with plaster, human hair, nails, seeds, pyrite, small chain, pebble, lavender, and a piece of a previous plaster work

120cm × 100cm × 10cm

艺术家的这幅肖像是非具象的"触觉"肖像,因其直接触及艺术家的身体及其亲密的细部。制作这些小作品的材料来自艺术家家族成员的故乡——秘鲁阿亚库乔地区的传统糊状配方,它是由面粉、水和石膏混合而成,因而使混合物具有面粉的延展性和石膏的耐久性。这种材料和工艺的选择让艺术家在创作中与家族的文化和历史重新联系起来。肖像中的每一件作品都有一些其他的材料或物体,当糯糊还是新鲜的时候就被插入其中。这些东西要么在艺术家的生活中具有一些特殊的意义,要么已经与她的身体直接接触了一段时间。这些作品被排列在墙上,它们伴随着两张小的宝丽来照片,让观众瞥见这些作品是如何与身体相遇的,以及它们所经历的亲密过程。这个小项目是通过材料和触摸而不是通过图像来记录的一种尝试。

This self-portrait of the artist is a non-objective "haptic" portrait, as it directly taps into the artist's body and its intimate details. Materials for these small-sized works come from the traditional paste recipe of "retablos" from the Ayacucho region in Peru, hometown of the artist's family. The retablos is a mixture of flour, water and plaster, and is malleable due to the flour, and durable due to plaster. The selection of materials and craftsmanship allows the artist to reconnect with the family's culture and history in her work. Other materials or items are inserted into each of the small-sized works while the paste is still fresh. These materials or items either have some special meaning in the artist's life, or have been in direct contact with the artist's body for some time. When they are exhibited on the wall, accompanied by two polaroid photos of the artist in her childhood, the viewers must be able to have a glimpse into how the small works relate to the body and the intimate process they are representing. This small project is an attempt to document through materials and touch rather than through images.

玛丽亚·奥尔特加·加尔韦斯
María Ortega Galvez

（西班牙 Spain）

地图	**Geographic Maps**
金属网、毛毡	metal meshes, felt
90cm×90cm×15cm×2	

艺术家所感兴趣的是地球宏观的运动：自然本身的创造与人类对其施加的破坏。地球本是一团固体、液体和气体的混沌，而因复杂的天气变化，生命得以诞生。运动则贯穿其中：地壳从诞生之日起就在不断变动，生命也是如此。各大板块不断塑造我们的大陆、海洋和其承载的无数生命。而今天的人类则制造着气候变化、大气污染和生态退化，温室气体源源不断地排放，海洋资源的过度开发使得我们的土地、天空与水体都不复往日。艺术家用金属网格制作了山脉、河谷与江流的浅浮雕，绵延不断而又交叉起伏的线条象征着大自然本身来自亘古的生命律动，而金属的光泽和规整的网格则又不可置疑地为其打上了人的烙印——它究竟是正在萌生，还是行将毁灭？这张地图是对唯物主义、对自然、对毁灭和创造的永恒循环的反思。

The artist is interested in the macroscopic changes of the earth: the creative activities of nature and the destructive ones by humans. The earth was originally a chaos of solids, liquids and gases, and life was born due to complex climate changes. Movement is the key: the earth's crust has kept moving since its birth, and so does life. The tectonic plates keep shaping our continents, oceans, and the countless lives they carry. In contrast, contemporary humans are causing climate crises, air pollution, environmental degradation, the greenhouse effect, and the over-exploitation of marine resources. Our land, sky and water are no longer what they were. The artist uses metal grids to create a bas-relief of mountains, valleys and rivers. Its undulating lines symbolize the eternal rhythm of life that is given by nature itself, while the metal gloss and the regularity of the grids undoubtedly brand it with a human mark - to be or not to be, that is the question. This map is a reflection on materialism, nature, and the eternal cycle between destruction and creation.

玛丽亚·托兰德尔
Maria Torrendell

（乌拉圭 Uruguay）

谁说脆弱的？	Who Said Fragile?
印刷玻璃、大理石	printed glass, marble
62cm×29cm×18cm	

"她不是像花一样脆弱，她是像炸弹一样脆弱"，弗里达·卡洛如是说。脆弱，是女性的气质吗？艺术家玛丽亚·托兰德尔试图用大理石和回收再利用的玻璃等材料重新探讨女性气质与玻璃概念。在她的作品中，石头代表女性坚实的灵魂，覆盖其上的玻璃则象征着她们脆弱的、闪亮的、美丽的外表。在玻璃涂层中的诗句来自弗吉尼亚·伍尔夫、西尔维娅·普拉斯和西蒙娜·威尔等著名的女诗人，展露着女性精神世界中的巨大能量。这些能量来自于女性的同理心、反叛、灵性、创造力、美感、感性、关怀、意识或幽默感，虽然这些力量曾被社会的工作方式所压制，但却闪耀在女诗人的作品中，一直是女性精神力量的核心。将回收的玻璃重塑成一个不同的物体，作者也喻指女性应有新的机会来做自己，能够更透明、更清晰、更诚实地面对自己的真相。

"She was not fragile as a flower, she was fragile as a bomb," Frida Kahlo said. Is frailty intrinsic to the womanly manner? Answering this question like Frida did, Maria Torrendell, in her creative combination of marbles and recycled glass, seeks to revisit the definition of women's character, as well as of the material of glass. Her design of glass-veiled marbles symbolizes women's adamant, marble-like souls, and mirrors their glassy but fragile beauty on the outside. Poetic lines from Virginia Woolf, Sylvia Plath, Simone Weil and other famous female poets are inscribed on the glass coating to exhibit the enormous power inside the mental world of women from women's strengths of empathy, rebellion, spirituality, creativity, aesthetics, sensibility, attentiveness, awareness, or sense of humor. Glancing on such lines, these strengths, though once restrained by social mechanism, have always been the cornerstone of women's tenacity. Reshaping the recycled glass into a different object, the artist also suggests metaphorically that women should have new opportunities to be themselves, and can face themselves in a more transparent, clearer and more honest way.

马丽贝尔·波特拉
Maribel Portela

（墨西哥 Mexico）

瀑布	**Waterfall**
纸	paper

190cm × 60cm × 45cm

雪花般的"瀑布"从空中悬垂而下，艺术家用回收的纸张和剪纸工艺塑造了一个纯净的、理想的美学乌托邦。艺术家的作品一直与自然相联系，对水的关注是作品中反复出现的主题。艺术家通过对回收材料的使用，通过想象力来构建新的物体和环境，让材料重新"活"过来，转化为颠覆性的、令人惊讶的审美景观与诗意空间。作者希望通过简单的材料创作让物质的过程显而易见，赋予材料以生命和意义的改变，让废弃之物通过想象力拥有新的维度和无限的形式。当观众置身其中，感受艺术家塑造的乌托邦之美丽、纯粹、生机与绽放的同时，也反思现实生活中的消费浪费、环境污染与生态破坏。

A snow-like "waterfall" hangs down from the sky, and the artist uses recycled paper and decoupage craftsmanship to shape a pure, ideal aesthetic utopia. The artist's work has always been associated with nature, and the focus on water is a recurring theme in the work. By using recycled materials, the artist constructs new objects and environments through imagination, "reanimating" these materials and transforming them into subversive and astounding aesthetic landscapes and poetic spaces. The artist hopes to make the material process obvious through simple material creation, to endow materials with changes in their lives and meanings, and to endow discarded objects with new dimensions and infinite forms through imagination. When the audience is in it, experiencing the beauty, purity, vitality and bloom of the utopia created by the artist, they also contemplate the consumptive waste production, environmental pollution and ecological destruction in real life.

玛丽卡·萨拉 / 理查德·弗莱芒特
Marika Szaraz / Richard Flament

（卢森堡 / 比利时 Luxembourg / Belgium）

涡流	Vortex
木棒、纺织纤维	wooden rods, textile fibers

300cm × 320cm × 120cm

根据空间折叠理论，人们可以利用强大的引力来制造空间的扭曲，将两个相距甚远的点重合，形成"虫洞"以供飞船穿梭。而连续制造这样的扭曲则会形成螺旋式的"反复翘曲空间"，这些不存在时间概念的漩涡贯穿、连接，在某种程度上就成为空间高速公路，允许人们以比光速更快的速度从宇宙的一端移动到另一端。艺术家用黑色的纤维材料制作了螺旋式的结构来模拟被扭曲折叠的空间，再以上色的木棍将其穿刺来模拟空间旅行的"星际隧道"，制造了独属于艺术家的关于星辰大海的浪漫幻想。

In a folding space, or a "wormhole", gravity-induced distortion facilitates direct space travel between two points far apart. A further distortion will then form a spiral and "repeatedly warped space", in which a space highway without the concept of time may appear. On this highway, people can travel faster than the speed of light, and may move from one end of the universe to the other. Inspired by this hypothesis, the artist "simulated" such a spiral, twisted and folded structure with black fiber, and then set up the "interstellar tunnel" with colored wooden sticks. Surrounded by "stars" and the "galactic seas", the artist is filled with a unique romance.

玛苏玛·哈莱·赫瓦贾
Masuma Halai Khwaja

（巴基斯坦 Pakistan）

这不是一场会议	Not a Conference
石膏条	plaster strips

<div align="center">38cm × 94cm × 94cm</div>

艺术家用石膏条创作了这些形象。她先制作了黏土泥人，并入窑烧成陶俑，然后在陶俑表面贴上保鲜膜，并用潮湿的石膏条覆盖，以制造成石膏像。当雕像一侧的石膏条干燥后，艺术家再转动雕像塑造另一面，构成完整的形象。循环往复，得到这样一群穿着白袍、失去面庞的人物：她们围成一个小小的半圆，仿佛在窃窃私语，像在古罗马的元老院。但作品的名称又在否认这一切："这不是一场会议"。艺术家在此构建了一个反讽。艺术家在此表达了她对社会的深刻观察，并利用石膏——这种本被用于修复骨折的材料——塑造了这组漠然的群像。

The artist created these figures with plaster strips. She first made clay figures, and turned them into pottery in a kiln. Then, plastic wrap was used to cover their surfaces before damp plaster strips were finally applied to form the outermost cover. After the plaster strips on one side of a figure were dry, the artist turned them to the opposite side to finish the whole construction. Repeating the action and such a group of faceless figures in white robes were obtained: they form a small semicircle, as if whispering, like in the Senate of ancient Rome. But the title of the work denies it all: *"Not a Conference"*. The artist presents an irony here. Here, the artist expresses her profound insights into society by using plaster, a material originally used to knit broken bones, to mold this indifferent group portrait.

孟禄丁
Meng Luding

（中国 China）

朱砂·祭	Cinnabar · Sacrifice
矿物质颜色、动物皮毛、兽骨	mineral powder, gel, animal fur, bones
尺寸可变（size variable）	

兽骨、兽皮、符号、朱砂成为《朱砂·祭》的四重元素，在这多重的关系中，孟禄丁建构了一个出对于精神世界和未知领域的探索过程。2018年夏天，在个人生活经验的偶然触动下，他开始将朱砂视作独立的创作语言。在近三年的最新探索中，朱砂、雄黄这些自带"能量"的材料，经由艺术家的牵引，在二维画面中获得了能量转化与增强。而材料基于特定文化背景衍生出的符号属性，与作品的符号表达，共同营造出一方涌动着原始能量的"场"——某种精神性的空间由此展开。在装置作品《朱砂·祭》中，他将自己名字中的"丁"字塑造成强有力的符号，印拓在悬置的两张牛皮及围列成一圈的12枚猪头骨之上。透过这种神秘古老的仪式，进一步探究"朱砂"的内在能量，营造出一种超验的生命场域。

Animal bones, animal skins, symbols, and cinnabar are the four elements of *Cinnabar·Sacrifice*. In this multi-fold relationship, Meng Luding explores the spiritual world and the unknown realm. In the summer of 2018, inspired by a sudden personal experience, he began to adopt cinnabar as a language of his independent creation. During his exploration in the past three years, cinnabar, realgar, and other materials with their own "energy", have been introduced to the artist's 2D images, onto which the materials' energy is transformed and enhanced. The symbolic attributes of the material, based on specific cultural backgrounds, together with the symbolic expression of the work, create a "field" covered with primordial energy, where a kind of spiritual space unfolds. In the installation work *Cinnabar·Sacrifice*, the artist transformed one of the characters of his name, "*Ding*（丁）", into powerful symbols, and printed them on two suspended cowhides and 12 pig skulls arranged in a circle. Through this mysterious and ancient ritual, the inner energy of "cinnabar" is further explored and a transcendent field of life is created.

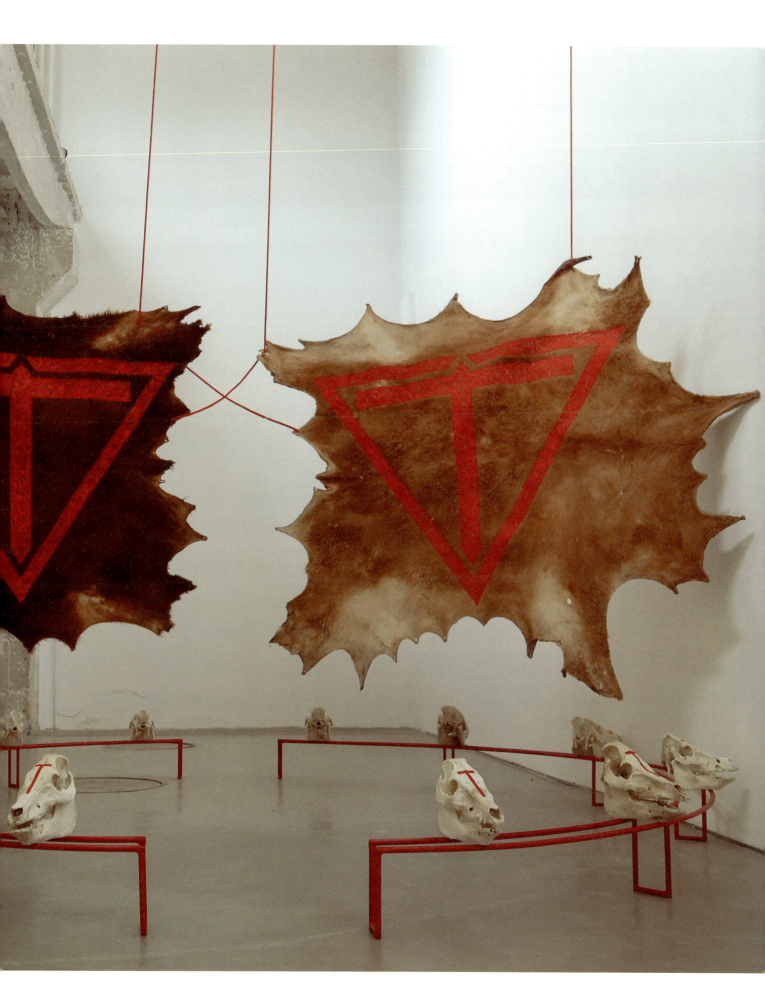

米罗斯拉夫·布鲁斯
Miroslav Brooš

（斯洛伐克 Slovakia）

纸的果实	Fruits of Paper
回收的废纸和织物	recycled waste paper and textile
700cm × 600cm × 120cm	

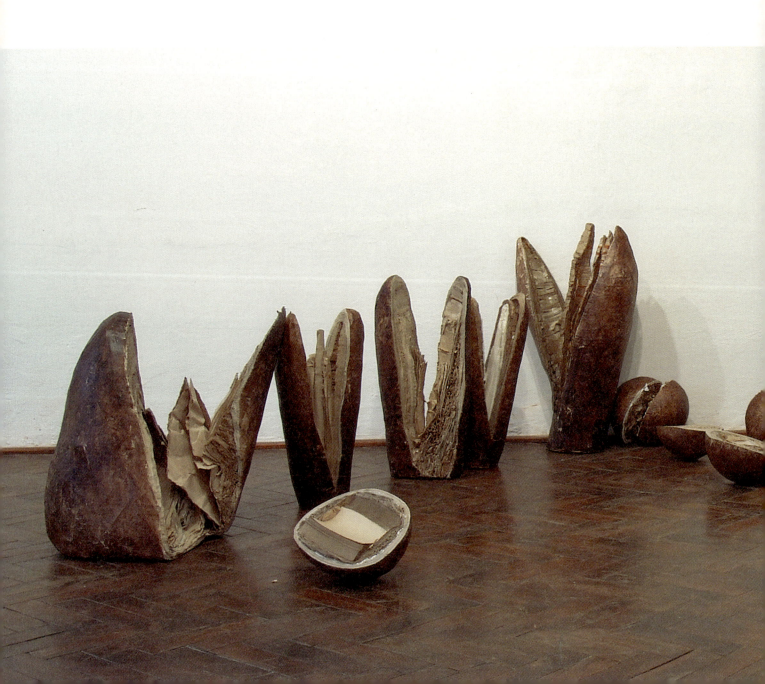

《纸的果实》是艺术家开启的一个长期艺术项目,他从 1994 年就开始制作这些装置,并在二十余年间不断收集各种"新的废纸"与"新的废布料"。迄今为止,艺术家已经积累了超过一百件系列作品。他通过一种有机化的美学语言来讨论资源和消费的问题。他关注那些退化、落后且被浪费的材料,希望大家重新评估和反思自己的消费习惯:纸张和布料等材料朴素的自然价值在消费主义社会中被长期忽视。作品希望通过其独特材质所构建的内部结构,与分解崩裂的形态,来呈现人与自然之间的矛盾关系:它们仿佛是自然的某种特殊果实,有着粗糙的外皮和轻微的开口,但其本质上是人类活动的果实,是浪费和抛弃的结果。

Fruits of Paper is a long-term art project initiated by the artist in 1994. For more than 20 years, he kept collecting sundries of "new waste paper" and "new waste fabric", and converted them into over 100 pieces of work. Resources and consumption are discussed in his organic and aesthetic language. Degraded, outdated, and wasted materials are reinvigorated in his call for the re-evaluation and reflection of everyone's consumption habits: the most simple and most natural value of materials such as paper and cloth has been ignored for a long time. The work hopes to present the contradictory relationship between man and nature through the internal structure of his creations. Their unique materials and the cracking form are telling: they are the special fruits of nature, roughly skinned, slightly open; they are essentially the fruit of human activity, the result of waste and abandonment.

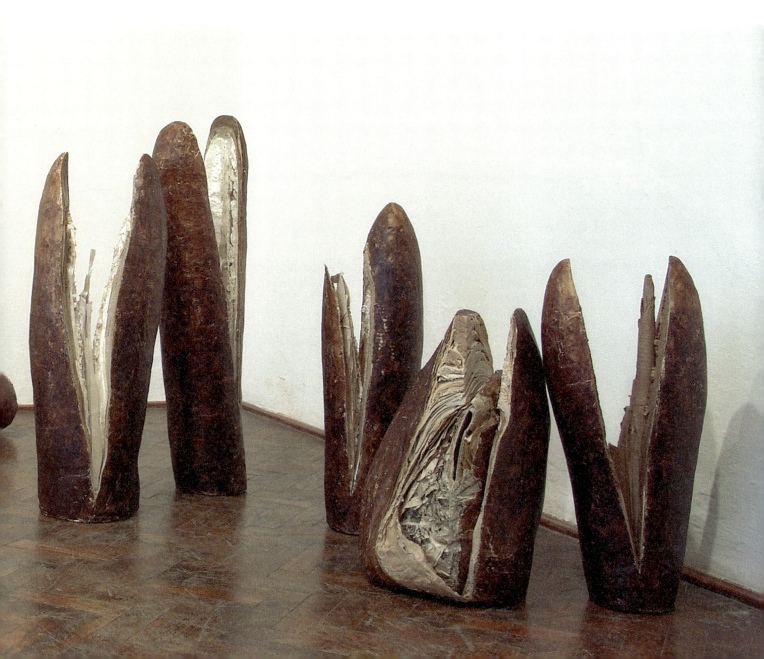

莫妮卡·莱曼
Monique Lehman

（波兰 / 美国 Poland/USA）

雨林	Rainforest
丝、人造纤维、羊毛、合成网	silk, rayon, wool, synthetic net
200cm × 300cm × 300cm	

作品《雨林》的灵感来自于太平洋的奇妙水下景观和夏威夷莫妮卡家附近植物园的悬挂植物，主题是生物物种的多样性。它召唤着瀑布的咆哮、鸟儿的鸣叫和青蛙的呱声。观者沉浸在色彩和纹理中，被不同寻常的色彩组合所吸引，使人联想到大自然的壮丽。无重力地浮动，无数条线连接在挂毯的主体上，创造出一种超自然的质量。

> 夜之雨林美得令人沉醉，
> 黑，很黑，森林在沉睡，
> 但并非所有都是黑色的，
> 月光照亮了瀑布的奔流，
> 紫色大闪蝶辉映着光芒，
> 栖在兰花床上烦躁不安，
> 蒸发的浓雾在空中升腾，
> 在刺绣的丛林中，
> 去感受静谧夜晚的魔力。
>
> ——莫妮卡·莱曼

The work Rainforest is inspired by the fantastic underwater landscape of the Pacific Ocean and the hanging plants in the botanical garden near Monique's home in Hawaii, and the theme is biodiversity. While it summons the roar of waterfalls, the chirping of birds and the croaking of frogs, the viewers are immersed in its colors and texture, and associate its unusual combination of colors with the magnificence of nature. Floating weightlessly, numerous threads connect to the body of the tapestry to create a supernatural vision. The artist summarizes her work through her own poem:

The whimsical beauty of rainforest at night, It's dark, very dark, the forest is sleeping, But wait, not all is impenetrably black, The moonshine lights up the waterfall's wispy strands, The iridescent purple morpho butterflies fidget on their beds of blue orchids, The thick moisture of evaporating fog rises through the air, The magic of a quiet night in the embroidered jungle!

纳蒂亚·迪亚兹·格拉薇兰
Nadia Díaz Graverán

（古巴 Cuba）

编织自己的女人	Woman Who Weaves Herself
木质扶手椅、灰色花蕊、锉刀、竹针	wooden armchair, gray stamen, filing, bamboo needle
108cm × 65.5cm × 78cm	

一个女人，坐在她的扶手椅上，专注于她面前的生活，一面看着自己，一面沉思着编织着自己，她或许不完整（谁又完整呢？），但也是一个见证者和参与者。编织是一种基于重复的冥想行为，它作为代代相传的传统将逝去和活着的人们联系起来，它象征着一种从头开始创造和塑形的能力，用简单的针线来构建温暖和美。这把椅子知晓家族中所有隐藏的故事，在漫长而绵延缠绕的时间长河里倾听着这个家庭的一切声音。艺术家家族中几代的女性长辈都在这把椅子上溘然长逝，并且还是艺术家本人喂养她三个孩子的地方，她在无数个日日夜夜怀抱着小小的新生命，为他们唱歌，哄他们睡觉。她坐在这里，和渐行渐远的人一起，也和初来乍到的人一起，通过编织，进入自己，完成自我的构建。

A woman sits in her armchair, concentrating on her life, looking at herself and knitting in thought. She may not be complete (but who is?), yet she still serves as a witness and a participant. Knitting is a repetitive byproduct of meditation. Life and death are connected by the passing of this tradition from generation to generation. With simple needles and threads, knitting can create warmth and beauty. In parallel, it symbolizes an ability to create and shape from scratch. Talking about this chair, it is acquainted with all the secrets of the family, listening to all the voices and stories in the winding river of time. Several generations of female elders in the artist's family have died on this chair, and it is also the place where the artist feeds her three children, while she embraces the little new lives on countless days and nights, singing for them and coaxing them to sleep. She sits here, with those who are drifting away or have just arrived, approaching herself, and completing herself, through weaving.

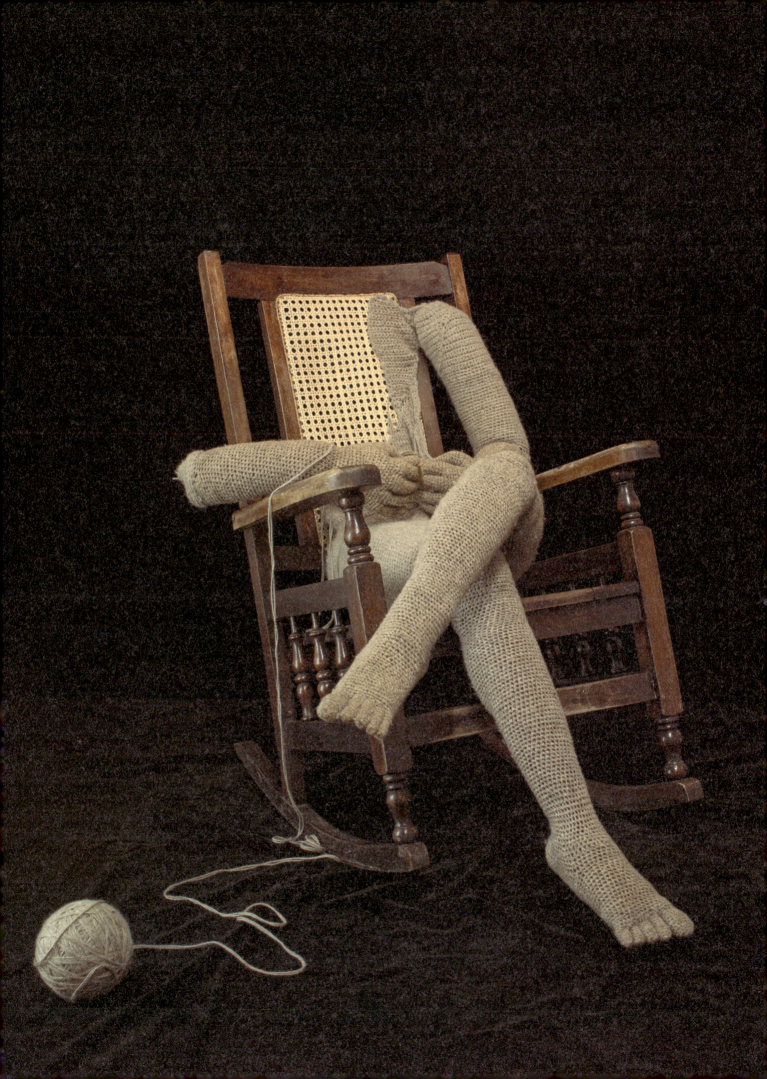

娜拉·吉琼
Nara Guichon

（巴西 Brazil）

麻木	**Dormência**
回收的渔网和时装业的棉花	recycled fishing nets and cotton from the fashion industry
225cm × 50cm × 50cm	

艺术家在巴西南部的海岸边收集了这些渔网，仔细地用水将它们清洗干净，再使用天然染料为其染色，结合她从纺织工厂与制衣工人手中收集的棉布与边角料，以及一些铁屑、泥土，加以烘烤，制作了这三只"茧"。世界上大部分人都还没有意识到气候危机、生态破坏等问题的严峻性，人们在面对触目惊心的污染时无动于衷，甚至拒绝采取任何行动，仿佛被困在茧中与真实的世界隔绝，变得麻木不仁。在艺术家看来，毫无节制的消费与时尚引发了这场前所未有的全球危机：发达国家每天产生数不胜数的废弃物，再倾卸到欠发达国家，用有毒物质、塑料、聚酰胺渔网毒害那里的植物、动物和海洋。她刻意强调"渔网"这一元素，因为后者在全球的海洋污染物中占据高达四成的比重。正如艺术家所说："这个星球正在死去，而我们仍酣然不醒"。于是，她使用这样一种诗意而严肃的语言创作了《麻木》。

The artist collected these fishing nets off the coast of Florianopolis in southern Brazil, carefully washed them with water, and dyed them with natural dyes. These three "cocoons" were made by baking the cotton cloth and scraps collected by the garment workers, as well as incorporating some iron filings and soil. The artist believes that most people in the world have not yet realized the seriousness of the climate crisis, ecological deterioration and other issues. People do nothing when shocking pollution is present. They are not only neglecting these issues, but actually stubbornly rejecting taking any actions, as if they are caged in a cocoon that is separated from the real world. They become completely indifferent. In her view, unrestrained consumption and fashion have triggered this unprecedented global crisis: developed countries generate countless waste every day, and then dump it into less developed countries. The waste includes toxic substances, plastics, and polyamide fishing nets, which all poison the plants and animals, and pollute the oceans. The artist deliberately emphasized the element of "fishing nets", which account for as much as 40 percent of the world's marine pollutants. As the artist said: "The planet is dying, and we are still awake". That is the reason that she created *Dormência* using such a poetic, but serious language.

娜塔莉亚·茨维特科娃
Natalia Tsvetkova

（俄罗斯 Russia）

独角兽的头颅	**Unicorn Skull**
金属、金属丝	metal, wire
	85cm × 40cm × 100cm

村上春树在《世界尽头与冷酷仙境》中，构建了一个让艺术家着迷的梦境。主人公从现实中死亡后，进入了一个他自己想象出的小镇，从事着从独角兽的头骨中读取人们"古梦"的工作。独角兽，这样一种浪漫而优雅的生物，春树描写道："与小镇居民垂死的记忆同呼吸，而独角兽死后，这些记忆则变成古老的梦"。主人公不断想要逃离，却最终在这里平静的生活中找到了自己，心甘情愿地成为这个小镇的囚徒。艺术家曾一度也是自己思想的囚徒，希望为自己的灵魂找到出口。独角兽的头颅之于春树的主人公，或之于艺术家，都是近乎一样的意义，成为追问自身，寻求真我的一种象征。艺术家用钢架编织了一只高贵生物的头颅，并结合以修长优美的独角，观者的目光仿佛触及某种古老神秘的灵媒，在森林深处中继续着世界尽头的朦胧幻梦。

In *Hard-Boiled Wonderland and the End of the World*, Haruki Murakami structured a dreamworld that fascinates the artist. After the protagonist died in reality, he entered a town out of his imagination, and was engaged in the work of reading people's "ancient dreams" from the skulls of unicorns. A unicorn, the romantic and graceful creature that it is, was described by Haruki as "breathing on the dying memory of the inhabitants of the town... And after the death of the unicorn's memory, it turns into old dreams...". In constant attempts to escape, the protagonist finally found his self in the peaceful life there, and willingly became the prisoner of this small town. At one point the artist was also a prisoner of her own thoughts, hoping to find an escape for her soul. The skulls of unicorns have almost the same meaning to the protagonist of Haruki, or to the artist - that is a symbol of further self-examination and seeking the true self. The artist uses steel frames to knit the skull of this noble creature, combined with a slender and elegant horn. The audience's sight of this skull seems to touch on some ancient and mysterious psychic medium, by which the audience can continue their hazy dreams about the end of the world in the depths of the forest.

尼科·卡帕
Niko Kapa

（希腊 Greece）

发掘	Exhumations
混凝土、火山灰、树脂、艺术家的血、丙烯酸	concrete, volcanic ash, resin, artist's blood, acrylic

58cm × 30cm × 30cm

拉兹洛·莫霍利－纳吉认为："必须再次强调对人类生活基本要素的感觉"。在作品《发掘》中，艺术家通过利用存在的原始物质（火山灰、血液、树脂等）来"想象"人类，展示了材料的各种创造性可能，如对脱离了身体的物质（艺术家的血液）的使用强调了一种内在的现实。作品呈圆柱形棱镜，灵感源自保存在实验室里的"取芯"管——用来分析地质构造的钻管。地质学是一种记录系统，在对沉积过程的发掘中传达出一种分层感，同时强调了纯粹的物理性。作品中，火山灰与血液混合形成"混凝土"，树脂与血液混合形成新的"矿物"，并在这个过程中研究材料的物理性和它们的转化潜力。当艺术家的血液熔铸其中，这件雕塑成为肉体的表现，成为自我挖掘的喻指。

László Moholy-Nagy believes: "the meaning of the fundamentals of human life have to be emphasized again". In *Exhumations*, the artist imagines human beings as volcanic ash, blood, resin, and other substances of primitive origin, and shows the diversity of the creative potentials of materials. For instance, the utilization of the artist's blood, through its separation from the body, underlines an inner reflection upon reality. The work is a cylindrical prism inspired by the drill pipes used to analyze geological formations. As a system of recording, geology demonstrates the layer separation formed during processes of sedimentation, and emphasizes pure physicality. The volcanic ash is mixed with the blood in this work to form "concrete", while resin is mixed with the blood to form new "minerals". In this process, the physicality of the materials and their transformational potential are studied. When the artist's blood is cast into it, this sculpture becomes a representation of the body and is a metaphor for self-digging.

尼娜·内纳多维茨
Nina Nenadović

(斯洛文尼亚 Slovenia)

无题	**Untitled**
废旧材料、纸塑、帆布上的丙烯颜料	waste material, papier-mâché, acrylic paint on canvas

<div align="center">65cm × 35cm × 16cm</div>

这件作品的基础是一幅画,它由废纸和颜料糅合、分层又组装而成。艺术家使用了记载着每日新闻的旧报纸、各种食品和饮料的包装等日常生活中常见的废弃纸料,并将它们变成纸浆,堆涂在旧画布上。这一过程中所有材料其本身都已包含了生活的记忆和历史的信息,艺术家认为这种材料语言富有即兴色彩而又颇具深意,仿佛一个记录时间的材料库。也正因此,艺术家以这种方式创造的形状和纹理似乎都是无形的内在力量的自发结果。故而艺术家不给这些作品命名,也刻意保持不完整、破碎的外观,以免干扰观众对这些"物质"最直接的思维过程。艺术家通过一系列手段引导人们重新审视这些"日常经验",促生对现代化的进程的思考。

Based on a painted work, the creation is layered and assembled from waste paper and pigments. The artist turns old newspapers, the wrapping paper of food and beverages, and other common waste paper into pulp, and piles the pulp on an old canvas. In this process, the creation automatically acquires the memory and history of the materials and their related lives. The artist believes that this language of materials is improvised, and conveys significance as a material library and time recorder. Its shape and texture seem to spontaneously reflect a kind of invisible inner force. Hence, the title is *Untitled*. With the deliberate maintenance of an incomplete and broken appearance, the most direct contemplation by the audience of these "materials" remains uninterrupted. And the audience is guided by the artist to re-examine these "daily experiences" through multiple approaches, so as to re-consider the process of modernization.

帕维尔·基尔平斯基
Paweł Kiełpiński

（波兰 Poland）

空间的解剖学	Anatomy of Space
羊毛	wool
	200cm × 200cm × 200cm

《空间的解剖学》灵感来自1510年阿尔布雷希特·丢勒所作的木刻版画碎片，该作品展现了一个带有独特的十字拱形穹顶的大厅室内视角，继而成为这一艺术织物设计的现成草图。艺术家使用了新的材料和技术——用多色粘胶纤维在黄麻原料上进行刺绣——使纺织材料和编织技术取代了从前老大师们的凿子。这一特殊的艺术实现基于一种特定的艺术程序，包括对环境要素的反转。在这一语境中，即是将带有建筑结构元素的室内视角，转变为对称的、同心的和纪念碑式的编织物件。艺术家在古老和现代的两种艺术之间，实现了时间、媒介、形式，以及最终的，空间的解构与重建。这项工作成为一个更大的项目"游牧纪念碑"的核心，其中包括一系列未完成的、至今仍在进程中的后续作品。

The *Anatomy of Space* was inspired by a fragment of the woodcut of 1510 by Albrecht Dürer. The fragment exhibited the interior of a hall with a distinctive cross vault, while this fabric design adopts the exhibition as its ready-made sketch. The artist creatively applies embroidery on raw jute with multi-colored viscose fibers, so that textile replaces masonry. This particular artistic realization is based on a specific artistic procedure involving the reversal of environmental elements. In this context, the interior perspective with architectural elements is transformed into a symmetrical, concentric and monumental woven object. The artist realizes the deconstruction and reconstruction of time, medium, form, and space between the modern and the ancient arts. This work is also the centerpiece of a larger project, "Nomadic Monument", which includes a series of follow-up works that are still in progress.

拉伊亚·约基宁
Raija Jokinen

（芬兰 Finland）

倾听一条河	**Listening to a Lake**
亚麻、PES 缝纫纱线、淀粉	flax, PES sewing yarns, starch
134cm × 52cm	

拉伊亚的艺术创作专注于日常的感觉、情境和想法,她观察情感和身体周围的关系。她着迷于与身体有关的细节,如皮肤、血管和神经轨道,它们类似于树根或树枝和许多其他有机物的形式。这些形式是支持生命功能或我们思想的最佳选择。她的工作方法可以与绘画、素描和雕塑相提并论,但在材料上她使用纤维和亚麻。此外,她用机器缝制来形成"绘制"的线条。她的方法和材料也与手工造纸技术有关,它们可以被定位在绘画、雕塑、造纸和纺织技术的交汇点。用这些方法,她能够创造出自由的形式,如切面和透明的结构,让强烈的阴影投射在墙上或占据周围的空间,混合物质和非物质的表象。

Raija's artistic approach is focused on everyday feelings, situations and thoughts, and she observes the relationship between emotional and physical surroundings. She is fascinated how body-related details, such as skin, blood vessels and nerve tracks, resemble the forms of roots or branches and many other organic things. These forms are optimal for life-support functions, and maybe also for our mind. Her working method can be compared to painting, drawing and sculpture, but as her choice materials, she uses fiber and flax. In addition, she uses machine stitching to form "drawn" lines. Her methods and materials are also related to handmade paper techniques, and they could be considered a "meeting point" between the techniques in painting, sculpture, paper making and textiles. With these methods she is able to create free forms, like cut offs, and transparent structures that allow strong shadows on the wall; shadows can occupy the space surrounding the work, mixing the presentation of materials with immateriality.

拉奎尔·勒杰尔格
Raquel Lejtreger

（乌拉圭 Uruguay）

在空旷中	Out in the Open
印刷的聚酯纸、硅胶绳、铅锤、珠子	printed polyester paper, silicone rope, plumb bob, beads

850cm × 850cm × 750cm

《在空旷中》是一个关于气候变化影响（尤其是洪水）的装置，它的诞生基于艺术家本人十余年来与那些受洪水影响的人们的交流合作。她收集了各种与灾民相关的图像、诗歌、证词、文件、实际工作中的记录和其他相关的文本，并将这些信息汇编成这件作品的基本要素。在环境问题成为某种"艺术潮流"的今天，这种视角具有相当的独特性。就形式而言，《在空旷中》是一件有机的作品，它可以适应任何空间，以任何形式展出，它呈现的是洪水为代表的灾难带走的精神与生活的碎片，但同时这些碎片自然也呈现出水一般流淌的性质。通过这种方式艺术家探讨了人们与水之间的矛盾心理，作品也由此成为一种诗意的思想材料。

Out in the Open is an installation about the effects of climate change, especially floods. It is created based on more than ten years of communication and collaboration between the artist and with those suffering from floods. Images, poems, testimonies, documents, actual work records and other relevant texts related to the victims are compiled to form this work. Even when the environment becomes the contemporary "art trend", this work still offers a unique perspective. It is an organic work with great spatial adaptability and morphological flexibility. Fragments of spirit and life are taken away by disasters; using floods in this work as an example, they are bluntly represented as a structure that resembles water flow. In this way, the artist explores the ambivalence between people and water, and the work thus becomes a poetic material for thought.

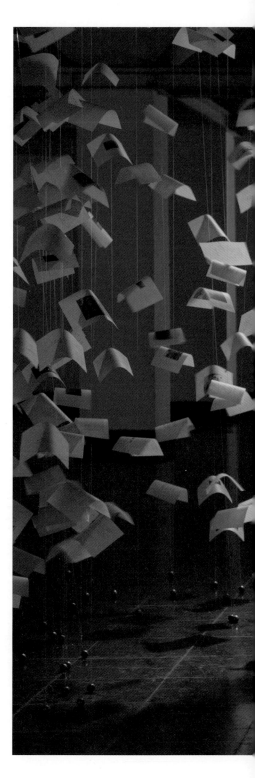

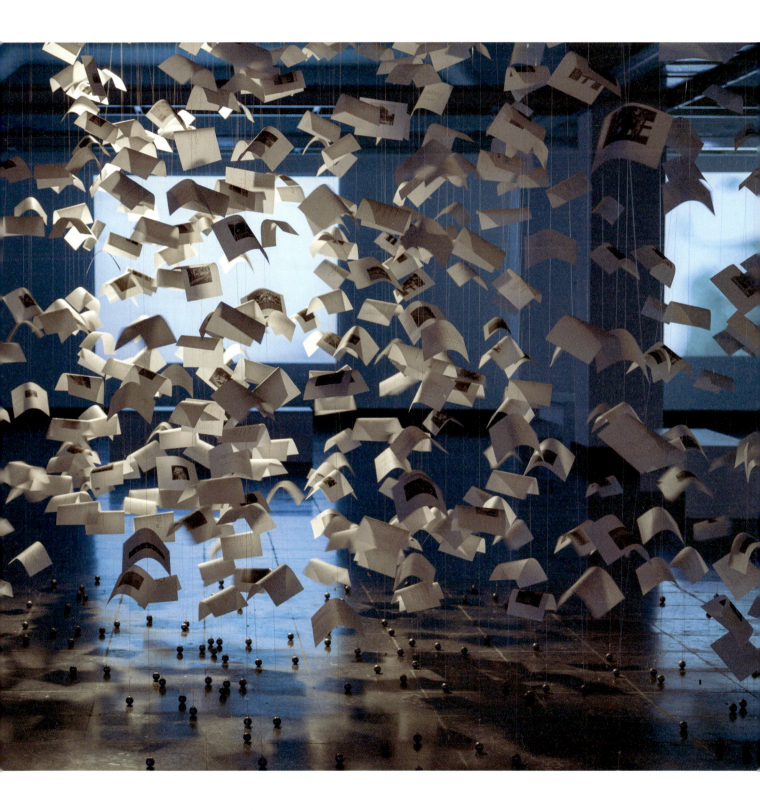

鲁兹卡·扎捷克
Ruzica Zajec

（克罗地亚 Croatia）

评论	**Comment**
纸	paper
	300cm × 200cm × 10cm

作为一件大规模的地面作品，《评论》聚焦于当今世界的信息过载和超快节奏。这些纸带裁自不同城市、不同时代的不同报纸，仅仅保留了一些碎片内容、图像和标题，因此人们无法从中获取信息，但却可以直观地感受到世界上有如此多的人、如此多的故事。艺术家将这些纸带重叠、卷曲，多卷纸带则排列形成流动的形状，以便这件作品适应任何一个展示空间；上缘的黑色轮廓线则将这些纸带连接起来，将承载无数信息的物质材料转化为空间中的图形，融聚、流动的黑色线条像是巨大信息世界中的一条河、一个涡流。作品象征着一条信息的河流，激发起观众的想象力和好奇心，他们却不能从报纸中找到哪怕一个完整的故事。人们只能站在作品的边缘，观察它的流向。

As a large-scale ground-based work, *Comment* focuses on the information overload and hyper-fast pace of the contemporary world. The paper strips used in the work are cut from different newspapers from different cities and eras. Only some fragments of the original content, images and headlines are retained. People will obtain little information from them, but may intuitively feel the diversified and enormous existence of people worldwide, and their stories. The artist overlaps and curls these paper strips into multiple rolls, and arranges them into a flowing shape. The work is then given immense adaptability for any exhibition space. Meanwhile, the paper strips are connected by the black outline on the upper edge, as is the information that the materials have carried. When the materials become graphics in space, the black lines merge with each other, flowing like river vortexes in an infinite world of information. In this sense, this work inspires the imagination and curiosity of viewers who cannot find even a complete story from these strips. They can only stand on the edge of the work and observe the "flows".

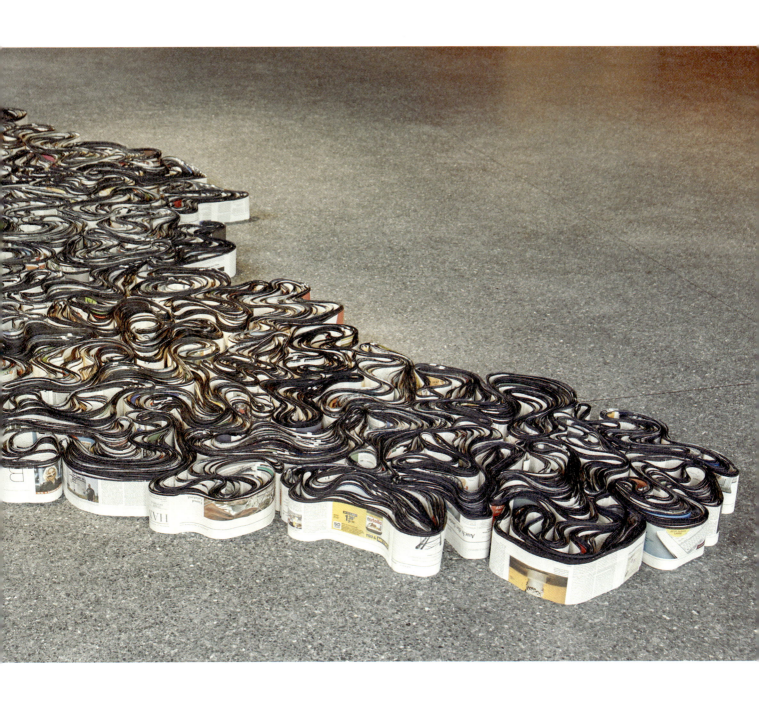

塞菲·加尔
Sefi Gal

（以色列 Israel）

时间的层次	Time Layers
回收纸	recycled paper
	70cm × 20cm × 15cm × 2

回收的纸在咖啡中染色形成了这件作品的原材料。锈迹、褶皱、开裂的纸包裹在简单的人体框架上，艺术家意欲在延展与收缩、刚性与弹性、稳定与失衡、扁平与凸凹、脆弱与强大之间的对比中探讨材料与人体之间的张力，试图将物质变成富有时间维度的精神载体与艺术作品，只留下存有本质的"剥落记忆"。纸张是可生物降解的，对再生纸的使用，标志着生命周期的延展、循环和结束，但这些微薄之物连接着过去和现在，讲述着时间的故事。作品中的雕像近乎平面，没有体积，呈现一种碎片化和压缩的状态，正如人们当下的生活；同时，这些形象是模糊的、不具体的、悬而未决的，突出了个人与群体之间日常事件的脆弱性和短暂性。当我们剥去华丽的外壳从内部审视自我时，高度压缩的时间的层次得以显现，咖啡沉浸的颜色则进一步强化了这种感觉。

Recycled paper dyed in coffee is the raw material for this piece. Rusted, wrinkled and cracked paper is wrapped around a simple human body frame. The artist intends to explore the relationship between materials and human bodies in the contrast between expansions and contractions, rigidity and elasticity, stability and imbalance, flatness and convexity, fragility and strength. The artist attempts to turn matter into a spiritual carrier and into a work of art that is rich in the time dimension, leaving only the essential "peeling memories". Paper is biodegradable, and the use of recycled paper marks the extension, recurrence and ending of life cycles; meanwhile, the insignificant entity connects between the past and the present, and tells the story of time. The statues in the work are almost flat and have no volume, showing a state of fragmentation and compression, just like people's current life; at the same time, these images are vague, unspecific, and unresolved figures, highlighting the fragility and transience of everyday events between individuals and groups. The layers of highly compressed time are revealed when we peel back the opulent shell and examine ourselves from the inside, a feeling further enhanced by the color of the coffee immersion.

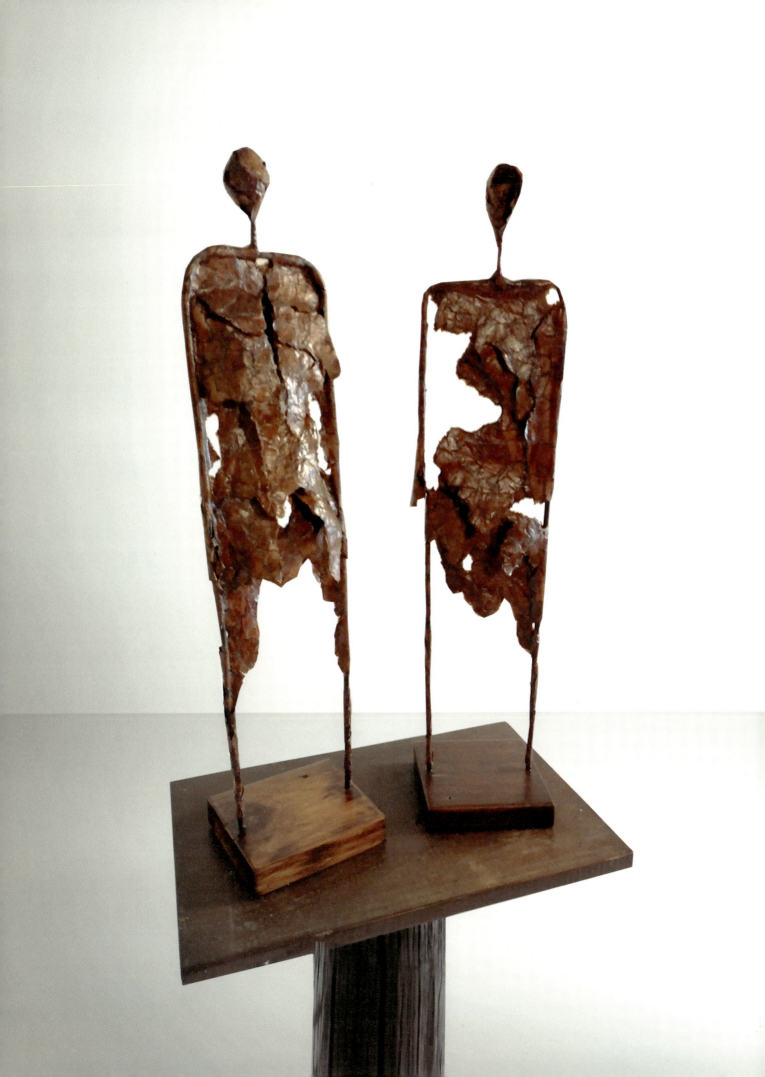

谢尔盖·贝罗基
Sergei Belaoki

（白俄罗斯 Belarus）

我们每天的面包	**Our Daily Bread**
美国纸币、聚合物树脂	USA banknote, polymer resin
每个约 13cm×19cm×8cm（each）	

美元与面包构成了这件作品的基本元素。灵感源自《新约》寓言故事中的"面包倍增奇迹"，耶稣创造了用 5 个面包喂饱 5000 个人的奇迹。不同的是，在作者的 5 个"面包"中，一个是真实的面包，另外四个是用树脂塑造的几近透明的面包形物体，透明的"面包"中包括美元纸币。作品中的面包实物会随

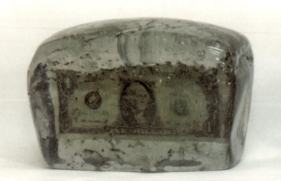
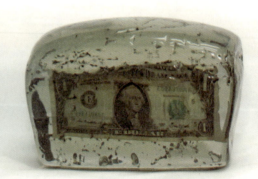
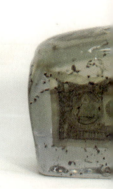

着时间产生质的变化，逐渐陈腐、发霉、开裂，最终溃成碎屑。而包含美元的透明树脂面包则保持不变，像琥珀（树脂化石）一样，拥有了某种永恒的特质，在光的照耀下，熠熠生辉，引发人们对这件明日之"化石"的欣赏与珍爱。作品的名称"我们每天的面包"取自基督教的主祷词"我们的天父"一文，表达了世界各地的基督徒都在祷告祈求上帝的帮助。如今主赐的面包与神迹已幻化成消费社会的金钱与物欲，在变与不变、短暂与永恒的对比中，作者探讨了现代消费社会中人类的生存、人们的愿望，以及对生命价值重估等问题。

This work is inspired by the "miracle of the multiplication of the loaves" from the New Testament, and the artist uses dollars and bread as its basic elements. In the New Testament, Jesus created the miracle of feeding 5,000 people with 5 loaves of bread. In this work, the artist exhibits one loaf of real bread, and four loaves of almost transparent resin "bread", into which dollar notes are mixed. The state of the real bread in the work will change as time flows: the bread will go stale, moldy, cracked, and will eventually crumble. The resin breads will remain unchanged like amber (fossil resin), which has a certain eternal quality. Light reflects on their surfaces, which draws people to appreciate and cherish this "fossil" of tomorrow. The title *Our Daily Bread* is taken from the (Christian) Lord's Prayer "Our Father", by which Christians around the world are asking for God's help in nourishment. Today, the value of God-given bread and miracles has been metamorphosed into money and material desires by a consumerist society. In contrast between the changed and the unchanged, or the ephemeral and the eternal, the artist inspires a series of discussions, including the survival and expectations of human beings in contemporary consumerist society, as well as the revaluation of life's values.

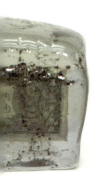

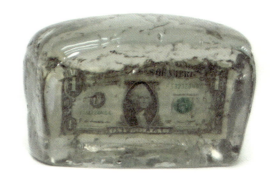

沈烈毅
Shen Lieyi

（中国 China）

雨	**Rain**
山西黑花岗岩	Shanxi black granite
	115cm × 80cm × 55cm

该作品创作于2001年，艺术家偶然从一本科普小册子上看到有关"雨"的图片后受到了启发，开始尝试用坚硬粗犷的材料表现柔美温润的水。他选择了花岗岩，结合精湛的雕琢和细腻的打磨，将两种极端表现融合在同一载体上，产生一种强烈的对比与反差。在中国传统文化中，"水"象征至阴至柔，而"石"象征至阳至刚，"刚柔并济"正是道家学说中一个蕴含丰富哲理的观点。水至柔，却滋养、灌溉万物。至柔亦是至刚，"水"的意象也由此升华。艺术家希望以当代的形式语言传递东方美学的意蕴，同时承载对中国哲学的部分表达：追求物与我、人与自然、艺术与生活的统一。作品传递出一份宁静、空灵、淡然的禅意，使疲惫烦躁的心灵得到抚慰与安宁。

Rain was created in 2001 when the artist was inspired by a photograph of rain in a pamphlet of popular science. He then began his artistic creation which features soft and gentle water, with hard and rough materials. In this work, granite, through delicate carving and elaborate polishing, merges the two extreme expressions into one. In this self-sustaining unity of contrast, the traditional philosophical idea of Taoism is conveyed: water, as the ultimate softness of *yin*, balances with stone, as the ultimate hardness of *yang*. Then, transcendentally, the ultimately soft water nourishes everything and becomes the ultimate hardness. Using the contemporary language of form, the artist aims to deliver the essence of Eastern aesthetics and to express the Chinese philosophy of the uniform coexistence between things and selves, humans and nature, as well as art and life. The work also represents a tranquil, ethereal and indifferent meditation, by which the audience receives comfort and calmness in the tiring and restless rhythm of life.

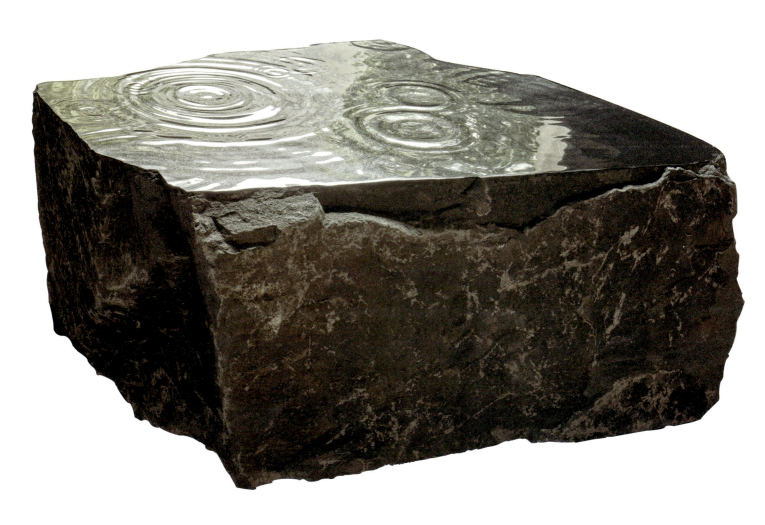

石富
Shi Fu

(中国 China)

猫	Cat
泡沫、丙烯	foam, acrylic

<div align="center">84cm × 84cm × 2</div>

猫喜欢挠东西，作者用身体的一部分——手在泡沫上模仿猫挠物体时的状态，进行浮雕式造型，然后将色彩涂抹成猫的颜色。作者以"猫挠式"的动作表现猫的本体形象，以猫的行为来表现猫的自身，更显"猫性"。同时，作者尝试用身体直接参与废弃泡沫的创作中，在彰显"猫性"的同时试图唤醒废弃物的灵性，寻找一些人性之外的其他形状。

Scratching is the nature of cats. The artist imitates a cat with his hand on waste foam. And the colored "cat" is scratching things on the foam, forming a relief effect. Symbolically, the artist uses the action of scratching to imply the existence of a cat. And more "cat-like" nature is excavated through this organic creation. Philosophically, this work is a combination of the flesh and the dead. A part of the human body is juxtaposed with the waste form, making itself a direct component of the creation. In doing so, the artist seeks to awaken the spiritual nature of the waste material and conjure up alternative forms of human existence.

石梅
Shi Mei

（中国 China）

一刀流	**One-Sword School**
综合材料	mixed materials
	120cm × 750cm

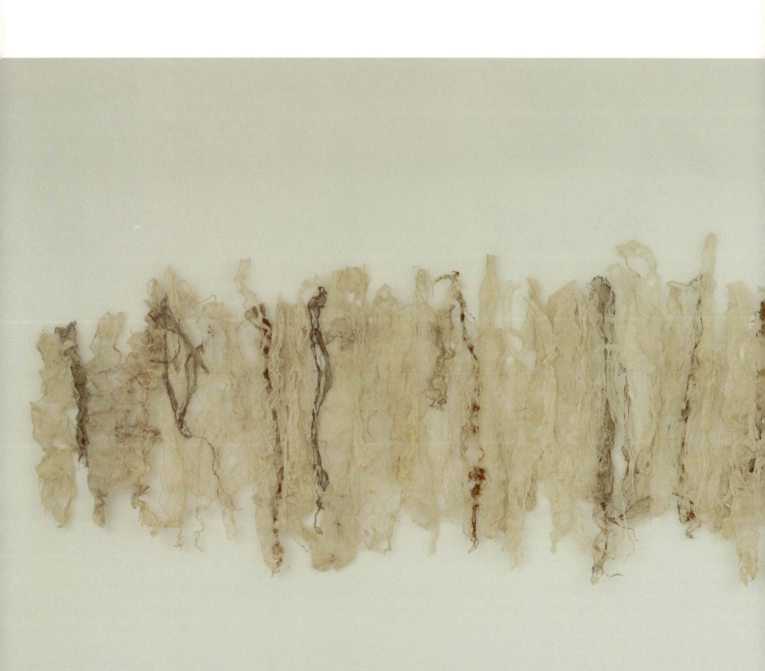

艺术家对剑道流派"一刀流"的观念很感兴趣。这个流派要求修炼者心无所住,犹如禅修。在比武时要忘却技术、忘却对手,甚至忘记生死,听凭直觉,坚定果断,涤荡杂念滞障,进入流水风吹般流畅的潜意识状态。于是艺术家试图使用综合的艺术手段来展现这种优雅自如而果敢干脆的精神:一缕缕、一丝丝的丝麻,半透明的黄色,似乎它们刚从刀尖上被断开,飘然飞起,但瞬间又凝固下来,而一旦它们一片片地并置起来,还在悄然地彼此应和,在风影中咏叹。作品形式结构简洁明快,一气呵成,不雕琢,不纠缠,听凭内心,随性而发。

The artist is very interested in the kendo ideas of *one-sword school*. Students of this school are required to reside nowhere, as if in a meditation. They should forget about techniques, opponents, even life and death, in any competition of martial arts. By listening to intuition, they become firm and decisive. After they have cleared away distractions and obstacles, they enter a subconscious state like the flowing of water and wind. Adopting these ideas, the artist uses comprehensive artistic means to show a spirit that is elegant, free and resolute. Strands of silk and flax in translucent yellow seem to have been disconnected by the tip of a sword. They flow upwards, but are solidified in an instant. Juxtaposed one by one, they quietly respond to each other and chant in the winds and shadows. The form and structure of the work is simple and clear, and it can be completed in one go, without carving or entanglement. The work is created from the heart and nature.

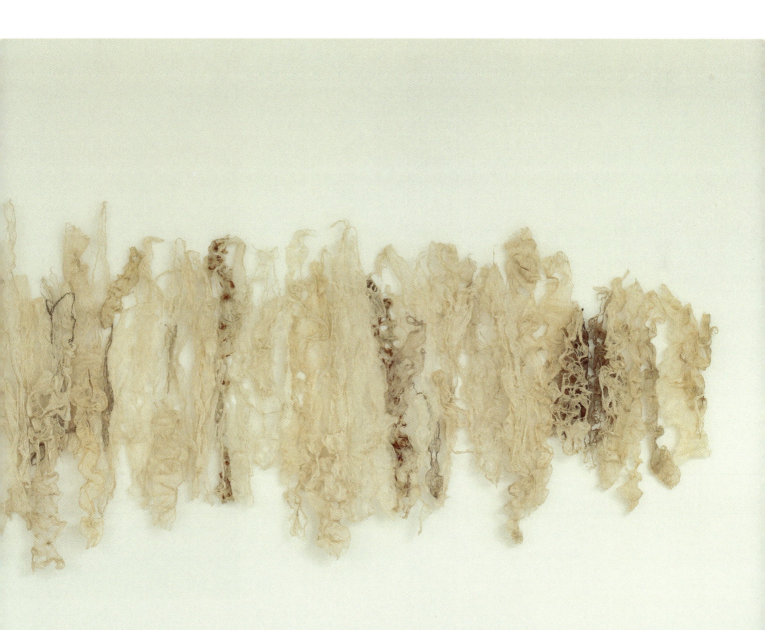

西比尔·黑恩
Sibyl Heijnen

（荷兰 Netherlands）

收集的风景	Collected Scenery
铝制饮料罐、木制托盘、松树	aluminum beverages cans, wooden pallets, pine trees

在池塘中的装置作品，池塘尺寸为 40m × 60m
（installation work in a pond, pond size 40m × 60m）

西比尔自 20 世纪 90 年代初以来所作的空间装置，最初可能给人以材料实验的印象。然而，她对纺织品、橡胶、人造草、天然材料和锡罐的干预对人们体验空间的方式产生了影响。她喜欢在现有的环境中，在公共空间和具有神圣或仪式功能的建筑中创作。在《收集的风景》这个临时装置中，数以千计的五颜六色的回收铝饮料罐和上面的小松树给她家乡的一个池塘带来了活力。散落在水面上的神秘"群岛"漂浮着，就像被淹没的土地上漂浮着的碎片。或者像浮冰，一个正在慢慢恢复色彩的雪域的残留物。用易拉罐创作产生了一种意想不到的绘画效果，让人忘记自己面对的是废料。它可以唤起人们对腐烂的思考，也可以让人联想到成长和光的喜庆回归。

The installations that Sibyl has made since the early 1990s initially made the impression that she was an artist focused on material experiments. However, her work with textiles, rubber, artificial grass, natural materials, and tin cans, is not only an experiment using unconventional materials, but also is a spatial experience for her audience. She likes to work in an existing context, in public spaces and buildings, with a sacred or ritual purpose. In Collected Scenery, a temporary installation, thousands of colorful recycled aluminum beverage cans, with young pine trees growing on top, gave vibrance to a pond in her hometown. Scattered across the surface of the water, the art resembled a mysterious archipelago floating like debris from a land that had been inundated and set adrift. Or, for others, it resembled ice floes, and remnants of a snowy area that is slowly regaining color. Working with cans has an unexpected painterly effect that makes one forget you are looking at waste material. It may evoke thoughts of decay, as well as associations with growth, and the festive return of light.

西蒙·法格斯
Simon Fagéus

(瑞典 Sweden)

五条腿的蜘蛛	The Five - Legged Spider
淀粉和营养粉末	starch and nutrition powder

220cm × 103cm × 46cm, 88cm × 50cm × 42cm

他摔了下来,虽仅有几厘米的距离,但男孩摔断了胳膊。在打了几个月石膏、在手臂上绑了手术杆之后,他似乎已经忘记了如何使用它。但是有一天,一位医生指着它说:你这是蜘蛛吗? 一只五条腿的蜘蛛?

在法格斯的作品《五条腿的蜘蛛》中,男孩让他的手,一只想象中的蜘蛛探索岛屿的风景。为了获得广阔海域中的渔业和矿产资源,人们必须"发现"一个新的岛屿。因此,曾经由大自然形成的一些微小造物被不惜一切代价保存下来,人们满心期待它们能创造出未来可能被称为"自然"的新土地,从而使获得"合法的"巨大财富。在艺术家的艺术实践中存在一条线索,即对于记忆功能的思考:私人的或社会的。他选择将人们建造的景观、机器和社会视为镜子,来观察人类作为族群的希望、思考和恐惧。这些微妙而荒诞的珊瑚岛于是成为他关心的对象,它们渺小、无关紧要,却是某种精心设计的希望的承载。他制作了这样一个岩石小岛,希望它成为人们反思人类社会、气候变化与地缘政治的一个奇点。

He fell, only a few centimeters but the boy broke his arm. After months in cast and surgical rods in his arm, he seemed to have forgotten how to use it. But one day a doctor pointed at it and said: Is it a spider you've got there? A five-legged spider?

In Fagéus work The Five-legged Spider, the boy lets his hand, an imaginary spider explore a landscape of islands. In order to gain access to fisheries and mineral resources in the vast ocean, one must "discover" a new island. Thus, some tiny creations that were once formed by nature were preserved at all costs, with the great expectation that they would create new lands that might be called "nature" in the future, and thus gain "legitimate" great wealth. The artist's practice is to ponder over the function of memory artistically: private or social. He looks at the landscapes, machines and societies that people build. They mirror the hopes, thoughts and fears of human beings as a species. These subtle and absurd coral islands then become the object of his concern. They are small and inconsequential, but are the carrier of some carefully designed hope. He has made such a rocky island, hoping it would become a singularity for people to reflect on human society, climate change and geopolitics.

宋春阳
Song Chunyang

（中国 China）

惹	**Provoking Series**
动物毛皮、PU革、填充面料	animal fur, pu leather, padded fabrics
	70cm × 950cm

材料可以带给我们直接的联想，通过视觉、触觉、嗅觉反映出最基础的情绪。作品将动物原生的形状和颜色皮毛与当下的人造皮革相混合，意在表达当下人们在生活中的情绪。这些穿着"皮草"的都市丽人，或三五成群，或踽踽独行，显示出一种在物质浮华表象下的慵懒、孤独和虚荣感，柔软、多彩、靓丽的皮草似乎能给他们带来某种舒适、慰藉和安全感。在艺术家看来，自然与人造材料的反差亦是一种协调。协调人们在生活中消失的安全感和日益增长的对物质生活的一种依赖性。

Materials can inspire direct associations and arouse our most basic emotions through sight, touch and smell. The work mixes the original shape and color of animal fur with artificial leather to express people's emotions in life. These urban beauties wear "furs", either in groups or alone. They show a sense of laziness, loneliness and vanity under the surface of material vanity. Soft, colorful and beautiful furs seem to bring them a sense of comfort and security. In the artist's view, the contrast between natural and artificial materials is also a kind of metaphor of people's lost security in life and their growing dependence on materials.

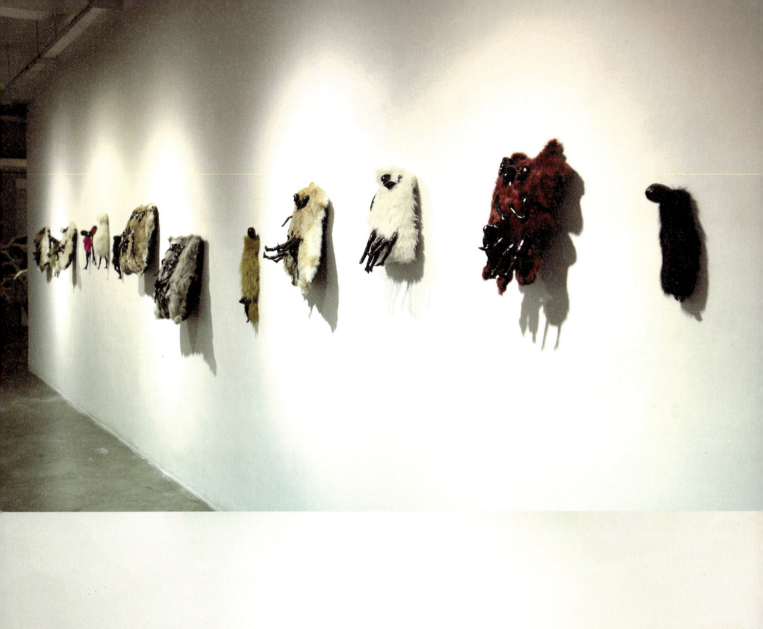
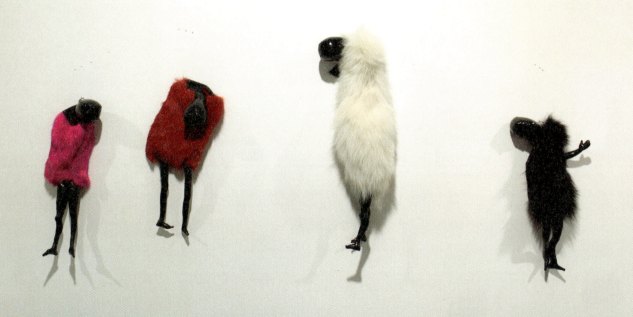

宋克
Song Ke

（中国 China）

物语	The Language of Objects
泥土、沙石、矿物颜料	clay, sand and gravel, mineral pigments
	200cm × 120cm

《物语》包含两层含义：其一，即物质材料的本质表达；其二，指物质材料除却本质属性之外的社会、人文价值，被艺术家提炼后所呈现出来的视觉符号属性。不同的材料带给观众不同的感受，金石质硬，布纸绵软。将这些材料通过揉搓、挤压、埋叠，又会形成新的视觉力量。材料作为绘画艺术语言的载体，其属性除了材料的形状、质地、色彩等基本特征外，艺术家更多的是在意其人文属性。《物语》通过主观化的处理，将泥土、砂石与矿物颜料进行碰撞，减弱材料的物理属性，更多的是观念的植入。作者汇集不同的材料，通过水油分离与层层叠加等手法，把隐含的思维转化为存在的观念，形成具有特殊意义的视觉符号。

There are two meanings of *Wu Yu* (The Language of Objects). First, the essential expression of materials. Second, the social and humane values of materials as a kind of visual symbol, which appears after being distilled by artists. Different materials evoke different feelings. Metals and stones are hard, whereas clothing and paper are soft. We assume new visual power by kneading, extruding, or folding these materials. Rather than paying attention to the basic properties of visual art, such as shapes, textures, and colors, artists often prefer to pay attention to the humanitarian aspects of materials. *Wu Yu* employs subjective treatment to decrease the physical properties of materials and add encourages more nuance, by combining clay, sand, and microscopic stones with mineral pigments. The artist collected various materials, applied water and oil separation, and superposition procedures, converted hidden ideas into existent concepts, and eventually made visual symbols with particular meanings.

孙继巍
Sun Jiwei

（中国 China）

浮生	The Floating Life
中国天然大漆、矿物质色粉、铝管	Chinese natural lacquer, mineral color powder, aluminum tube
	152cm × 146cm

艺术家长期从事漆画创作，她认为抽象、单纯的艺术语言体现漆材料的本质语言。于是，在探究抽象形态与现实物质之间内在联系的过程中，她选择将反复出现的线性符号作为自己漆语言的表述方式。在她的作品中，单一的形式关系中蕴含着丰富而厚重的线性力量，每一根线条看似被复制，但又无可复制，呈现出唯一性。作品中的线在律动、疏密、粗细的节奏中，在秩序中充满了丰富的变化，进而迸发出集聚的力量，引发情感与精神层面的共鸣。在浮光掠影的线之流动中，艺术家塑造了人生的浮动、繁华、漂泊、游离之感，用漆的语言传递出静态表征下的一种生命经验。

The artist has been engaged in lacquer painting for a long time. She believes that abstract and simple artistic language can reflect the material essence of lacquer. Therefore, in her exploration of the intrinsic relationships between abstract forms and real substances, she uses recurring linear marks to express her language of lacquer. In her works, simple relationships of forms are represented by abundant and solid lines. Every line seems to be duplicated, but also seems too unique to be duplicated. Between the thick and thin lines, sparse and dense variations burst out of order in grooves. The power is concentrated to trigger the resonance between emotions and spirits. Through the flow of lines, the artist expresses the turbulence, prosperity, homelessness, and isolation of life. The language of lacquer under static representation, therefore, conveys a form of life experience.

孙永康
Sun Young Kang

(韩国 Korea)

永线	The Endless Line
棉线、镜子片、泡沫板、博物馆板、胶水、糖粉	cotton thread, mirror sheet, foam board, museum board, glue, sugar powder
尺寸取决于空间(size varies depending on the space)	

《永线》是艺术家为一座文化公园举行的国际艺术家交流计划所作的作品,该文化公园建设在一座规模甚巨的糖厂遗址基础上。在作品中,艺术家使用了极为特殊的材料,完成了独一无二的艺术表达:白色的棉线从顶棚悬垂到地板,形成透明的柱状形式;每个顶部都有一面镜子,反射着底部的糖堆。柱状的形式既是边界的隐喻,也是两个相反理念之间的通道——历史悠久的糖厂终被废弃的悲惨过去,及该地为充满活力的文化公园的未来,从地面的糖(过去)通往顶棚的镜子(未来)。通透细腻的柱子,在深沉质朴的建筑背景下,还代表着对精神和神灵的信仰,正是这种信仰支撑着该地的人们度过艰难时期,开辟新的明天。

The Endless Line is a work for the "International Artists Exchange Program" of a cultural park, and it is built on the site of a huge sugar factory. The artist has used some special materials to achieve this unique artistic expression: white cotton threads dangle from the ceiling to the floor to form transparent columns; and, each column has a mirror at its top, and a sugar pile at its bottom. The columns serve as a metaphor for both the boundary and the link between two opposing ideas - the tragic past of the abandoned sugar factory (the sugar piles) and the future of the site as a vibrant cultural park (the mirrors). Meanwhile, the transparent and delicate pillars, against the deep and simple architectural background, represent the beliefs in the spirit and the gods. Viewers are inspired to have faith when going through difficult times, and to trust in the emergence of a new future.

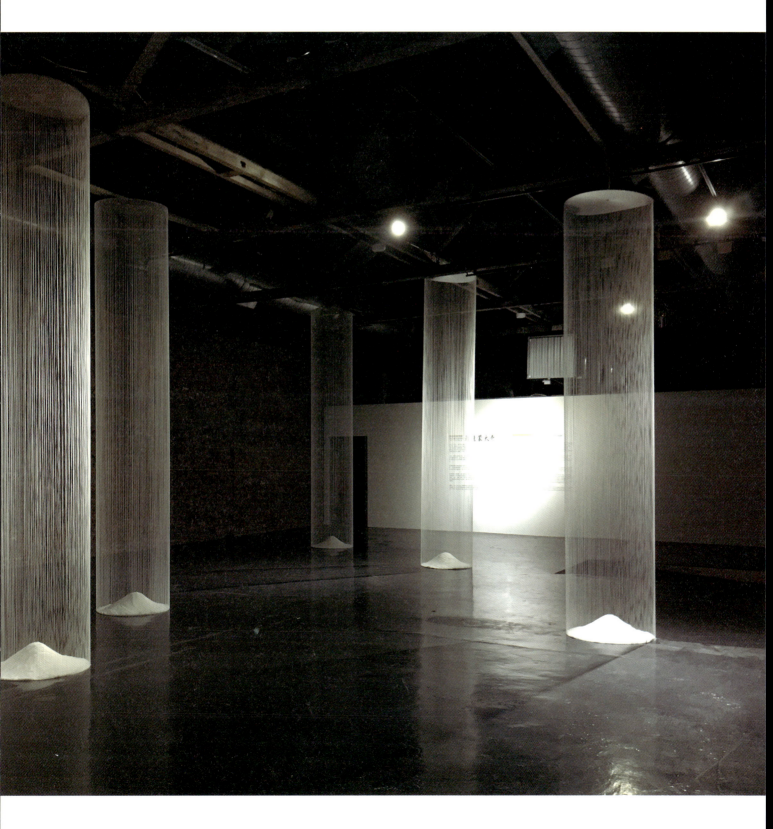

孙月
Sun Yue

（中国 China）

"新石器时代"工业印章	"Neolithic"Industrial Seals
陶瓷	ceramics
	110cm × 10cm × 70cm

艺术家常年关注非线性时间、概念界限与世界认知的主题，专注尝试用传统的陶瓷材料的或"泥土"，或"岩石"，或"尘埃"的不同自然状态，作品尝试运用陶瓷这一传统材料的不同形态，竭力从不同的角度切入，试图冷静地、不带感情色彩地模糊现实与虚拟的边界。作品来自"非非影地质实验室计划"，这是一个由十组作品组成的伪造认知的游戏项目。其中《"新石器时代"工业印章》是一组伪装成岭南地区新石器时代沉积层地质考察出土的陶制印章。而观众在互动使用时会发现所有"出土"印章印出的图案是日常工业产品的印记，由此探讨概念的形成与认知过程，创造出新的感知体验。

The artist always pays attention to the themes of non-linear time, conceptual boundaries, and human cognition. Different natural states of the traditional ceramic material, such as "soil", "rock", or "dust" are used to probe into the material from different angles. And the serene, emotionless, fuzzy boundary between the real and the virtual is explored. The work is based on the *Geo' Project*, which is a cognition-reshaping project (in the form of an interactive game) with ten groups of works. Among them, this group of ceramic seals are disguised as excavated antiques from Neolithic sedimentary layers in the Lingnan region. The audience will find out that they are actually manufactured products when they interact with these seals. The aim of the work is to create a new experience of perception where the formation of concepts and the process of cognition can be discussed.

苏珊·泰伯·阿维拉
Susan Taber Avila

（美国 USA）

森林	The Forest
线、数字印刷的丝绸、手工染色的织物残片、工业毛毡	thread, digitally printed silk, hand dyed fabric remnants, industrial felt
20 条带鞋的腿（10 对），每条 274.32cm × 49.53cm × 20.32cm	[20 legs with shoes (10 pairs), each 274.32cm × 49.53cm × 20.32cm]

艺术家早在 20 世纪末就开始关注自然与环境问题，不过她选择了一个别具一格的视角。在《森林》中，她选择使用手工染色的织物、数码印花丝绸和工业毛毡，制作了 20 条镂空的"腿"，都由树叶一般的绿色碎片拼接而成。奇特而幽默的外观，与残断的肢干形成鲜明对比，作为荒谬扭曲的人类社会与支离破碎的自然的隐喻。使用这些人造材料来重建一种"自然"的躯体，艺术家认为人类必须做好创造人造环境以代替自然的准备：在人口不断增加、城市化进程迅速发展、各种自然资源逐渐枯竭的情况下，人类或许必须努力实现，并最终接受，如该作品一般滑稽的"再造自然"。

As early as the end of the last century, the artist began to pay attention to environmental issues, but she chose a unique perspective. In *The Forest*, she chose to use hand-dyed fabrics, digital printed silk, and industrial felt, to make 20 hollow "legs". Green leaf-like fragments were spliced to the "legs". The strange and humorous appearance, in sharp contrast to the broken limbs, serves as a metaphor for the absurd and twisted human society and the fragmentation of nature. Using these artificial materials to rebuild a "natural" body, the artist asserts that humans must be prepared to create an artificial environment to replace nature. In the face of an increasing population, rapid urbanization, and gradual depletion of various natural resources, human beings may have to finally accept the funny "reconstruction of nature", like this work, and work hard to realize it.

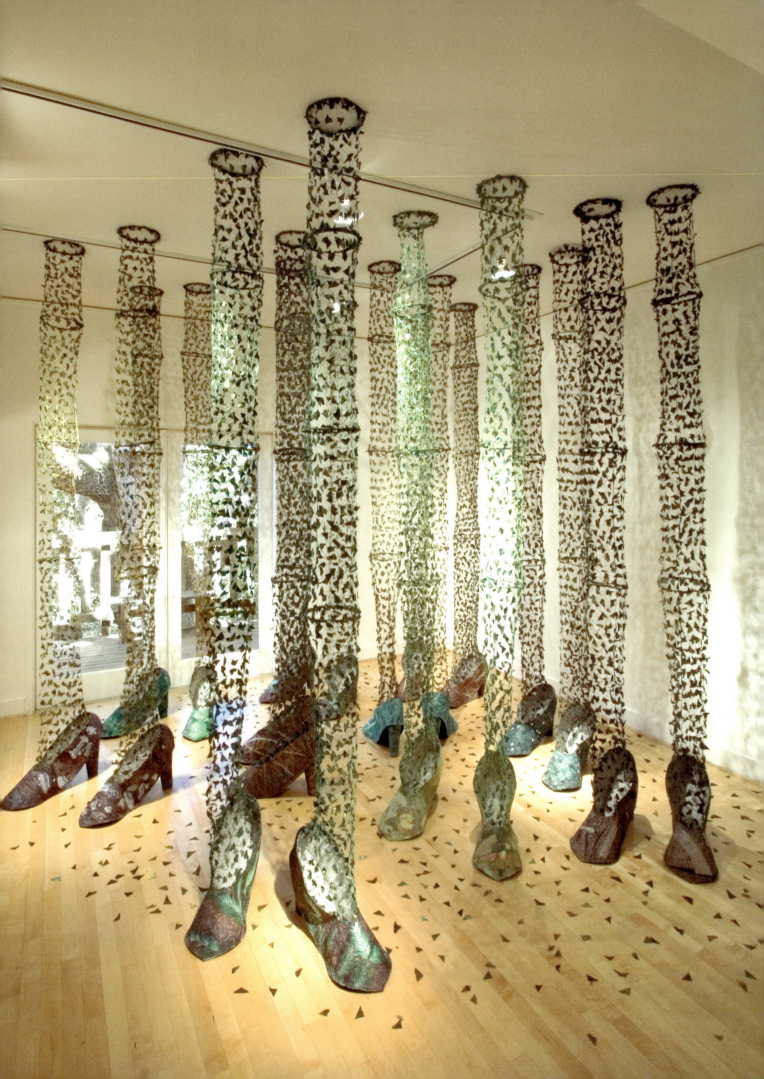

谭勋
Tan Xun

（中国 China）

彩虹中国计划之 2、3、4号	Rainbow China Project No. 2, 3, 4
彩钢板、铆钉	color steel sheet, rivets

230cm × 170cm × 150cm，250cm × 260cm × 230cm，
220cm × 130cm × 150cm

在飞速变迁快速发展的中国，临时建筑材料"彩钢板"被广泛应用。2017年末，艺术家利用废旧的彩钢板制作了第一件以其为材料的"彩钢石"作品，命名《彩虹》。此后，艺术家以"彩钢板"为线索调研了中国各线城市的发展现状，并将其延伸为一个更加庞大的《彩虹中国计划》，数十块"彩钢石"以当代艺术的姿态穿行于中国各大城市之中。《彩虹中国计划》系列作品通过当代艺术的介入方式，对同样"跃迁"式发展的中国社会做出积极回应。由此，该作品既是中国现代化、城市化进程的物证，也是改革开放四十年来中国社会飞速发展的精神纪念碑。

In China, "colored steel plate" temporary building material is widely used to meet the needs of rapid infrastructural changes and development. At the end of 2017, the artist created the first work made of stone-coated colored steel plates, using scrapped colored steel plates, and named the work "Rainbow". Since then, the artist has investigated the development status of various cities in China, based on research about colored steel plates, and has extended the original work into a larger "Rainbow China Project". Dozens of stone-coated colored steel plates are now exhibited in Chinese cities, in the form of contemporary art structures, and they represent the soaring development of Chinese society. This work can be regarded as the material evidence for the modernization and urbanization of China, and as a monument to the Chinese spirit in over 40 years of such development, under a reformed and open policy.

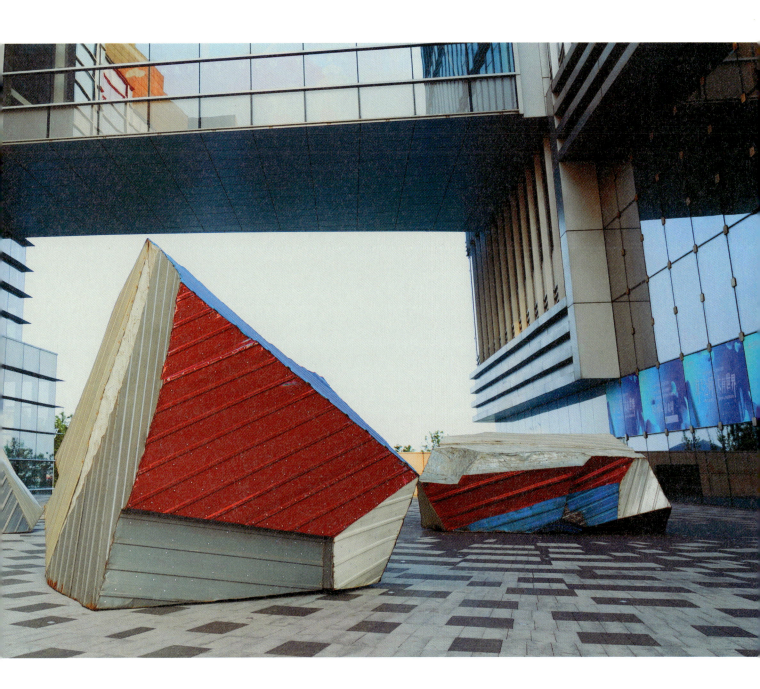

缇娜·玛莱
Tina Marais

（加拿大 Canada）

海流之下	Under Currents
茶叶袋、开心果壳、刺绣线、棉布衬底	tea bags, pistachio shells, embroidery thread, on cotton backing
225cm × 300cm × 4cm	

出于对地图和材料的轨迹的兴趣，艺术家使用茶包和开心果壳创造线条，形成了一幅关于它们运输轨迹的地图。这幅地图的形状与南非的地图相呼应，因其曾作为自东向西运输物料的关键点。她经常思考原材料在跨越海洋和跨越国界运输中多种多样的旅程，它们可能经过很多人的手，直到它被变成有用的东西，纳入人们的日常生活中。同时，艺术家也在思考身体、服装和水之间的相互关系，这是日常生活中的流动印记。在作品中，被丢弃的开心果壳和作为一次性使用物品的茶包成为与皮肤相关的表征，艺术家通过手工缝纫和刺绣的方式将它们缝缀成一幅流动的地图（又像是倒置悬挂的衣服），揭示了表面之下的轨迹、逻辑和生命力，探讨了人类和非人类实体之间的纠缠关系。

Fascinated by maps and trajectories of materials, the artist uses teabags and the shells of pistachios to create lines. These lines map a trajectory across a shape that echoes a map of South-Africa, a critical point in transit of materials from the east to the west. The artist often considers the multiple cross-ocean and cross-border journeys that raw materials make. She also considers the production process, passing through many hands until it is rendered useful to be included in people's daily lives. Meanwhile, she also reflects on the inter relationship between the body, garments and water, a fluid imprint on daily life. In the works, the discarded shells of pistachios and tea bags as single-use items become skin-related representations, which the artist stitches together, by hand sewing and embroidery, into a flowing map (also resembling clothes hanging upside down), revealing the trajectory, logic and vitality beneath the surface, exploring the entangled relationship between human and non-human entities.

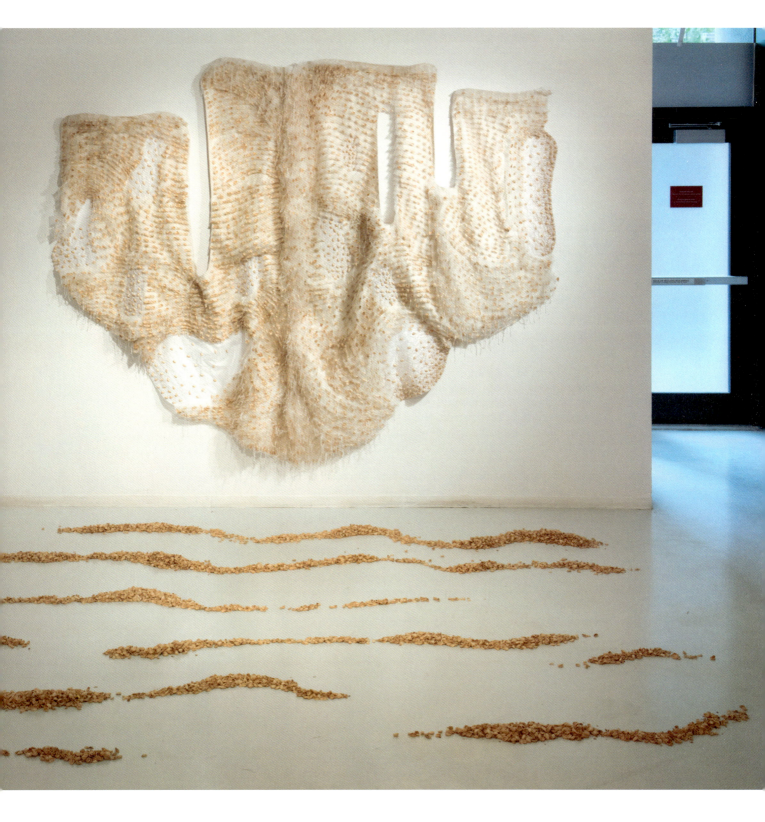

乌苏拉·盖伯·森格
Ursula Gerber Senger

（瑞士 Switzerland）

今日的游牧民 III	Present Day Nomads III
铜网、铁丝	copper mesh, inox wire
50cm × 30cm × 6cm	

在这个迅速变化的世界中，人们的工作流动越来越快，人际关系也面临更多的挑战，社会关系变得更加脆弱；人们被信息的洪流充斥着，感觉自己无所不在，又无处存在，像个无根的漂泊者，不断地想寻找自己的家园和归宿。作者基于这个主题所创作的系列作品，人物都是用金属网编织而成，抽象成一种移动的符号，剪影式地体现当代人在生存中漂浮、移动和脆弱的特质。在《今日的游牧民》系列作品中，这群人变成了现代意义的、被信息洪流驱使的人们。和之前群体性的表现不一样，这些人物形象都呈现为独立的个体，不透明的圆形小脑袋和铜丝精编的身体，每个人被放置在窄小的平台上，光线可以透过身体，给人一种漂浮的、移动的、独立而顽强的印象。

In this rapidly changing world, people appear to move more frequently to work in different places, while their interpersonal and social relationships are becoming more fragile and unstable. Torrents of information have gushed into people's minds, making them feel that they are everywhere, and simultaneously, nowhere. Like a rootless wanderer, they are unceasingly seeking their true homes and their final destinations. Grounded on this theme, the artist created a series of works that this work belongs to, in which the figures are all silhouettes woven with metal mesh, symbolizing mobilized, drifting contemporary people that can easily be broken. In the *Present Day Nomads* series, these flocks of people are becoming herded by torrents of information in a modern sense. Unlike when they were in groups previously, their figures are all presented as independent individuals, with opaque round heads and finely woven copper wire bodies, each being placed on a narrow platform. Light can pass through their bodies and create the impression that they are drifting and moving, but simultaneously, they remain independent and tenacious.

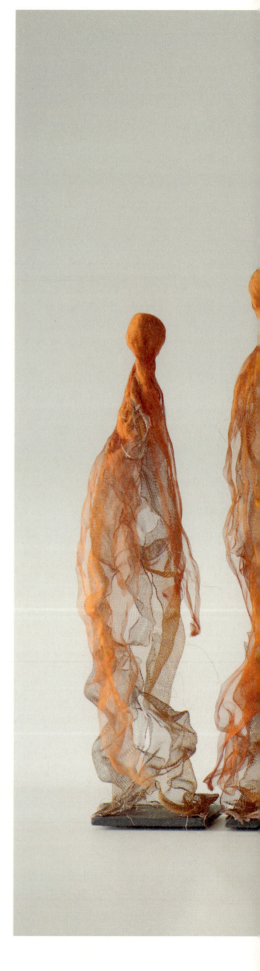

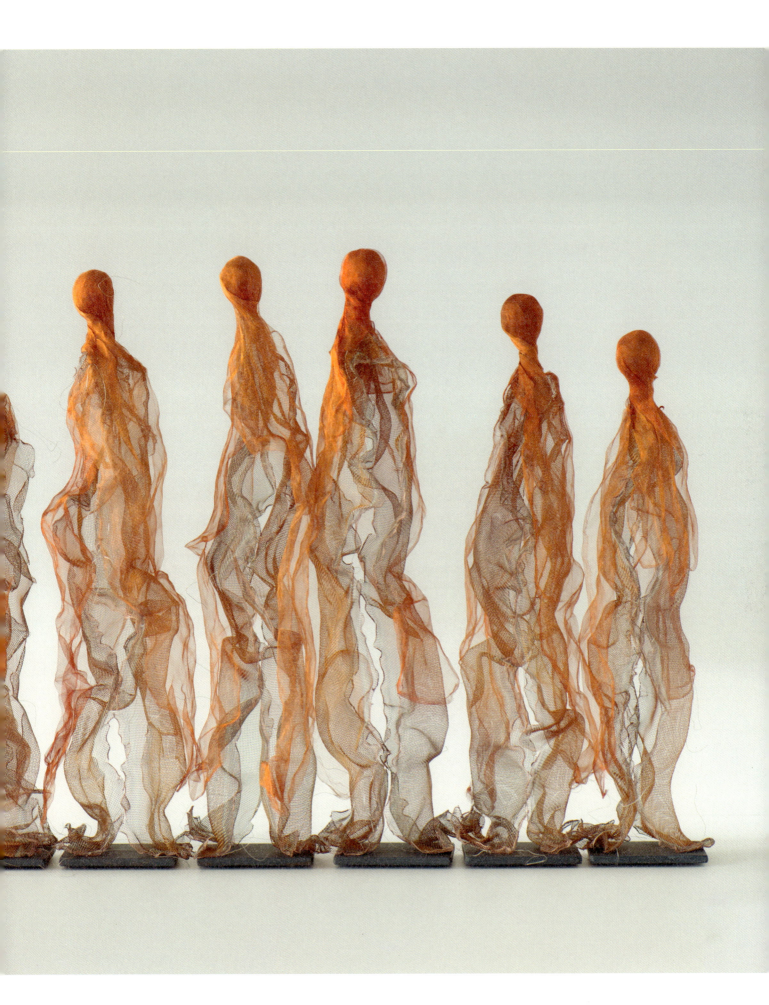

万里雅
Wan Liya

（中国 China）

天长地久系列 – 5d	Everlasting Series - 5d
陶瓷	ceramics
62cm × 38cm × 37cm	

一团黑色的物质，表面起伏缓和，遍布细碎的皲裂。它似乎是一节带着树瘤的木块，在亿万年前在山火中被烧成黑炭，又被深深埋藏于地下在高温高压中生长出了这些闪亮深邃的鳞片。这是来自于自然一种特殊的结晶，物质在生命与毁灭之间流转，使有机与无机相互交融，凝结出真正的"天长地久"。这是艺术家对陶瓷本体语言的探索，注重于表现客观物质材料的固有属性，并探寻这些物质属性对个体生命产生了何种的观照。由此产生的作品成为一种基于客观的主观表达，创造了材料在模拟和表现之间的暧昧空间。

It is a chunk of black substance that resembles a piece of tumorous wood. Tiny cracks crawl on its undulating surface, as if the chunk was made into coal. Imaginably, the wood was burnt down in a mountain fire hundreds of millions of years ago, and then was buried deep below the ground. These glistening scales were able to grow because of extreme temperature and pressure. During this process of natural crystallization, the flow of matter between life and destruction blends the organic and the inorganic together into the real "eternity". This is the artist's exploration of the ontological expression of ceramics. The intrinsic nature of objective materials is revealed, while the reflection of their characteristics on individual life is materialized. In this creation, subjectivity finds a place within objectivity, giving birth to an ambiguity of materials between simulation and representation.

王海燕
Wang Haiyan

（中国 China）

蕾丝系列	Lace Series
综合材料	mixed materials
30cm × 30cm，20cm × 20cm	

艺术家钟情于中国民俗中花卉的表现形式，因其淳朴本真，造型概括洗练，色彩热情浓郁，承载着人们的期盼与向往，又宣泄着原始炙热的情感本能。而蕾丝则是近代舶来的欧洲时尚产物，又称"花边"，最初就是以纱线捻制花卉纹样的装饰物，在当代语境中逐渐变为女性特质、柔美精致的代表。艺术家选取了这样一种外来文化的材料，结合中国传统民俗的纹样，以"花"制"花"，糅合创造出一种独特综合的形式美感。艺术家认为，"花"从自然界中来，实际上已成为根植于人类内心深处的一种关于"美"的理念形态，因此在不同的文化地域中都显现着多样的审美理想和生命价值尺度。

The artist expresses Chinese folk customs in the form of flowers. The works are simple and authentic, with refined shapes and energetic colors. Expressing innocent passions, they represent the expectations of the people. In contrast, lace is a modern product of European fashion. Originally a decorative object with flower patterns twisted by yarn, it has gradually become a representation of femininity and sensuality in the contemporary context. The artist combines foreign culture and Chinese patterns in material processing to create such a unique and comprehensive form of beauty. Using lace, the artist creates flowers, which she believes are summoned from nature, and have become an ideal form of "beauty" rooted in people's minds. And so, through this series, various aesthetic ideals and values from different cultural regions are expressed.

王建
Wang Jian

（中国 China）

马	Horse
PLA 树脂纤维、塑料线	PLA resin fiber, plastic thread
180cm × 100cm × 60cm	

作品《马》是用树脂纤维材料以 3D 打印笔立体手绘制作。艺术家通过探索材料与形象塑造之间的相互适应性与融合性，表现人与社会、传统与科技、人造与自然的互通关系。在作品中，艺术家持续关注商品的社会化属性与人工以及自然环境的微妙关系。随着技术的进步，我们对于材料的感知比以往更加多元：在虚拟与现实的技术中感知世界，通过新颖又综合的材料媒介认知环境。艺术家试图用这些具有商品属性的材料与传统编织工艺相结合去创造一件新型作品：我们看到的是怎样的生命？人们能否在信息洪流编织再生的形象中感受到马匹的吐息，或是其背后广袤无垠的原野？

Made of resin fiber with 3D printing pens, this work explores the mutual adaptability and integration between materials and image shaping. The artist tries to express the interaction between people and society, tradition and technology, as well as humans and nature. In his work, the focus is on the subtle relationship between the socialized attributes of commodities, and the artificial and natural environments. With the development of technology, our perception of materials becomes more diversified than ever: we perceive the world through virtual and real technologies, and we perceive the environment through novel and comprehensive material media. The artist tries to create a work by combining materials with commodity attributes and traditional weaving techniques: What kind of life do we see? Can people feel the breath of horses in this image of woven information flow and regeneration; and, can people feel the vast wilderness behind these horses?

王家增
Wang Jiazeng

（中国 China）

物的褶皱系列	The Folds of Things Series
铁、铝、不锈钢	iron, aluminum, stainless steel

250cm × 170cm × 80cm

王家增作品始终围绕着与个体生命经验相关的记忆、感知进行艺术表达——代表时代阶段发展的钢铁工业与他个人的故事，在时间里不断发酵、变化与生长。他近两年创作的钢铁综合材料作品在艺术媒介语言拓展的同时，将艺术表达力再次提升——对废旧钢铁的敲打、揉搓，以身体参与的方式将情感、故事与思考投射于作品之上。通过对"物性"的观察与表达，进一步强调和突出对"物"与空间、时间的关系，与观者关系的思考。作品物的褶皱系列，其灵感源于2018年冬天。彼时他在一间工业材料市场，看着"整齐排列、色彩斑斓又无比颓废"的二手钢材，他心里产生制作作品的冲动。利用不同的材料——手工纸、金属等，挤压后塞进盒子中，试图传达一种"挤压和禁锢的感觉，一种当代生活的压迫感"。

The artist likes to focus on the memories and perceptions that inspire individual artistic experiences. He creates works which represent the era of steel, and he juxtaposes his own personal stories into these works – stories which evolve, change and grow as time passes. Over the last two years, he has expanded his artistic language and artistic expressiveness through these mixed media steel creations. The artist projects his emotions, stories and thoughts onto these creations through his physical participation in altering these metals – beating and molding them into the sculptures that they are. The physicality involved in the creation process, to the artist, is a meditation celebrating our relationship with materials, space, and time. The artist's initial idea to create these sculptures came in the Winter of 2018, after he visited a market where he found beautiful second-hand steel products. Using this second-hand steel, the artist squeezed various materials, including handmade paper and metals, into a box to create a "fold". In doing so, he created art which conveys "a sense of congestion and imprisonment, and a sense of repression within contemporary life".

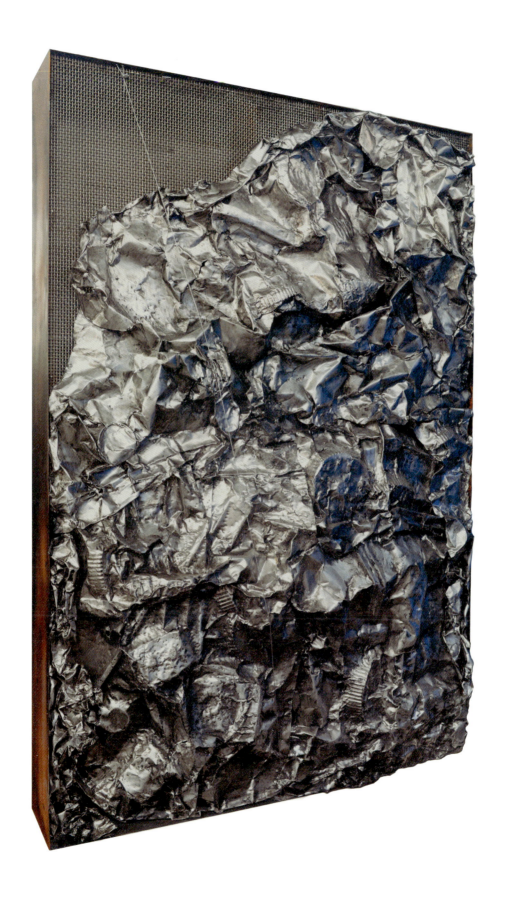

王雷
Wang Lei

（中国 China）

文锦中华 2018	Brocade for China 2018
2018年全年《北京晚报》搓线	threads made of 2018 full-year *Beijing Evening* News papers
	394cm × 569cm

这件作品从形成方案到制作完成，历时一年有余。其中花费最多时间的当然是其材料本身：一年份的《北京晚报》，每天准时被邮局投送到艺术家的邮箱，带来2018年某一天中关于中国方方面面的大事小情。艺术家通过纤维技术将这些报纸变成一股股"丝线"，再编成一整幅巨大柔软的织物。作品是物的载体、信息的载体，也是时间的载体。在作者"一针一线"的表达中，所有的事情都在理念层面融为一体，被编织进这一片中华"织锦"图。

The creation of this work, from concept to realization, took over one year to complete. Most of this time was spent on collecting the material itself: a full year's *Beijing Evening News* (2018) was delivered to the artist's mailbox every day, and so was daily information about China each and every day. The artist turns these newspapers into strands of silk-like thread (through fiber technology) and then weaves them into a huge soft fabric. This work is the carrier of things, information and time. Thread by thread, all things are integrated at the conceptual level and woven into this piece of "brocade" for China.

王立伟
Wang Liwei

(中国 China)

蓝色骨头	**Blue Bones**
牛皮、树脂、木板	cowhide, resin, wood
	120cm × 60cm × 136cm

崔健在他的歌曲《蓝色骨头》中写道："太可惜，也太可气，我刚刚见到你，你是春天里的花朵，长在了秋天里。"青春如流水落花，而生命亦如是。在人类历史的长河中，人生匆匆几十年无疑是短暂的；文明千年的演变，在宇宙数以百亿计的生命中却也是须臾。若跳出时空来看，你我皆与夏虫毫无分别，"生"的底色即为"死"。既然无可逃避的死亡是每个人注定的结局，我们则必须面对死亡的终结来生活，此即海德尔格谈及的"向死而生"。艺术家用有机的温暖皮革制作出人形，这本是生命的原调；而部分骨骼则呈现出深沉悲郁的蓝色，仿佛是糅合进身体的死亡印记，它象征着这具躯体最终毁灭的结局，却也是定义它不可或缺的部分。这旋转扭动的躯体仿佛就是生与死的写照，是自由与锁链的缠绵，是灵与肉的纠葛。

"It's a pity, and it's so annoying. I just saw you. You are a flower of spring, growing in autumn." In Cui Jian's *Blue Bones*, youth is depicted as the flowing water, and so is life. Compared to humans' history, a life in decades is undoubtedly short, while civilization is also dwarfed in time span when put on the scale of the universe. Outside of time and space, there is no difference between us and an insect in summer, for whom "life" takes the background of "death". We have to admit that it is a destined journey on which we are, as Heidegger commented, "living toward death". The artist uses leather material to create a human figure. It is warm and organic, which is the major tone of life. Tinged with a melancholy blue, some bones symbolize the integrated mark of death on the body, foreboding the final destruction. This posturing creation is the demonstration of the entanglement of life and death, freedom and constraints, as well as the spirit and the flesh.

王晓昕
Wang Xiaoxin

（中国 China）

冥想之联	**Connected Meditation**
黄铜、金	brass, gold
	28cm × 28cm × 28cm

《冥想之联》是以 3D 打印技术结合传统铸造技术完成的具有科技感的作品。乍看上去，这件作品有些类似中国传统工艺的嵌套透雕技术，但实际上却是以计算机软件设计，以机器打印制造的"工艺品"或"雕塑"。这是新的铸造技术，而这样的技术手段必将改变传统艺术的创造方法。基于此，作为传统的工艺美术和造型艺术得以实现更为复杂的创造意图，其造型语言也必将发生改变。作为造型形象的基础，该作品重复链接的是人的"图腾"式形象，象征并寓意着人工智能时代人类基于科技所产生的新的社会链接。

Connected Meditation is a work tinged with technological senses. It is completed via 3D printing technology that integrates traditional casting techniques. Its initial resemblance to a nested open work, made by traditional Chinese craftsmanship, turns out to be a printed piece of "artwork" or "sculpture" designed by software and manufactured by machines. This work adopts new casting technology, and such a technology will surely change the way of traditional artistic creation. Consequently, the design language will inevitably change, as artistic intentions with more complexity are able to be achieved by the coexistence of traditional artistic craftsmanship and design art. The basis of the design image of this work is a recurring "totemic" image of humans. These recurring actions of image linking represent and symbolize the new social links between humans that are generated by technologies in this AI era.

王绪远
Wang Xuyuan

（中国 China）

墨·影	Ink & Shadow
光、塑料、水（冰）、陶瓷、宣纸等材料	light, plastic waste, water (ice), porcelain, rice paper, etc.

350cm × 350cm × 150cm

《墨·影》是一件水墨光影装置作品。它采用塑料垃圾作为主材料，透过光线与空间的调配，在宣纸上呈现出一幅广袤冰山图。注满蓝色液体的塑料瓶与真实的冰块一起构成了"冰山"脚下的景观，在灯光的照射下营造出冰与水的通透感。冰下银光闪烁的 LED 光导纤维顺流而下，预示着冰川将化为融水，直至消失的现状，企鹅母子立于冰面愈加显得孤立无援。装置正面的肃穆静美、流光溢彩的美景与背面的凌乱无序、混杂堆砌的塑料垃圾形成鲜明的对比。艺术家通过运用多种材料，在同一空间，展现了两种完全不同的世界。这种冲突性引发人们的思考：我们日常所见的物品，在不同的环境中产生了截然相反的作用。出于对环境保护与极地气候的关注，艺术家希望以此作品来引发人们对生态变化、环境污染的反思。

Ink & Shadow is an installation of ink, light and shadow. It is made from plastic garbage and Chinese art paper as the main materials. The work represents a vast iceberg, and is exhibited with controlled lighting and spatial distribution, as directed by the artist. The plastic bottle filled with blue liquid forms the landscape at the foot of the "iceberg" together with real ice. Under the light, the audience can sense the translucence of ice and water. The silvery LED optical fiber under the ice flows down like a river, and the ice seems to melt and eventually vanish. Meanwhile, the penguin mother and baby appear to be more isolated on the ice. The glistening solemnity of the scenery in the front is in sharp contrast to the cluttered disorderliness of plastic garbage in the back. By using multiple materials, the artist shows two completely different worlds in the same space. This conflict leads people to consider the possible negative outcomes from humanity's use of daily plastic objects when they wind up in various wild environments. Inspired by the arctic climate, and aware for the need for environmental protection, the artist hopes to use this work to trigger people's reflection on ecological changes and environmental pollution.

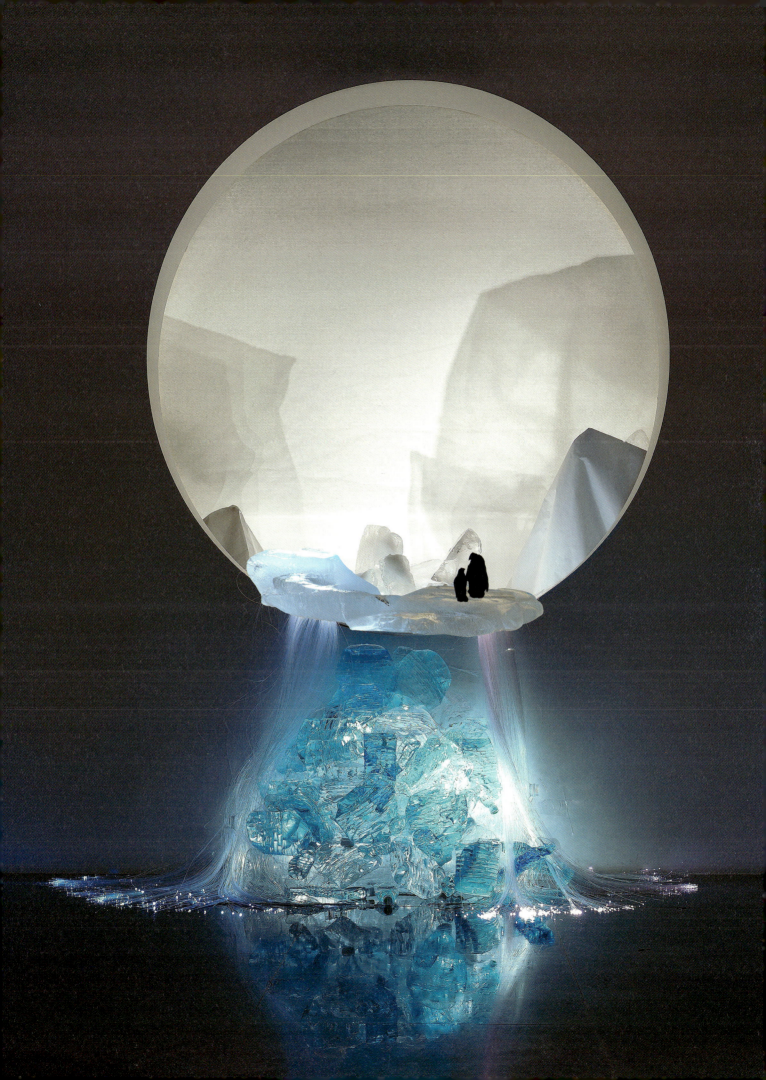

王忠民
Wang Zhongmin

（中国 China）

沉默？	Silence?
天然生漆、麻布、瓦灰、三合板、松节油	natural lacquer, linen, tile plaster, plywood, turpentine

<div align="center">90cm × 90cm</div>

大漆作品《沉默？》主要从两个维度来表达基于材料的艺术语言的多种可能性。一是从漆材料和工艺角度，漆艺的每道工序都是经过手工的重复打磨、推光、揩清等实现漆面的坚硬、光感和平滑感。作品中麻布的粗糙和黑色贵宾犬身上的光滑明亮形成鲜明的对比，表达了黑色大漆独有的质感语义。二是从中文造字的隐喻角度，"默"字由"黑"和"犬"结合而成，构成了"沉默的主体""沉默的大多数"等语汇。但艺术家希望在这个时代人们可以不再沉默，于是在作品名称后面加了"？"。作品中贵宾犬的剪影十分光滑，可以映射出每一位观者。每个人在观看作品时都是凝望着一个黑色镜面后的"自己"，使作品与观者形成了互动关系，形成了人与物、与己之间想象的可能。

This work of lacquer art is an exploration of the multiple possibilities of material-based artistic language. The two dimensions of expression are material craftsmanship, and metaphoric ideographs. On the one hand, the hard, glossy, and smooth surfaces of lacquer are created through repetitive steps of lacquer handcraft, including polishing, glossing, and wiping. Crude dusters are juxtaposed with a smooth and glossy black poodle to demonstrate contrast in the texture of black lacquer. On the other hand, the Chinese character "*Mo*" (silence) is composed of the characters "*hei*" (black) and "*quan*" (dog). The inclusion of these characters suggests: silent subjects, the silent majority, and so on. In the hope that people are no longer silent, the "?" is added to the title. The silhouette of the poodle is so smooth, that it can even reflect the audience. When observing the work, the audience seems to be gazing at themselves from behind a black mirror. It thus becomes an interactive work, where the audience is inspired to reflect upon themselves, but also on the relationship between themselves and the objects in the work.

瓦达·纳伊姆·布哈里
Wardah Naeem Bukhari

（巴基斯坦 Pakistan）

空间中的躯体	Body in Space
棉线、绳子	threads and ropes
尺寸可变（size variable）	

当代艺术在保护和继承传统文化的事业中能够扮演什么样的角色？瓦达给出了她的答案。生活在享誉全球的南亚民族珠宝中心木尔坦，珠宝成为艺术家的兴趣中心，她希望用全新的方式来向世界介绍这项濒临灭绝的传统工艺——"帕托利"。她遵循传统，用打结工艺制作装饰性的花环，展现出线与绳之间精彩的缠绕、曲折和联系。艺术家选择人体内的静脉、动脉和器官的结构来构建这样一个雕塑性的装置，似乎通过巫术般的古老传统将人的躯体解构展现在一个开放的空间中，从而将一种民族的记忆转化为极具当代性的艺术形式。

How can contemporary art contribute to the protection and inheritance of traditional cultures? Wardah gives her answer through this work. Living in Multan, Pakistan, which is a world-renowned South Asian ethnic jewelry center where jewelry has become a center of interest for artists. Wardah hopes to introduce this endangered traditional craft, "pattoli", to the world in a new way. Following the tradition, she uses knots to create decorative wreaths, showing wonderful twists and connections between threads and ropes. The artist models on the structures of veins, arteries and organs in this sculptural installation. It deconstructs the human body into an open space seemingly through the ancient tradition of witchcraft, thereby transforming an ethnic memory into a contemporary art form.

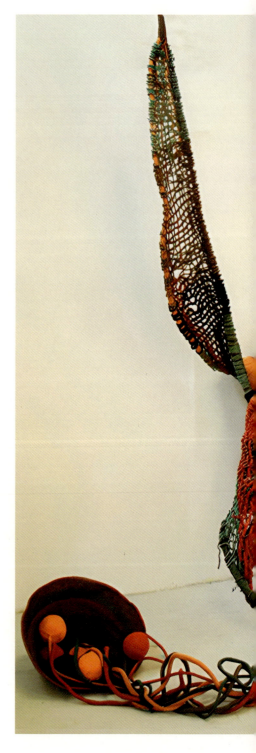

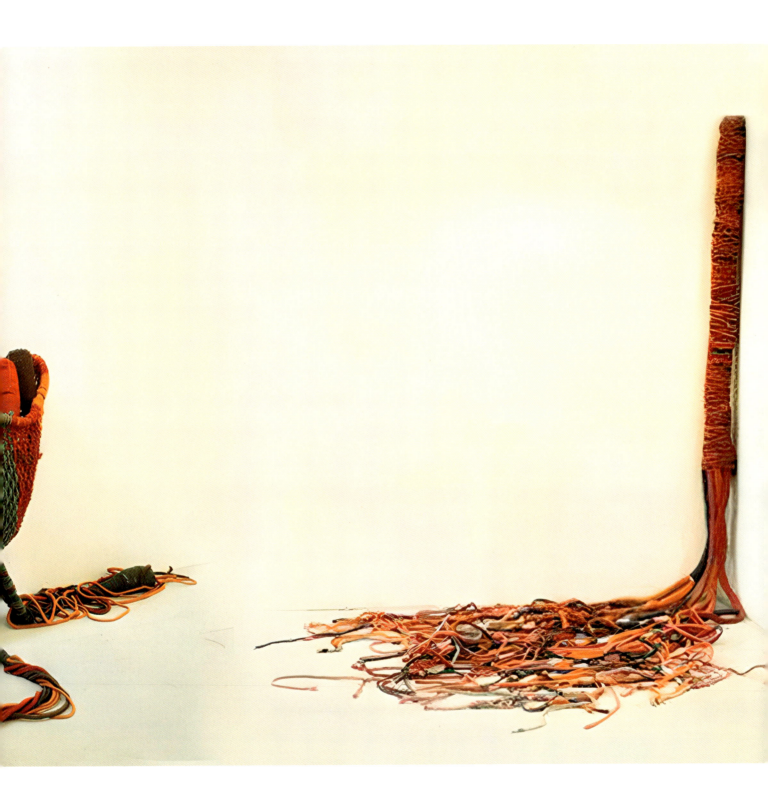

瓦坦舒特·汤加特雅
Wattanchot Tungateja

（泰国 Thailand）

东方思维	Oriental Mind
木材、陶瓷、金属	wood, ceramic, metal
	90cm × 500cm × 10cm

艺术家对世界和自然怀抱着真切的热爱，他像从古至今的亚洲人一样，乐于向自然学习，将尊重自然、与自然共存作为一种普世的信念。他认为，尽管在全球化程度极高的今天，各种类型的亚洲文化传统都已混合到一起，但这样一种关于自然的思维方式仍是所有亚洲人共有的基因。艺术家结合自己在亚洲旅行的经历，将亚洲各民族在日常生活中使用的一些常见物品融合到他的作品中，综合运用木材、陶瓷和铁器——古老文明的基本材料——创作出这些独具风情的半抽象作品，展示独属于亚洲的生活、信仰、传统和爱情。

The artist shows an ardent love for the world, an Asian inheritance from ancient times. He is eager to learn from nature, to respect nature, and to believe in coexistence with nature. Even in today's extremely globalized world, he still believes in the mixture of various types of Asian cultural traditions. In this mixture, Asian principles for thinking about nature are expressed. Combining his travels in Asia, the artist incorporates into his works some common objects that are used in daily life by diversified peoples in Asia. He also adds wood, ceramics and ironware—the basic materials of ancient civilizations—to these unique pieces. It is a semi-abstract style of work that showcases life, beliefs, traditions and love unique to Asia.

吴昊宇
Wu Haoyu

（中国 China）

新石器 2020—No.1	Neolithic 2020-No.1
瓷	porcelain
61cm × 20cm × 41cm	

《新石器 2020—No.1》是以瓷为工艺制作的造型艺术。该作品看似貌不惊人，像是博物馆展出的新石器时代原始祖先的磨制石器。"石器时代"是文明的转变时代，人类从自然中取材，循着天然造型而加以改造。在人类学家看来，工具与艺术都是劳动创造的产物，而人类创造的第一件工具便同时是第一件艺术品。带着纯真的目光，或以现代主义的视角，作品回望着人类最初的创造之物，这种造型的单纯却同时是美的合规则的观念表述。

Neolithic 2020-No.1 is a piece of design art made via porcelain craftsmanship. The work appears to be unremarkable, like the stone tools on display in the museum, used for polishing by our primitive ancestors of the Neolithic Age. The "Stone Age" represents an era of transformation of civilization, when humans began taking materials from nature and transforming them, while simultaneously taking advantage of their natural shapes. From the perspective of anthropologists, both tools and art are products of labor. The first tool of humanity is also the first piece of artwork. Looking with a pure mind, or looking with a modernist view, the work traces back to the emergence of human beings. The simplicity of shape in this work represents a formal notional expression of beauty.

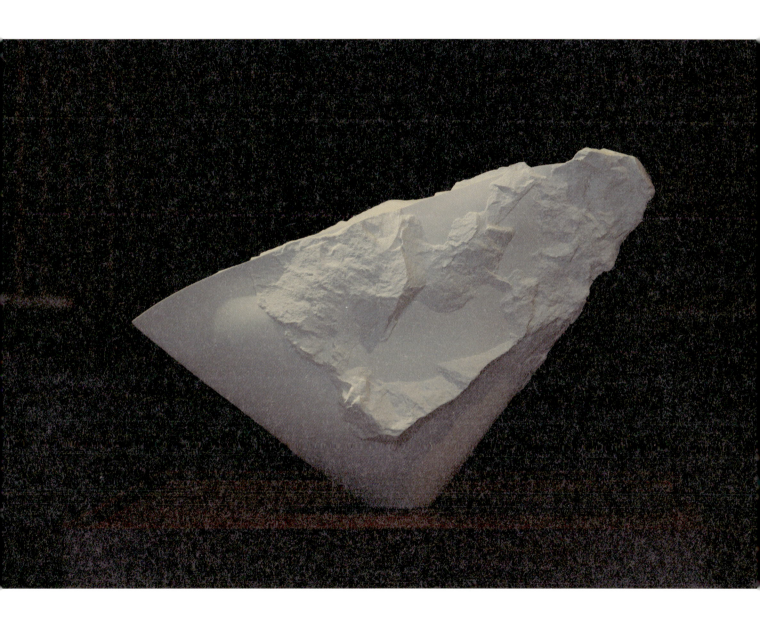

吴九沫
Wu Jiumo

（中国 China）

《舞者》系列	"Dancer" Series
墨、宣纸、布面油画	ink, rice paper, oil on canvas
60cm × 50cm × 2	

碎片化的拼贴成为当下社会生活的表征。人们每天接收的信息量超负荷且不完整。不断产生的图像及网络信息等同于杜尚的现成品,与浩瀚的人类历史共存。"碎片化"与"共享图片"带有"并置"与"混杂"的特点成为艺术家创作的出发点。她试图描绘复杂的混合体,因为任何时代人们的感受总是"百味杂陈"。她希望通过非单一的图像母题表现出这种混杂的情绪,希望通过作品在现实世界的苦难,升腾起一种类似舞蹈的轻盈。这组《舞者》是在疫情期间画的,内容包括穿防护服的医生与消费时代的广告等形象。作品以拼贴的方式将碎片化的"时代切片"并置成"婆娑世界"的曼妙舞姿。

Contemporary life can be characterized as a "collage" of fragments - our overloaded and incomplete intake of daily information. In this work, the constantly generated images and network information that we are faced with in the modern world, are juxtaposed with the ready-made products of Duchamp - a "coexisting" of humanity's vast history. Juxtaposed and mixed "fragments" and "shared pictures" are the focus of the artist's creation. She tries to include a complex mixture, because people's feelings in any era are always "mixtures" (they are always complicated). She hopes to express this sentimental mixture through non-monotonic motifs of images. Moreover, she wants to inspire a lightness of dancing from out of this world of suffering. In this series composed during the COVID-19 outbreak, we see fragments of COVID images, such as doctors in protective clothing, juxtaposed with ads from our "age of consumption". In each of the collages, a "wavering world" in the shape of a graceful dancer is unfolded.

向阳
Xiang Yang

（中国 China）

《陶瓷系列》之喜字双罐、三色冬瓜罐	The Ceramic Series - Double Jars with the "*Xi*" Character & Tricolor Winter Melon Jar
陶瓷	ceramics

27cm×22cm×10cm，24cm×24cm×19cm

艺术家在此呈现的系列陶瓷作品，都由源自于中国千年瓷都景德镇自唐至民国时期瓷窑遗址出土的"窑渣"制作完成。这些在制过程中产生的残次品往往被遗弃，俗称"窑垃圾"。它们伴随窑址的坍塌被掩埋，在自然环境中生成的外观特征，原本实用的定型器物在物理性上产生了千变万化的独一性。它们用一种物质性的、"更真实"的路径传递着文明背后的故事。艺术家则发掘了它们的价值，使其每一个都成为独一无二的抽象的形体。它们是文化传承过程中遗缺的部分，是被折叠和隐藏的部分。艺术家通过拣选、清洁、分离、打磨和雕琢，将器物从毁灭的事件和失败的记忆中独立出来，以这些"历史的残渣"为材料，为人们提供了认识它们乃至其背后历史的不同方式。

The ceramic works presented here are all made of "kiln slag". The slag was unearthed from the historic Tang Dynasty porcelain kiln sites in Jingdezhen city, the millennium porcelain capital of China. These defective products were abandoned and are commonly known as "kiln garbage". They were buried as the kiln sites collapsed, and the characteristics of their appearance, generated by the natural environment, make them physically unique. Due to the natural deterioration their suffered while underground, they are unlike the original artifacts meant for practical daily use. The work adopts a material and realistic method to convey the story behind civilization. The artist has explored the value of each piece and has made each of them unique with an abstract form. They are the missing parts of cultural inheritance, which are folded and hidden. Through selection, cleaning, separation, polishing and carving, the artifacts are brought back to life from the memory of destruction and failure. These "historical residues" are messages inspiring the viewers to consider themselves and their own history differently.

闫晓静
Yan Xiaojing

（加拿大 Canada）

灵云	**Spirit Cloud**
淡水珍珠、灯丝、铝	freshwater pearl, filament, aluminum
350cm × 120cm × 330cm	

《灵云》是一件悬挂式的装置作品，该作品由33000多颗淡水珍珠构成，通过数千根透明丝线悬挂在空间之中。这些珍珠构成了空间之中发光的点阵，造型灵感来源于中国园林的假山石和中国传统的祥云造型。从物理构成来说，云主要由水和空气构成，是气象变化的重要构成要素。从物理形态来说，云总处在变化之中，其形象并不固定。但在中国，云被赋予了吉祥的文化寓意。基于此，艺术家模仿了云的造型，并以珍珠代替云朵中的"水滴"，从而将千变万化的云固定了下来，使之成为可供人们持续观赏的艺术作品。

Spirit Cloud is a suspension installation composed of over 33,000 freshwater pearls with thousands of transparent silk threads. These pearls form a luminous lattice in space, with a shape inspired by the Chinese garden rocks and the traditional Chinese auspicious cloud shape. Clouds are physically formed by water and air, and are an important component of meteorological changes. On the other hand, their forms are constantly changing, presenting unfixed images. Moreover, clouds are endowed with auspicious cultural connotations in China. Therefore, the artist imitated the shape of the cloud and replaced the "water droplets" in the cloud with pearls, thereby making the ever-changing cloud "fixed" and making it a work of art that people can constantly watch.

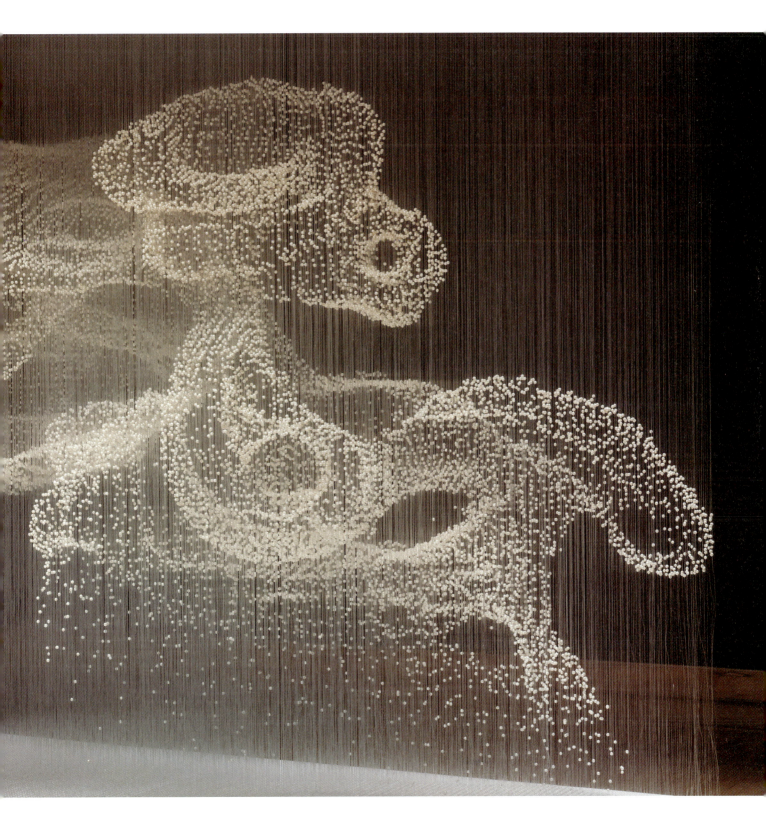

徐小鼎
Xu Xiaoding

(中国 China）

《城市肌理》系列之北京、香港	City Texture Series - Beijing, Hong Kong
纸雕	paper carving
75cm×75cm×2	

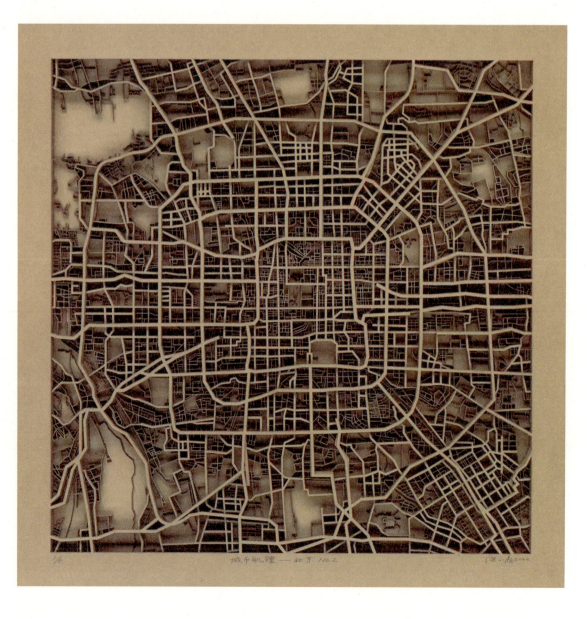

如果从天空中的"上帝视角"观看，每个城市都有其特殊的城市肌理。形成这些肌理的原因包含了地理、政治、宗教、民族性格等多方面的因素，因此，城市地图在形式之外有着深刻的内涵。艺术家选取世界上一些极具符号化的城市地图作为表达对象，试图在作品中将这些城市肌理浓缩在多层纸雕带来的具有体积感和纵深感的平面中，用方寸之间的画面展现人类文明进行的痕迹。

Viewed from God's perspective, every city has its own unique urban texture. The reasons for forming the textures include geography, politics, religion, national character, etc. Therefore, city maps have profound connotations besides their forms. The artist selects maps of some highly symbolic cities around the world as the expression objects, and tries to condense the textures of these cities on a plane with the volume and depth of multi-layer paper carving. Within the inches of space of the work, the traces of human civilization are intended to be presented.

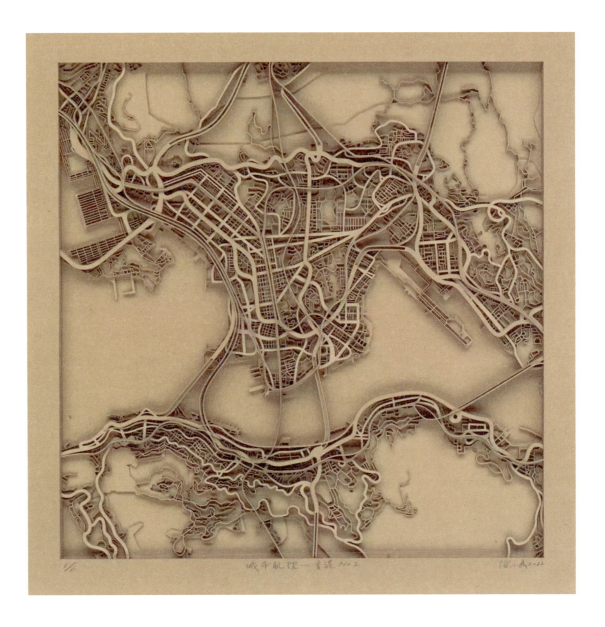

许正龙
Xu Zhenglong

(中国 China)

凳之根	**The Root of a Stool**
木、沙石	wood, sand
高 120cm（in height）	

一个从泥土里生长出来的凳子，有根，有生命，完成了从日常物到生命体的嬗变。艺术家将这种功能性的现成品以艺术的方式将其从日常中抽离、陌生化，使人们开始注意到这些物品的来源——它们是来自于大自然的馈赠与恩典。这些器物在实用性中消泯了自我，它们无处不在，承载着日常生活，但又不被看见和重视。艺术家以巧妙的方式再现了其生命的过程与缘起，在看似荒谬的组合与荒诞的场景中，让凳子在聚光灯下再次生长、昂起头颅、奋勇向上，引发了一场关于器与不器、用与不用、在与不在、生命与场域内外等诸多问题的隐喻与思考。

A stool growing out of the soil has roots and life: the artist demonstrates, in this work, the transformation of a daily body into a living body The artist has created an abstract and artistic representation of an object from daily life. By doing so, he tries to inspire the audience to reflect on the source of these types of objects. We forget that these common daily objects are gifts from the grace of nature. They are everywhere, bearing the weight of daily life, but they are not perceived and valued. The artist reproduces the life and origin of a stool in an ingenious way. Through this seemingly absurd combination and scene, the stool "grows" from the soil under the spotlight, bravely "raises its head", and exists. The metaphor of the work inspires reflection upon many problems, such as the choice between useful and useless, being and not being, and the relationship between life and death.

杨思嘉
Yang Sijia

(中国香港 Hong Kong, China)

皮肤分解	**Decomposition of Skins**
海藻(加工过的海藻提取物)、蚕丝蛋白	algae(processed seaweed extract), sericin (silk cocoon protein)
	60cm × 40cm × 2cm

《皮肤分解》是以新型生物组织材料对时尚纺织业进行探讨的作品。服装是覆盖在人体之外的人造物,也被认为是人类"延伸的皮肤"(马歇尔·麦克卢汉)。但围绕服装的时尚产业,其生产过程和消费过程却产生了大量污染,并影响到全球气候的变化。本作品立足于此背景展开,将纺织生产中废弃的"丝胶"加工成了新型的生物纺织材料。应对于温度和湿度的变化,这种新型的生物纺织材料会在造型和肌理上发生改变,是与传统材料不同的可降解材料。从材料入手,这件作品对于服装从原料生产到时尚消费的全部环节进行了反思和重新设计。

Decomposition of Skins, made with novel biological tissue materials (algae and sericin), is meant to inspire a discussion regarding the fashion textile industry. Clothing, an exterior artificial object that covers the human body, is also considered to be the "extended skin" of human beings (Marshall McLuhan). However, production and consumption of clothing in the fashion industry have caused severe pollution and affected global climate change. In this context, this work processes the discarded "sericin", that is collected from the process of textile production, into a novel biological textile material. This material adapts its shape and texture depending on the changes in temperature and humidity, and is a degradable material, unlike many materials used today in fashion. Using the biological material as a reference, this work reflects and redesigns the entire process of clothing from raw material production to fashion consumption.

杨洋
Yang Yang

（中国 China）

咫尺天涯	So Close, Yet Worlds Apart
麻纸、矿物/植物/土质颜料、沙、金银粉、蚕丝	hemp paper, mineral/vegetable/earth pigments, sand, gold and silver powder, silk
	173cm × 540cm

作品选用蚕丝作为主要材料，蚕丝的特性使其能够在画面中呈现出丝丝缕缕、绵延不绝的视觉感受，正如当今的时代变迁，网络高科技缩短了人与人、人与物、物与物之间的距离，世界似乎变小了，获得信息的方式很多、很快，沟通变得轻松简单，而心与心、心与物的交流却被快节奏的生活慢慢淹没……作品强调了心灵的沟通与观照，通过使用植物、矿物、土质颜料，金银粉等材料对麻纸反复着色、渲染和处理，力求薄中取厚，呈现出时间的光泽。蚕丝用植物颜料染色，凭感觉将其撕扯、抖落、抛洒于画面之中，在此过程中自然形成画面的点、线、面，由于不同的动作的发生，使画面呈现出"软硬、松紧、虚实"的空间关系。

The work uses silk as the main material. The characteristics of silk enable a continuous and unending visual effect. The modern age is full of constant changes, and the advanced technologies of the Internet have shortened the distance between people, and have blurred the differentiation of people versus objects. The world seems smaller, and information seems easier to obtain. Yet, in the context of seemingly easier communication, authentic communication between human minds, as well as between minds and objects, is buried by fast-paced life. The work emphasizes the importance of communication and reflection. Through the use of plants, minerals, soil pigments, gold and silver powders, and other materials, coloring and processing on hemp paper are repeatedly done to create a thick texture on a thin material with a vintage gloss. The silk is dyed with plant pigments, and torn, shaken off, and thrown intuitively by the artist. In this process, the dots, lines and surfaces form naturally. Due to the various actions, the picture represents a spatial relationship of "soft versus hard, loose versus tight, as well as vague versus concrete".

余慧娟
Yu Huijuan

（中国 China）

《褪》系列	"Fade" Series
大漆、灰料、蛋壳、色粉	lacquer, ash, eggshell, powder
80cm × 80cm × 2	

蛋壳与镶嵌技法是当代漆画重要的材料和艺术语言。蛋壳的表现，在更多的场合被视为具有裂纹肌理的明亮事物的叙事性表达。然而，什么是纯粹的蛋壳语言？艺术家在追问和探索中，希望创作出不同于传统漆画中的蛋壳表现方式。在系列组画《褪》中，蛋壳不再是一种装饰，而是布满画面的独立艺术语言，均质有致的蛋壳、斑驳的肌理质感和灰色的微妙变化，艺术家试图说明蛋壳作为一种漆画语言也可自在言说和思想。在剔除叙事性、装饰性之后，艺术家将蛋壳表现的物性特征引向了精神层面，经由材料来追溯一种自由的心性表达。

Eggshells and the mosaic technique are important materials and an artistic language of contemporary lacquer painting. Eggshells are often used to present narrative expressions of light objects with a cracked texture. However, what is the pure eggshell language? Through inquiry and exploration, the artist hopes to find a distinctive expression of eggshells from traditional lacquer painting. In this series of paintings, the eggshells permeate through the paintings as a form of independent artistic language, as opposed to being used purely as an ornamental accent. With homogeneous shape, mottled texture, and gray nuances of color, the artist tries to claim that eggshells, as a language of lacquer painting, have the free ability to speak and think. After removing the narrative and decorative features, the artist brings the physical characteristics of eggshells to the spiritual level. In doing so, a free expression of materials is explored.

原博
Yuan Bo

（中国 China）

灵璧问道	Asking for the Tao at *Lingbi*
瓦楞纸箱、稻草、纸屑	corrugated cardboard, straw, paper scraps
100cm×55cm×15cm×3	

中国古代文人将石视为审美对象，观赏其造型，品鉴其格调，参悟其内涵与哲理。一些石头被称为"灵石"，因为人们在对这些造型优美的石头的观赏玩味中，实现了人与自然的对话，在物我双向的观照中，获得了超越物象直达内心的感悟，这些石头似乎也拥有了灵魂、灵气，成为寄托文人精神与情感的理想之物。当今社会，在快递和物流的推动下物质消费愈发泛滥，大量消耗的包装正吞噬着自然资源。在作品中，艺术家用回收的快递纸箱、稻草和纸屑为材料塑造了当代的"灵璧石"。艺术家在材料替换中引发物欲时代下的审美反思，从日常废弃物的再生中寻得材料价值的升华。

Ancient Chinese literati regarded stones as aesthetic objects. By appreciating the shapes and types of each stone, the literati discovered associations and messages directly from nature. Some stones are called "spiritual stones". Through appreciating their elegant shapes and styles, people can converse directly with nature; they gain enlightenment by appreciating the connection that exists between themselves and these "spiritual" objects. The literati believed that stones could possess a soul, and that they could bear the ideals and sentiments of the literati.

In our current society, driven by express deliveries and logistics, material consumption has become rampant. We can observe the large number of consumed packages, and the natural resources that are being devoured. In this work, a contemporary "*Lingbi* stone" is made out of delivery cartons, straw and paper scraps. The artist endeavors to provoke reflection upon our aesthetics in an age of materialism. By replacing the material of a real stone with that of regenerated waste, the artist creates a representation of our search for new values today.

张筠
Zhang Jun

(中国 China)

惊蛰系列 –3–18A	Awakening of Insects Series - 3-18A
羊毛	wool
65cm × 13cm × 20cm	

"惊蛰"是大地苏醒、万物萌生的开始,是春天到来的信息,是生命的始兆。作为女性,孕育生命给艺术家带来了前所未有的强烈感受,以及对于生命律动最直接的体验。受到这种力量的震撼,艺术家将生命、孕育、繁衍融入了惊蛰系列的作品中。雕塑的造型浑厚而灵动,富含韵律的线条和张弛有度的曲面在空间中汇集,相互交错,在不同角度演绎着生命的篇章。柔软轻薄的材质经过千百次"锤炼",被塑造得既厚重坚实又细润温和,既朴素无华又圣洁大气。这就像生命从无到有的过程,在无数次的雕磨中越趋纯粹。

The *Awakening of Insects* series represents the awakening of nature, all things, spring's messenger, and life. As a woman, giving birth to life brought an unprecedented, strong shock to the artist. Consumed by the most profound rhythm of life through her own motherhood, the artist integrates life, nurturing and reproduction into this series. The lines of this thick but agile sculpture are rich with rhythm, while its curved surface evokes a feeling of relaxation within the exhibition space. With its interwoven character, it suggests life's multi-dimensional chapters. Meanwhile, the soft and thin material of this creation has been tempered thousands of times, making it thick yet delicate, solid yet gentle, unpretentious, as well as holy. This is also a process that symbolizes life, in which purity is gradually cultivated through countless carvings.

张伦伦
Zhang Lunlun

（中国 China）

场所中的雕塑	Sculptures in Sites
综合材料	mixed materials
250cm × 200cm × 200cm	

《场所中的雕塑》是以各种现成品构造而成的具有抽象形态的"雕塑"作品。从外观形态来看，这一系列的作品呈现出抽象的雕塑形态，当归入现代主义带有"拼贴"性质的抽象雕塑。但就组成作品的现成品材料本身来说，它们本身却随机取材于当时周遭的环境。与通常意义上对于现成品的选择和意义再生不同，这些作品最大程度保留了环境本身的社会含义，时间和空间的社会学语境亦被编织进入了作品之中，并从形态上切入了美术史的语境之中。因为都是即兴创作的"雕塑"作品，荒诞和虚无的感受非常强烈，具有很强的禅宗和达达艺术的意味。

Sculpture in Sites is a "sculpture" with an abstract form that is constructed from various ready-made objects. As for its appearance, these objects jointly constitute an abstract creation with a sculptural form, which can be categorized as a modernist abstract sculpture with "collage-like" character. As for the adopted ready-made materials, they are randomly selected from the surrounding environment where the work was created. This is an unusual method of selection which allows for the regeneration of ready-made objects. These objects retain their social meanings, in terms of the environment, to the greatest extent. Moreover, their sociological context of time and space is also woven into the work, and they interfere with the traditional context of art history, simply by their form. Since the work is an improvised "sculpture", an absurdity, and a nothingness - as well as evoking the senses of Zen and Dadaism – it appears in front of the audience as a strong "presence".

张姗姗
Zhang Shanshan

（中国 China）

1271–D	1271-D
综合材料	mixed materials

200cm × 120cm × 2cm

在 20 世纪 50 年代中国农业机械化的起步阶段，拖拉机无疑扮演了特殊角色，是介入现代农业与生活的存在。本作品则着眼于将拖拉机从原有的历史语境中提取出来，单色平涂的背景与立体描绘的拖拉机构成了一种反差，在将对象的时空关系虚化的同时，产生了一种丝网印版画的视觉效果，突出其最具标记性的特征与局部，从而注入新的场域与秩序。画面中强烈的光感和浓艳的色彩迫使观者从今天的文化视角看待历史的存在；历史则褪去斑驳的锈色在反观当中焕然一新。

In the initial stage of China's agricultural mechanization in the 1950s, tractors undoubtedly played a special role and bridged modern agriculture with daily life. This work focuses on extracting tractors from their original historical context, by using a background of monotonous coloring in contrast to the dimensional depiction of a tractor. Through the visual effect of mesh prints, the space-time relationship of the tractor is obscured. The featured part is highlighted, while new details and shapes are introduced. The bright and colorful quality of the work inspires the audience to consider history from the perspective of contemporary culture. The mottled rust of history has thus faded and history obtains a new look from this retrospection.

张雯迪
Zhang Wendi

（中国 China）

玩偶 6 号	Toy Figure No.6
钢网、钢	steel mesh, steel
200cm × 170cm × 120cm	

在视觉文化时代，动漫因其时尚性与娱乐性深受广大青少年的喜爱而不断发展壮大。在《玩偶》系列创作中，艺术家把这些跨越时代的玩偶形象塑造在一起，使伴随几代人成长的玩偶符号共同呈现出欢愉、幸福的场景。它不仅再现了玩偶时代的印记，更是对快节奏高压紧张生活下对人们产生的紧张、焦虑心理所需要的情感"治愈"。艺术家通过缝制的方法利用钢网材料完成了造型的塑造，同时又保留了玩偶形象原有的手作痕迹。材质自身的通透性使作品视觉上增加了轻快感和柔软性，叠加后的虚幻效果产生了记忆的模糊性和时间感。艺术家保留了钢网自身的低明度灰色，产生一种虚化朦胧的视觉效果。金属材料的光感象征着光阴闪烁，钢网风化后的自然锈色更暗示着岁月流逝。

In the era of media culture, animation has continuously been popular among young people because it is modern and entertaining. In the "Toy Figure" series, the artist merges these time-transcending characters together, and gathers the cartoon characters, which represent the growth of several generations, in the same happy and joyful scenario. It not only reminds viewers of the cartoon era, but also emotionally "heals" people's tension and anxiety caused by the fast-paced and high-pressure quality of modern life. In this work, the artist uses steel mesh to build the design and creates "traces" of the original cartoon figure. The permeability of the material visually increases the lightness and softness of the work, and the illusion effect of superposition suggests the fuzziness and remoteness of memories. In addition, the light gray color and pattern of the steel mesh is retained to generate a blooming and hallucinatory visual effect. The shine of the metal material symbolizes the flicker of time, and the natural rust color of the steel mesh after corrosion further indicates the passage of time.

张晓雪
Zhang Xiaoxue

（中国 China）

低烧1~8号	Low Fever No.1-No.8
绢片、水性颜料、机械装置等	silk sheets, waterbased pigments, mechanical devices, etc.
尺寸可变（size variable）	

《低烧1~8号》是以绢构筑的机械装置的综合材料作品。这些绢构成了"果实"或"蛹"等形态的作品，外表涂满了红色颜料，被以悬挂的方式展示着。如触角般薄薄的每一片绢呈现出一种非常低幅度的蠕动状态，无数独特的小触角在微微地张合，形成了一个可沉浸的极为柔软又极具潜在吞噬力的生长空间。低烧形容人体在疲劳，焦虑下的一种存在状态。同时反思了人沉迷于被"人造物"不断丰盈绚丽的欲望表象之下，反之被"人造物"不断重塑但又不易察觉的生命状态。作品构建了一片可以进入又不可进入极高饱和的红色场域，一片饱和到不能透气的红色风景。

Low Fever No.1-No.8 is a work of mixed media made of silk-based mechanical devices. The devices include a "fruit", a "chrysalis", and others. Their surfaces are painted red and exhibited by hanging. In terms of its content, the work expresses itself in an extremely restrained way that reflects people's subjective feelings. The wrinkled and withered devices in this work seem to symbolize the dispirited state of life. In addition, the red shapes of the devices express the inner "tiredness" or "anxiety" of humans that may be related to the pressure of urban life. The work constructs a field of red that is accessible and inaccessible, a red landscape so saturated that it cannot breathe.

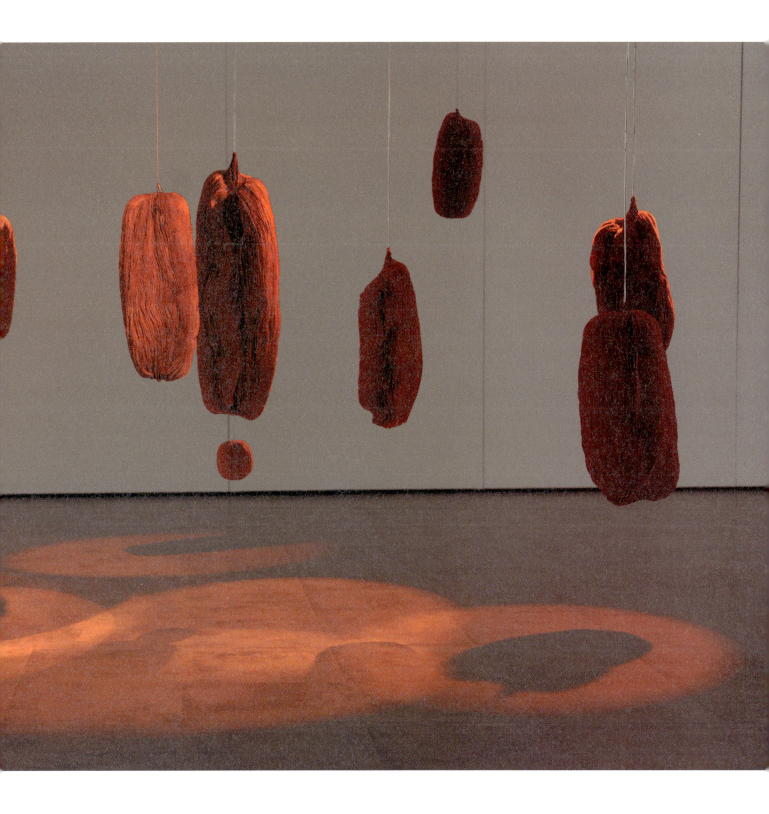

张元
Zhang Yuan

（中国 China）

红荷湿地	Red Lotus Wetland
综合材料	mixed materials
80cm × 65cm	

《红荷湿地》系列组画是艺术家带学生到山东微山湖畔写生后创作的综合材料绘画作品。微山湖湿地千里漂荷，气势磅礴，画家行舟湖中感慨万千。深秋的残荷虽失去了盛夏的美妙靓丽，但更具有丰富的联想语境和诗情画意。"荷"，尤其是"残荷"，既有"出淤泥而不染"的高洁品格，又有"无可奈何花落去"的忧郁气质，艺术家在作品中一面表现这样独具特色的中国文化诗意情趣，一面探索"物质感的绘画"的多种可能，充分发挥主观联想和材料的表现力，力图在人文气息的主题和画面中传递感受和精神性。

The artist took art students to Weishan Lake in Shandong Province for sketching, and created this series made with mixed media. Miles of lotuses afloat on Weishan Lake presented a magnificent scenery that astonished the artist. Although the lotuses of late autumn are not as fresh as they are in the summer, they conveyed a richer associative context and a more poetic flavor. The "lotus", especially the "residual lotus", has both the noble character of "coming out of the mud without being contaminated" and the melancholy character of "having no choice but to watch the flowers withering away". In the work, the artist not only shows a poetic interest that is unique to Chinese culture, but also explores various possibilities of "material painting". The artist expresses his feelings and spirituality through subjective association and the expressive force of the materials used.

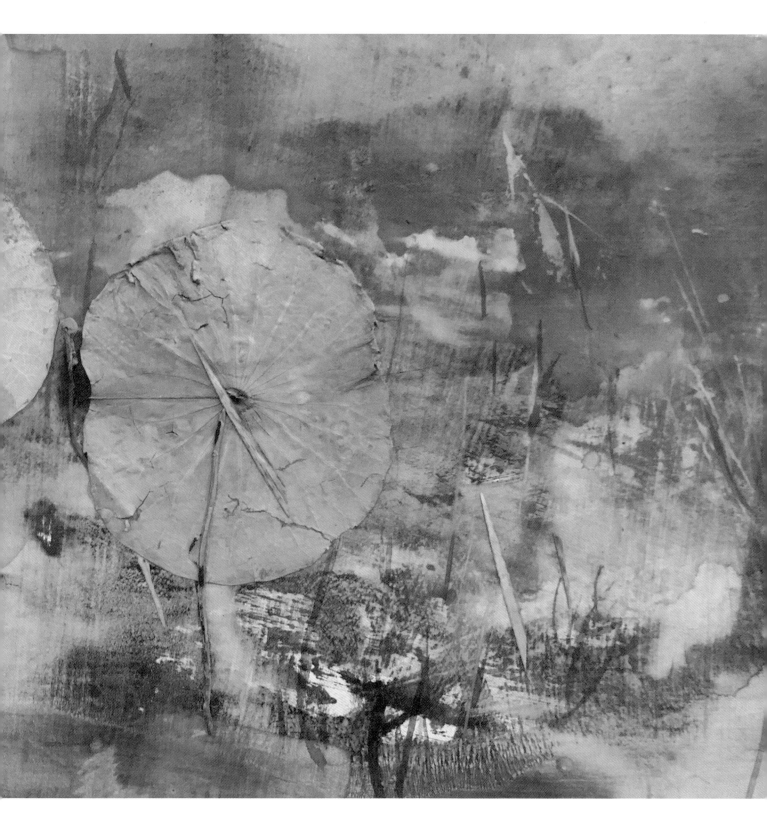

郅敏
Zhi Min

（中国 China）

天象四神—朱雀	The Four Celestial Godly Tokens - Chinese Phoenix (*Zhuque*)
陶瓷、金属	ceramic, metal

620cm × 150cm × 220cm

朱雀，与青龙、白虎、玄武合称"天神四灵"，源于上古星宿崇拜，是一种象征南方的赤色玄鸟。艺术家通过一片羽毛的塑造，用部分喻整体，完成对古典传说中朱雀的想象。作品以陶瓷为主要材料，由数千片可拆卸的瓷片单体，吸附在流线型的载体之上，每一片都经过1350℃的高温手工烧造，以朱砂红主色、橘色间色等红色的渐变，做鳞片状的穿插排布，远观犹如一片燃烧的羽毛。艺术家以陶瓷为主要媒介进行创作已近30年，不断尝试拓展陶瓷的边界，他以小片的陶瓷单体作为表意符号，通过无限拆解和重构，让陶瓷与雕塑相结合，突破体量限制，可随意赋形。作品《朱雀》以弧度形态、饱满的色彩以及陶瓷特有的渐变光泽，让坚硬的材质具备了轻柔的力量。

The Chinese phoenix, the Chinese dragon, the white tiger and the giant black tortoise are four celestial constellations from Chinese ancient astronomy. The Chinese phoenix is a red mythological bird that symbolizes the south. The artist has represented the phoenix in this work as a fiery red feather. Ceramics are the main materials for this piece of art. It is made of thousands of detachable ceramic slices, which are attached to a curvy carrier. Each slice is hand-made and baked at 1350℃. The transition between the main color of vermilion, the secondary color of orange, and other red gradients, is accompanied by the scale-like interwoven arrangements. In doing so, the work appears as a burning feather from a distance. The artist has been using ceramics as a main medium for nearly 30 years. He has been trying to expand the boundaries of utilizing ceramics. Using small slices of single ceramics as expressive symbols, he combines ceramics with sculpture. Through unlimited possibilities for disassembly and reconstruction, he breaks through volume limits, and designs at will. This work is characterized by a curvy design, vivid color, and gradient gloss of ceramics. Through this work, soft power is granted to material with a hard texture.

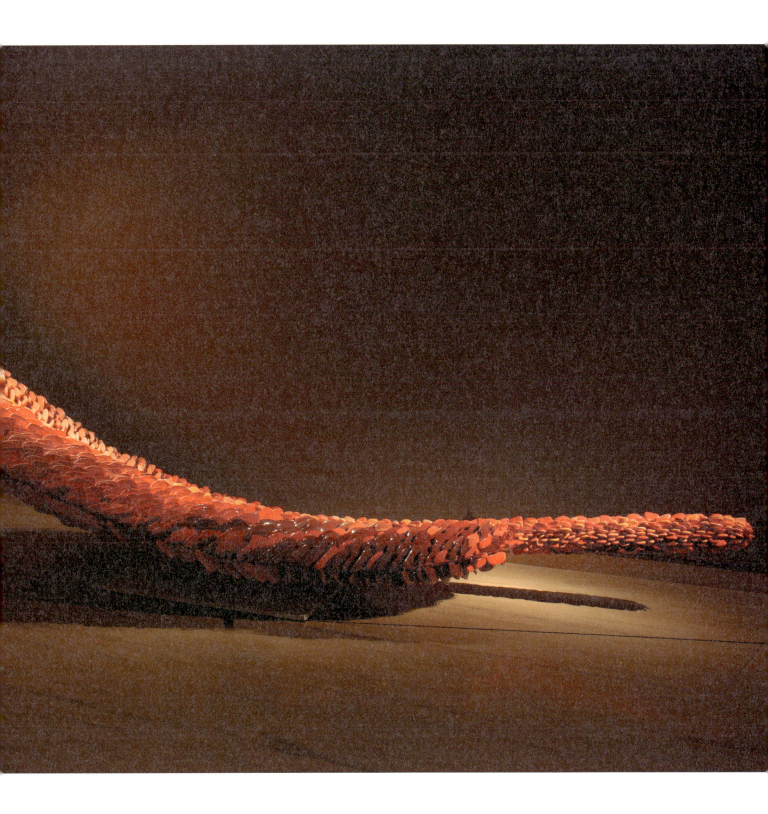

周军南
Zhou Junnan

（中国 China）

纸衣系列Ⅲ—石窟	Paper Clothes Series Ⅲ - Grotto
纸、天然漆	paper, natural lacquer
95cm × 70cm × 95cm，45cm × 40cm × 58cm，55cm × 25cm × 40cm	

《纸衣系列Ⅲ—石窟》是以纸张和天然漆为主的综合材料作品，打造的是中国古代佛教造像的"石窟"形象。因为该作品主要以"纸"构成外形，故而并没有"骨"的部分，造型也就可以随意改变。除了上述材料，"水"也是创作作品偶然性的辅助材料。经过水的浸湿，纸张随着"干""湿"的转化发生着形变，带动了"石窟"发生改变。"水"的加入，将时间的因素带入了作品之中。在艺术家看来，这就如同自然对于石窟的侵蚀，人们仿佛经由作品的变化看到了岁月带来的历史文化变迁。

Paper Clothes Series III - Grotto is a work of mixed media created mainly with paper and natural lacquer. It suggests the image of a "grotto" full of ancient Chinese Buddhist statues. Since this work mainly uses paper to form the structure, the work has no "bones", and the shape can be changed at will. In addition to the above-mentioned materials, water is also an auxiliary material that adds to the contingency of the work. Soaked in water, the paper transforms from "dry" to "wet", and the "grotto" changes likewise. The addition of water integrates the element of time into the work. From the perspective of the artist, this is like nature's erosion of a grotto. People seem to witness the historical and cultural changes of humanity through observing the changes in the work.

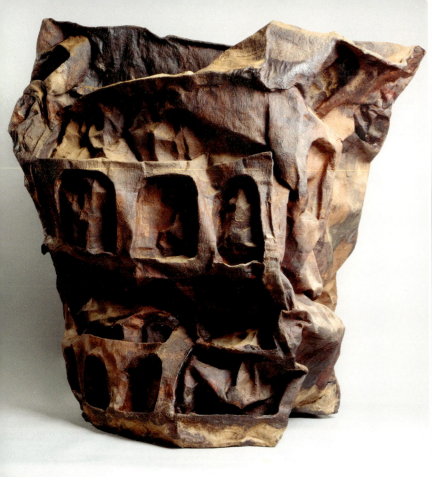
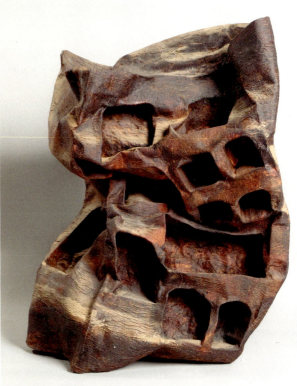
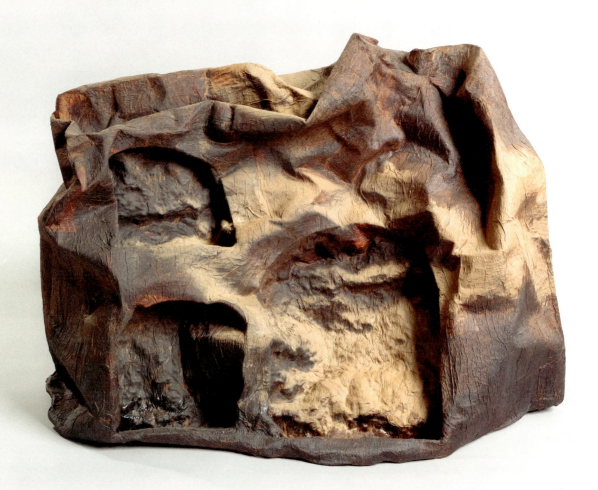

周小瓯
Zhou Xiaoou

（中国 China）

退一步	One Step Back
半透明白麻布、宣纸、木炭等	translucent white linen, rice paper, charcoal, etc.

这件作品创作始于2020年初"新冠"疫情肆虐期间，断断续续，历时一年，创作的过程也是作者为此次灾难祈祷的过程。作品经过了多个创作历程。第一阶段，经过了中国传统宣纸和香火的"对话"，塑造了作者心中的"佛"。第二阶段，初期作品经过了电脑的图像处理，达到了用原始手工无法达到的视觉效果。第三阶段，运用新型现代材料和现代打印技术，在原图形上进行层次变化并放大无数倍，终于达到了最初所设想的视觉效果与创作意图。所谓"退一步"即在视觉上，让观者在通常的展厅里，以习惯的距离很难看清此"形"的真貌，只有退出一定的距离，或更远的距离，人们才能清晰地看到作品本身——"一尊佛"的形象。而人世间，大千世界，想获得觉悟，何尝不是如此，退一步"佛"就在眼前。

The creation of this work began at the beginning of 2020 during the COVID-19 outbreak and quarantine. The creation lasted for one year intermittently, during a year which was represented by humanity praying for the elimination of the virus. The work has gone through several stages. In the first stage, through the "dialogue" between Chinese art paper and incense, the artist created the "Buddha" out of his mind. In the second stage, the initial work was processed by computer to achieve a visual effect that could not be achieved by handwork. In the third stage, the artist used novel modern materials and printing technology to make numerous layers based on the original picture. In doing so, the desired visual effect and the artist's aim was realized. *One Step Back* means that, in terms of vision, it is difficult for the audience to get an overview of the "shape" of the work. Only by stepping back a certain distance, can people clearly recognize the work - an image of "a Buddha". And in the vastness of the world, if you want to gain enlightenment and see the "Buddha", you also need to take a step back.

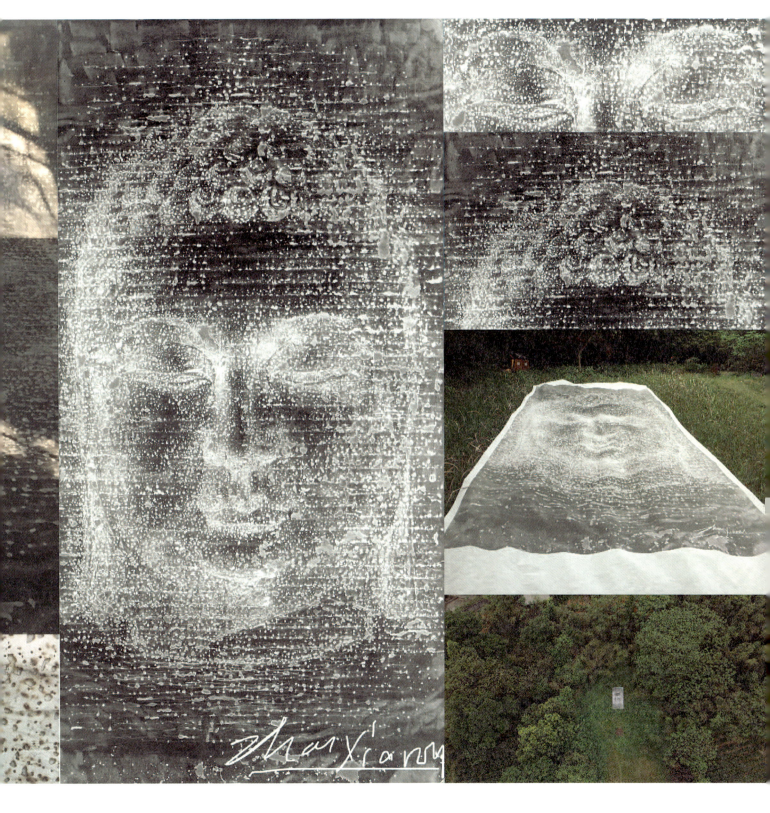

唯物思维 | Material Thinking
首届国际当代材料艺术双年展
1st International Contemporary Material Art Biennale

青岛云上海天艺术中心 Tsingtao Haitian View & Art（2022.6.20–2023.2.27）
北京南池子美术馆 Beijing Nanchizi Museum（2022.12.17–2023.3.5）

主办：清华大学
Host：Tsinghua University

联合主办：青岛国信集团
Co-host：Qingdao Conson Development（Group）Co., Ltd.

承办：清华大学美术学院当代艺术研究所、青岛国信海天中心建设有限公司、青岛国信文化旅游管理有限公司、北京南池子美术馆
Organizer：Contemporary Art Institute, Academy of Arts & Design, Tsinghua University, Qingdao Conson Hai Tian Center Construction Co., Ltd., Qingdao Conson Culture Tourism Management Co., Ltd., Beijing Nanchizi Museum

学术支持：《清华美术》、国际材料艺术研究（IMAS）
Academic Support：Tsinghua Art, International Material Art Study

学术委员会 Academic Committee

奥西尔·伯顿 Åsil Bøthun（挪威 Norway）、白明 Bai Ming、卡门·因巴赫·里格斯 Carmen Imbach Rigos（阿根廷 Argentina）、陈辉 Chen Hui、陈琦 Chen Qi、董书兵 Dong Shubing、顾黎明 Gu Liming、杭春晓 Hang Chunxiao、胡伟 Hu Wei、林乐成 Lin Lecheng、鲁晓波 Lu Xiaobo、马赛 Ma Sai、玛丽亚·奥尔特加 Maria Ortega（西班牙 Spain）、莫妮卡·莱曼 Monique Lehman（美国/波兰 USA/Poland）、彭刚 Peng Gang、拉圭尔·勒杰尔格 Raquel Lejtreger（乌拉圭 Uruguay）、尚刚 Shang Gang、尚辉 Shang Hui、王平 Wang Ping、王家增 Wang Jiazeng、吴洪亮 Wu Hongliang、许正龙 Xu Zhenglong、于洋 Yu Yang、张敢 Zhang Gan、张子康 Zhang Zikang（按姓名首字母排序 The names were listed in alphabetical order.）

组织委员会 / Organizing Committee

总策划：彭刚
General Director：Peng Gang

学术主持：马赛
Academic Host：Ma Sai

总策展人：张敢
Chief Curator：Zhang Gan

执行策展：梁开、尤维塔·撒克朗斯凯特
Executive Curator：Liang Kai, Jovita Sakalauskaite

展览统筹：陈燕、雅行
Exhibition Coordinator：Chen Yan, Ya Xing

展览执行：袁媛、刘震、郭歌、冀文渊、贺强、张瑜洋
Implement：Yuan Yuan, Liu Zhen, Guo Ge, Ji Wenyuan, He Qiang, Zhang Yuyang

视觉设计：刘德坤
Visual Design：Liu Dekun

展陈设计：王建 & 艺清文创设计工作室
Exhibition Design：Wang Jian & Art Tsinghua Design Studio

图录撰写：梁开、谢泽豪、刘飓涛
Catalog Writing：Liang Kai, Xie Zehao, Liu Jutao

翻译校对：卡塔日娜·萨迪伊、梁开、孟彤
Catalog Translation：Katarzyna Sądej, Liang Kai, Meng Tong

论坛组织：尤维塔·撒克朗斯凯特、梁开、王瀚生
Symposium Organizing：Jovita Sakalauskaite, Liang Kai, Wang Hansheng

图书在版编目（CIP）数据

"唯物思维"首届国际当代材料艺术双年展作品集= "Material Thinking" 1st International Contemporary Material Art Biennale Catalogue / 张敢主编；梁开执行主编 . —北京：中国建筑工业出版社，2022.12
　ISBN 978-7-112-28213-5

Ⅰ.①唯… Ⅱ.①张…②梁… Ⅲ.①艺术—设计—作品集—中国—现代 Ⅳ.①J121

中国版本图书馆 CIP 数据核字（2022）第 222023 号

责任编辑：费海玲
文字编辑：汪箫仪
责任校对：芦欣甜
书籍设计：张悟静
封面设计：刘德坤

"唯物思维"首届国际当代材料艺术双年展作品集
"Material Thinking" 1st International Contemporary Material Art Biennale Catalogue
主　　编　　张敢
Chief Editor　　Zhang Gan
执行主编　　梁开
Executive Chief Editor　　Liang Kai
*
中国建筑工业出版社出版、发行（北京海淀三里河路9号）
各地新华书店、建筑书店经销
北京雅盈中佳图文设计公司制版
北京富诚彩色印刷有限公司印刷
*
开本：880毫米×1230毫米　1/16　印张：22$\frac{1}{2}$　字数：582千字
2022年12月第一版　　2022年12月第一次印刷
定价：**208.00**元
ISBN 978-7-112-28213-5
　　　（40290）

版权所有　翻印必究
如有印装质量问题，可寄本社图书出版中心退换
（邮政编码 100037）